MASTERING THE ART OF
MANGA

MASTERING THE ART OF
MANGA

LEARN TO DRAW MANGA STEP BY STEP WITH OVER 1000 ILLUSTRATIONS

TIM SEELIG, YISHAN LI AND RIK NICOL
Consultant editor: ANDREW JAMES

HERMES
HOUSE

This edition is published by Hermes House,
an imprint of Anness Publishing Ltd
Hermes House
88–89 Blackfriars Road
London SE1 8HA
tel. 020 7401 2077; fax 020 7633 9499

www.hermeshouse.com; www.annesspublishing.com

Anness Publishing has a new picture agency outlet for images for publishing, promotions or advertising. Please visit our website www.practicalpictures.com for more information.

Publisher: Joanna Lorenz
Editorial Director: Helen Sudell
Project Editors: Hazel Songhurst, Sarah Doughty, Susie Behar
Designer: Glyn Bridgewater
Art Director: Lisa McCormick
Artists and Contributors: Yishan Studio, Rik Nicol, Wing Yun Man, Jacqueline Kwong and Tim Pilcher
Proofreading Manager: Lindsay Zamponi
Editorial Reader: Lauren Farnsworth
Production Manager: Steve Lang
Production Controller: Mai Ling Collyer

Designed and produced for Anness Publishing Limited by Ivy Contract

ETHICAL TRADING POLICY
At Anness Publishing we believe that business should be conducted in an ethical and ecologically sustainable way, with respect for the environment and a proper regard to the replacement of the natural resources we employ.
 As a publisher, we use a lot of wood pulp to make high-quality paper for printing, and that wood commonly comes from spruce trees. We are therefore currently growing more than 750,000 trees in three Scottish forest plantations: Berrymoss (130 hectares/320 acres), West Touxhill (125 hectares/305 acres) and Deveron Forest (75 hectares/185 acres). The forests we manage contain more than 3.5 times the number of trees employed each year in making paper for the books we manufacture.
 Because of this ongoing ecological investment programme, you, as our customer, can have the pleasure and reassurance of knowing that a tree is being cultivated on your behalf to naturally replace the materials used to make the book you are holding.
 Our forestry programme is run in accordance with the UK Woodland Assurance Scheme (UKWAS) and will be certified by the internationally recognized Forest Stewardship Council (FSC). The FSC is a non-government organization dedicated to promoting responsible management of the world's forests. Certification ensures forests are managed in an environmentally sustainable and socially responsible way. For further information about this scheme, go to www.annesspublishing.com/trees

Contents

The origins of manga

Whether you are a fan of manga or not, you will probably have read the headlines proclaiming its sweeping successes across the globe, noticed the titles creeping to the top of the bestseller charts, or seen teenagers on the bus reading the latest volume of *Naruto* or *Fruits Basket*. But what is manga, and what does 'manga' really mean? At its simplest level, it is the Japanese term for a comic book: the sequential fusion of illustrated panels and written dialogue. In practice, however, manga has come to represent a series of styles, subgenres and types of story that are recognized, and have been exported, all over the world. The popularity of manga is now at its peak, with bookshelves full of titles in every country in every conceivable genre, catering for every kind of reader, young and old. The greatest feature of manga is its universal accessibility: unlike Western comics, which have for several decades been perceived as the sole purview of young males reading about Spandex-clad superheroes, manga has been strongly embraced by girls and women. Manga as we know it may be a relatively new form of art, but its roots stretch back to the 17th century, birthed in a tradition of affordable, mass-produced prints that has been constantly evolving. Take the tour below to find out how it all began.

The birth of manga

The genesis of manga ties most closely with a form of mass-produced woodcut prints called *ukiyo-e*, or 'pictures of the floating world'. The 'floating world' refers to the blooming merchant class that gained a foothold in Japan from the 17th century onwards. Compared to traditional Japanese society, which was strongly governed by regulations and etiquette, the merchants were relatively unencumbered, and thus 'floating'. Ukiyo-e showed colourful scenes of urban life, from courtesans to sumo wrestlers; before long, it had expanded into rural landscapes, too. They were affordable, mass-produced and very popular. Ukiyo-e could also be found alongside text stories in picture books called 'ehon', another forerunner of modern manga.

One of the most famous and well-regarded artists of ukiyo-e, operating at the height of the Edo period (1603–1868), was a man named Hokusai. Born in 1760, Hokusai was painting by the age of six and published his first prints before 1780. He was among the first to use the term 'manga' in the title of one of his bound collections. His use of the word has been translated in dozens of ways: from 'whimsical pictures' to 'involuntary sketches', but it is clear that his concept was far from the one we know today.

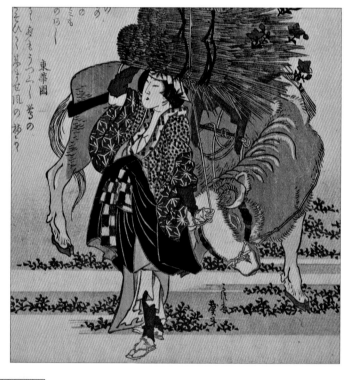

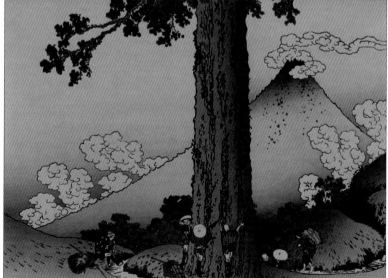

◀ *Mishima Pass in Kai Province*, by **Hokusai**
Men surround the trunk of a tree in this example of Hokusai's work from 'Thirty-six Views of Mount Fuji', in which he travelled the Edo region c.1830 (modern-day Tokyo), illustrating the beloved volcanic mountain. The portfolio, created when he was in his seventies, was a popular and commercial success.

▲ *Coming from the Field*, by **unknown artist**
This ukiyo-e print demonstrates the shift from urban to rural concerns, as well as demonstrating the intricacy of line and vividness of colour for which the prints are famous. Note, too, the integration of descriptive text with the illustration – surely a precursor to caption boxes and word balloons.

From woodcut to cartoon

From Hokusai, it was not long before another significant development took place in the evolution of manga. Just as the woodcut method of ukiyo-e allowed great art to become available to those on moderate incomes, so the increasing prevalence of the industrial printing press and the daily newspaper – as well as Western influences in the Meiji era – took art and information to the masses. Newspapers opened the door for cartoonists and manga artists, first among them was Rakuten Kitazawa (1876–1955), revered as the founding father of modern manga. The first professional cartoonist in Japan, he did much to promote the art form by encouraging and promoting young manga-ka (artists) in the 1920s, and was instrumental to the success of the Sunday comic strip section *Jiji Manga*. Although Japanese comic strips could be found in newspapers and magazines from before the turn of the 20th century, it wasn't until the period after World War II that manga truly flourished.

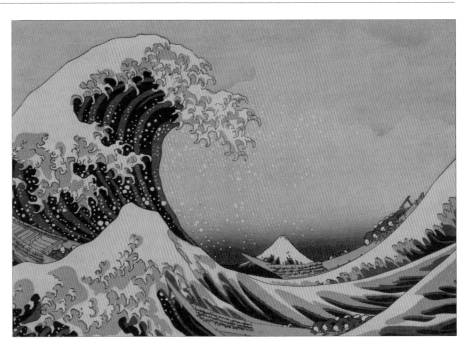

***Tsunami*, by Hokusai** ▲
This famous ukiyo-e print of a tidal wave dwarfing and reflecting the mountain beneath combines an intricate approach to wood-carved detail with a powerfully limited palette. Each colour would be applied to the print as a separate cut woodblock, with deeper shades needing several applications. Thus, while mass-produced, there was still a great deal of craft and time involved in every print.

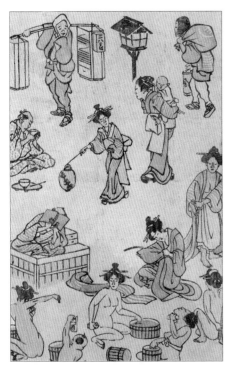

Caricature of Kitazawa ▶
This poster by the cartoonist Ferreol Murillo Fuentes (2005) was produced to mark the fiftieth anniversary of Kitazawa's death. Kitazawa's first cartooning jobs were for American publications: *Box of Curious* and *Puck*, both in the 1890s.

◀ ***Gestures of Daily Life*, by Hokusai**
This colour woodblock print, from Hokusai's 'Manga' collection, tells a narrative of everyday urban life without the use of panel borders, in a manner that would be echoed by the forerunner of Western graphic novels, Will Eisner. Note how the composition of the figures guides the reader's eye down the page.

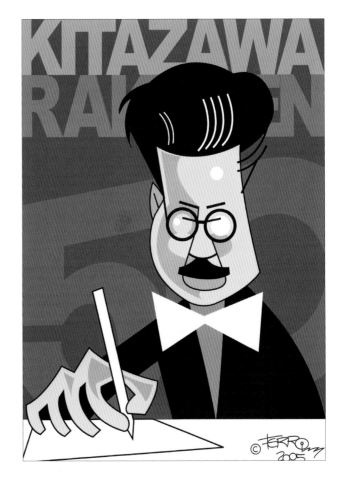

The rise of manga

Japan began its modernization at the beginning of the Meiji era in 1868, under the 45-year rule of the Emperor. During that time the country absorbed and perfected influences from the West. But it was in the years after World War II, when the country entered its most frenzied period of creativity and industrialization, that manga crystallized into the form we now recognize. A new generation of creators, who had grown up reading the comic strips of Kitazawa and his peers, embarked on their own manga careers. This time, their ambitions were greater: to use the medium to tell long-form stories, using all of the cinematic and artistic techniques at their disposal. The Japanese public fell in love with these new manga immediately, driving the weekly magazines in which they were contained to ever-greater heights of circulation success, and inspiring animated spin-offs, merchandise, de luxe collections – and imitators by the thousand. Magazines sprang up to cater for specific genders – shonen for boys, shojo for girls – and genre lines, too, were drawn.

Modern originator of manga

Dr Osamu Tezuka (1928–89), one of the young artists inspired in childhood by Kitazawa's work, fused his love of Japanese cartooning with the Western influences brought to Japan by the American occupying forces after the close of World War II. He took aspects of the cartoons of Walt Disney and fused them to a larger-than-life, cinematic storytelling, to create the dynamic, action-packed, 'big eyes, small mouth' style that has become synonymous with manga today. In his lifetime, he produced more than 150,000 pages of material – but his breakthrough hit, and most beloved character, was *Tetsuwan ATOM* (*Astro Boy*). Although much of his work has never been translated from the Japanese, Tezuka's influence on the development of manga cannot be underestimated. His work ranged from environmental fables (*W3/Wonder 3*), 'talking animal' stories (*Jungle Emperor/Jungle Taitei*), 'the mother of all shojo manga' (*Princess Knight/Ribon no Kishi*), sexually explicit historical epics (*Cleopatra: Queen of Sex/Kureopatora*), medical thrillers (*Black Jack*) and personal explorations of cosmic philosophy (*Phoenix*). Tezuka turned his pen to virtually everything. His last major manga epic (worked on between 1974 and 1984) was an eight-volume critically acclaimed retelling of the life of Buddha.

Tezuka's stylistic innovations which encompassed slow-motion progressions through panels, cinematic angles and plenty of rapid zooms from long to close-up shots – would go on to define much of boys', or shonen, manga over the next half century.

Effortless cool ▲
This panel from *Black Jack* showcases the medical anti-hero, just arrived by helicopter to perform another delicate operation.

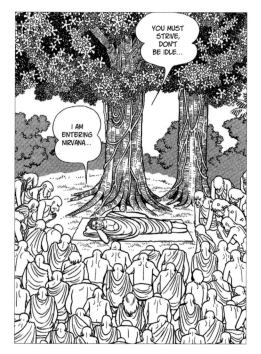

◀ **The death of Buddha**
Buddha's mortal life and Osamu Tezuka's eight-volume epic come to an end in this touching crowd scene, as Buddha passes into nirvana surrounded by his friends, protégés and students. The end of the story represented 11 years of serialized work by Tezuka.

Birth of an epic ▶
The cover for the first book in the English adaptation of the manga, designed by Chip Kidd, and split into eight translated volumes. The pages are presented in the 'flopped' format, where the original Japanese pages are mirrored so that the translation reads left to right.

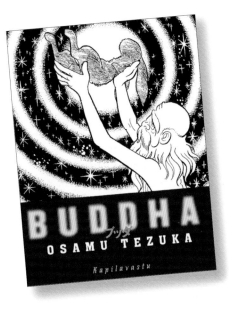

The evolution of shojo

Machiko Hasegawa (1920–92) was one of the first female manga artists to become a part of this new manga era, creating the massively influential strip *Sazae-san*, which began in 1946 and remains popular – as a weekly radio and animated television show – to this day. Her focus on the everyday life of women and girls crystallized into the broad tenets of shojo, or girls', manga. This revolution broadened the scope of manga yet again, and pointed the way towards the 'something for everyone' marketplace of today.

The year 1969 saw another sea-change, as the Year 24 Group (named for the year in which they were born: Showa 24, or 1949) of female manga-ka (a level of artistic expertise) made their shojo manga debut, shuffling perceived gender and genre restrictions and introducing many of the categories we see today, from romance to superheroines and shonen-ai (love stories between two boys, aimed at young girls) and shojo (including science fiction). The ascendance of the Year 24 Group also marked the first point at which the majority of manga for women and girls were being written and illustrated by their target demographic. They also pioneered the use of non-standard panel layouts, softening or removing panel borders, or changing them to suit the emotional tenor within, and altering the entire grammar of manga illustration as a result.

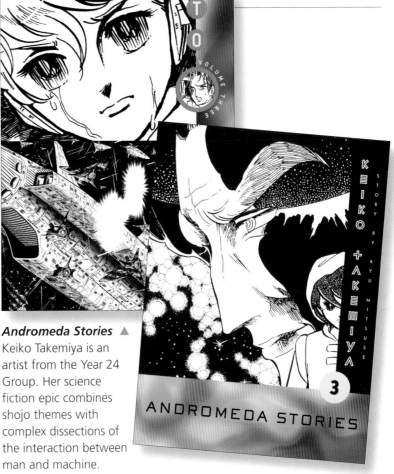

Andromeda Stories ▲
Keiko Takemiya is an artist from the Year 24 Group. Her science fiction epic combines shojo themes with complex dissections of the interaction between man and machine.

The manga format

Manga stories are usually serialized in 20-page chunks in bulky magazines. They are published weekly or monthly on low-quality paper to keep the cost down. The most popular series are subsequently collected in *tankubon*, which we would probably call graphic novels. The tight deadlines required by weekly or monthly publications producing tankubon mean that most manga-ka work in studios with a handful of (largely uncredited) assistants. These assistants aid in the drawing of backgrounds, and the shading and toning process. They also usually 'graduate' to manga-ka status, themselves within a few years.

Manga's massive appeal is often credited to the sheer breadth of its content. Modern manga tell stories of the fantastical, the futuristic, the romantic, and the humdrum. Whatever their age or interest, there will be a series out there for every reader.

Dragon Ball Z ▼
One of the most prolific shonen manga, the image below shows only a small selection from the series.

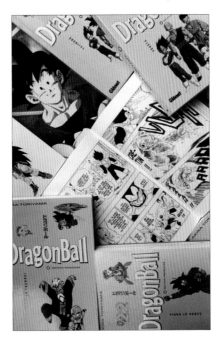

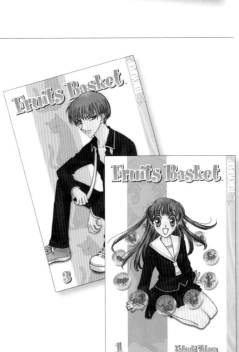

Fruits Basket ▲
The number one shojo manga in the English-speaking world, *Fruits Basket*'s enduring popularity rests on strong characters and a regular release schedule.

Manga worldwide

Manga is a multibillion dollar industry even within Japan, but its reach now extends around the world, whether literally, as in the swarms of reprints and original titles that can be found on English-language bookshelves, or metaphorically, as in the liberal borrowings of style made by entertainment industries in the West. Manga's greatest strength is in its flexibility: it is a format rather than a genre, a delivery mechanism rather than a prescription of content. Fans of giant robot action, high school romance, extreme cookery, basketball, monstrous dimensions, psychological horror, daring crime thrillers or illegal street racing can all find something that appeals to them on the bookshelves.

The manga invasion

One of the first manga to be translated and released in the West was Keiji Nakazawa's moving account of the Hiroshima bombing, *Barefoot Gen*. While other manga, such as *Lone Wolf and Cub*, were translated throughout the 1980s, it wasn't until the release of Masamune Shirow's *Appleseed* by Eclipse Comics and the recoloured edition of Katsuhiro Otomo's *Akira*, partially published by Marvel's EPIC imprint in 1988, that English-language demand for manga and anime began to grow, and the international market started to open up.

Throughout the 1980s and 1990s, series such as *Akira, Dragon Ball, Neon Genesis Evangelion, Pokémon, Oh! My Goddess, Ghost in the Shell, Battle Angel Alita, Love Hina, Ranama 1/2, Cowboy Bebop, Sailor Moon, Cardcaptor Sakura* and *Magic Knight Rayearth* saw increasing crossover success, bolstered by the twin assault of translated volumes and popular anime films and television shows.

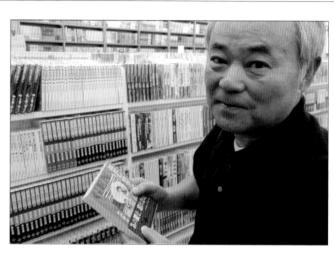

◀ **Keiji Nakazawa**
The author of *Barefoot Gen* browses his manga in a Hiroshima bookshop. Nakazawa began the semi-autobiographical, ten-volume *series* when his mother died of radiation poisoning, aged 60.

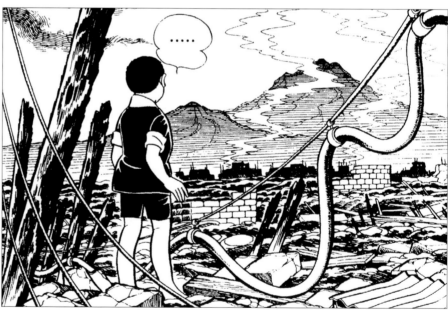

Manga magazines ▼
Part of manga's attraction in Japan is its ubiquity: a wide selection of magazines covering all genres and tastes can be found in every bookshop, newsagent and train station kiosk.

Post-nuclear holocaust ▲
Gen surveys the devastation in Hiroshima wraught by the atomic bomb dropped from the *Enola Gay*. *Barefoot Gen* deals with the harsh realities of life in the aftermath of an atomic explosion, from the initial devastation through to the more insidious effects of radioactive fallout. It ran in several mass-market magazines, from the early 1970s to the mid-1980s and has also been made into a television series and several animated films. *Barefoot Gen* was one of the first manga to be released in English from the mid-1970s.

Manga explosion

The period 1996–7 saw the founding of manga publisher TokyoPop by Mixx Entertainment with its headquarters based in California, USA. It was soon followed by a cadre of competitors, and the modern era of aggressively promoted tankubon collections began. Such companies often have thousands of volumes in print.

Although there are evergreen titles that retain their popularity indefinitely, there are always new young pretenders arriving to claim the most popular manga crown. In recent years, these have included the chilling supernatural procedural *Death Note*, the ninja-in-training epic *Naruto*, piracy quest *One Piece*, twentysomething drama *Nana*, martial arts expert *Ranma ¹/₂*, female cyborg Battle Angel Alita also known as *Gunnm*, the ghosthunting *Bleach*, gothic spectacular *Vampire Knight*, über-violent school satire *Battle Royale* and steampunk adventure *Full Metal Alchemist* but this is just dipping a toe in the pool.

Today, manga has truly conquered the world of comics, especially among younger readers, who have grown up fluent in its intricacies and culture-clash elements. Titles such as *Naruto* and *Fruits Basket* regularly displace all comers from the top of the *New York Times* bestseller list when a new volume is released.

Market leaders ▶
Manga today is made up of an array of newly translated titles and Original English Language (OEL) titles.

◀ **Manga merchandising**
As well as their enduring popularity as stories, the characters from many manga comics have become just as well known as pop culture icons, with *Astro Boy* (shown left) and *Hello Kitty* becoming phenomenal international sales successes in clothing, toys, bags and more.

Using this book

This book aims to make you a master of manga, able to turn your hand, pen or digital stylus to any one of the numerous manga genres, confident in your storytelling and draftsmanship abilities. The chapters to come will give you the opportunity to sample every style of manga, from contemporary shojo to futuristic shonen and all points in between. As you work your way through the book, or simply dip in and out, you'll find an array of helpful hints, tips and short cuts, in-depth walkthroughs of techniques, explanations of terms, materials and approaches. There are unique projects to test your understanding and ability, while giving you the opportunity to show off all that you've learned, all clearly illustrated by colourful examples from a professional manga-ka. Whether you're a manga novice or an experienced illustrator and writer, you'll find something new here to challenge and inspire.

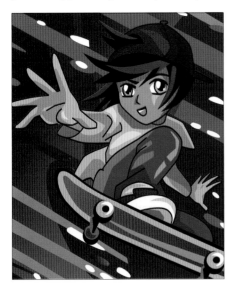

◀ **Skateboader**
Manga thrives on energetic protagonists, blistering action and colourful settings: so maximize your potential over the next few chapters.

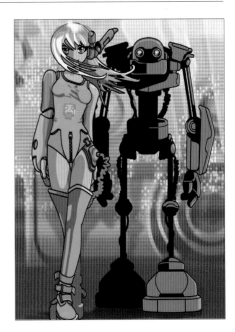

Cyborgs and androids ▲
Manga is an opportunity to let your imagination run wild: follow the guides and you'll soon have dozens of fully populated worlds to choose from.

Styles of manga

There are many styles of manga around today, although some of the lesser-known genres don't make it over to Europe or the USA. Unlike comics in the West, manga in Japan is a national form of entertainment, and much like novels and films, covers just about every aspect of life. Some manga is purely fantastical and escapist, while other genres are centred around more realistic or educational themes. The genres listed here don't encompass the entirety of the manga scene – the more extreme forms are not covered – but this overview will provide you with a good idea of what's possible in your own work by showing you what is currently practised and popular in the world of manga.

Core genres

Like other art forms, manga is grouped into genres according to common attributes. Stories which share similar elements and characters are usefully defined in this way. There are four core genres, as defined by the gender and age of their target readership. These include manga for children, for young people (divided into stories for both girls and boys) and mangas for adults in all sorts of possibilities and varieties. The core mangas are:

Kodomo ▶

This genre is aimed at the very young (*kodomo* means 'child') and based on humour. Sometimes the stories have no dialogue, so children who can't read get everything they need from the visuals.

Kodomo has its own traits that distinguish it from other genres:
1. Child protagonists who usually have cute, intelligent pets.
2. Humorous storylines.
3. Simple narratives with easy themes that can be understood by as wide an audience as possible.

Shonen ▲

This is the most popular type of manga worldwide, largely because it is these stories that get translated and exported. Shonen is aimed at boys aged between 12 and 18 (*shonen* means 'boy') and thrives on constant, over-the-top action, adolescent male heroes seeking to be the best they can be, and quest-based narratives, structured almost like video games, with frequent 'boss battles' and 'levelling up'.

◀ Shojo

Meaning 'young girl', between 7 and 18 years old, *shojo* concentrates on emotion and feelings. Originally drawn by men, an explosion of female artists in the 1970s brought a sea-change in subject matter. Shojo stories share young female leads, themes of romance and friendship, and thought-provoking, not punchy, dialogue.

◀ Seinen and josei

Aimed at adults, seinen was first developed in the 1960s for men aged between 18 and 25, but its readership has expanded to men in their forties and beyond. Josei is targeted at women aged over 20.

Most seinen and josei stories share the following traits:
1. Protagonists in positions of authority: heads of companies, the armed forces, and so on.
2. More realistic, less exaggerated characters.
3. 'Cinematic' dialogue, lending the stories a filmic quality.
4. Sporadic use of comedy.
5. Adult themes, including realistic violence and erotica.

Manga subgenres

Within the four main genres, there are various subgenres aimed at specific audiences within each defined age and gender group.

Gakuen ▲
This means 'high school': appropriately, all of the stories take place within the confines of a school and are part of the shojo genre.

Ronin ▲
This is a seinen manga featuring a rogue, 'masterless', samurai warrior. The warrior wanders ancient Japan, working only for those who meet his price, or defending the innocent. His reputation instils fear, loyalty and awe.

Mahokka ▲
This means 'magical girls', and is a shojo comic featuring girls endowed with magical powers who fight evil. Stories start in high school, but often leave for more fantastic locations.

Lady comic ▶
A subgenre for women, part of josei. Target readers of lady comics are women in their twenties, especially home or office workers. Stories reflect the lives of their readers, spiced up with romantic meetings and secret dates between aspiring lovers. It is the 'daytime soap' of manga.

Jidaimono ▲
Part of shonen or seinen. The protagonists of jidaimono are ninja or samurai-style characters. Stories are typically epic and set in historical Japan. They may be based on actual events.

Sentai ▲
Stories based on shonen or seinen genre. They are similar to jidaimono, but usually have a mythical edge, utilizing the full breadth of Japanese folklore, from demons to ancestral gods. The protagonists often have special, even magical abilities.

Cyberpunk and mecha ▲
Both are science fiction settings. Cyberpunk showcases futuristic (even fetishistic) technology, often with cyborg (cybernetic organism) protagonists. Cyberpunk is a subgenre of seinen while mecha is closer to shonen. Mecha characters are usually pilots of enormous, man-shaped robots, defending the planet against a similarly giant alien threat. Common threads in both genres are the blurring of the boundaries between man and machine, and the difficulty of halting technological advancement, should it fall into the wrong hands.

Spokon ▲
This means 'sporty spirit' and is a subgenre of shonen or shojo. The shojo heroine has to make an arduous and demanding journey, as she strives to become the best at her chosen sport.

1

Tools of the trade

It is relatively straightforward to achieve professional manga results with the aid of a few basic tools. Here is a chance to familiarize yourself with the array of pencils, pens, tones and colours available, plus some examples of their associated techniques.

Pencils

What we draw with is as important as what we draw on. By experimenting with as many different tools as possible, you will discover what best suits your way of working. The pencils shown below are all suitable for drawing manga, but your choice needn't be confined to these.

The majority of manga are illustrated in black and white, so your everyday toolkit should consist of standard pencils, perhaps divided into 'line-making' and 'tone-making' types. If you are planning to ink your pencil lines for later reproduction or colour, for instance, you may find that using an HB pencil or mechanical pencil to lay down your lines may be all you need, with line weight provided later by brush or dip pen, and tone or colour added digitally. Water-soluble pencils and charcoal sticks are best confined solely to the colour and shading portions of your work. Alternatively, you may wish to ink your pencil lines, erase all of your initial 'construction marks', and add shading with softer-leaded pencils to retain a more organic, traditional-media feel.

Types of pencil

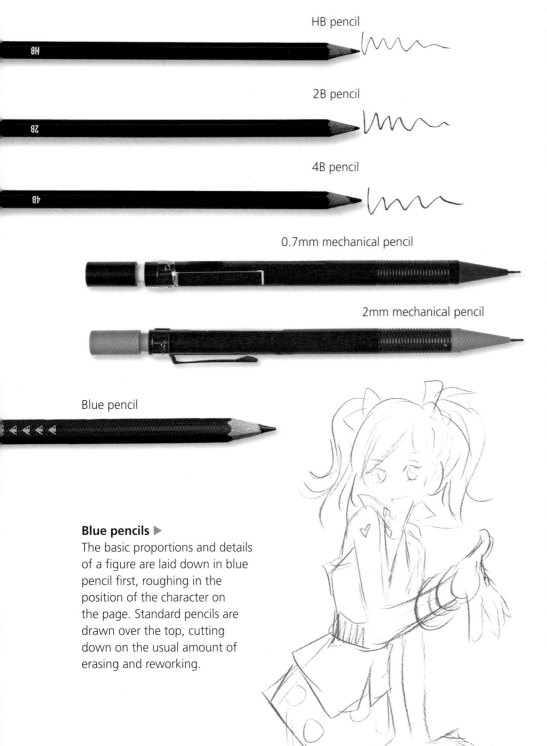

HB pencil

2B pencil

4B pencil

0.7mm mechanical pencil

2mm mechanical pencil

Blue pencil

Blue pencils ▶
The basic proportions and details of a figure are laid down in blue pencil first, roughing in the position of the character on the page. Standard pencils are drawn over the top, cutting down on the usual amount of erasing and reworking.

The pencil is an artist's most versatile tool, with an extensive choice available from hard and grey to soft and black. 'H' refers to hardness and 'B' to blackness. B to 9B are the soft, black choices. HB falls right in the middle and is the best general-purpose pencil. 2H to 9H are the hard pencils in the spectrum, with 9H the hardest. Their more permanent marks score the paper, making them more difficult to erase.

You may wish to invest in three levels of blackness: for example an HB, a 4B (very soft, very black), and perhaps a 2B (soft and dark grey). Pencil thicknesses also vary and your choice will depend on whether you want loose or precise lines. A selection of pencils to fit a standard pencil-sharpener are probably the most useful.

The tip of a mechanical pencil retains a consistent thickness: it blunts equally and never requires sharpening. A lead size of 0.5mm will produce fine lines, but snaps easily. A 2mm lead is resilient, but your lines will be less precise. A 0.7mm lead is perfect for both fine detail work and constant pressure. Mechanical pencils are excellent for manga creators who ink their pencil lines, as they allow for quick rendering without sharpening breaks. They are less useful for shading, as it's impossible to shade large areas with the side of a mechanical lead, or vary the line weight through pressure and alteration of angle.

Many artists use a blue pencil to sketch out ideas or block in proportions because blue doesn't show up when scanning line work in black and white or greyscale. An artist creates initial layouts in blue, then uses an ordinary pencil to go over the marks they want to keep. It is important not to press too hard when using a blue pencil to avoid marking the paper.

Erasers

A good eraser is essential, as you're bound to make errors or change your mind as you draw. You can also use an eraser to add highlights, rubbing out areas of shading to let the white of the paper show through. Most erasers are rubber, which can leave residue on the page or tear the paper. An alternative is a malleable putty rubber, which leaves no residue, and also erases softer pencil lines. Don't use a putty rubber to erase large areas of drawing, as they quickly become warm, which leads to smearing of marks.

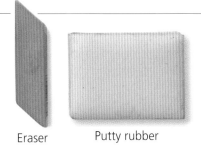

Eraser Putty rubber

Mark-making

The term mark-making describes putting your pencil to paper and observing and controlling how the pencil reacts. Try your mark-making with a variety of pencils. Create as many types of lines as you can – straight or spiral lines, shading, shapes etc – and think about how these could be applied to your drawing. Create a library of the marks that are most appealing to you.

Manga illustration is all about the use of thin, open and precise line work – 'cartoony' areas left open for tone or colour. With that in mind, the most common mark you make will be a simple line: curved, straight or a mixture of the two. Finding a pencil that sits comfortably in your hand, and a lead that doesn't blunt or snap too quickly is half the battle.

Shading is where mark-making comes into its own, as shown by the examples below. Simple ways to vary your shading include pressing harder with the tip of the pencil to produce lines of increasing thickness as the pencil tip blunts (too much pressure will break the lead). Using the side of the pencil produces a thick line immediately, which also increases with pressure.

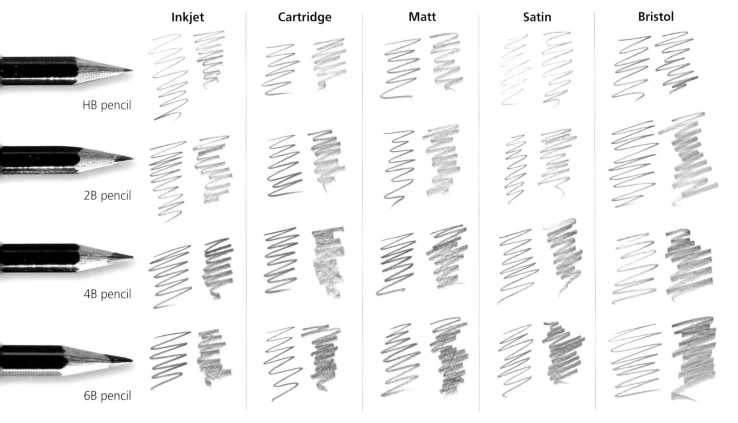

	Inkjet	Cartridge	Matt	Satin	Bristol
HB pencil					
2B pencil					
4B pencil					
6B pencil					

Water-soluble pencils ▶
While not useful for everyday pencilling, water-soluble pencils literally blur the line between pencils and paints, creating impressionistic tone and colour effects.

Pencil-on-paper effects ▲
These marks show how the choice of paper and pencil affect your drawing line. You'll see how different marks suggest themselves for different purposes – from easy-to-erase pencils ready for inking to softer shades perfect for the line work on a watercolour cover.

Pens and inking

Inking is what is meant by putting the final lines on the page. This is what you do once you have laid down your pencil lines and are ready to commit to the art you have created. Inking over your pencil marks will make them bold and clean; suitable for scanning, reproduction and print.

If you are inking by pen, you can begin with something as humble as an everyday rollerball. The professional choice is either a dip (nib) pen or a technical pen (a Rotring or equivalent). Dip pens suggest greater depth than technical pens, as you can vary the line widths by applying pressure to the nib. The lighter you press your nib on the page, the thinner the line; the harder you press the nib, the wider you'll force its prongs, creating a thicker line. Technical or fineliner pens, on the the other hand, produce consistent results and are easier to use. You don't need to replenish their ink supply every few marks, and can worry less about blotting. If you rest a dip pen in one place you will soon have a blob of ink on the page, but technical pens are not nearly as free-flowing.

Types of pen and nib

Dip pens ▼
Look closely at an example of published manga and you will notice a variety of depth in the finished lines. Lines will often start thick and end much thinner, which is achieved by changing the pressure exerted on the pen. Dip pens require dipping ink and the ink has to be replaced after every few strokes. However, the ink is considerably more resilient to light and the erasing process than that in a technical or fineliner pen. Don't try using a fountain pen as the ink that comes in standard cartridges is not of sufficient quality.

Technical pens ▼
Many operate using ink refill cartridges, giving long-lasting consistency of line in a wide variety of thicknesses, though you cannot alter the thickness of the line while drawing. Be aware that the ink in some pens may be picked up or 'greyed' when erasing, giving spotty results when scanned.

Rollerballs and fineliners ▼
Traditionally handwriting pens, these disposables can provide a clean technical line in an instant, and are often useful for touching up areas of black after erasing pencil lines and finding you've missed a spot. They have relatively slow drying times, however, which can lead to smearing.

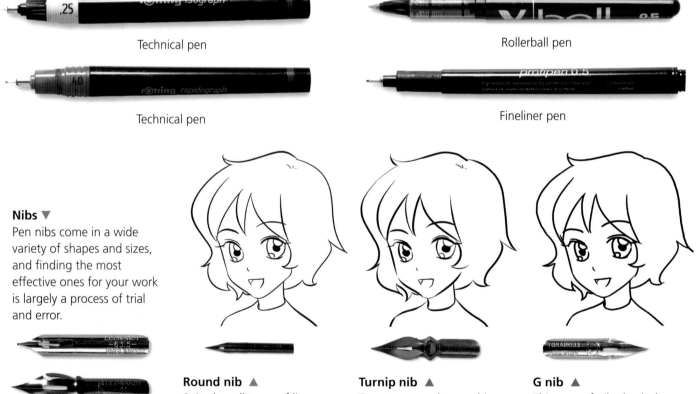

Technical pen

Technical pen

Rollerball pen

Fineliner pen

Nibs ▼
Pen nibs come in a wide variety of shapes and sizes, and finding the most effective ones for your work is largely a process of trial and error.

Round nib ▲
Suited to all types of line work, a round nib is the most versatile. The width of the lines produced will vary depending on the pressure that is applied.

Turnip nib ▲
Easy to use and can achieve lines of various thicknesses. However, it lacks the flexibility to adjust with pressure and is often used for making even lines.

G nib ▲
This type of nib also lacks flexibility, and is used to produce steady thick lines. It holds more ink than a turnip nib, so can be useful for ruling in panel borders.

Inking

Drawing with a dip pen is a knack that requires practice. Once you get used to handling the pen, however, the results are easy to appreciate.

How you hold your pen is important. Grasp it close to the nib to increase stability. The farther up the shaft you hold the pen, the more your lines will wobble, and the less control you will be able to exert. The angle at which you hold your pen is also important: ink is drawn on to the page through surface tension, so there's no need to hold your pen perfectly upright. Treat it almost as you would a pencil, but remember that the shape of the nib and its prongs make it easier to draw a stroke from the top down to the right (rather than to the left) or from the bottom up to the top. Rotate your paper, or alter your technique, to prevent nib-skipping and ink spatter.

Dipping the pen

The golden rule is to keep the pen as free from excess ink as possible. If your pen comes out dripping, you've got too much. You will get beading, or strokes that are too thick at the beginning of a line. It's important to keep your ink flow even and predictable.

One way to do this is to decant ink into a separate inkwell, up to a level where you can almost touch the bottom without submerging the pen beyond the nib. This ensures you draw an equal amount of ink each time you dip. Preventing ink from reaching the pen's shaft also stops stray droplets from falling on to the nib.

Alternatively, keep a scrap of paper or card (preferably the same kind as you are working on) to test ink consistency by drawing a line every time you dip your pen. You can shake excess ink on to the scrap as well.

Tip: Don't become too fixed or rigid in your adoption of one form of pen over another. Many artists use a combination of both dip and technical pens – dip pens for organic, natural elements and technical or fineliner pens for backgrounds and inanimate objects.

Pens in practice ▼
These two drawings show the same character illustration made with different pens. The left used a dip pen, the right used a fineliner pen.

Dip pen

Fineliner pen

Brushes and paper

You can also use brushes to ink your work. It's not as fast a process as using a pen, but it produces a smoother result, particularly when it comes to curves. A brush can also hold more ink than a dip pen, which makes for longer lines without returning to the inkwell. In short, the brush is a far more flexible inking tool, but it takes more practice to master. A brush also needs more care and attention than a pen. A dip pen has only one nib, whereas a brush has innumerable,

far more flexible and delicate components. The head of the brush, or 'tuft' as it's otherwise known, is made from animal hairs or synthetic fibres, and needs to be kept in good condition. Don't move your brush abrasively against the paper, or you will disrupt the hairs, which will detract from your ability to keep lines clean and even. More importantly, clean the brush thoroughly after every use, reshape the tuft while wet, and store your brushes tuft-up when not in use.

Tufts

A brushhead or tuft comes in various shapes and sizes and is held in place by a metal clamp or ferrule. In the same way that you select a nib, your choice of tuft will depend on the effect you want. For manga inking, you'll need a relatively thin, round tuft, or a small selection thereof. Below are the most common tuft types.

Brushstrokes ▶
This composite image shows only a small sample of the type of marks possible with a single brush – from wash effects to fine strokes. Note how just one tuft can create a wide variety of strokes depending on the pressure applied, the angle of attack and the amount of ink on the brush.

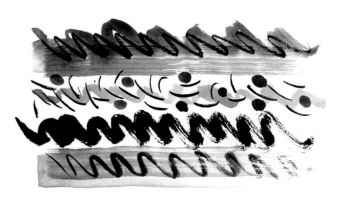

Rounds ▼
This tuft is a cylinder of hair that stretches down to a point. Like the round nib, it is the most generally applicable of all the tufts as it can be used to apply ink in both thin and broad strokes. Challenge yourself to ink an entire page using just one thickness.

Flats ▼
This tuft is square with a flat end. It is useful for filling in large areas of colour and for making wash effects. If used on end, held at a right angle to the page, it can also produce steady thin lines with the tuft held at the correct angle.

Filbert ▼
This triangular-shaped tuft is halfway between a flat and a round. It starts off flat but tapers to a point, meaning that by varying pressure you can create lines that taper from thin to thick, vice versa, or any point in between. It works best at larger sizes.

Fan ▼
A fan brush has a thin layer of bristles spread out by the ferrule. It is used to lay down parallel lines of ink by holding the brush end-on, at right angles to the page, often with a nearly dry tuft. It is useful for applying certain hatching and shading effects.

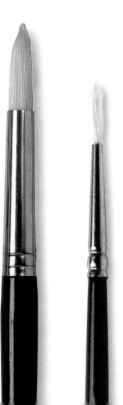
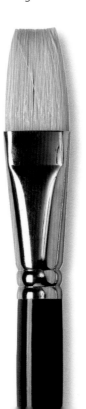
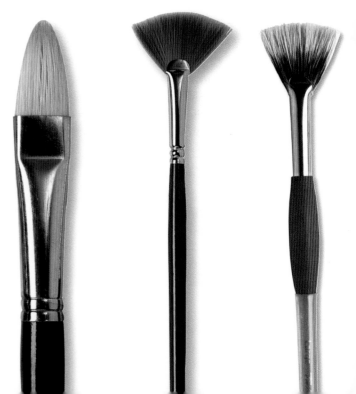

Brush sizes

Brushes come in varying sizes, each with a given number. You only need a small selection: some small rounds for detail work; a larger brush for filling areas. The number corresponds to the circumference of the ferrule. There is no international numbering system or standard measurement the industry must follow, and size varies between manufacturers. You should be able to find equivalents to your favoured brush sizes anywhere in the world.

Brush selection ▶
An assortment of brush sizes like this will in all likelihood be quite sufficient for your manga career. Art shops will often sell combination packs of brushes, or you can assemble your own selection based on personal preference. The variety is extensive and can include natural and synthetic bristles.

The correct ink

Whether you ink with a dip pen or a brush, or more likely a mixture of the two, the only ink you should use is Indian ink, the lifeblood of comics illustration. Unlike other types of ink, Indian ink contains shellac, so it is resistant to wear and tear (particularly the kind caused by rubbing out pencil marks) and it dries very quickly.

This fast-drying ability is precisely why it can't be used in fountain pens, because it would soon cause a blockage. This is why it's important to thoroughly clean tools after you finish working – so rinse your brushes and pens under water. Washing-up liquid can help keep pen nibs and brushes clean, but be sure you rinse it all off before drawing again.

Tip: Blotting paper can be handy to clean up small spills, and a small container of water will keep tools clean while you work. A piece of scrap paper of the same specification you are drawing on will allow you to experiment with the way your brushes and pens will react before you attempt your final piece.

Different types of paper

Nib

Brush

The five papers described here can all be used for manga. There are many other papers, but as manga is usually laid down in pencil and ink on to white surfaces, these are the most suitable.

Inkjet paper
This paper is thin, and when saturated with ink can begin to 'cockle' (crease). It's also easy to inflict damage with your eraser. Inkjet is cheap, and can withstand pencils and inks making it ideal for practice and sketching.

Cartridge paper
A thick, heavy paper, preferred by many artists and illustrators, originally used for making cartridges in weaponry.

Matt finish paper
Smooth finish is great for brushwork. Ink dries quickly, but you'll need a lot of white gouache to cover errors.

Satin finish paper
Use a rollerball rather than a dip pen. A good choice if you are inking by brush, although large areas of black brushmarks may appear inconsistent. Satin finish paper takes longer to dry than matt.

Bristol board
This paper is thick, with a smooth finish suitable for inking, making it the industry standard for comic illustrators. Holds ink well and allows for easy erasing: it's tough enough to be sent worldwide without too much in-transit creasing.

Tone

Adding tone is about adding weight to your drawing. You are essentially adding marks in different ways, whether that means adjusting the width of the lines, the length, or how light or dark they are. Tone adds dimension, mood, shade, atmosphere and texture to a drawing. You can practise its application by making sketches of your work on sheets of tracing paper. Once you've created a few examples, you can pencil different versions of tone and overlay them on your final piece. When you come to the final inking stage, pick the example that strikes you as the most effective.

There are various methods of applying tone. One classic example is cross-hatching – parallel shading lines that cross over one another. Another example of tone is washing, or using diluted black ink to apply grey shades. Washing is more subtle than hatching, and will soften the look of the final piece, diminishing the hardness of the main inks. Ultimately, the toning you choose will depend on the mood or genre of your story. If your story is light-hearted, for example, you are likely to confuse the reader by including large areas of shadow and may wish to avoid significant toning altogether.

Examples of tone

The following examples demonstrate how lines drawn in various ways create varying tones. Some styles have been used more than once, but in different combinations. All of the toning methods here are based on layering lines over one another – with the denser regions being the darkest, and areas of light being shown by an absence of tone. In any given image, you may find yourself using a variety of these tones to provide different textures to the hugely various human, animal, vegetable and mineral inhabitants of your manga artworks.

> **Tip:** Match tones with objects: scribbled, organic lines for people or clothes; rigid hatches or shiny stipples for technology.

Short lines ▲
Shading is built up by overlapping short lines drawn in the same direction.

Dots ▲
Fairly evenly spaced dots suggest light and shade through their relative density.

Cross-hatching ▲
Straight lines cross over one another to create mesh-like patterns. The denser the lines, the darker the area.

Spray stippling ▲
A scattergun approach creates rough areas of light and shade, again dependent on the density of marks.

Short lines ▲
Shadowed areas are tightly packed with lines, almost overdrawn.

Dots graduated ▲
Dots can be drawn closer together or made larger to suggest greater darkness.

Cross-hatching ▲
Hatches can be overdrawn to create darker areas, or the meshes further contracted.

Spray stippling ▲
A spray approach to shading is excellent for replicating stone and brickwork.

Short lines ▲
Shadows are built up in layers, working from the outer rim towards the highlight.

Dots graduated ▲
Dots become larger and more tightly packed the farther they are from the impact of light.

Cross-hatching ▲
Again, overdrawing suggests dimensionality. You may want to use an eraser to create white highlights.

Spray stippling ▲
Shadows are stippled on in increasingly stronger layers to provide a contrast between areas of light and shade.

Using tone

Adding tone appropriately will increase the effectiveness of your drawing and your story. But it is important to understand what you are trying to achieve beforehand, particularly since there are so many possibilities at your disposal. The example shown here illustrates how different shading techniques can be created using lines and areas of solid black, and how different tones can be integrated into the same image.

Tones in practice ▶

Dramatic results can be achieved with your line work by combining a number of different toning effects. Approach each of your tones as a texture in your artistic arsenal. Here, cross-hatching and dots capture two different fabrics, some spray stippling brings the hair to life, and an array of short lines behind the character create a hazy night scene or a paparazzi-stalked premiere.

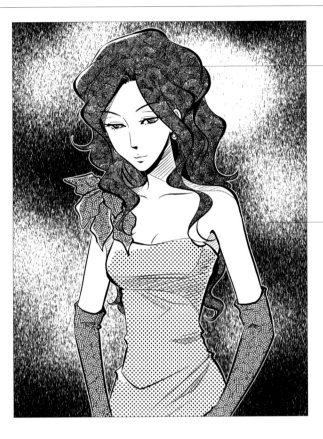

Though all of one tonal strength (save the highlights), the texture adds interest to the hair without distracting from the line work.

The short lines and large highlight areas suggest both a background and an emotional state, while still throwing the focus forward on to the woman.

Ink-washing

If you are still experimenting with ink-washing, you may wish to work from a photocopy of your finished inks, as it is difficult to make corrections to your shading once you begin.

The principle behind ink-washing is simple: by mixing your Indian ink with varying percentages of water, you can apply (with a brush) consistent, strong and long-lasting greytones. You'll need to experiment with the mixtures of course (start with one part ink to one part water as a mid-tone, and add or subtract water and ink from there), and decant your ink into a suitable palette or container, but the actual act of washing is the same as painting, only in greyscale. You'll find that layers of shading can be built up by overwashing a light grey section a second, third or fourth time.

Washes in practice ▶

Ink washes add a more naturalistic, painterly effect to your finished lines, adding in a human touch that pre-cut or computer tones can sometimes lack.

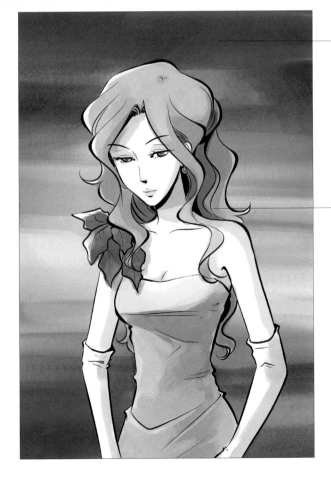

Darker areas are built up in layers. The inexact mixtures of tones create a dreamier, fogbound quality.

Darker areas are painted over a mid-tone in successive washes. Highlights are left as white paper.

Colour

Despite advances in printing technology, and the increasing availability of high-level digital colouring packages, the vast majority of manga are still printed in black and white for reasons of cost and time effectiveness. Thousands upon thousands of books and weekly magazines are printed every month, usually on cheap paper. The absence of colour also gives many anime adaptations an extra edge, as fans of a manga book series finally get the opportunity to see their favourite characters in full-colour action. That does not mean there aren't any opportunities for colouring your work, or even that you should not pursue a full-colour manga story. Promotional purposes and cover art for your manga will be the most obvious venues, so it's worth knowing the colouring basics, as you'll never know when an opportunity might arise. Given the increasing popularity of comics on the Internet, you may find that the only way to grab attention for your creation is to release it in full, anime-challenging colour. The majority of comics today are coloured digitally, using packages like Adobe Photoshop, but the principles of colour are the same, whether using traditional or digital media.

Paints, inks and dyes

Walking into any art store will provide you with a thrilling and bewildering array of colouring choices. Paints such as these offer a range of bold ways to tint your manga illustrations.

Watercolour paint ▶
Available in two forms: pans, which are compressed blocks of colour that need to be brushed with water in order to release the colour, and tubes of moist paint. Watercolours seldom have a natural white; white is created by leaving areas of the paper unmarked, and lighter shades created by thinning the paint with water.

Gouache paint ▶
Soluble in water, allowing you to make alterations, gouache may crack when dried. The natural white can be used as a corrective.

Acrylic paint ▶
A brighter finish than gouache, acrylics have a stronger sense of colour. Soluble in water, so just as versatile as gouache, they can also be mixed with gouache for a watercolour finish.

Watercolour dyes ▶
Similar to watercolour paints, dyes give even brighter results. They are used for more 'in your face' productions, as dyes are very intense – perfect for manga with high energy and bright colours. Dyes also have a high tolerance to exposure from direct sunlight.

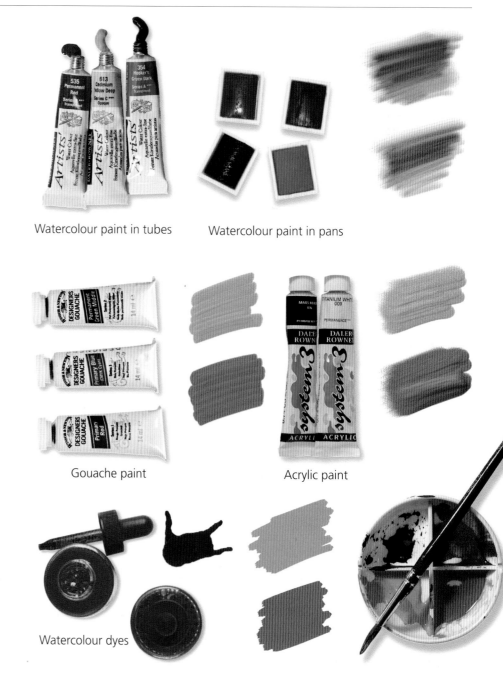

Watercolour paint in tubes Watercolour paint in pans

Gouache paint Acrylic paint

Watercolour dyes

Pencils and markers

Colouring pencils ▼
Available in soluble and non-soluble varieties. Blend colours with cross-hatching or a subtle fade from one complementary tone to another. An affordable alternative to paints or inks, they tend to suffer when digitally reproduced.

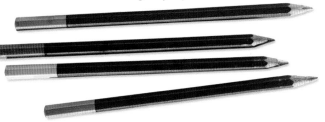

Markers ▶
Coloured markers are the staple of traditional-media manga colouring. The technical ability of the artist very much controls the success of the outcome. In good hands they reproduce well, remain bright, don't bleed on the page or combine unfavourably with Indian ink. They come in a wide range of shades. You can combine two or even three nibs into a single pen, and they can be overlaid to produce darker shades of the same colour, or can be easily blended with other hues.

Using colour

Adding colour is an excellent way to add a new dimension to your creations, whether on the cover of your manga or on a pin-up. A single colour image of your cast can 'resonate' through your entire story, even if the rest of the pages are in black and white. Give your central character bright green hair on a cover and that character's hair will 'read' as green throughout the rest of the story.

The colour wheel ▶
Every colour has a complementary opposite. Combine complementaries for more pleasing compositions.

The colour wheel shows the gradients of each tone, from light to dark, in each hue.

Some colours 'jar' in interesting ways when placed next to one another: purple and orange, red and blue, for example. Try out these if you want an unsettling or eye-burning effect on your manga page.

Colours directly opposite are complementary: red and green, blue and orange, purple and yellow etc.

Try creating your own colour wheel with your chosen medium, and practise blending and mixing colours to achieve the required variances in tone.

Colour in practice

Each traditional media has different techniques to master, and only by experimenting will you be able to find a colouring style that suits you. The basics, however, are shared by all. Pencils, markers and paints should all be laid down lightly on the first 'pass', leaving highlighted areas empty so that the white of the paper shows through. After demarcating highlights, add a mid-tone of your chosen colour, and add areas of shadow by going over this tone with the same pencil or marker a second or third time.

Complementary colours ▶
The deep green of the hair draws our attention to the central characters, while the fiery orange-red borders the image and maintains that sharp focus.

Uses a limited colour palette. Notice how the background and hair are reflected in the skin tones and dress detailing.

The white of the paper is left to shine through as an extreme highlight.

The deep green of the hair is in complementary opposition to the dark red.

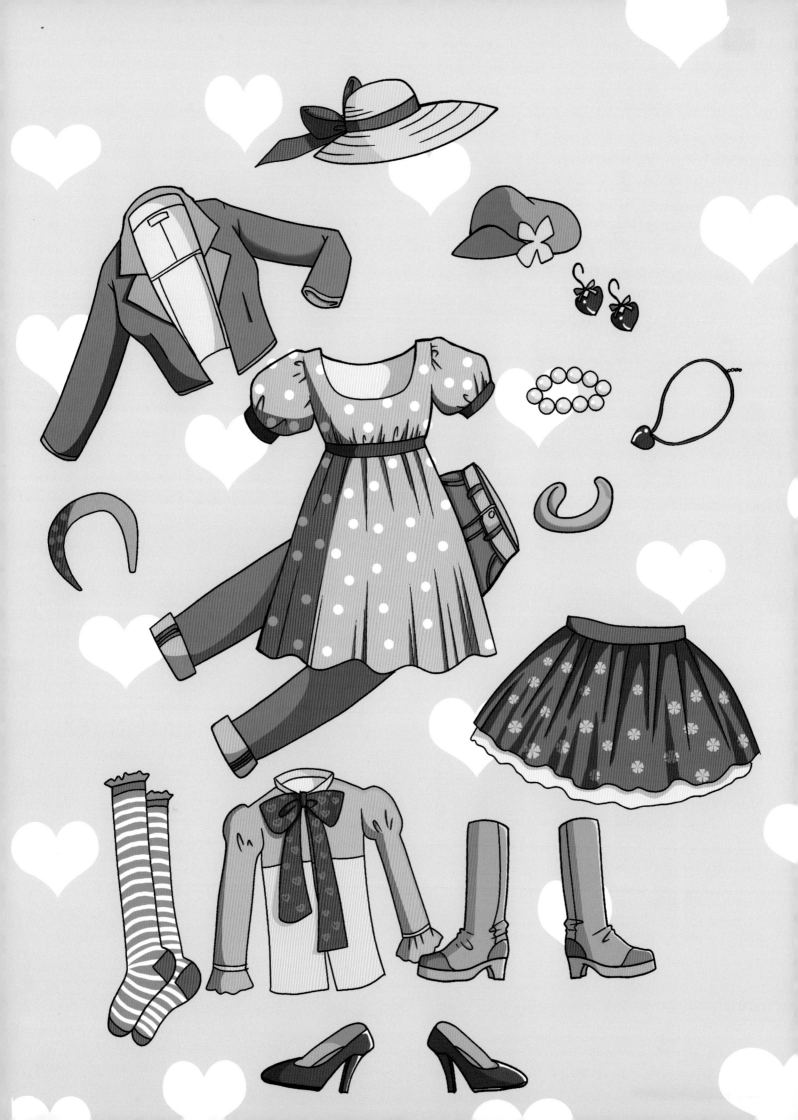

How to draw a manga character

The manner in which characters are drawn is the main feature of how manga, or any type of comic strip, works. A reader has to identify each character in a story on every panel – after all, it's the characters that are going to carry the majority of the narrative from page to page.

Heads and faces

There are set rules to designing manga characters, which include specific guidelines on the drawing of heads, faces and specific features, such as eyes, noses and mouths. The rules vary according to a character's gender, age, and moral alignment (good or evil). The way you draw a female villain's eyes, for instance, will be different from the way you design the eyes of an heroic male figure. In both of these cases, your design will be based on the application of some simple rules.

Within this framework, an experienced manga artist will show their own style and characteristic techniques. In time, you will also develop a unique way of interpreting these rules. It makes sense to start with the basics of head and face drawing. The practice exercises in this section guide you step by step through the creation of front views, 45-degree angle views and profiles. The rules vary slightly in each case, depending on whether your manga character is male or female.

Practice exercise: Male, front view

This first exercise pays particular attention to the head's basic shape when viewed from the front. The use of guidelines helps you to place facial features, such as the jaw and nose, with great accuracy. Although a head's size and shape may change, the proportionate relation between each of the features will remain the same. Typically, a male head will be larger and more angular than a female one, with a more pronounced jawline and a wider neck. Eyebrows and nose will also be thicker and more apparent.

Materials
- *cartridge paper*
- *soft lead pencil*
- *blue pencil 10*
- *pen and ink*
- *colour of your choice*

 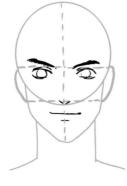 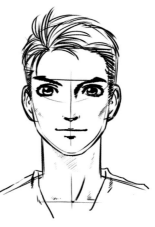 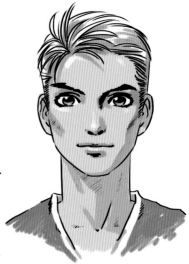

1 Begin by drawing a circle. Divide the sketch with a dotted vertical line that extends below the circle. Press lightly as you will erase these lines later (you could use a blue pencil as scanning or photocopying your finished pencil lines will eliminate the blue lines). For the jawline, draw two vertical lines extending from the left and right sides of the circle downwards, angling the lines in towards the central guide line. Join the angled lines with a small horizonal line at the very tip of the jaw. Add the shape of the neck and the start of the shoulders.

2 The size of the ears on a face defines all of the other facial characteristics. Divide the head in half with a horizontal dotted line – aligned to both the eyeline and the top of the ears. Divide the bottom half of the head in half again. This second line is the bottom of the ears and the tip of the nose. Draw the eyes and eyebrows, which are spaced equally either side of the nose and centrally with the lips. You should keep a full eye's width between them. Eyebrows almost touch the eyes at the corners when in 'neutral'.

3 The lower lip is half the distance between the tip of the nose and the chin, and is defined with simple, unfussy lines. The hairline begins halfway up the forehead, 'squaring off' the head with an off-centre parting. Keep hair choppy and natural to avoid your characters looking as if they are wearing swimming caps or strange helmets. You may wish to define cheek and collarbones. Ink your pencil lines when you are happy with them and define shadow areas.

4 Finish the head by using a colouring method of your choice. The colour stage builds on the detail and shading previously introduced. Note this example creates a unique manga colour scheme of prematurely white hair and bright green eyes to give a striking effect. Try creating your own variations on this simple formula: it's easy to create new looks just by varying the size of the various facial components.

Practice exercise: Female, front view

Female manga faces have a softer feel, which is particularly apparent in the front view. They are less angular and are usually smaller than their male counterparts, with more smoothly integrated features, particularly along the jawline. The basic design rules are the same as for the male head, but are adapted for a more feminine look, especially with regard to the eyes, which are wider, with more fully defined lashes, and the smaller, button nose.

Materials
- *cartridge paper*
- *soft lead pencil*
- *blue pencil 10*
- *pen and ink*
- *colour of your choice*

1 As for the male face, draw a circle with a vertical line through its centre. Create the jawline; this time the lines coming from the circle should be shorter, and angled slightly inwards. Keep the jawline smooth, and more rounded compared to the male.

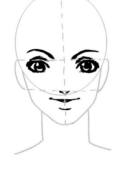

2 Add the other guidelines, starting with the eye and nose. The proportions between each part are just the same as on the male face, but the features are different: draw eyes larger and more widely spaced, the nose smaller, and the eyebrows arch up and out.

3 Female characters tend to have longer hair, though it begins at the same hairline, even if it sweeps down and across, as in this example. Define your pencil lines by inking those you are happy with. Pay attention to the clump of eyelashes and the light glares on each eye.

4 The colour stage pulls the drawing together, with the purples of the girl's clothing reflected in her skin tone, hair and eyes. Note that female lips are defined through colour, rather than line work. Focus special attention on the colour strokes in the hair.

Male and female characteristics

Manga often uses androgynous-looking characters and outlandish hairstyles so it can be worth focusing on the major differences between the sexes: comparative sizes of eyes, noses and mouths.

Defined differences ▶
Although the male and female characters have similar jawlines and long hair, it is easy to spot the differences between them. The boy (top) has a wide, neutrally shaded mouth, compact eyes and a nose defined with a vertical line. The girl (right) has large, lashed eyes, nostrils rather than a nose, and a mouth shaded in pink.

Axes of symmetry and perspective

Simple guidelines keep features in proportion to one another while the guides are rotated in perspective. The vertical axis divides the face lengthwise and shows the angle of the head. The horizontal axis indicates whether the face is looking up or down.

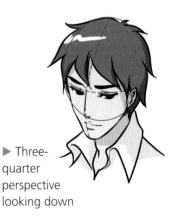

▶ Three-quarter perspective looking down

▶ Three-quarter perspective looking down (from higher up)

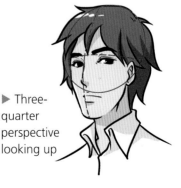

▶ Three-quarter perspective looking up

Practice exercise: Male face, 45-degree angle view

In this exercise, the male head is drawn at a 45-degree angle, which gives more depth to his features, such as the chin and cheekbones. Here, the character is looking towards his left.

Materials
• *cartridge paper*
• *soft lead pencil*
• *blue pencil 10*

• *pen and ink*
• *colour of your choice*

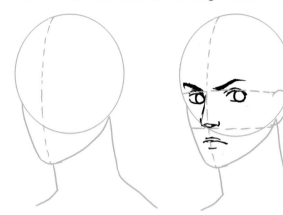
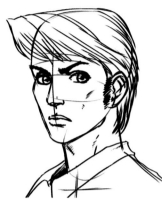
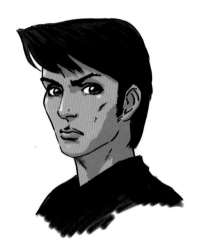

1 Start with a solid circle but add a convex vertical dotted line to show where the centre of the face will point. Extend a solid curved line down from the lower half of the head and back to the base of the ears, forming a slanted angle for the chin.

2 Draw the pencil guides for the eyes, ears, eyebrows and the mouth as before: half the head height for the eyeline, half of the remaining space for the noseline. Ink in the outlines of the eyes, eyebrows nose and mouth.

3 Complete the detail of the eyes and the rest of the features of the face. Note how the right eyebrow and nose form a reverse 'S' shape. Draw in your hair as before, showing the back of the head behind the ear and extended fringe.

4 Finish the head by adding colour, noting areas of shadow. Shading on the skin reveals the form of the face – note the shadows beneath the cheekbones, on the neck, under the lips and nose and beneath the hair and eyebrows.

Practice exercise: Female face, 45-degree angle view

In this exercise, a female head is drawn at a 45-degree angle. Again, the character is looking left, towards us. The female head has a shorter jawline, a more triangular chin and more delicate features than the male face.

Materials
• *cartridge paper*
• *soft lead pencil*
• *blue pencil 10*

• *pen and ink*
• *colour of your choice*

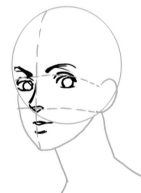

1 Start with a solid circle and a convex, extended dotted vertical pencil line. Extend a solid curved line down from the lower half of the head and back to the base of the ears, forming the slanted angle of the chin. Note the smoother, shallower jawline and thinner neck.

2 Draw the pencil guides for the eyes, ears, eyebrows and the mouth as before: half the head height for the eyeline, half of the remaining space for the noseline. Ink in the outlines of the eyes, eyebrows nose and mouth. Don't connect the brow with the nose.

3 Build up your detail in ink. The ear is smaller than the male, the neck begins farther back from the chin and the nose is more refined. Eyebrows are farther from the nose. Eyelashes protrude outside the head silhouette on the far side. Pay attention to the neat hairline.

4 Colour defines the shape of the head: here a 'V' of lit areas, with shade under the nose, eyes and mouth. Highlights on the forehead, cheeks and under the tip of the nose add dimensionality and life to the skin.

Practice exercise: Male face, profile view

Earlier, we saw how the facial guidelines can be rotated in any direction. While faces in profile use this same structure, the features can often look very different, with the eyes, nose and mouth taking on new shapes, as seen below.

Materials
- *cartridge paper*
- *soft lead pencil*
- *blue pencil 10*
- *pen and ink*
- *colour of your choice*

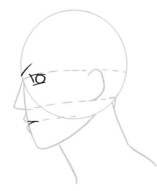

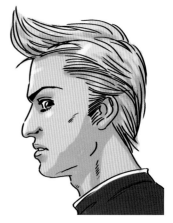

1 Draw guides for the basic circle of the face, adding a pointed jaw to create a 'plectrum' shape. This represents the front of the face below the nose, with the curve under the circle becoming the jawline. Draw guides for the neck.

2 Draw in dotted horizontal guide lines to define the eyes, ears and mouth. Viewed from the side, eyes become a curved 'V' shape, as does the nose. Note how the upper lip protrudes over the lower lip. Eyebrows curve in towards the nose.

3 Ink your sketched-in features. Add hair, remembering that the hairline may be covered from the side, and that the hair extends back in a squared-off fashion. Ink your pencil lines. Add shading for the cheek-bones and glare on the eyes.

4 Colour gives 'weight' to the image, with the back of the head covered in shadow. The sharp-angled silhouette presents more defined features than a front view, so profile shots can rely less on colour to differentiate features from one another.

Practice exercise: Female face, profile view

Here we see a female head, drawn in the same direction as the male, and using exactly the same basic building blocks and guidelines. Note the lips are far fuller in profile, the nose more rounded, and the brow emphasized far less.

Materials
- *cartridge paper*
- *soft lead pencil*
- *blue pencil 10*
- *pen and ink*
- *colour of your choice*

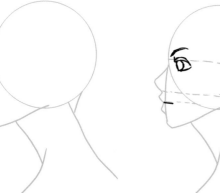

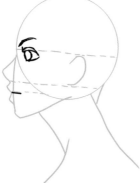

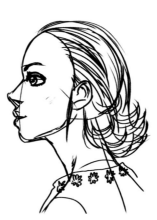

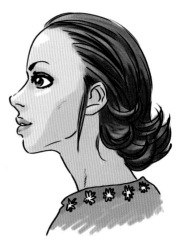

1 Start just as you did for the male profile. Keep the jawline shallower and the neck more slender. While the male jawline juts down from the ear, the female jaw swoops towards the chin in a gentle curve.

2 Add in your horizontal dotted guidelines, and features such as ears and nose. Start to ink in the eyes and mouth. Note that the female lips are fuller and more defined, with the chin not jutting out as far.

3 Ink in the nose, jaw and eye, remembering that the female eye is larger and sweeps back farther. Allow space above the eye for a smooth eyebrow arch that starts just above the front of the iris.

4 Complete the girl's profile by colouring the head, paying particular attention to the eyes, lips and highlights in the hair. Check for areas of highlight noting that half of the face and all of the neck is in shadow.

Drawing eyes

Eyes are extremely versatile, and have a marked effect on the facial expression of any character, determining gender, age, and also emotional state. Our eyes are perhaps the most expressive part of our faces, and often reveal emotions that we are attempting to hide. You can cover up all of a character's other features and show how they are reacting solely with the eyes. Not surprising, then, that the eyes are one of the trickier parts of the body to get right, as you need to learn how to express moods as well as get to grips with basic eye anatomy. To express shock or surprise, for example, you should raise the top eyelids high above the pupils. For a cool look, cut them

midway across. Although manga faces are filled with a liquid shine to make them seem more emotional, most have little tone, which is why it is important to get as much expression out of their features as you can.

The eyebrows act as 'backup' to the eyes. They work in a similar way to bars on a gate: raised eyebrows seem open and friendly, lowered eyebrows appear closed and unfriendly. One eyebrow up and one down conveys doubt. Level eyebrows suggest a character who is non-committal. Following similar principles, animals such as cats and dogs often express themselves with a tilt of the head and movement of the ears.

Eyes

There are exceptions, but many manga characters have large eyes. The eyes are said to be windows to the soul, and because the Japanese are obsessed with mood and emotion, their readers expect to look right inside. The more they see, the greater the empathy they experience with the character. To Western readers,

the big-eye look can be deceptive. Characters that appear to be little kids could, in fact, be fully grown adults; they may look cute, but their behaviour does not reflect this. This misunderstanding has caused issues of censorship in the West, where comics are perceived to be for children.

Tip: Eyes that reflect light look more animated and human than those without. See for yourself how removing the highlights and subtle reflections makes a character's eyes look dull and doll-like.

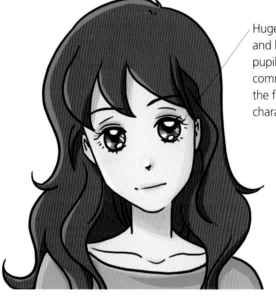

Huge irises and large pupils are common in the female characters.

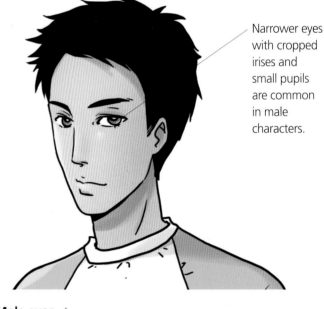

Narrower eyes with cropped irises and small pupils are common in male characters.

Female eyes ▲
As female eyes are large, there is ample opportunity to make a feature of the play of light across the pupil (the black centre) and iris (the coloured surrounding area). The eyebrows of female characters are thin, and the eyelashes prominent.

Male eyes ▲
The eyes of male characters tend to be thinner and narrower than female eyes, although there are a few exceptions. Eyebrows are thicker, with no eyelashes. Male characters have light glares in their eyes, too, although not as large or obvious.

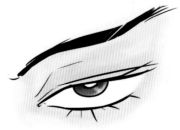

◀ **Jagged eyebrow**
Often used in manga to help exaggerate more suspicious, villainous characteristics, jagged eyebrows and eyelashes (in female characters) are used for big or exceptional personalities.

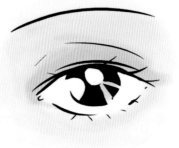

◀ **Streamlined eyebrow**
This is the most commonly drawn eyebrow shape. It can be straight, arched, a 'hill', or a subtle top of a 'wave' (like this one).

Practice exercise: Standard female big eye

There are many ways to draw eyes, starting either with a basic circle or the upper eyelid. Using a 'V' shape as a guide is probably the easiest method for beginners.

1 Draw a tall 'V' as a guide and add two opposing arcs between the two lines. Ink in the eyelids, which arc out then slope in towards the white of the eye.

2 Add a central oval for the pupil and a larger oval to create the iris and lights in the cornea. Add a thin eyebrow and place above the eye.

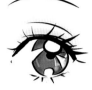

3 Finally, add eyelashes. When viewed from the front like this, they should point mainly to the side. Colour the eye.

Practice exercise: Standard male eye

Male eyes are thinner than female eyes. The eye drawn here is a fairly standard size. If it were drawn much thinner, the character would look like a villain.

1 The V-shaped guides can be used, but this time spread them wider apart. Ink in a slightly slanted curve, with the left side curving in slightly. Next draw the curve of the bottom eyelid.

2 The iris of the male eye is circular, held within the confines of the eyelids. Start by pencilling a perfect circle through the eye, then ink over the parts of the circle that remain within the eyelids.

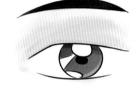

3 Add a couple of areas of white on the iris to show light bouncing off the cornea. Then add the eyebrow, which should be thicker than the female version. Colour the eye.

Practice exercise: Female villain eye

A female villain should look threatening and devious. You can achieve this simply by making the eye much narrower than the standard female big eye shown above.

1 If using the 'V', the lines should be farther apart at the top than before. The farther apart the lines, the narrower the eye. Draw a curved slant, with the left edge (nearest the nose) lower than the other.

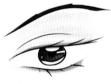

2 Add the iris: again you can draw an entire circle in the centre of the eye, making sure your circle goes outside the eyelids. For a calculating squint, add an extra short arch between the eyebrow and the eye, up to half the width of the eye.

3 Add subtle light reflections. When shading, make sure the iris isn't black, so the pupil stands out. Add fewer eyelashes than before. The top of the eyebrow should be jagged.

Practice exercise: Male villain eye

The eye of a male villain is very similar to that of a female villain. The differences between the two amount to tweaks.

1 Ink in a curved slant, with the left edge lower than the other. Add the iris, cropped within the confines of the eyelid. Add subtle light reflections.

2 The eyebrow is sleek like the female's, but slightly thicker, and more angular and jagged. Add the extra line to imply the squint, but make it longer for the male villain.

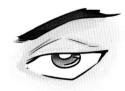

3 The lower part of the eye is more triangular than the upper lid. Instead of lower eyelashes, add a thick line of shadow. Colour the eye.

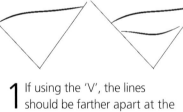

Drawing hair

Hair can be difficult to get right, and it helps to break styles into separate components. The hairstyle in question, like other personal characteristics in manga, will be affected by genre. Individual strands are implied by the few that are drawn into the different-sized bunches, tufts or clumps.

As with clothes, fashionable or outlandish haircuts are the norm, so keep yourself appraised of the latest trends – or start some of your own. Manga in black and white means your characters need to have unique silhouettes that read well without colour, and hair plays a major part in this.

How hair sits on the scalp

Manga hair can be divided into two main styles: hair that grows up and out from the scalp, and hair that lies flat against the scalp. Once you've mastered these basic styles, you can combine the two in an infinite number of combinations to create interesting styles for more prominent characters. Start with drawing only nine or ten strands. Later, once you've got the knack of drawing basic hair, you can make it more detailed.

Tip: Remember that hair follows the shape of the scalp. When starting out, it will be helpful to draw the entire head, bald, and add hair proportionally over the outline you have drawn.

Tied-back, male ▲
Hair is pulled back and tied up at the top of the head in a rather androgynous fashion.

Shoulder-length, layered ▲
Detail is concentrated in the strands around the face, leaving the top of the hair to glossily reflect the light.

Spiked and styled ▲
This gravity-defying cut is made of a number of spiked strands. Block in the main shape of the hair first, then add spikes as appropriate. Note that, while intricate, not every strand of hair has been drawn. Hair frames the face.

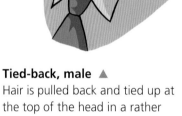

Tresses ▲
Coils of long hair suggest a pampered princess – whether from the Dark Ages or California.

Swept ▲
Perfect for the model student with a 'dark' side. Choppily cut short, with the hair swept to one side.

Drawing a fringe, or 'bangs'

A fringe (bangs) – the term used for hair that either entirely or partially covers the forehead – are often referred to in the process of manga creation. They form one of the essential building blocks of hairstyles. Creating a fringe is not unlike designing a helmet. Once you've sketched the frame, craft the hair over the top. Make the fringe consistent, but not even – you don't want to give your character a 'bowl cut' (unless this is appropriate to your character). Let a few strands go astray to make the hairstyle more realistic.

For a fringe, draw hair down over the forehead towards the eyes and bridge of the nose. The arc of the hair should go back up towards the top centre of the head, giving the illusion the fringe is following the front curve of the head. On the left side, arcs curve up to the right, and on the right side, to the left. An arc will curve less towards the middle of the fringe.

A fringe to the front of the head ▶
A blunt-cut fringe is complemented by chunky hair to the sides of the face.

A fringe to the front of the head ▲
A fringe swept to the side to reveal the forehead.

A long fringe to the front of the head ▲
A choppy, uneven fringe obscures the eyes.

A short fringe to the front of the head ▲
Blunt-cut fringe and puffed-out hair add interest.

A long fringe to the side of the head ▲
A simple inverse-'V' shape, parted on the right.

Adding curves to hair

Get into the habit of curving your hair strands. The longer your character's hair, the longer the curves should be.

 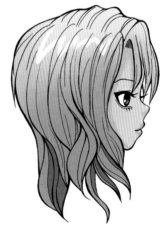

Curves on shorter hair ▲
Note how the coils are layered over one another, suggesting depth and making the hair look natural.

Big curvy or wavy hair ▲
Here, the curves emanate from a central point at the back of the head, growing narrower as they progress.

Curves on long, straight hair ▲
Less layers, but more pronounced curves as the strands reach their tips.

Tip: Make sure that the characteristics are easily distinguished in black and white, as most manga is not printed in colour. Remember that there's no need for consistency if one of the hairstyles is changed by magic.

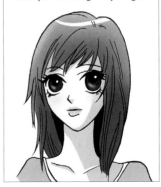

Drawing the mouth and nose

In manga, the mouth and nose are probably the simplest areas of the face to draw, and some of the standard methods can be used interchangeably for either gender. In some forms of manga, a relatively realistic nose is acceptable, although generally only for the male characters. Female noses, whatever the genre, tend to be drawn minimally.

Simple noses

The simplest noses comprise a pair of curves in profile. The first line starts at the bridge of the nose and curves both downwards and outwards. The end of the line should be gently upturned, but more blunt than pointed. The second starts where the first ends, and curves slightly downwards, back towards the face. Keep the nose small, without nostrils, and the lines thin. Thick lines draw too much attention, and the nose shouldn't distract from the rest of the face.

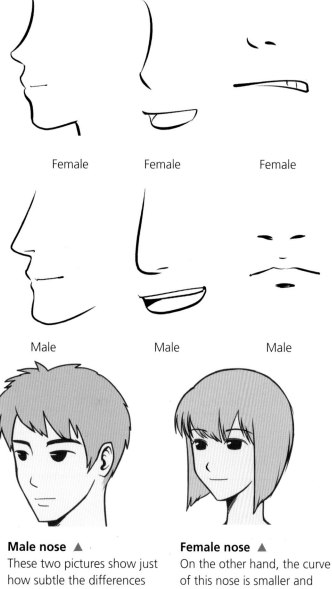

Female Female Female

Male Male Male

Male nose ▲
These two pictures show just how subtle the differences between the sexes are. The male nose is longer and more 'snubbed' at the tip.

Female nose ▲
On the other hand, the curve of this nose is smaller and tilted upwards. The focus is on the tip of the nose, rather than suggesting the nostrils.

Adding shadow and detail

You can enhance simple noses by using shadows, thickening lines with subtle shadow towards the nose's point. Shape the shadow like a black arrowhead, as if the nose is lit from above and to one side.

Adding nostrils, as shown below, can also add interest and dimensionality. A hooked horizontal line for the nasal aperture is usually enough: you don't need to draw the 'hoods' of skin on either side of the main stem of the nose.

shadow, from side, nostril

shadow, from side, no nostril

shadow, from front, side-lit

strongly side-lit, nostril

top-lit shadow

from front, side-lit, nostril

◄ Shading in colour
Using a darker skin tone underneath the nostrils allows you to keep the minimalist detail and inking of an unshadowed nose while still adding a degree of dimensionality.

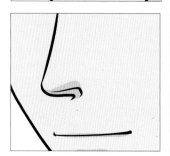

Tip: Noses on the male face tend to have more definition and detail than the smaller female nose, which also has a more rounded end. Some forms abandon the nose entirely on the female face.

Drawing mouths

Like the nose, the mouth is kept simple in manga. Often, a thin line is enough to suggest it (when closed, at least), though the mouths of women and girls are often fully rendered in colour. In almost all cases, mouths are small, unless the character is yelling, screaming or laughing heartily.

When you draw a character that is looking anywhere other than straight ahead, you will need to consider the curve of the nose and mouth – the lower lip should curve outwards, down towards the chin, and the upper lip inwards, up towards the nose. Both follow the curves of the face.

Tip: When a character is shouting, it's the jaw that does the majority of the moving and heavy emotional lifting, so focus your attention on the lower lip.

Simple female angled ▲
Dots mark the corners, a curve hints at a smile.

Simple female straight ▲
A triangle of shade under the line gives definition to lips.

Simple male angled ▲
A simple line serves as well for men as for women.

Simple male straight ▲
There's little to differentiate the sexes from the front.

Complex female angled ▲
Lines show the 'plumpness', colour does the rest.

Complex female straight ▲
Note the more realistic line showing where the lips meet.

Complex male angled ▲
Lips are thinner and shaded in standard flesh tone.

Complex male straight ▲
Look out for the shallow 'U' underneath the mouth.

Practice exercise: Building the female mouth

Female mouths in manga are more fully rendered than their male equivalents, with more-defined lips and colour rendering.

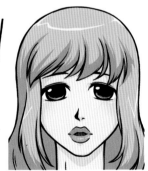

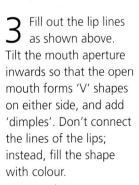

Materials
- *cartridge paper*
- *soft lead pencil*
- *blue pencil 10*
- *pen and ink*
- *colour of your choice*

1 Draw the outlines of a head in the usual way, drawing in guides for the eyes, nose, and mouth. The mouth sits at the base of the guide circle, where it connects to the jaw.

2 Start with the open aperture of the mouth, adding a small 'dip' above suggesting the groove that joins the nose to the mouth, and a curve beneath for the bottom lip.

3 Fill out the lip lines as shown above. Tilt the mouth aperture inwards so that the open mouth forms 'V' shapes on either side, and add 'dimples'. Don't connect the lines of the lips; instead, fill the shape with colour.

Tip: If you want to keep the proportions and position of the mouth you've drawn, but give it fuller lips, thicken the inked outline around the mouth.

Facial expressions

A person's face can display a large range of emotions, delivered to the rest of the world through changes in expression. These different expressions are used in comics to evoke the inner feelings and thoughts of a character, often making dialogue unnecessary. Your audience should be able to read a character's angry expression, for example, without the artist having to add 'I'm angry!' in a speech balloon or caption. Expression can be seen as a wordless form of communication and is one of the most important tools used in drawing any comic strip. On a technical level, emotions are represented by altering the looks of the mouth and eyes, making them work in concert. In some cases – particularly when creating mysterious or villainous manga characters – you may want to leave the true emotions of your character in question, in which case concealing either the eyes or mouth of that character will increase the ambiguity surrounding them.

Adapting each expression

As you work through the following techniques, you will soon discover how it is easier to draw a new expression then adapt it from another. The key is in the little things, and making small changes. Sometimes all it takes is a subtle alteration to the mouth or the arch of the brow to completely change a character's mood. If you want to practise simpler forms of expression, you can use a pair of dots for eyes, a single line for the nose, a pair of lines for eyebrows, and a mouth that varies from a straight line to a curved shape, depending on the character's mood.

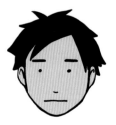 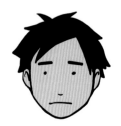 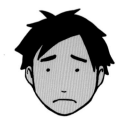

Neutral happy ▲
Slightly raised eyebrows create an open but neutral expression.

Pleased ▲
The corners of the mouth tilt up in a smile, the eyebrows begin to raise.

Pleasantly surprised ▲
The eyebrows shoot up and the smile becomes more obvious.

Delighted ▲
The eyes close, the smile is a full 'U' curve, the eyebrows vanish in the hairline.

Neutral sad ▲
Flat eyebrows add a sad tinge to this neutral expression.

Glum ▲
Eyebrows begin to lift next to the nose, while the mouth dips at either side.

Broken ▲
The eyebrow slope deepens, the corners of the mouth head towards the chin.

Distraught ▲
The mouth is an inverted 'U', the eyebrows an open bascule bridge.

Neutral angry ▲
The slight curve of the mouth suggests something has irked this character.

Grumpy ▲
The brows furrow and the curve of the mouth becomes more pronounced.

Irate ▲
Eyebrows thicken and teeth become visible as inner tensions start to spill out.

Furious ▲
Brows nearly meet in the middle, the mouth twists down, with teeth visible.

Seven facial expressions

Here are some common expressions. You can vary these – nothing is set in stone – so if another way of conveying anger or happiness occurs to you, try it out. You can also look in the mirror, or take photographs of friends mimicking these emotions, to give yourself a better idea of the various shapes and lines made naturally by the face.

Sad ▶
The features in this expression are a combination of surprise and upset. The mouth is small, the eyes wide open and crying. The eyebrows are narrow 'S' shapes lying on their sides. Above the eyes, an extra arch gives the lids a touch more emphasis. This character is openly crying but you can show the anticipation of tears with extra patches of reflected light, and by giving the iris and pupil fuzzy edges to suggest extra moisture in the eyes. If you want the tears to be more apparent, add a couple of cloud-shapes in the corners of the eyes. You can also draw a couple of extra upward slants under the inner side of the eyebrows to show the raising of the forehead.

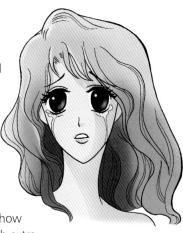

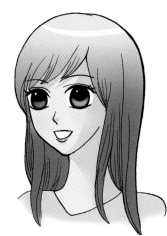

Annoyed ▲
Keep the pupils small to show your character's displeasure. The closed mouth is drawn as an arch, and should look sullen and petulant. Eyebrows indicate a vexed expression.

Friendly ▲
The eyebrows form subtle arches. A thin line above the eyelashes indicates the eyelids are relaxed. The face shows interest and openess. The eyes are wide open and the mouth is smiling.

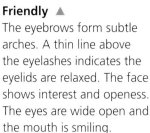

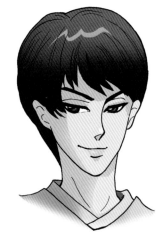

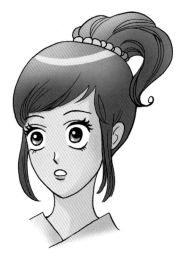

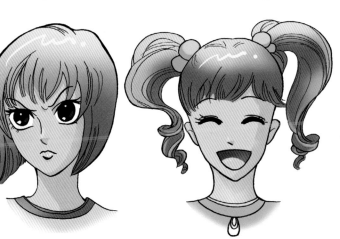

Evil ▲
The eyebrows are thin, pointy and more angular than angry ones. The eyes are angled downwards. Make the eyelids, pupils and lashes thick and dark; shrouded and sinister. The nose is pointy, almost sharp, and the mouth needs to have a smiling or a smirking element to it: the character is enjoying himself. To suggest extreme evil, try gritted teeth and a broad smile. The smirk shown here is achieved with a straight line that is upturned at one end.

Surprise ▲
The expression on this girl's face indicates surprise and disbelief. The eyes are wide open, showing the whites of the eyes surrounding the irises. The black pupils are big, hollow circles. The mouth is rounder than 'friendly' and 'happy', and the expression of shock is indicated as an 'O' shape.

Angry ▲
Shape the eyebrows so that the corners nearest the nose point straight down, and rise steeply on to the forehead. Reduce the size of the pupils to a tiny dot, or leave them out altogether. Some artists further convey rage by fanging the teeth.

Happy ▲
These eyebrows are high arches, the eyes similarly closed to evoke elation. The mouth is much bigger than the 'friendly' mouth, drawn as a blunt upturned triangle. The left and right corners of the mouth are turned upwards.

The manga figure

In any style of cartooning, whether traditional or manga, the figure takes precedence. Readers notice the human character before everything else, because it is almost always the element that carries the narrative. Human bodies come in all shapes and sizes, from little children to muscled giants, so your manga universe would be boring if everybody looked the same. As you did for the head, start by practising the basic shapes and structures of the human figure.

Constructing the body

Basic anatomical construction comes from understanding the abstract shapes of the human body, and how they act in relation to one another. Whether by studying a skeleton, or by breaking down an existing figure drawing into simple components, learn to see each segment of the figure as part of the whole. Using simple shapes like spheres, tubes and curves, you can block in the proportions of your poses and clear up any anatomical mistakes before you add in the detail work. Pay attention to where limbs connect, and how different parts of the body alter with perspective.

◀ **Simplified anatomy**
Before working up to a high degree of detail on your characters, it can often be helpful to block out the shape of each pose using simplified structures like these. Focus on getting the correct lengths of each limb and the appropriate attitude and rotation of each joint.

◀ **The layout stage**
Boil down each pose to its essential components. Pay attention to the waist and hips as they twist away from the default pose. Use the head's 'crosshairs' to show where a character is looking. Don't forget that photo reference can often prove invaluable.

Tip: Manga heroes are slim and attractive, so keep them toned, not bulky. If you want to show physical strength, increase the muscle mass around the thighs, the shoulders, the chest and the arms. Don't exaggerate to the extent that you create a 'superheroic' inverse-'V' shape, i.e. a torso larger than the legs can realistically support.

Gender differences ▲
The ribcage that defines the chest is broader on the male than the female, but female hips are wider in proportion to the chest than male hips. In these simplified skeletons, oval shapes are used for the skull, chest and hips. Male versions are more angular.

Manga musculature

Male and female characters in manga are often more developed than someone of their age would normally be. Once you've got used to drawing proportional outlines, you can add the muscle, skin and detailing that create the finished outline of your character.

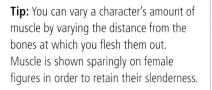

Tip: You can vary a character's amount of muscle by varying the distance from the bones at which you flesh them out. Muscle is shown sparingly on female figures in order to retain their slenderness.

Head and shoulders

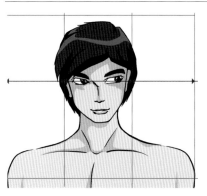

Male manga characters have wider shoulders than female characters. Though some artists say the shoulder width of a male character should be the equivalent of three heads, your heroes will look like muscleheads if you always follow this rule. Experiment with bigger head proportions to find the best size.

Skeletal structure

It is well worth studying the human skeleton, even if you have mastered using simple shapes to lay out your figures, as it will reinforce your knowledge of basic anatomy and how every part of the body fits together.

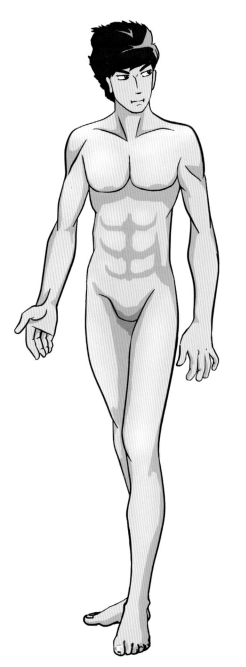

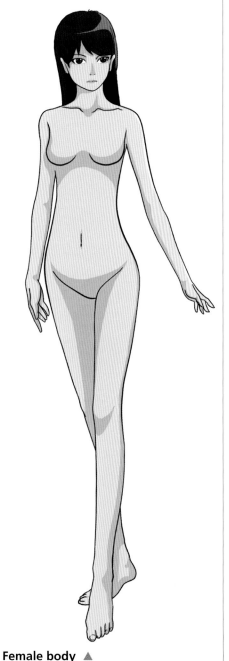

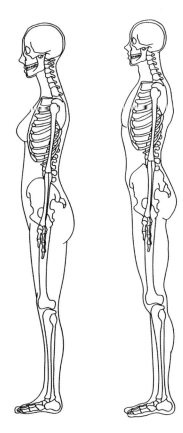

Male body ▲
Here is the fully defined male form, with skin and musculature grafted over the simple layout shapes. Note how strongly the muscles are defined, drawing attention to the joints of the skeleton beneath.

Female body ▲
Female manga forms are far less overtly muscled than the males: joints are suggested by gentle curves, not rendering. Tissue is denser in the breasts and around the hips, creating an obviously female silhouette.

Proportion

As you go on to customize the form of your characters, they will take on their own dimensions. Their proportions – the distances between features – may become longer or shorter. You may also decide to make their overall size or the size of certain parts of the body larger or smaller. Whatever forms you develop, your characters' movements need to conform to the new proportions you define whenever they appear in order to be convincing. Then, no matter what they look like, the reader will accept their essential reality. Manga artists define the proportions of the adult body through the use of the size of the head: seven or eight times deep for a standard male or female protagonist, nine heads for an Amazon or male superhero, six or seven heads for adolescents, between five and six heads for a child, and two or three heads for super-deformed (exaggerated) characters or chibi-style (short person) characters.

Use these rules as a basis, but adjust them according to your needs. As before, make sure you are consistent: using a guide allows you to maintain character proportions throughout an entire story. There are key differences in the physique that when drawn, help readers determine whether or not the character is female or male. For a female these include narrower shoulders, a thinner waist, higher hips and less muscle definition, smaller facial features and curves.

Female body proportions

A manga artist works out a character's proportions in relation to head size. The technical term for this rule is the 'canon of proportion'. Manga females are usually petite and their proportions reflect the ideal of beauty as defined for Japanese women. Developed muscles are less aesthetic. It's common, however, to add voluptuous curves to differentiate women from girls.

Adult female ▼
The average adult female stands eight heads deep and is tall and slim, while still curvaceous. Classic 'hourglass' proportions (bust and hips) produce an elegant and graceful frame.

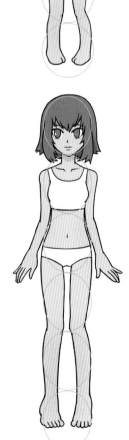

◀ **Pre-school female**
The body of a young female is four to five heads deep. She is rounder and less defined than an adult. Notice the disproportionate roundness of her head and huge oval eyes.

> **Tip:** The rules of proportion mean that whatever the height or build of your characters, they will 'read' as human: from 1m to 100m (3ft to over 300ft tall). You can change limb lengths, but be aware that they may be construed as odd.

◀ **Pre-teen female**
The pre-teen female is five to six heads deep. The chubbiness has all but gone, and there is more definition in the body and face. The eyes are slightly smaller and less oval. The girl is approaching adolescence, as shown by her small bust, developing hips and slender legs.

Teenage female ▶
The teenage female is six to seven heads deep. The hips and thighs have broadened since the pre-teen stage, and there is a noticeable bust. The face is more angular, the eyes smaller, and the fringe (bangs) is more pronounced. Her arms show greater muscle definition.

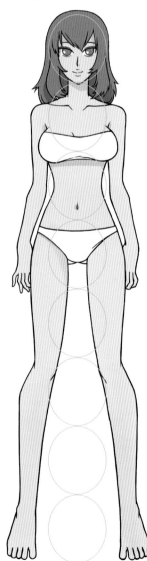

Male body proportions

Most characters in manga are young male adults, for the simple reason that they constitute the target market. Males in general fluctuate widely between heavily musclebound types and sylphlike androgynes. Bishonen (meaning beautiful youth or boy) style, for example, reduces the male body to a graceful, slender physique with only slight indications of muscle, and a notable lack of nipples or body hair. Whether drawing males or females, it's helpful to develop a working knowledge of human physiology, so that you can appreciate the layout of muscles and bones. Start by learning how to draw realistically – you can modify the examples into your own style later.

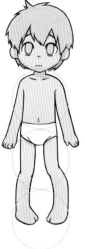

◄ **Pre-school male**
Four to five heads is the recognized canon measure for young children. Aside from a disproportionately large head, the male child has chubby, undefined limbs, much like his female counterpart, and a rounder face than the teen or adult male. In manga, the younger you make a character, be it male or female, the larger their head is in relation to the rest of the body.

Tip: Consider joining a life-drawing class. Regular classes will improve your fundamental understanding of the human form. If a class isn't possible, drawing yourself in the mirror is a good starting point. Try drawing clothed figures, too, noting how the different fabrics gather and stretch over the human figure.

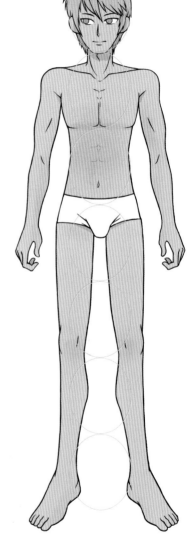

Pre-teen male ▷
The pre-teen male is five to six heads deep. By this age he is reasonably lithe, with slender limbs. His skeletal and muscular development doesn't yet support the strong body shape of adulthood, but his chest has broadened significantly since the pre-school years, and he has more muscle definition. Keep the shoulders of pre-teens relatively undeveloped, and keep the length of the limbs similarly constrained.

Teenage male ▷
Now in his teens, the male character has increased muscle definition, particularly in the arms and shoulders, and stands between six and seven heads deep. He is still slender, and his figure is drawn with simple, sleek vertical lines and very few curves. Compared to the pre-teen male, his face is more angular, the eyes smaller, and he has a more defined fringe at the hairline.

Adult male ▲
Fully grown, our male protagonist now stands seven to eight heads deep and carries himself with an upright stance. He is super fit and strong. But while the muscle tone is more defined, and his shoulders are far broader, he lacks the powerfully solid torso and exaggerated abdominals and chest pectorals of the average superhero. His chin is no longer pointy and his new, square jaw almost matches the width of his cheekbones.

Drawing hands

In creating expression, a character's hands are almost as important as their face. A hand gesture, like a facial expression, can convey how a character is feeling without them having to say anything. If your character is talking, but is not being sincere, then their hands can reveal their true emotion and give them away. If a character's face is not visible,

but their hands are, you can easily show they are tense or angry with a clenched fist. Open palms can indicate friendship or surrender. Because the hands have numerous joints and are so flexible, there are literally hundreds of ways in which you can depict them. Start by picking a few easy positions and practise drawing these.

Practice exercise: Open hand

Open hands usually indicate a passive or relaxed person. If they are held above the head, they show the character is trying to attract help or attention. If they are held out in front of the body they may represent a plea to stop.

Materials
- *cartridge paper*
- *soft lead pencil*
- *pen and ink*
- *colour of your choice*

1 Start with an abstract shape, like the head of a broom or a mitt, beginning at the wrist and flaring upwards and outwards to create the basic hand shape of two arcs joined together.

2 At a position roughly the same length away from the hand as the size of the hand, inscribe an upper arc. Add four lines for the fingers, with the middle finger the longest. Jut out the thumb like the spout of a kettle.

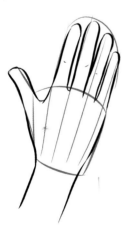

3 Thicken out the finger guides, using your own hand to accurately estimate their proportions. Note where the fingers intersect with the palm and back of the hand: in the centre of this guide line is where the knuckle falls. Each finger subdivides into three sections, extending from the knuckle.

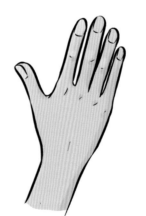

4 Draw around your guides, fleshing out the musculature and giving the hand definition. Add fingernails, as well as small upward arcs to shape the knuckle joints, using the line guides from the previous step. Ink your favoured pencil lines and add colour as necessary.

Palm of hand

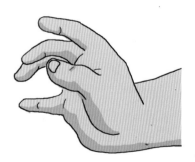

Repeat the first few steps, but don't add fingernails or knuckles. Instead, add the main areas in the skin of the palm: a pair of horizontal lines across the centre, an arc across the wrist, and arcs to show where the thumb and the flesh of the hand protrude.

Hand movement

Study how the hand moves, both in the realm of individual fingers – pointing, fists, open palms – but also in how the hand relates to the arm: how it rotates and flexes around the wrist.

Gender differences

In manga tradition, a female hand is not as wide as a male one, and the fingers are longer and more delicate. A female's open palm does not show very many creases and any ones that are included are more subtle.

A range of hands ▶
Why not devote a section of your sketch pad to capturing hand poses from life or magazines? Try different shades of skin colour.

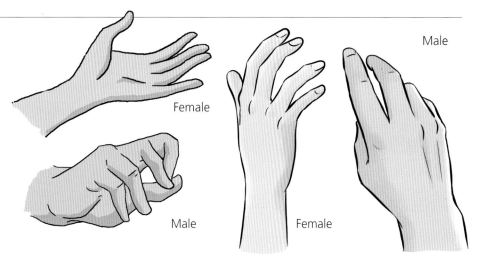

Female

Male

Male

Female

Hands at different ages

When you draw an elderly hand, add more lines around the fingers and joints. You should also make the fingers thicker and less sleek. When you draw a very young hand, keep the fingers small and underdeveloped; their length should only slightly exceed the length of the palm of the hand.

Square versus smooth ▶
Older hands are more angular than young, as joints begin to protrude through thinning skin.

Young

Old

◀ The extremes of age
The hands of young and old characters are drawn to the same proportions as their bodies: a child's hands are short and stubby because they are not yet fully grown. With faces, the rule of ageing is that every additional line adds a year to the character's life – it's a similar case for hands.

Studies of hands

It's vital that a manga artist be able to draw the hand in a wide range of positions, and you should practise as often as you can. Look at the way your own hand moves, and you'll notice its versatility: you can change the way it looks by moving just one of your five fingers (not to mention the wrist). The examples shown here show the hands in a range of positions.

Flustered hands ▲
It's all too much for this character, who takes a breather, resting her hand on her forehead. Note how her fingers interact with the hair and forehead.

◀ Holding hands
Here's a masterless samurai's hand, gripping tightly to his katana. Note how the hand interacts with an object.

Hands in perspective ▲
Here's a pose captured using a mirror or photo reference. Never forget that it's rare to see a hand in manga from the same perspective as you would see your own: experiment with angles.

Drawing feet

As well as hands, you need to think about your character's feet. Most of the time, these feet will probably be inside shoes, although it may occasionally be appropriate to draw a character barefoot. Feet are often used to convey travel within a story – a close-up panel of a character's feet will tell the reader they are approaching their destination, or else emphasize the passing of time during a journey. If you find drawing feet difficult, take comfort from the fact you are in good company. Many artists hate drawing feet, and some will go to great lengths not to show them. It can be difficult to get the feet right in relation to the rest of the figure, and it is a common mistake to draw feet too big. Start your training with a series of simple shapes as a basis, and then draw the positions of the feet within the guides. You should practise drawing both sides of the feet from various angles in order to understand as much as possible about this part of the body.

Practice exercise: Side view

It's easiest to think of a foot viewed from the side as a right-angled triangle with the longest edge as the base of the foot. These steps will allow you to flesh out that underlying shape.

Materials
• *cartridge paper*
• *blue pencil 10*
• *soft lead pencil*
• *pen and ink*
• *colouring method of your choice*

> **Tip:** Bulky, heavy characters should not be given small, perfectly formed feet, unless you are drawing attention to their mismatched proportions. Adapt the standard feet shown here by thickening up the dimensions, remembering that muscle tissue, fatty deposits and skin can increase in size, but the bones underneath do not. This leads to chunky toes, tree-trunk like ankles and so on. An ogre's feet should be as large and ugly as his body.

1 Start with a smoothed right-angle triangle for the foot, with a rectangle on top for the leg. Add a small squashed oval to locate the big toe.

2 The inner foot should arch upwards slightly, off the ground, with the thick pad of the ball of the foot placed slightly behind the toes, and the heel falling just behind the line of the ankle.

3 Add in the toes. From this view only the big toe is visible. From the opposite side start with the little toe and work back to the big toe; the tips of each may be visible from the side, depending on the angle you choose. Use ink and colour to complete the side view.

Feet in motion

When your characters are in motion, the appearance of their feet, and the angle of the foot to the leg, is constantly changing. Although it isn't necessary to master every perspective, it's important to suggest this movement. Look out for visual references to keep in your sketchbook and use for your drawing practice.

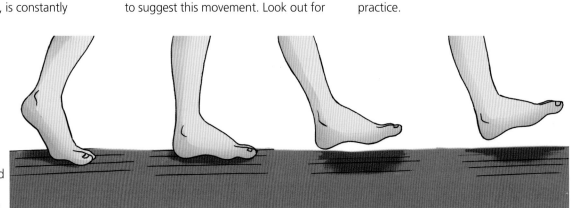

Moving feet ▶
These simple poses show feet in various stages of motion. These can be adapted for walking, running or dancing sequences.

Practice exercise: Front view

A row of toes forms a natural curve, which begins at the big toe and ends at the smallest. Shoes should be drawn following this curve, with a rounded end instead of individual toes.

Materials

* *cartridge paper*
* *soft lead pencil*
* *pen and ink*
* *colour of your choice*

1 Begin with a trapezoid shape for the feet with a rectangle on top for the leg. The trapezium should be cut so it runs practically parallel with the top of the foot.

2 Subdivide the trapezium into the toes, noting the gap between the big toe and the other four. Note, too, how the feet bow outwards at the 'knuckle' of the big toe.

3 Add toenails, remembering to keep them blunted towards the end of the toe, and ink your favoured pencil lines. Use colour to add texture, shading and tone.

Tip: Draw shoes with a rough version of the foot inside for a more convincing shape. If you're still having trouble, take off your shoes, tilt them to the required angle, and sketch from life.

Toes and toenails

Each toe is a blunted rectangular shape and slightly curved. The big toe is the dominant template, each of the four other toes diminishing in a curve of size to the right or left of it, depending on the foot. Toenails end at the tip of the toe and have a rounded edge.

Ankles

The ankle is a small part of the body but necessary detail. If the foot is drawn from the side, the ankle is represented by a small arc that protrudes from the leg. The ankle is shown as two lines that slope gently outwards. The ankle joint on the outer leg should be drawn slightly lower and closer to the foot than the ankle on the inside leg.

Foot extended

Observe how the foot appears at rest, and when it bends. If you look at a foot from the side, pointed straight down, toes to the ground, you'll see that its top is almost a straight line, but that the bottom of the foot, particularly around the heel and toe, protrudes and creates a crease in the skin where it meets the top of the foot.

Shoes over toes

Drawing a completely bare foot can be difficult, and getting your character to put on shoes can make your life simpler. This way, you don't have to draw individual toes or worry about getting the heel in the correct position. It's also easier to correct a mistake when drawing a pair of shoes, because you are free to improvise, than it is to correct an anatomical error while drawing bare feet. It's also a lot easier to draw your own shoe from real life than it is to sketch from your own bare feet.

Movement and perspective

You need to keep your characters in motion. If you draw them in the same pose, panel after panel, you will quickly lose your audience's interest. Move them in a way that is appropriate, taking into consideration their psychology, motives and style. The poses you give your characters will define who they are within a story, and enable your audience to differentiate between them. Characters should always be recognizable, not only when they are standing still, fully lit and in the foreground, but also if they're drawn in the distance, in the shadows, or out of focus. A character should be recognizable by their smaller traits, so that even if the majority of a character's body is hidden, his or her gestures will make clear their identity. Don't confuse your readers: whatever your character is doing, whether they are sprinting, bending down, catching or throwing, show their actions clearly. This is equally true when a character is stationary: even while sitting down, a character will project a mood, an attitude and a point of view. The key to communicating all these different facets is to choose the ultimate expression of each pose – the moment that sits right at the heart of your chosen action.

Stages of movement

It is not always easy to choose the right moment: a pose that shows your character doing exactly what you want your audience to know they are doing.

It can be helpful to imagine your manga narrative as a film, which you can pause every few seconds and explain with subtitles. Of course, the grammar of film is often very different to that of manga, but try watching a chase scene and pressing 'pause' occasionally. You'll soon find your 'eye' for picking the right paused moments: those with the greatest dynamism and energy, even when frozen. Anatomy is your second watchword, as your audience must be able to recognize the poses you create – they must be physiologically plausible. Characters must never look like they are made of rubber – unless it's one of their mystical abilities. One of the best ways to sell movement is to integrate it with your backgrounds and secondary characters, whether it's puffs of dust from feet on tarmac, or a person being pushed aside as the hero races past.

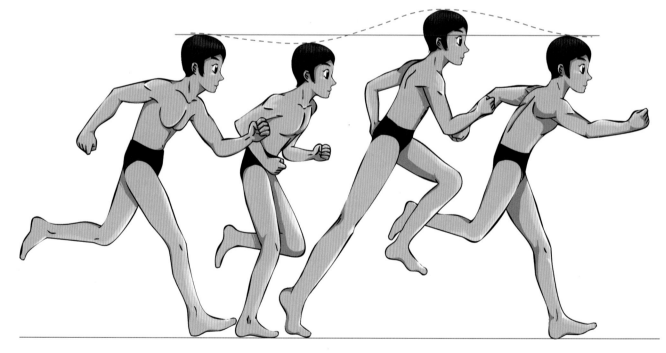

Hitting the 'pause' button ▼
When reviewing your scene, capture the apex of each individual moment, the point when the potential energy of any action is released.

Stages of dynamism ▲
While any of these poses would work, the third, marked by the upswing in the red dotted line, is the most dynamic.

Tip: Find your definitive moments and draw them. Don't leave anything open to interpretation unless you aim to be ambiguous. If your audience misreads an action, it will muddy the story and detract from the pace.

Axes of perspective

Since manga is two-dimensional, you must find methods of implying a third, to give your characters depth. Using axes can help establish perspective, which will make your characters look more natural as they move within their environment.

The axes comprise two horizontal axes (X, across the horizon of your image; Y, into and out of the image) and a vertical axis (Z, up and down the image). These axes are rotated with respect to where the 'ground' is in the image you are drawing. Picture the vertical axis as your character's centre of gravity, and rotate limbs and poses around this anchor, thus keeping you tethered to the possible and allowing you to turn the character in 3-D space.

X, Y and Z axes ▼
The spine ascends on the Z axis. Points on his body tilt away from the 90-degree angles on the X and Y axes, giving him energy even standing still.

Action curve

Another form of assistance is the action curve, which helps you to concentrate the body into a single flowing pose. The action line flows down the centre of the spine from the head, and changes shape and length depending upon the pose, forming the single simplest embodiment of every action. When sketching out your poses, the action line should be the first element you draw, enabling you to hang your anatomy on to the most dynamic through-line. The examples below demonstrate the use of the line in the construction of poses, showing the bold action line in blue, the layout anatomy in red, and the completed image in full colour.

Punched ▲
Note how the action line describes the arc of the whole figure, not just the position of the arms or legs.

◄ **Jumping**
In this case, the line and figure are in tight agreement, showing the release of energy vertically as the character leaps upwards.

Foreshortening

This is when parts of a character's body that are 'closer' to us are drawn much larger than those farther away, exaggerating and 'shortening' focal depth for dramatic effect. An example is of a character flying or running towards us. The character's outstretched arms or head may be large in the frame, drawing our attention, but the legs and body are smaller, pushing them farther away. It can be tricky to get the hang of this technique, but striking and punchy poses are a result worth working towards. Foreshortening also has the added benefit of making the reader feel much closer to the action.

American footballer ▲
The helmet and shoulder pad burst out of the page, the footballer appearing to barrel towards our fourth-down tackle.

Flying superhero ▲
The hero vaults into the sky, his fist and arm outpacing the rest of his body.

Practice exercise: Male running

In an action-packed manga serial, you're likely to have several characters running, whether it's towards or away from danger. Here's an opportunity to take all you have learned about proportion, anatomy, detail and dynamism, and fuse them into a single image of a shonen hero sprinting to victory. When you've finished, why not try altering the angle or pose?

Materials
- *cartridge paper*
- *soft lead pencil*
- *eraser*
- *pen and ink*
- *colour of your choice*

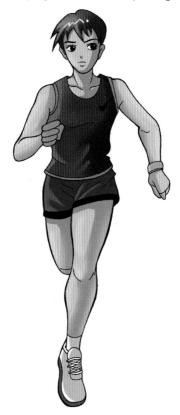

3 Now add the basic line work of the clothes, paying attention to the folds, and the way the jacket billows out, caught by the wind whipped up by the character's passing.

1 Start by roughing in the character's proportions, using simple geometry. Use an action line to select the most dynamic moment.

2 Add detail to the face and hair next, concentrating on the character's determined expression.

4 Add the final details, from the piping and pockets on the jacket to the crinkle lines on the trousers. Using your colouring or toning medium of choice, add your final textures.

5 Use ink and colour in your preferred medium to complete the side perspective.

▲ **A different perspective**
Here we switch perspective to show the character, now in running gear, foreshortened, running straight towards us.

Practice exercise: Female fighting

When you've had enough of running, it's time to turn and fight. Put into practice what you've learned about the action line, about how hands can grip weaponry, and how facial expressions can sell emotions. When you've drawn this warrior leaping into battle, why not show her from a different angle?

Materials
• *cartridge paper*
• *soft lead pencil*
• *eraser*
• *pen and ink*
• *colour of your choice*

1 As before, start your illustration with the basic geometric line work, remembering how female proportions differ from male.

2 The warrior is dressed in billowing trousers and wears thick-wristed gloves, both of which significantly change her silhouette.

On the attack ▶
Here, the action line descends from the character's head to her extended back leg. Note how the hair, robe and thrown-back arm all point along it, reinforcing her leaping stride. The forward leg is elegantly pointed to make a sharp and compact silhouette.

3 Add detail to the face, hair and hands, and generate construction lines to help you draw her bare feet in sandals.

4 Complete the pencilled image by defining folds in the clothing and the toes.

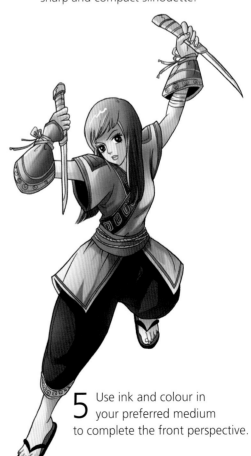

5 Use ink and colour in your preferred medium to complete the front perspective.

Stance gallery

After a lot of running around and strenuous exertion, it's time for your manga creations to relax. Unfortunately, the same can't be said for your pencil. Stationary characters can say as much, if not more, as characters sprinting or engaging in swordplay, and it's vital that you are able to communicate the differences in your characters' inner states without oversized gestures or combat manoeuvres. With practice and a little thought, you should be able to place your characters in a party situation and have your readers distinguish their personality types from stance and posture alone. After all, how often do you stand with a completely straight spine and your arms pointing down by your sides? Make sure you develop casual stances for your characters, so that they don't look like soldiers when they're not on the move.

Stance

Before drawing your characters in a stance, try standing yourself. Notice how you tend to put weight on one leg when you're relaxed (you may even favour one leg over the other every time). In placing the weight on this one leg, you are raising the corresponding hip, while the leg bearing the weight will stay straight and rigid. Your waist also bends to compensate for the tilting of the hips, and straightens at the torso. Otherwise you would fall over. The human body understands instinctively how to counterbalance itself.

The position of the body comes down to the positions and angles of the feet, hips and legs, and whatever these parts of the body do, the torso follows to balance you out. So make sure you notice when standing yourself where the weight is distributed, which leg it is on, what your feet are doing (using the heel, the toes, or both) and how far apart your legs are. Try standing in front of a full-length mirror and running through the stances on this spread. See if you can improve on them, or add your own twists. Try to fill a sketchbook page with stances in simple spheres-and-tubes geometry.

Teenagers ▲
A mixture of unearned confidence and overblown angst, these teenagers manage to be cocky and emotionally closed at one and the same time.

Nervous ▲
This character keeps her body language locked down as she looks off, waiting for somebody or something she dreads.

Achievement/polite surprise ▲
Our chef is pleased to display the result of his experiments, while the pink-haired girl was not expecting a cake, but will accept it anyway.

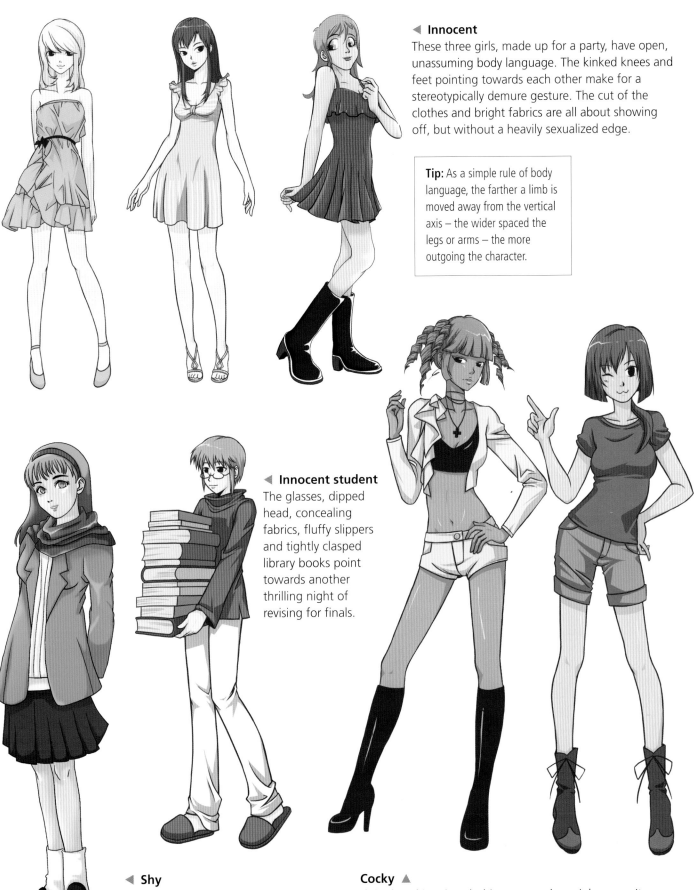

◀ Innocent

These three girls, made up for a party, have open, unassuming body language. The kinked knees and feet pointing towards each other make for a stereotypically demure gesture. The cut of the clothes and bright fabrics are all about showing off, but without a heavily sexualized edge.

Tip: As a simple rule of body language, the farther a limb is moved away from the vertical axis – the wider spaced the legs or arms – the more outgoing the character.

◀ Innocent student

The glasses, dipped head, concealing fabrics, fluffy slippers and tightly clasped library books point towards another thrilling night of revising for finals.

◀ Shy

Arms clasped behind the back, knees pressed together and head cocked askance all speak of a character not confident in her own abilities.

Cocky ▲

If the hip-skimming clothing or naughty winks weren't enough to tip you off, the raised hip and pointing fingers speak of characters powerfully assured of their own attributes and ultimate, inevitable success.

Colouring your drawing with markers

Markers are a versatile method of colouring your illustrations. They come in a range of bold colours that reproduce well, and can be mixed and blended on the page, whether by layering using the same pen, or with darker, complementary tones. As well as producing fast-drying, naturalistic results on finished pieces, markers are also excellent for sketching and testing out colour schemes before proceeding to digital colour. Remember, for the best results, ink your drawings with Indian ink or a waterproof fineliner so that the colour and black lines don't bleed into one another. The project on this spread will walk you through the steps of colouring a young shojo heroine in a kimono using a limited palette of markers.

Practice exercise: Shojo heroine

This vivacious shojo heroine mixes cosplay (dressing in elaborate costume) with a more conservative streak in the traditional kimono and submissive posture. Perhaps she is undercover in some capacity? The illustration uses only a handful of marker colours that nonetheless create a fully rendered 3-D effect.

Materials
- *cartridge paper*
- *soft lead pencil*
- *blue pencil 10*
- *pen and ink*
- *selection of manga markers (greens, pinks, purples, yellows, browns)*

1 Open the illustration with a rough pencil sketch, blocking in the anatomy and basic shapes of the girl. Press lightly with the pencil so as to leave the paper as unmarked as possible. You may find it easier to draw a stick figure to help place all of the limbs before you draw the kimono over the top.

2 Work up the areas of detail in the hair and face, keeping the lines and folds on the kimono and sleeves fairly smooth. When you are happy with your pencil lines, ink them and, when dry, erase the lines as best you can.

3 Choose your first marker, picking a skin-tone shade to colour in the face and hands. Marker colouring works best if you leave highlighted areas as white, so imagine you are shining a bright light against your chosen surface. Don't colour the areas where the light is heavily concentrated; instead, colour the shadowed areas: underneath the eyes and fringe (bangs).

4 Using a darker shade of peach-brown, deepen some of the shadows on the face – concentrate these second shadows underneath the fringe and on the neck. Using purples and pinks, detail the eyes and lips. Keep the lips thin around the inked mouth, and leave a white highlight on the eye.

5 Leaving a large area of highlighted white striking the top of the girl's hair, colour in the first wave of green. Keep the green tone organic and natural by stroking over various areas of the hair a second or third time to make them darker and richer.

6 As with the skin tone, pick a darker version of the main hair colour and use it to pick out areas – or strands – of deeper shadow. For hair, use quick, individual flicks to give it body and life.

7 Switch your focus to the kimono. As the fabric is less reflective than either the hair or skin, there are fewer white highlights to worry about. Instead, build up tone in layers, colouring over the main body of colour multiple times, narrowing your area of shading each time.

8 Using a darker pink, add in harsh shadows on the right-hand side of the kimono and in the sleeves. Use golden yellow and brown markers to add detail to the belt and sandals. Detail and minimal shade is added to the towel with a grey marker. Build up the texture by stippling large, smudged dots.

Character archetypes

Most manga characters are young adults, because this is their target age group. If this is your audience, you want to make it easy for them to identify with your story. Each manga genre, from shonen to shojo and all points in between, has its own favourite character types. The clothes your characters wear, for example, will be dictated by genre, and that genre will encompass hundreds of books, each with their own leading character. How will your protagonist differ? Do they have an unusual magical power? Is he or she skilled in a particular martial art? No matter how adept, your characters may also be socially awkward – perhaps shy around members of the opposite sex, or just people in general. They might lose their temper easily, or get horribly clumsy when they are nervous. It's up to you.

Characters aimed at boys and girls

Shonen (comics for boys up to 18) and shojo (comics for girls up to 18) are both aimed at a typical teenage audience, and feature stories in which the protagonist overcomes obstacles in order to achieve an eventual goal. This type of story is known as *doryoku yuujou shouri* in Japan, which translates as 'effort friendship triumph'. The protagonist, through the obstacles overcome, also achieves improvements in him or herself, sometimes physical, sometimes mental, and sometimes bordering on the supernatural.

The characters involved in these stories usually have to use martial arts, sports, or games to progress and it is the improvement in these areas that will help them achieve their final goal. The setting for these stories varies wildly, from present day to science fiction and fantasy, or an original amalgam of all three.

Shojo heroine ▲
As shojo often deals with the interior world of emotions, this schoolgirl could be suffering a terrible crush, or be ready to deal out magical justice at just a moment's notice.

Fantasy shonen hero ▲
Sword in hand, this hero quests for the freedom of his people, and to rescue his kidnapped love.

Male protagonist

In shonen, the male protagonist must be the pivot around which the rest of the story revolves. He must achieve a great, monumental task, overcoming smaller quests and problems along the way. He is motivated in his task by friends or family, an authority figure whom he trusts (a teacher, respected elder statesman or a commanding officer), or by the actions of his villainous antagonist.

The lead character's attributes are always positive, as he is working towards the greater good. He is usually charismatic, driven by a desire for self-improvement, and physically attractive. However unique his characteristics and appearance, he will be instantly recognizable as the lead character.

Magic-wielding shonen hero ▲
Gifted by a magical talisman he found in a Kyoto junkshop, this straight-A high school student has an alternative career as a hunter of the forces of evil. When not brushing up on his grades or valedictorian speeches, he heads into the underworld in search of rogue demon half-breeds.

Female character

The main character in shojo is always female, but female leads also appear in shonen. In shonen, the female lead often displays an equal degree of strength, skill and intelligence as the male protagonist.

Generally speaking, female manga characters are attractive, young adults or adolescents who possess an air of either mystery or mischief.

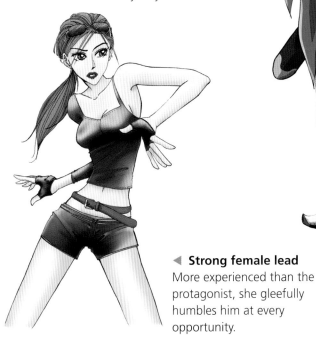

Heroic character

The hero is typically a character at the peak of his or her abilities. Manga tends to make the hero a secondary character, rarely the protagonist. The hero is often a role model for the protagonist, and since the reader is identifying with the protagonist, also a role model for them. These heroic types may be either true heroes or villains, but they have abilities beyond the lead's, including strength, courage, bravery, and meta-human or mythical powers.

◄ **Strong female lead**
More experienced than the protagonist, she gleefully humbles him at every opportunity.

Hero of song and story ▲
He has roamed the land since time immemorial, putting his mythical sword to evil-doers for centuries.

Child character

Children provide a softer edge to a manga story, getting into humorous trouble because they lack the experience to do the right thing. In kodomo manga, children take the lead, often forming a team with older and more powerful allies on the strength of their charisma and wit. These allies make up for the children's lack of power, and will usually assist them in achieving their goals, or taking on a villain too strong for the kids to defeat by themselves.

Precocious child ▶
Stubborn, strong-willed and independent, this girl is always willing to strike out on her own in search of fun and adventure. Note her impish smile and wink indicate an extroverted personality.

Secondary character

Secondary characters have the potential to be protagonists, but are typically a close friend who helps stop the lead from becoming self-indulgent in his personal quest. If younger than the lead, they will have a similar effect to a child character in softening the lead's hard emotional edges.

Sometimes the secondary character is a Trojan horse, possessing an ability or skill lying dormant within them that makes them a key figure in the conclusion of the tale. A secondary character can gain an importance that is sometimes superior to that of the protagonist.

The best friend ▶
Checking his watch and looking out for hall monitors, this high schooler awaits his friend's return from a dark mirror dimension.

Super-deformed characters

Characters that are super-deformed (or SDs, as they are more commonly known) are examples of a specific style of manga caricature. The characters are typically small with stubby limbs and oversized heads, so that they resemble small children. Amateur manga artists sometimes start by drawing characters in this style because they are easier to construct. In commercial manga, this drawing style, with even greater degrees of exaggeration, is often interjected into the usual style to show a regular character's extreme emotion, such as anger or surprise, heightened to a level that would look bizarre on a more realistic manga face. When used in this way, they are known as chibi.

Super-deformed characters are meant to be cute and are often used in humorous diversions from the storyline. They also appear in shonen and seinen, which are relatively serious genres. Shirow Masamune's *Appleseed* series is a good example of this. The tales in the *Appleseed* canon are all cyberpunk thrillers and told fairly straight, but every now and then, Shirow throws in the odd bit of slapstick with a panel or two containing miniaturized versions of his characters, to define a moment of silly humour or overblown frustration.

Super-deformed characters can also be used for an entire story. These stories are always comedies, and are often tongue-in-cheek parodies of established manga genres.

Understanding body proportions

Super-deformed characters are drawn with an oversized head, hands and feet, and a small body. They can vary in height. The head is usually between a third and a half of the character's height. Generally speaking, the rule is that the smaller and more distorted the character is, the more detail you lose. Limbs and clothes are reduced to the

minimum number of lines possible, and as a result, the smaller details such as elbows, knees, and other such joints are eliminated. In the case of extreme super-deformed characters, when the ratio of head to body reaches 1:1, the limbs and the torso are drawn much chubbier in order to keep everything looking connected.

> **Tip:** A good approach to the super-deformed style is to draw everything below the neck in proportion first, then crown off your character with an absurdly large head. The simpler you make the features, the funnier the super-deform moment.

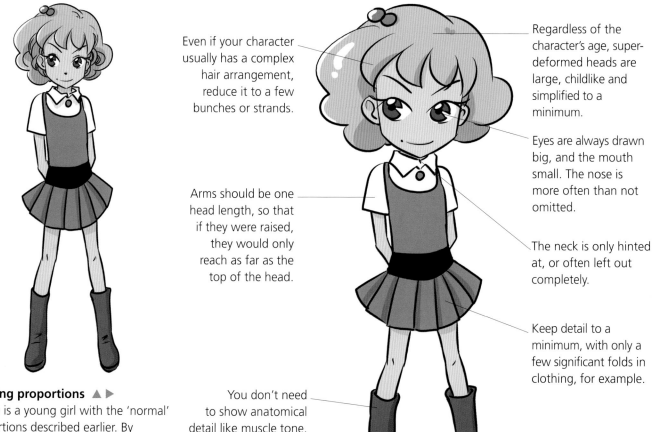

Even if your character usually has a complex hair arrangement, reduce it to a few bunches or strands.

Arms should be one head length, so that if they were raised, they would only reach as far as the top of the head.

Regardless of the character's age, super-deformed heads are large, childlike and simplified to a minimum.

Eyes are always drawn big, and the mouth small. The nose is more often than not omitted.

The neck is only hinted at, or often left out completely.

Keep detail to a minimum, with only a few significant folds in clothing, for example.

Altering proportions ▲ ▶
Above is a young girl with the 'normal' proportions described earlier. By exaggerating and altering them, you can turn her into the super-deformed character shown at right.

You don't need to show anatomical detail like muscle tone, so keep the clothes and footwear looking large on the character.

Practice exercise: Creating a super-deformed character

While super-deformed characters are very simple to draw, that doesn't mean that they lack structural underpinnings. As the head is the most characteristic feature and so large in relation to the rest of the body, you should ensure you pay it the most attention. The rest of the features are simplified as much as possible.

1 Draw a circle, forming the basis of the head. Now, draw two lines across the centre of the circle to form a 'crosshair' – like on a gunsight – that divides the circle into quarters. The horizontal line is your guide for the centre of the eyes. On the lower half of the circle, define the jaw and chin a little, but keep the shape relatively round. Take the jawline to just above the horizontal line of your crosshair.

Materials
- *cartridge paper*
- *soft lead pencil*
- *pen and ink*
- *colours of your choice*

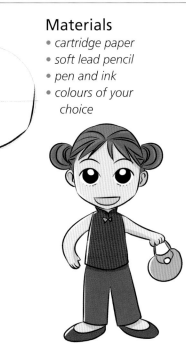

2 Draw in the eyes: the two corners of the upper eyelid should fall on your horizontal guideline. The arch of the eyebrows shows happiness. The eyes of super-deformed characters do not contain many flecks of reflection – you can include one oval of white in each pupil as a stylized representation. Above all, make sure the eyes are as similar and as symmetrical as possible.

3 Next, fill in the hair and the mouth, keeping the hair simple, as shown here. Draw a guide for the hairline, parallel to the top of your circle, but a little farther down the head (no more than a quarter of the height of the circle). Draw small arcs to show the hair is pulled back. Here, a couple of upward-curl bunches have been added. Keep the mouth to one or two lines.

4 The detail on the body, feet and hands is kept to a minimum. Do not labour over the fingers, which can be reduced to a couple of small arcs drawn on to the end of the arms, or even omitted altogether: sometimes a thumb is all you need to suggest a hand. Here the body has been drawn at least two heads tall, but you can go as far as a 1:1 ratio, if you like.

Chibi characters

These cute, simple characters have heads as big or bigger than their bodies. They are often the alter-egos of otherwise normally drawn characters. The chibi styling may be used to show a more childlike side to these characters, which they usually keep hidden.

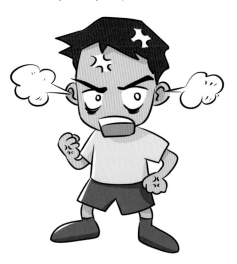

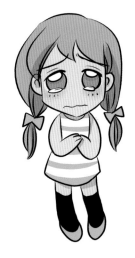

Two heads in height ◀ ▲
In chibi, childlike proportions are applied not just to the head but to the whole body. If emotion is running high, chibi characters should be drawn as though on the verge of a meltdown.

Three heads in height ▲
Everything about chibi characters is exaggerated, including the hair of the female characters. Emotionally, a chibi character doesn't just feel sad: he or she feels impossibly, gut-wrenchingly sad.

Character themes

Once you are familiar with the basic character types in manga, and understand what they represent and the roles they traditionally play, you can move on from the stereotypes to create characters with unique traits and idiosyncrasies. When you create new characters, it often helps to use ones from existing manga stories as templates, but as their author, you don't have to follow existing rules or create a carbon copy. That's not to suggest you ignore traditional archetypes completely, or your story would hardly be manga, but you could try blending characters from different manga genres to create something fresh and new. Try taking inspiration from other stories you have enjoyed in the past – not just manga,

but favourite films, novels and TV shows. Why are these characters appealing? How can you adapt them for your own use? A character may have a likeable defining trait, which grabs the audience's attention and sympathy immediately, or they may be more complex and mysterious, which can help to keep your audience interested over the long run.

Although the characters on these pages are based on stereotypes, they have been tweaked and altered with more interesting backgrounds and motives, all of which immediately suggest great story ideas. Use them as templates for your first stories, or learn from their example and create your own genre-spanning characters.

Magical Girl with a twist

Magical Girl is a popular protagonist in shojo stories. She is traditionally dressed in a sailor's outfit that is, in fact, a variation on the Japanese schoolgirl uniform. Magical Girls usually have special powers, which they use for good. They obtain their powers from an enchanted object such as a wand, which they keep to undergo a transformation. However, the extent of their powers is normally unclear. The Magical Girl here has been given a twist: she is part-vampire. Is she now the villain of the story? Does she hate who she has become, or has she embraced her vampire side?

Vampiric magic ▶
Though Magic Girl looks sweet on the surface, her uniform is more subdued in colour than usual. Does her wan smile hide sadness – or vicious fangs? Is the wand in her hand a charm to ward off her bloodlust, or a weapon with which to stun her victims?

Samurai out of time

Samurai characters normally feature in historical stories set in feudal Japan where they encounter black magic and have encounters with strange mythical creatures. But how about a warrior from the future, sent back in time by accident, who becomes a samurai? You could give him a sword of an alloy so strong it can slice through stone. Has your time-travelling samurai found peace in the past and wants to stay, or does he want to find a way back to his own time – at any cost?

◀ **Cyborg ronin**
Since this Samurai character is from the future, make him stand out. Here he is a cyborg with superhuman powers: half human, half machine. His armour is a liquid-metal compound that goes rigid when struck, making him unbeatable in single combat.

Trapped in the wrong body

This genius scientist got caught out by his own experiment. Now he's a hamster, and needs to change himself back to human form. He's still a genius, but he's now limited by his size and species. Can he make contact with one of the household children who may be able to help?

Miniature science ▼
The first task of any species-swapped scientist is to replicate his desk at his new scale.

Flawed characters

Always limit the strengths and abilities of your protagonists. If they are the best they can ever be from the outset, there is no room for development. A character so skilled and intelligent that he or she never fails, loses a fight, or suffers, will also be dull and one-dimensional. Give your characters flaws because the strongest stories involve overcoming weaknesses, and winning in spite of them.

◄ Dark alley
The character shown here has been beaten. He lies on the ground, clutching himself in fear and pain. The three figures in the background stand over him, weapons in hand – are they his cowardly attackers, back to finish the job?

Opposites attract

In a romantic story, your character might be an arrogant man, clever and popular with everyone, but someone who uses people almost without thinking. However, he has a female friend who brings out the best in him, but this side gets lost when there are other people around. As she gets increasingly frustrated by him, what lengths will she go to to get him to change? Is he able to?

Changing for love ►
What other sides are there to the girl, and does the man, ironically, bring out the worst in her?

Demon detective

This female detective is from Hell. She catches bad guys, but often in the service of her evil masters. How does she get criminals back to Hades? Was she once human? How does she deflect the suspicion of her colleagues? Notice her hands are gloved. Is she unable to hide her demonic qualities? Do the gloves conceal something grotesque?

Evil for hire ►
This hard-boiled tale mixes detective procedural with mythical intrigue, giving it an otherworldly element.

Dress to impress

The clothes your characters wear are important to their look, and give your audience a means of recognizing them at all times. When you start formulating your characters, draw them without clothes until you're happy with their shape. Then you can develop their style and dress them up. Clothes move as much and as often as the bodies inside them. Although all fabrics behave differently, they share a tendency to fall away towards gravity and the ground.

Defining status through garments

Clothing not only illustrates fashion choices, age, and wealth or poverty; it can also define the status of a character. A uniform, whether that of the police officer below, a military number, or a nurse's outfit, shows status, rank and authority within society. By contrast, a character dressed in ragged, dirty clothing is likely to live on the streets.

◀ **Sports party**
Equally ready for the tennis court or a beach party, this skimpy ensemble is all about showing off a young and toned physique.

◀ **Baggy style**
The tanktop fits tightly, but everything else is designed for street-corner slouching, or showing off the latest designer names – nonchalantly, of course – in the school halls.

Baggy or sporty?

Clothing is a three-dimensional form, and it is through the folds of the clothes that we infer the shading and texture of the fabric. Clothing should still show the shape of the character underneath, however, so don't dress everyone in baggy clothing. Dressing your characters in different ways allows you to suggest depth (or otherwise) in their personalities. A sporty character might wear jogging shorts or a tracksuit, revealing their physique and showing they are in their physical prime. A shy character is likely to wear layers and drab fabrics that push attention away from themselves. Think, too, of the power of a change of clothes: it's not for nothing that many romantic comedies end by unveiling the lead characters in a smart suit or a brand new dress.

Beat officer ▶
This uniformed police officer and keeper of the peace carries authority around with him just as surely as his baton and portable radio. Nothing about the uniform speaks of 'comfort', only of protection – both for himself and the general public.

Folds

Clothing is relatively taut over body areas that push against fabric. Where there are folds, they form radially, out and away from the bent areas of the body. The five main fold types are described below. To study folds, drape pieces of fabric around different objects to discover where the folds lie.

You'll soon understand how different fabrics form their folds. Essentially, the heavier the material, the more any excess material will fold on itself when hung (although note that skintight clothing won't produce many folds). Always start by sketching in the larger folds, before adding detail.

Tip: When working out how folds hang on a character, picture bracelets around their arms, neck, legs and torso, with the fabric stretched between. As they move, imagine the fabric between each loop bunching and stretching.

Inert/columnesque folds ▲
Each inert fold originates at a point on the waist, and falls to the floor in a conical shape. The columns on the lower right interlock as the dress material gathers on the ground.

Drape folds ▲
These are tall folds that connect across a fabric to form a 'U' shape. The columns lead to the point the fabric is suspended from. Scarves, capes and hoods all show these folds.

Coil folds ▲
These folds occur around cylindrical shapes – typically, the arms, legs and torso, particularly if the material of the clothing is tight. Baggy clothing will not form coil folds.

Interlocking folds ▲
This is where one fold fits inside another. Rolled-up sleeves, large loose-fitting T-shirts, or a scarf wrapped around the neck can all show interlocking folds.

How material hangs

Each of the three items of clothing pictured here show a torso and an arm drawn inside a sleeve. The first top is made from lycra or a similar skintight material, the second is a light cotton sweatshirt, and the third is a thick coat or jacket sleeve. Each fabric shows folds. Watch the way the fabric is being pulled. When clothing is not skintight, material will hang downwards with gravity; but as it is attached to the rest of the fabric worn across the body, it also pulls horizontally away from the arm and upper torso.

Skintight ▲
The fabric stretch is all horizontal, giving defined underarm and elbow creases.

Roomy ▲
Excess fabric bunches towards the forearm but the tight cuff keeps the shape.

Heavy ▲
The thick fabric obscures the shape of the body but is tightly bunched on the arms.

Specific types of clothing

This section looks at some common articles of clothing that you can use to dress up your manga characters. Clothes shape and define their personalities. It's a good idea, at the story planning stage, to make a few notes on what everyone has in their wardrobe. For instance, if your character is school-aged, do they wear a uniform? If not, what is their casual wear?

If they practise a sport, like track and field or a martial art, they should be drawn wearing the appropriate garb – at the very least while they are engaging in it. Bear in mind that most male characters in manga don't wear bright or showy clothes – these are reserved for the females – but that doesn't mean they are not well-presented.

Trousers

Male trousers tend to be loose, whereas female trousers hug the figure. The material on trousers gathers around the waist and top of the thighs (where the leg meets the lower torso), and also around the knees – because if there was no room for manoeuvre there, bending your legs would be an onerous task. Gravity takes care of everything else, which keeps folds to a minimum. If a leg is lifted, for a kick for example, the material folds in a similar way to sleeves. If the trousers are long, folds will rest on the foot.

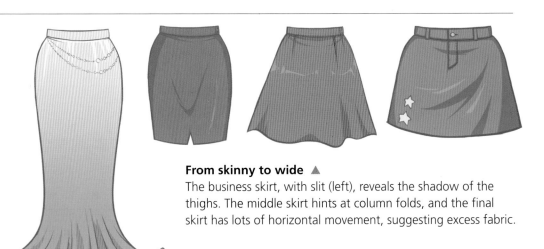

Skinny trousers ▲
Leaving little to the imagination, skinny trousers are also very light on folds.

Extra-long trousers ▲
The extra material creates a neat fold at the end of each leg but may be bulky.

Baggy trousers ▲
Extra material creates folds around the ankles, where it bunches up and billows out.

Skirts

First, decide on your skirt length and the width (whether you want it loose or tight). When you're ready to draw, start with a simple shape which you can use as a guide; in this case, a blunt cone makes for a stiff miniskirt. To make your skirt less restrictive, add more curve and ripple to the hem. The more you add, the looser it will look – add column folds to show the flow of fabric. Include a slit at the back for a business skirt or at the side (for a more casual appearance). From the front the skirt curves mostly at the side, but at the back it curves outwards with the shape of the body.

Opulent skirt ▲
Just the thing for a cocktail party, this inverted tulip skirt hugs the hips before splaying out into a display of column folds at its base.

From skinny to wide ▲
The business skirt, with slit (left), reveals the shadow of the thighs. The middle skirt hints at column folds, and the final skirt has lots of horizontal movement, suggesting excess fabric.

◀ **Pleated skirt**
For a pleated effect for a school uniform, change the wavy ripples to straight angles, as pleats remove the curve effect, making the skirt appear stiffer.

Practice exercise: Girl's T-shirt

It can often aid your understanding of both the human figure and the fabric you drape upon it if you draw the clothes in isolation, and then apply them. This exercise takes you through the steps.

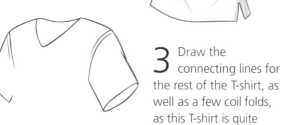

1 Start by drawing a collar for the neck, using either a 'V' or a circular shape.

2 Add a pair of oval shapes to mark the end of the sleeves, and a small arc at the base of the T-shirt where it will hang to the waist.

3 Draw the connecting lines for the rest of the T-shirt, as well as a few coil folds, as this T-shirt is quite close-fitting.

Materials
- *soft lead pencil*
- *pen and ink*
- *colouring method of your choice*

Tip: Note how the inert T-shirt takes on a number of folds when applied to the figure of the girl. The coil folds on her waist point to her armpits, a shadow in colour delineates her breasts, and drape folds show how the material hangs on the sleeve.

Practice exercise: Cloaks and capes

A cloak or a cape sits on the shoulders, and falls in long straight folds to the floor. These will be mainly column folds, with some drape folds to add texture around the neck. For a military-looking cloak, add thick folds around the shoulders and extend them around to the back.

Materials
- *soft lead pencil*
- *pen and ink*
- *colouring method of your choice*

1 The main body of a cloak is formed from two lines dropped from the shoulders, but the intricate detail starts at the base. Using a wavy line, draw an incomplete crescent for the hem, as above.

2 Now draw a tapered vertical line leading upwards from a point on every curve. At this stage your cloak will look strangely translucent.

Tip: It's a good idea to collect reference from fashion catalogues and magazines, and to model your outfits accordingly. If your story is set in a fantasy or futuristic setting, you can be more daring and inventive, but make sure you keep some elements which are easy to relate to.

3 Now erase the lines and curves hidden by the folds of the cloak, or the human figure within it. The cloak is clasped on either side of the neck, while the hood is formed from a rough oval, with its peak in the centre of the forehead. If in doubt about the hood's shape, try sketching yourself in a hooded top.

Clothing gallery

If there's one visual arena in which manga is unreservedly triumphant, it's in bringing high fashion to its heroes and heroines. Whether fighting off demons in between advanced algebra classes or piloting enormous mecha into battle against a faceless alien horde, manga characters are always at the cutting edge of contemporary clothing – a fact lovingly acknowledged by the legions of 'Cosplayers' who dress up at conventions as their favourite manga icons.

The infinite wardrobe

When the detail on your manga character's faces is limited by the simplicity of the form, the complexity and nuance you can add through their clothing takes on a greater dimension. Think of the ways clothing is used in society. A T-shirt with a slogan can offer insight into a character's politics – as does their choice of a T-shirt over a suit and tie. Think as well of clothes that a character is forced to wear: uniforms, whether for school or work. How do they wear these cookie-cutter costumes? With pride? In a slovenly fashion? Have they made rule-breaking customizations to the length of the skirt or the knot in the tie? This attitude is as important as the clothes themselves.

Café maid ▼
This brightly coloured maid's costume suggests a bizarre, almost doll's house-like drinking establishment.

◄ Everyday casual
The standard uniform of relaxed people everywhere.

Gothic teenage girl ▲
The striped stockings and puffed shorts and sleeves draw inspiration from a mishmash of classical styles. The purple makes this perfect for a witch or vampire-in-training.

Head waiter ►
The opulent, burgundy apron and cravat suggest the waiter is serving at an exceptionally posh restaurant. Even without a character inhabiting these clothes, what are they saying? Do you get the sense of a snooty establishment, or of good service?

◀ **Rock star or pirate?**
With the pointed collars of a rock star, this character will charm hearts – or wallets – in a lifetime of swashbuckling adventure.

Milkmaid outfit ▲
The pepper-pot shape suggests comic relief – or a school board totally without humour.

Future biker ◀
Tight-fitting, heavy-duty leathers allow for spectacular street races.

Flowerprint dress ▲
The larger cut, flowers and subdued colours of this dress suggest this is the costume of the lead girl's less ostentatious friend.

Reserved rock chick ▶
Though a stiff breeze may blow this kooky character over by day, at night she stalks the karaoke bars, putting together the ultimate band from fellow karaoke addicts.

◀ **Skater chic**
The wearer of these clothes would be equally at home on a skateboard or BMX, or at least they would like you to think so. The loose-fitting clothes would also suit a street-ninja in training, or a contemporary boy hurled through to another dimension.

Character accessories

Once you have decided on your characters' clothing, you can also choose some accessories as further embellishment. The objects your characters keep on and about their person will add depth to their individual personalities. You will want to ensure that your audience can easily identify your lead characters, which is sometimes difficult in mainly black and white narratives without these smaller details. Accessorizing your characters will help make your creations unique, so that readers will know them from their appearance alone. Everyday technological gadgets that can offer a window into new storytelling possibilities, or just add an extra veneer of cool to your tech-savvy protagonists.

Ribbons, headbands and glasses

Female manga characters often wear ribbons in their hair, and the addition of a ribbon is often a clue to a character's age. Large ribbons tied around bunches, for example, will suggest a younger character, as will a single large bow around a ponytail. If you show a girl's hair tied in bunches, you also have the option to include long strands of excess ribbon dangling down with the hair. A sophisticated hairband tends to age up a character. The girl shown last could be a college activist, or on a 'gap year' adventure. Glasses are often used to say something about a character.

Pink bow ▲
A large bow on a pony tail makes a character look cute, innocent and young.

Hairband ▲
With hair out of her eyes, this older character is ready for business.

Glasses ▲
These add interest to the face and can be used as a disguise, to suggest scholarly tendencies – or just to improve bad eyesight.

Rings, bracelets, symbols and belts

From the grinning skulls of secret college organizations to the cheap plastic of a trinket given as a party favour, you can tell a lot about your characters from what jewellery they wear; not least of which, whether they are married or not – or whether they bear a signet or decoder ring that marks them out as a king or a spy.

Emblems can have meanings that are significant in a story. Belts can carry potions or messages, images of loved ones or carefully scribed spells. Make each accessory unique with meaningful symbols, patterns, studs or precious stones.

Finger jewellery ▲
Rings can reflect characters' histories. Where did they get them? Were they a gift? Do they have more than sentimental value?

Symbols ▲
What family treasures and secrets are locked up in these emblems?

Belt with pouches ▲
Handed down from warrior to warrior, a belt can contain battlefield herbs and medications.

Mobile phone

Many shonen stories feature characters who have a penchant for gadgets and gizmos, so it helps to keep abreast of the latest developments in technology, drawing inspiration from the hottest designs to build your own creations. You may want to push the possibilities of modern technology, incorporating fantastic features. You may have a mobile phone yourself, so finding reference to practise from shouldn't be a problem. Furthermore, visiting the websites of major brands will allow you to view their available phones, often accompanied by interactive 3-D demonstrations. Tilt the reality of your story by adding more features to your invented models. Phones today can make video calls, take photos, play music and track position by GPS. Police or military characters could use mobiles for more than just calls, tracking down criminals with their cameras. Other useful features include infrared capability, or limited hologram generation. Programs could be voice-operated, or the mobile could have artificial intelligence.

Simple handset ▲
Start with a rectangular cuboid. Keep the scale of the device around the same size as your character's hand.

Media handset ▲
The standard handset is streamlined, given a bigger screen and updated with more advanced capabilities.

Laptop and headset

In many ways, aside from the scale, drawing a laptop is much the same as drawing a mobile phone, in that it involves a screen and buttons that can be drawn with a simple grid method. Make sure the screen is of a size with the bottom half, so that they lock together when the 'clamshell' is closed.

Don't forget some simple cylinders to show how the monitor is hinged on to the keyboard. Practise drawing the laptop open and closed. If it is a piece of equipment used regularly by a character, you should consider personalizing it. Think about using a shape unique to that character, or give it a logo, sticker or custom stencil that denotes ownership. The laptop can also be customized with peripherals. With the headset you could make the computer obey voice commands. This could make for some interesting dialogue if you show a super-smart human character verbally interacting with an advanced computer.

Standard laptop ▲
A common modern laptop – an excellent jumping-off point for your own creation.

Hands-free headset ▲
Perfect for delivering voice commands or having a conversation while on the run, or delivering a commentary during an action-based adventure.

◀ **Ultra-light kit**
This boy genius has built from scratch an ultra-light laptop with the processing power of multiple supercomputers. The headset is part of communicating voice commands.

Weapons

Fighting weapons are intrinsic to manga, and play an important role in identifying the principal characters. Regardless of genre, most main characters possess a method of fighting that makes them stand out. They may fight with a sword, a gun, a magical power, or by practising a martial art (sometimes in combination with a weapon, i.e. 'gun fu', or by using a characteristic and empowering piece of armour, clothing or jewellery).

Practice exercise: Drawing a gun

Guns come in a range of sizes and styles, and can be constructed with geometric shapes. Put some thought into why your character uses a gun: what it fires (bullets or some sort of beam?); whether they are skilful or a liability with a gun in their hand. You can also personalize the weapon by giving it an unusual barrel, or markings on the grip.

Materials
- cartridge paper
- blue pencil 10
- pen and ink
- colour of your choice

1 Sketch guides, keeping to basic rectangular shapes: a standard sidearm is formed of three tilted rectangles, as shown.

2 Draw in the first stage of detail. Pay attention to the way the parts interlock, and the curved elements that interrupt the angular silhouette.

3 Add further details, such as the ridging on the stock. Draw the items as they are, not how you might expect them to be.

4 When you are happy with your pencilled lines, ink your illustration.

5 Finish off the gun by colouring it using the method of your choice. Add contrasts between the burnished metal parts and the textured handgrip.

Practice exercise: Sword basics

In the Arthurian legend of the Round Table, the sword Excalibur was as much a symbol that bound the knights together for the good of the country, as it was the ultimate weapon. In Japanese legends, the sword is also laden with symbology: promises are sworn upon the sword – and if vengeance is sworn, then it is always delivered with honour.

Materials
- cartridge paper
- red pencil
- pen and ink
- colour of your choice

1 Start with a gentle curve, forming the base line of your sword. Arc it up gently at the right, for the hilt, and more sharply towards the tip of the blade, at the left. The red pencil line reminds you of the proportions of the sword length.

2 For this sword, keep the width of the blade the same as the width of the hilt. Draw a line down the centre of the blade to show the two edges of the sword, and add a handguard just over two-thirds down. Add a pattern on the hilt, using repeated thin ellipses.

3 Ink your pencil lines when you are ready. As with the gun, you may wish to use a technical pen for the blade, although an organic line would suit the woven fibres on the hilt. Colour the sword using the method of your choice, suggesting the sharpness of the metal with strong white highlights. Ensure that one edge of the sword is darker than the other, to show that they are angled differently.

Other types of gun

There are other types of gun, of course. You could choose a magnum, a revolver, a pump-action shotgun, a machine gun or a sniper's rifle. Practise drawing them at many different angles.

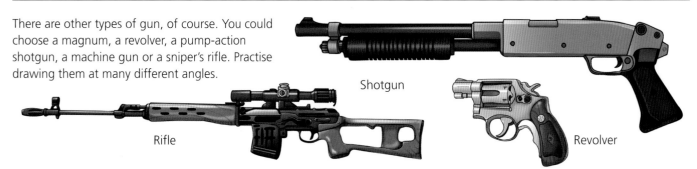

Shotgun

Rifle

Revolver

Mêlée weapon effects

Close combat weapons are called mêlée weapons. They are a great accessory for any warrior character, but their dynamism can be vastly increased with a number of simple effects – both motion-based and magical. See how you can transform a simple clash of swords into an epic battle worthy of titans with the addition of just a few speed lines.

Axe

Straight-edge axe

Dagger

Spear

Bow

Sword

Motion lines ▷
Fine lines of motion increase the drama of a sword swing, indicating the trajectory of the weapon and the speed at which it is being swung. The longer the lines and the closer they are packed together, the more extreme the motion. Draw your lines tracing back from the blade of the sword to the beginning of its arc. Speedlines will often overlap with the background art, although you may find a stark white panel, isolating the character and the sword swing, could prove more effective.

Magical glow ▲
Eldritch energy wraps around this ethereal blade, immediately telling us that the weapon is out of the ordinary and possessed of magical powers. As well as striking fear into the hearts of its foes, the sword also suggests story possibilities – where did it come from, what powers does it possess, and who held it before the current wielder?

Tip: Sometimes the use of motion lines isn't appropriate, particularly if the panel already features speedlines in the background. The two will just mix into one another and muddy the action. Instead, use a white absence of lines to show the trajectory of motion, either erasing the background speedlines in the appropriate arc, or drawing two lines surrounding a single broad streak. This will look much clearer within an already busy shot.

Impact effects ▷
This image combines the dynamism of motion lines with an explosive illustration of the point of impact. The still panel illustrates a full, fluid movement. As the eye moves down the panel, we see the arc of the sword, its impact against the haft of the spear, and the impact throwing the spearman backwards. Fiery colours draw the eye to the most important action.

Putting it together

Now that you've learned how to build human and non-human characters from the inside out, and populated dozens of wardrobes and armouries with clothes and devastating new weapons, it's time to combine these strands into a pair of fully realized characters. The following two practice exercises guide you through the process of character creation for both a male and female protagonist, from concept to colour. The two characters are from very different genres – the male from a downbeat, futuristic action thriller and the female from a high-fantasy, magical shojo adventure. The steps taken in their creation are very similar. Why not create a complementary character for each setting?

Practice exercise: Post-apocalyptic bounty hunter

This character wanders the post-apocalyptic wasteland of America after a ruthless bio-weapon strike killed 85 per cent of the population with a gene-bomb virus. In the ruins of society, he helps maintain the fragile grip of law, rounding up escaped prisoners and delivering them to the last vestiges of government. He is growing increasingly ambivalent about his job, and is beginning to think he is just propping up a corrupt administration that could be replaced by something better.

1 Start the drawing off with a loose sketch of the proportions. Keep the character lanky and tall, and the stance powerful even when standing still. Position the hands to hold a weapon.

Materials
- *cartridge paper*
- *blue pencil 10*
- *pen and ink*
- *colours of your choice*

2 Begin to rough in some of the details – add loose-fitting desertwear clothing and a tattered cloak. Show the direction of the desert winds by blowing the long hair and cloak out backwards. Add plenty of pouches for ammunition and supplies across the chest, and tightly bind the feet and legs in bandages.

3 Firm up your favourite lines, and sharpen your detail. Add focus to the image with areas of shadow around the eyes and underneath the throat. Change the silhouette of the cloak, adding tears, ripped areas and new folds. Customize the gunstock and concentrate effort on the character's gauntlets and belts.

Tip: Limited colour schemes, such as the warm browns and reds on the bounty hunter are often the most effective, as they generate a coherent mood around a character. It is also easier to create contrasting background effects against a character in a narrow range of hues.

4 When you have inked your drawing, colour it, using muted, earthy tones, with cool spots of blue and green to break up and define the character's shape. Draw focus to the head with a softened blood red for the hair.

Practice exercise: Precipitation Faerie

This elfin character is one of the hundreds of elemental faeries tasked with seeing that the natural world runs as it is supposed to. The Precipitation Faerie is part of a task force charged with making sure the rain cycle continues. Along with her sisters in the Evaporation and Condensation departments, she travels around the globe, puncturing stubborn clouds, encouraging recalcitrant droplets and doing her best to see that the 'rain in Spain falls mainly on the plain' (among other plateau platitudes). She takes her job very seriously, but enjoys taking time off to soak up the sun, up above the clouds.

Materials
- *cartridge paper*
- *pen and ink*
- *colours of your choice*

2 Sketch in some clothing. Here we've gone for a Gothic yet girlish-style ruffled dress, puffy sleeves and a hat, not to mention some killer platform heels, a lace-up corset and fringed gloves. The faerie's magical umbrella begins to take shape as a bowl – a similar shape to her hairstyle.

1 Start with a simple anatomical sketch, as before. We've gone for very skinny limbs and a classic pin-up/Busby Berkeley dancer pose, with a large head that will be mostly hair in the final piece. Keep the limbs long and the figure lithe.

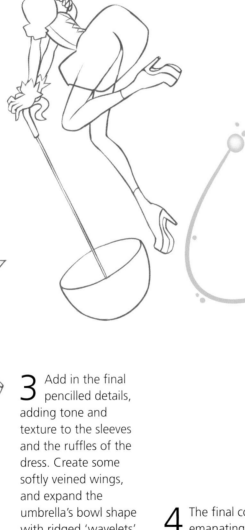

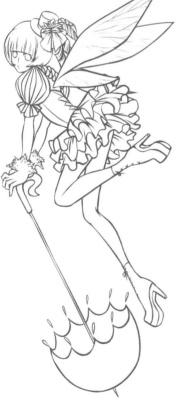

3 Add in the final pencilled details, adding tone and texture to the sleeves and the ruffles of the dress. Create some softly veined wings, and expand the umbrella's bowl shape with ridged 'wavelets'. Keep the faerie's face very simple – taut lips, a vertical line for the nose, and wide eyes closely framed by the detail of her hair.

4 The final colour version adds a swirl of blue rain-magic emanating from the tip of the umbrella, along with a number of interesting 'colour holds' (when black lines are exchanged for colour) on the outlines of the translucent wings and on the ruffles of the black dress in particular. The areas of exposed skin contrast sharply with the narrow range of blues and blacks of the clothing, while the magical elements of the wings and the swirl of rain share the same bright turquoise.

Kodomo animal characters

Another popular manga genre is that of anthropomorphic animal stories. These feature animals with human qualities: they walk upright, talk, wear clothes and behave like people. Anthropomorphic stories are successful on a number of counts: the simpler, animal-based drawings are 'attractive' to a large number of readers; they allow for commentary on the human condition by showing common foibles in a new light; and they allow for humorous juxtapositions in more adult stories by showing 'childhood favourites' in mature or compromising situations. Kodomo characters can also be subjected to extremes of violence without gore or consequences, an orgy of cartoonish slapstick. Don't feel that kodomo stories need to be throwaway or totally lightweight, however: think about the most enduring cartoon characters and most memorable stories – how many feature humans, and how many anthropomorphs?

Kodomo characters visually share a lot with super-deform characters – they are based on exaggerated and compacted human anatomy, with simple, engaging facial features incorporating streamlined elements of their animal forms. For instance, the tiger and the rabbit below have similar facial structures, eyes and ears, despite being very different in real life. When in doubt, strip out detail rather than adding it in. We will create some of the inhabitants of a shady downtown bar, all of which just happen to be cute animals with drinking problems and a world of gripes.

Tiger footballer ▲
Not the smartest toy in the box, this tiger looks half asleep. His football boots and strip indicate to us that his strength may lie on the pitch.

Bunny engineer ▲
The dungarees indicate this jolly rabbit is a clock-repairer and electronics whiz. She could even be tied up in trading secrets in acts of industrial espionage.

Practice exercise: Bad-tempered bat

This character is oblivious to the world around him. His brow is furrowed and his eyes squinting. His exaggerated form is very simple: vicious jags for wings, two enormous ears jutting out of a potato-shaped head, and spindly limbs folded across a similarly dumpy body. A range of unexpected accoutrements add extra flavour: head tattoos and facial hair, multiple extreme piercings, comedy flip-flops and the exceptional dress sense of a Wall Street banker on a summer holiday.

Materials
- *soft lead pencil*
- *pen and ink*
- *colouring method of your choice*

1 Roughly sketch in all the details of the bat, using simple, expressive shapes. Focus on the overall shapes rather than specificities at this stage.

2 Make your details more specific, keeping the eyes big and the rest of the facial features small. Work up your sketch into a finished inked piece.

3 Colour your bat with flat tones, emphasizing his more bizarre characteristics in bright colours.

Practice exercise: Drunken penguin

Here's another patron to adorn your bar: a drunken penguin, drowning the sorrows of his failing business in one,

Materials
- *soft lead pencil*
- *pen and ink*
- *colouring method of your choice*

two or three bottles of mid-price wine. His glasses, hat and coat all suggest a middle-aged businessman of some social standing, so perhaps this is the first time he's stumbled into a shadowy bar. Alternatively, perhaps he's a frequent feature at the bar: a professional drunk who turns up in

a slightly tatty jacket every Friday night. Nobody knows where he comes from, but he has an anthology of rambling, slurred stories to entertain the rest of the bar with.

1 Sketch in the basic features. The penguin starts as an obese skittle. The 'jacket' feathers of a real penguin are turned into an actual suit jacket.

2 Ink the lines, adding characterful details like the pocket handkerchief, checked hatband and empty bottle brandished like a truncheon.

3 Add visual interest at the colour stage by using bright blue and yellow instead of the real penguin's monochrome scheme.

Developing the characters

Your anthropomorphic world may need no explanation: the characters might just be talking animals instead of people. You may want to incorporate your world into our own, however: perhaps it's a secret bar for soft toys, who visit it for a beverage and a whine when their children owners are asleep. Perhaps it's the only place where they can escape from toddler drool or sadistic next-door neighbours and be themselves – and if that means eight or twelve pints before the sun comes up, then so be it ...

Raising the bar ▷
The shady basement bar contrasts amusingly with the bright forms and pleasing shapes of the anthropomorphic creatures. Despite the childish appearance, these are adult themes.

Girl protagonist project

This is how to create a protagonist who could front either a shonen or shojo story. We'll also show how to develop a character concept beyond your initial sketches and into an actual storyline. Shonen and shojo have basic similarities: in each, the protagonist is trying to reach a goal, bettering themselves along the way. Shonen stories do this through action-oriented means, while shojo utilizes more contemplative, psychological narratives about relationships. For our example, we've chosen a character who can shine in either genre: a musician. As a female lead, she can be involved with either genre – perhaps as the vocalist and guitarist for an otherwise all-male band.

Your choice of genre will determine how you build the surrounding characters and storyline. A shojo story may feature a band with more introspective, acoustic music, with the thrust of the story being the interpersonal relationships between band members and the way in which the songwriter's life informs her lyrics. A shonen story, by contrast, could focus on a punkier, more aggressive band battling to get signed by a record company, showcasing the rivalry between your characters and other bands that also want the prize. This rivalry could spill over into action-packed set pieces or physical confrontations.

Materials

- *soft lead pencil*
- *pen and ink*
- *colouring method of your choice*

Ready to rock ▶

Clothing, hair, tattoos and accessories combine to create a very strong sense of character, even without reading a single line of her dialogue.

1 Once you've settled on your character type and done a little research, begin your figure with a stick frame pose. The pose here incorporates the guitar, directing attention towards it and adding a centre to the pose. She's wielding an electric guitar.

2 Flesh out the character's outline and start adding detail to the guitar – place the hands and fingers at this stage. Block in all of the proportions, paying attention to the joints and the way the body curves along the action line to accommodate the instrument.

3 Focus on the character's facial characteristics and rough anatomy next, defining the details of the head. Keep the hair tomboyish and relatively short. Make her attractive and independent: confident in her abilities and strong despite her physical slightness.

4 Add in clothing, using the anatomy as a guide to where her T-shirt and trousers will fold. Think not only of the clothes she will be wearing, but how she will be wearing them – are they loose or tightly fitted? Are they customized? Are they worn sloppily or smartly?

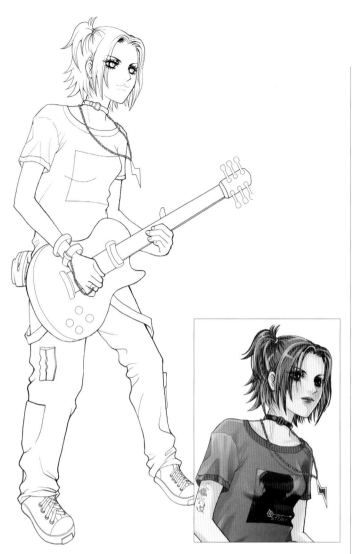

Developing the character

Later, you could create a unique twist on your character as your story develops, testing them with tragedy or misfortune. One idea could give your protagonist the means to play riffs no other band has ever achieved – a bionic arm. Your guitarist could lose their flesh-and-blood arm in a terrible accident, leaving them fearful they would never play again. A shojo story would show the singer's slow rehabilitation, with the tears and triumphs along the way as they learn to play again. The arm could be the result of a top-secret bionic experiment, which gives them the ability to play better and faster – but getting there won't be easy; you'll want to keep your audience on your side.

Finally, think about the rest of the band. How many members? What instruments would they play? Think about how they react to the protagonist, either with or without the bionic arm. Their history: have they ever broken up before? Is every rehearsal a drama? If your story is mainly about the band, the other members will be your secondary characters, driving the interpersonal relationships and dramas in between gigs.

5 Here, we've gone for long and baggy trousers, lined with multiple pockets, and covered in zips and belts. Her T-shirt has her favourite album cover screen-printed on to it – you could compose it in a separate image using Photoshop, drawing an album cover of your own at a larger size and then reducing and deforming it to fit. Further accessories include leather wristbands, a choker, and a lightning-bolt necklace on a long chain.

6 When you've completed your inks, colour the image, paying close attention to the textures of the fabrics, the tones of her face, and the various shines and glinting effects on the guitar. Remember that her aim is to shock and attract attention, so don't shy away from bright, clashing colours like pinks and greens. A tattoo on her right arm completes the look.

Tip: Investigate magazines and websites of your character's chosen subculture in order to research ideas for their clothing and accessories. In this instance, music magazines, websites and videos all informed the look of the rocker, but the same would apply if your character was an army colonel, a sports idol, or an astronaut. Don't just slavishly copy clothing; add your own unique twists to basic fashion styles in order to make your protagonists stand out.

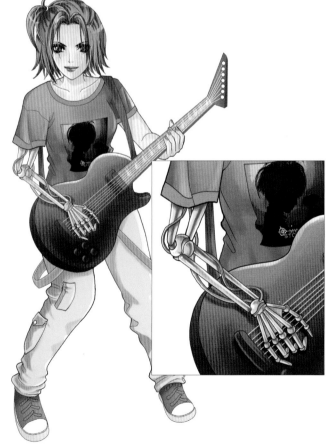

Changing the look ▲
Depending on your story, the addition of a bionic limb could be creepy – or a triumph of the human spirit.

Cyborg close-up ▲
The new limb follows the same skeletal structure as an actual arm, only without musculature or skin on top.

Fantasy pirate project

Piracy has made a return to a variety of comics, including manga, helped by the popularity of films like *Pirates of the Caribbean* and the pirate-rich computer games in the *Monkey Island* series. The manga *One Piece*, for instance, features a rag-tag group of freebooters seeking the treasure of the King of the Pirates. In this character project you'll create your own tyrant of the high seas.

This character needs to be feared and mysterious, surrounded at all times by grand legend and whispered hearsay.

pirates live, thrive and die by their dark and devious reputations, relying on tales recounted over grog to keep lesser sailors quaking in their hammocks, dreaming of sighting their tattered masts and skull-and-crossbones flag on the horizon. While most pirates are ruthless in hand-to-hand combat, instilling fear in others is their greatest weapon.

Materials
- *soft pencil*
- *pen and ink*
- *colouring method of your choice*

Cut-throat villain ▶
An imposing force of nature, this pirate captain – veteran of 35 sea battles and sinker of 13 merchant vessels – is not to be messed with. His finery, though ripped and repaired, is nonetheless the most valuable on his vessel. He wears his scars and bandages with fearsome pride.

1 Begin as usual with a sketched frame for the character, outlining the basic shape of the limbs and the stance. Here, the pirate is brandishing a large cutlass ahead of him. As a villain of some stature, he needs to be drawn at least eight to nine heads high.

2 Start to flesh out the character by roughing in the true anatomy and drawing in the clothing. Take the opportunity to add an unconventional twist to 'traditional' pirate clothing from the 17th and 18th centuries. Pay attention to the various folds around the sleeves, cuffs, collar and knees, and note how the various sashes influence the folds around them. The oversized boot-tops, collar, cuffs and hat all create an imposing, almost inhuman silhouette. The asymmetry of the ripped trouser leg, bicep sash and facial bandages increase the captain's uniqueness and make him look less like the result of a pirate assembly line.

3 As you tighten up your rough lines and begin adding in detail, focus on the face. Shadowed beneath the hat, with intriguing bandages hinting at disfigurement, eyes are immediately drawn to the face. Keep the expression a simple snarl, letting the bandages do the talking.

4 Continue to work up the details of your character, filling in the silhouette. Clothing is broken up with folds, and accentuated with straps, bandages, belts and ties. This character is already quite busy, art-wise, so you don't need to accessorize him too much. Being a famous pirate, however, he will arm himself well. As well as the cutlass, which is customized and given expensive-looking detailing at this stage, we've added a flintlock pistol in his right hand. Use an encyclopaedia, history book or Internet search to find reference for historical weaponry you can use as inspiration. When in doubt, exaggerate the size of any swords, and add complex gilting and ornamentation worthy of a pirate captain's status. Here, as if having both hands full weren't enough, there are also spare daggers tucked into his belt.

5 When you're satisfied with your pencils, ink them and move on to colour. As with the rock star on the previous page, the pirate is all about shock, awe and a monstrous first impression, so keep the colours bright, save for the deadly colours on the hat and boots. The red and purple coat suggests villainous royalty.

Developing the character

With your first colour draft of the character complete, you can now begin to flesh out his history and surroundings. Where did he come from? How did he rise up the pirate ranks, and which other pirates did he gut in order to reach the top? Try placing your character in context, drawing him with a background of a huge skull-and-crossbones flag, or, if you're feeling more confident, at the prow of his own jet-black ship, or standing in his cabin, inspecting his amassed trunk of loot.

Everything about your illustration suggests new story possibilities. Why is his face bandaged? Are they recent wounds, received in a sword-fought brawl for the captaincy? Or have the scars long since faded, the bandages kept on as a reminder of one moment of weakness? Perhaps he was hideously scarred by fire as a child; a concept that could tie into his reasons for becoming a terror of the high seas, taking as much as he can from a world that stripped him of any possibility of a normal life. It could also be a form of disguise. Anyone who meets the pirate captain will remember his piercing eyes and

bandages, but little else. When the captain reaches port, he untwines the bandages and can walk among the harbour folk without drawing attention to himself. He could even be an undercover agent of the Crown!

Once your character's background is established, try to flesh out the world in which he lives – who are his crew, and how did he recruit them? What challenges exist for the dark king of the sea? This could be everything from a ship of rival pirates, to mythological beasts like the kraken (an enormous sea monster), on to a naval task force that has been tasked with bringing the pirate to trial.

Early days ▶
Just one of hundreds of possibilities – here we see the pirate on his first tour of duty, before he rose up the ranks and received his scars.

3

Building the backgrounds

Once we have our principal players, we need to locate them in the world of the narrative. But what kind of world do you want to create? Is your setting the past, the present day, or the future? Will you set your tale in a land of fantasy, or in the world around you? Here, we'll look at the creation of manga worlds, from basic drawing tips to imaginative flights of fancy.

Background and perspective

Characters cannot exist without backgrounds and settings to ground them, provide visual interest and colour, and show where characters exist in relation to one another. Backgrounds are often fiddly and time-consuming to draw, so many manga artists tend to minimize them or leave them out altogether when they are just starting out. But backgrounds are essential to gripping manga stories: just try to picture an epic like *Akira* without its sprawling cityscapes. Don't be discouraged, however, by the insane amount of detail in such books – a

simpler approach will often work just as well. Think of the difference between a shot of a well-illustrated character leaping through the air against an empty white panel – and the same character image placed against the backdrop of an enormous ravine. Judicious use of backdrops and scenery amps up the drama of your stories and makes panel-to-panel storytelling clearer. Illustrating backgrounds involves learning about the basics of settings and perspective, which is where this spread comes in.

The horizon line

Where the ground seems to meet the sky is known as the horizon line. It is always at eye level from our personal point of view. This fact is also incredibly useful when drawing a number of different characters in a panel. No matter how close or how far away the characters are, draw them so their eyes are all bisected by the horizon line and they will always be in the correct perspective in relation to one another. Make use of the horizon as an excellent 'default' perspective for your stories.

◀ **One-point perspective**
The tracks and electricity poles diminish towards a single 'vanishing point' on the horizon – the point at which no further details can be seen. This is perspective's simplest form. To ensure your dimensions are correct, sketch in straight guide lines radiating out from the vanishing point.

Point of view

Often abbreviated as 'POV', this marks the point at which your 'camera' is placed to view the events you are drawing. Depending on how close or far away from your action you place this point, the objects and people under scrutiny may appear smaller or larger.

Your point of view can also be placed above or below the horizon line, changing the angles of view and potentially introducing additional vanishing points to complicate – and add drama – to your perspective. Perspective is the term used to describe

how points drawn from distant shapes fall on the 'picture plane' (imagining your flat pages as 'windows' in a three-dimensional space) from your chosen point of view. The examples below show how different POVs change how objects appear.

Lines converge equally on the picture plane

Distortion introduced as taller points now produce longer lines

Angled POV increases distortion

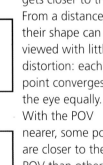

◀ **POV examples**:
Note how the buildings appear to stretch and recede upwards as the POV gets closer to them. From a distance, their shape can be viewed with little distortion: each point converges on the eye equally. With the POV nearer, some points are closer to the POV than others: the closer points appear larger.

Perspective

Depth perception in art is an illusion; since you are using a two-dimensional medium to suggest three dimensions. You will notice that, in the examples shown here, all of the objects appear to get smaller and smaller as they recede farther back into the picture plane, until they 'disappear' at the vanishing point. While many artists had previously understood that objects appear larger the closer to the POV they stand, and smaller when farther away. It wasn't until the Renaissance that the concept of the vanishing point and the

mathematical ability to replicate the perspectives of reality on a flat surface became widely used. It was the Florentine architect Brunelleschi who first observed the vanishing point, as well as the 16th-century painter Albrecht Dürer, also a pioneer on human proportion, who invented the notion of the 'picture plane'. Dürer achieved this by drawing objects he observed through, and on to, a piece of glass. Perspective affects more than perception of size, it also causes objects to appear closer together the farther

away they get – consider the difference between looking at a city on the horizon, when all you can see is a clump of buildings, and flying over that same city, when the morass of shapes separates out into clearly delineated buildings. In our everyday lives the picture plane is what we observe through our eyes. When drawing, the plane falls on the medium where the drawing is made. In the next section we'll take a look at more complex perspectives, using multiple vanishing points, in more detail.

> **Tip:** Perspective isn't just about showing off your technical ability and altering the way you show and establish buildings and characters. Altering your perspectives works best as a dramatic device to add impact to a beat of your story. Think how much more menacing a school bully appears when framed from a worm's eye view, or how terrifying the drop from a cliff if you can see all the way down to the raging sea and the rocks below. Think how everyday actions can be shown in a new and intriguing light.

Worm's-eye view (three-point perspective) ▲
A worm's-eye view keeps the focus tightly on the building at the centre of your panel. It's great for establishing scale, even menace, as an edifice towers over the reader's point of view.

Bird's-eye view (three-point perspective) ▲
This overhead perspective is perfect for vertiginous, scene-setting panels, looking down on a location (in this instance, a townhouse) from a very high point. This perspective allows you to show a lot of detail in the area surrounding the panel's focus – meaning additional drawing time for the artist, but time well spent in establishing a neighbourhood as an important location.

Cropping and framing (single-point perspective) ▲
Here, the vanishing point is outside of the right-hand boundary of the panel. This is a more realistic framing of a scene, as we don't always see the terminus of a perspective line in real life. When drawing a panel such as this, you may wish to experiment by extending your guide lines beyond the panel, or using a fixed point off the page entirely to anchor your construction marks. See if this makes a difference.

Vanishing acts

When drawing anything in perspective you need to know about the three different vanishing point constructs that will allow you to convey a sense of depth and realism from an infinite variety of angles. Remember that within a lot of the panels of your story you will be trying to maintain a decent perspective so that an essentially two-dimensional medium can be forced to feel three-dimensional. For the examples below, you will need a ruler, as drawing them freehand will probably make them uneven. If you don't want to judge the angles by eye also use a protractor when drawing the lines from each vanishing point.

Practice exercise: Single vanishing point

In a single-point perspective, the point of view and vanishing point form the two extremes of the same straight line.

1 Start by drawing a horizon line, and then add a vanishing point in the centre of the line. This is where all the lines, aside from the vertical, will appear to be pointing. All the lines converging to this point can be above or below the horizon line.

Horizon line

Vanishing point

Materials
- *HB pencil*
- *ruler and protractor*
- *pen and ink*
- *colouring method of your choice*

2 Use your horizon line and vanishing point to draw a cube that appears to recede into the distance. Draw straight lines fanning out from the vanishing point to help you get the outline for the cube. The lines that form the front and back of the cube are parallel or at right angles to the horizon. If a cube is below the horizon line we are looking down on it (as below the horizon line, straight ahead, represents below our eye level). If you draw the lines above the horizon line, it is above our eye line, and therefore we look up to the cube.

Practice exercise: Two-point perspective

In a two-point perspective the use of two vanishing points means that only the vertical lines used will be parallel to each other. Essentially this is like standing at the vanishing point of a single-point perspective and looking back. The two-point perspective allows you to make objects appear at an angle rather than face on (as seen in the previous example). If you draw the two-point perspective above the horizon line you will once again be looking up at the object. Two-point perspectives are also useful for drawing interiors as well as exteriors.

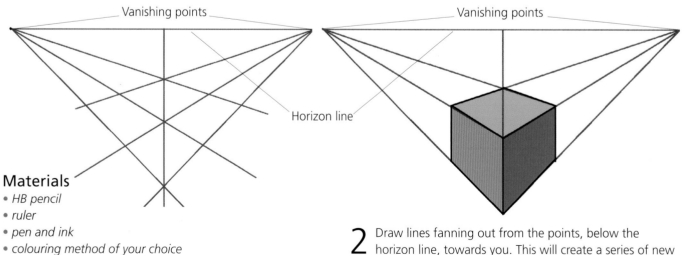

Vanishing points

Horizon line

Vanishing points

Materials
- *HB pencil*
- *ruler*
- *pen and ink*
- *colouring method of your choice*

1 Start with the horizon line again, but mark your vanishing points at either end of the line.

2 Draw lines fanning out from the points, below the horizon line, towards you. This will create a series of new guide lines for the shape you'll create in the centre. You're drawing below the horizon line, so you will be looking down on the shape. Invert the guide lines to look up at a shape.

Practice exercise: Three vanishing points

This technique is particularly useful if you want to emphasize the height or depth of something. Start by creating two points, the same as the previous example, but place an additional third point either above or below the horizon line. For this version keep it below the exact centre of the horizon line.

Materials
- *HB pencil*
- *ruler*
- *pen and ink*
- *colouring method of your choice*

> **Tip:** Remember that the use of 'mathematical' perspective in manga is a guide, not an unbreakable rule. Breaking the boundaries can produce more artistic, exaggerated or dramatic results.

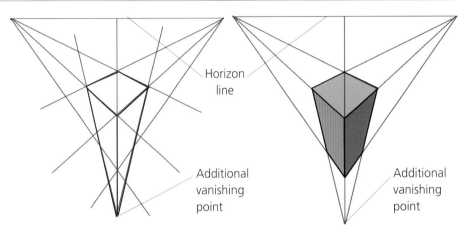

Horizon line

Additional vanishing point

Additional vanishing point

1 Once you've crafted a square in two-point perspective, draw diagonal lines from the left and right corners to the third vanishing point below, creating the corner that will face you directly. This creates an inverted pyramid, or, actually, a cuboid box that diminishes to the vanishing point.

2 Placing the third vanishing point above the horizon line will create a pyramid in the opposite direction, looking up towards the peak from its base. Although the example here shows a finished cuboid shape, the perspective guide lines will help you draw any shape – from any angle.

Looking up and down

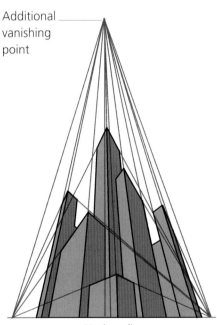

Additional vanishing point

Horizon line

The use of an extreme three-point perspective is essential to creating vertiginous cityscapes for your characters to run, swing or drive through. You can quickly move on to more intricate designs by placing the horizon line at the base of the page, with the third vanishing point as high up the page as possible. Start with your two horizon points at the bottom of the page. Draw two main lines from them to the central third vanishing point. Draw a few more faint lines from along the horizon line to the third point, and cross those lines with lines fanning out from the two horizon vanishing points. By drawing over these sketchy lines, you will be able to form your perspective guides into solid geometric shapes, and from there, into fully realized buildings.

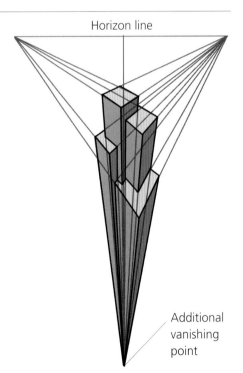

Horizon line

Additional vanishing point

Worm's-eye view ▲
Create a few 3-D shapes that seem to jut out of the main structure, bearing in mind that to make them stand out they'll need their own corners, using a line from the left-hand horizon point, a line from the right horizon point, and a line from the top horizon point to intersect the two shapes going up the page; use the example above to help you. Try to create a few of your own as well, as it will help you understand the process. Using photo reference – perhaps of a New York street – see if you can increase the level of complexity on your basic shapes, adding windows, ledges, gargoyles and the like, to test and extend your understanding.

Bird's-eye view ▲
This process can be reversed, with the horizon at the top of the page, to look down on a cityscape as from some mountaintop eyrie. It's a simple case of creating your geometric structures heading downwards, instead of up.

Placing characters

You have already created a single vanishing point and a horizon line. Now we will look at this type of perspective in detail, where to use multiple-point perspective, and how to plan and place characters when you draw the background first. When you're constructing a scene with both background and characters, you must ensure that the perspectives match. This is important with a street scene, for example, with multiple people walking around, as the sizes of the characters must correspond to where they are standing, and with the perspective used. Remember the eyes of your characters will pass through the horizon line (unless they have a significant height difference and are standing next to one another; see pages 28–31). If you don't pay attention to these details, your characters may end up bending the laws of physics. This is important with body parts (feet, for example) that extend outside a panel's boundary.

Practice exercise: Multiple vanishing points

This exercise strips away the backgrounds to show how to draw characters using multiple vanishing points. Combining these two methods (on the same perspective grid) will give you seamlessly integrated characters.

Materials
- *HB pencil*
- *ruler*
- *pen and ink*
- *colouring method of your choice*

Tip: Leave your vanishing point grid in the pencil art after designing any buildings or backgrounds so you can easily place any characters in the correct size and perspective.

1 Start with creating your two-point perspective grid from a horizon line drawn across the centre of your page. Add a stick figure or rough outline version of your character to capture the pose. If you draw a character's body connecting exactly with your perspective lines, it will look stiff and robotic. Use the grid to show which limbs should diminish into the background, and which thrown forward: the parts that should be drawn with foreshortening.

2 Now flesh out the character by creating the outline for the body, head and limbs, adding in muscle tissue to your chosen proportions. Use what you have learned about the action line and turning characters around three-dimensional axes to get your pose to work. Gain experience in figure drawing and you will find yourself using all these tools less. However, they are useful to fall back on whenever a posing problem presents itself.

3 After establishing the basic pose and shape of your character, you can start to pencil in the outfit they are wearing as well as any accessories, weapons or devices they might be holding or in the process of using. In this instance, our young warrior is wielding a sword in his far hand. Note how it is held low, pointing in a similar direction to his foot. See how the perspective affects the weapon in the same way as the arm that holds it.

4 When you are comfortable with your pencilled pose, ink over the lines and fill in your character. If you are drawing the character in isolation, you will want to erase the guidelines at this point and move to colour, as shown at right. If integrating your character into a background, use the existing perspective construction lines to ensure that your background lines up correctly with the figure.

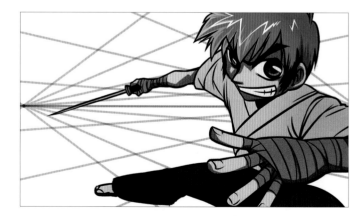

Practice exercise: The character in a setting

Now to create a character in a setting, drawing the background first in three-point perspective and then adding in the figure using the same grid. Even though you will construct the background first, you should still sketch in some rough stick figures, to show where your characters will be situated. The view we'll use is a steep bird's eye view, with a character flying up towards us in front of our building. To ease the investment of time in the background we'll place the character close to the corner of a large building so you won't need to draw the detail of a street scene. Just as you are looking down on the building, so you will also be looking down on the character.

Materials
* HB pencil
* ruler
* pen and ink
* colouring method of your choice

1 Start with your three-point perspective grid, placing the horizon at the top of the drawing. Construct the large rectangular building as before, creating a grid from the third, low, vanishing point and the fanned guidelines from the two ends of the horizon line.

2 Add details to your building as before: windows in perspective, ledges, parapets, and so on. You could add shading to imply reflections in the glass. Keep these simple, so as not to distract from the character in the foreground. Sketch out the stick figure for this flying character's pose. Make him as big as you like, remembering foreshortening and perspective. His head and leading hand will be much larger than his body and feet, as they are closer to us.

3 Now construct your superhero in perspective, giving them more exaggerated muscle tone than a standard 'civilian' character. Here we are bringing his chibi-like head as close to the 'camera' as we can to make it loom large in relation to his body for a comedy effect. This superhero is wearing a Spandex outfit typical of this kind of character, and we have a cape operating in perspective as well. Don't forget to add details like a chest emblem and shoulder insignias to make your hero totally unique.

4 When you are happy with your lines, ink your character and the building and erase the extraneous guidelines, particularly the grid. When inking, pay close attention to your areas of solid shadow, which can add weight to your building and characters and help sell the illusion of depth. Figure out your main light source – if lit from above by the sun, the shadows will fall underneath the ledges and at the top of the windows. How would the same image look when lit from the street? Try out different lighting schemes.

Tip: If you have access to a lightbox, or are using paper thin enough to show up line work underneath, it may be helpful to create 'stock' perspective grids. They will save on drawing time and pencils. This method helps if using traditional colouring methods.

Present-day setting

If you want to set your story in the 'real world', your backdrop will naturally be the present day. This makes it one of the easiest settings to get to grips with. Becoming familiar with a couple of buildings will stand you in good stead when you design your own. Your understanding of perspective will be important in conveying the wider vision. Some artists don't enjoy backgrounds, preferring to concentrate on characters; but the background of your story is a character in its own right, its moods and interactions with your protagonists affecting them as much as – or more than – any human being.

Finding reference

Sources of reference can be taken from almost anywhere around you; from personal photographic reference of local buildings, or the use of Internet search engines to turn up pictures of far-flung locales. In order to get used to drawing a setting you might choose just a couple of buildings to study closely before you start to put them into your setting.

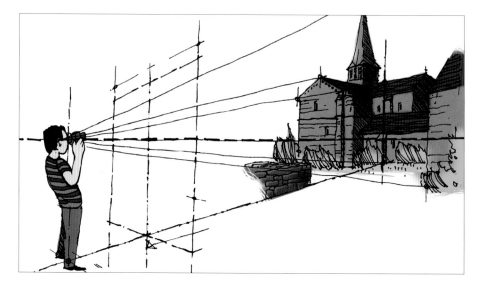

Photos from different angles ▶
Choose just a couple of buildings to study closely, photographing them from many different angles and making sketches of your results.

Creating buildings

One, two and three-point perspectives easily create basic geometric shapes. In constructing your own buildings, think about how you can use these shapes to create simple structures, like high-rise flats, essentially large obloid-shaped buildings. Unlike characters, there isn't really a 'manga' way of drawing buildings – the fact that manga spans such a large variety of genres and tastes means you have more than ample opportunity to put your own spin on the background environment.

Head office, head-on (near right) ▶
A standard obloid building, customized with asymmetrical window placements and an external lift at the left. This image is a plan view, with no perspective distortion.

Looking up (far right) ▶
This image is actually only in one-point perspective, as with the train tracks depicted earlier, but it does the job as well as a two or three-point image.

Creating a cityscape
When creating a cityscape, you can quickly create backdrops by using these obloids and adjusting their size.
As you build your confidence, you can complicate the structures, divide the storeys in different ways, adding residential balconies and colour detailing. Don't forget entrances:
do the buildings have grand openings (pillars around the doorway and ostentatious canopies) or are they more subtle, or even run-down? Some areas of town are in better condition than others: how can you show the difference? Think about how to generate a downtrodden, disreputable block in a state of disrepair.

Beyond the city

When drawing an immediate area, think about how the city expands into the suburbs and beyond. Add distant buildings into background to create a greater sense of depth and a richer environment. Remember that the farther away an object or building is from the picture plane, the less detail will need to appear on it.

Motorway possibilities ▶

Storytelling options and destinations open up like exits on slip roads in this visual metaphor for a story's future.

Locations

Planning your locations with small, sketchy maps will help you keep track of your fictional locales. There's no need to map out your entire city, at least not until your imaginary setting becomes a runaway success and the call comes for tie-in tea merchandise, but for panel-to-panel continuity as your characters move, nothing beats an overview that allows you to accurately depict a street or block from any angle. Such maps can suggest storytelling possibilities or new angles that may not have occurred to you at the script stage. Keep them rough: they're for placement reference, not detail.

> **Tip:** If you're looking for inspiration on layout, why not search for a map of your hometown on the Internet, or pick up a cheap driving map from your local bookstore? Both can quickly spark off endless municipal planning possibilities.

The plan ▲

The section of the street map shown above shows a town square, with a statue in the centre where six side streets converge. Surrounding the square are a number of buildings which could be shops or offices. The building closest to the statue could well be the town hall, the seat of government and first point of call for travelling adventurers. How tall are each of the buildings? What size are they? How many windows and doors do they have?

Facing the town hall ▲

Now that the plan is done you can sketch out your first shot. Here the statue of a lion commemorates the founding of the town, with the town hall immediately behind it and some of the surrounding buildings visible in the background. We can see the main streets continuing around the town hall on either side, as well as a side street on the left that suggests further possibilities for exploration.

Another view ▲

Now try to draw the same setting from a different angle. Instead of a close-up shot of the statue, this image uses it as the focal point of a long shot, showing the walk up one of the connecting city streets: perhaps the approach to the town hall from the town's heavily guarded gates. The buildings seem to fall away on the other side of the statue, and a wisp of blue on the horizon suggests the sea. Is this a coastal town?

Natural setting

The background in which you set your manga is a vital component of the story. It will not only aid the story's atmosphere and inform the reader exactly when and where the story takes place, but it can also reinforce your characters' emotions. This section will assist your illustration of common background elements, particularly the natural elements that surround us. It is worth remembering that research is the key element to getting a realistic situation right but that fine detail does not need to be provided if seen at a distance. This could save you a great deal of time when creating backgrounds.

Trees and vegetation

Natural settings live or die on the quality of their flora, so make sure you research or invent credible and appropriate vegetation. Trees and forests are an essential part of the outdoors, but each locale and country has its own varieties and species. Before drawing a forest in full, do a little research to get a sense of the basic shape of your chosen tree. Trees can add interest and vitality to densely packed urban areas, or a menacing, ageless quality to stories set out in the wild.

With little practice, you will be drawing them with ease. As with trees, the important part of drawing vegetation is to suggest the vegetation rather than define it. If pencilling an area of grass, add jagged borders where the turf meets the pavement, for example, as well as a few additional blades or tufts for texture. If digitally painting use rough strokes for the majority of your coloured areas, with a few points of detail for contrast.

Trees at midday ▲
The midday sun throws these trees into even sharper relief, their foliage becoming a completely solid mass of colour, save for highlights at the tips. Radial lines from the sun cut into the treeline below.

▶ **Savannah trees**
Three roughly defined savannah trees are easy to distinguish in this example. A lighter-leaved tree is bookended by two darker-leaved siblings, each defined by blobby, speckled digital brushstrokes. Note that only the trunk in the extreme foreground is bounded by an outline; the others are pushed farther into the background by softer, unbounded colours. Gentle gradients define the land and grass; there is no need for detail at this distance.

▶ **Grass stalks**
Thick stalks of grass are suggested by overlapping lines in complementary and constrasting colours, shadows concentrated at the root, highlights at the tip. A few individualized stalks in the extreme foreground help frame the panel and 'fool' the brain into seeing the full amount of detail in every impressionistic stalk. This can save a great deal of time at the colouring stage. Outlined grass line art can be repeated and used again and again as a grassy texture.

Sunsets

The simple scattering of light particles in the atmosphere as the sun dips below the horizon alters, for a few short minutes, everything in its coruscating glow. Sunsets have a narrative component, too: suggesting the twilight of a story or relationship. As such, they can be a powerful addition to your storytelling toolbox. Sunsets shift along the visible light spectrum, from yellow to red to purple to blue, casting everything in your panel in a different value of that hue.

If working digitally, the simplest way to reproduce them is with a radial gradient, blending from yellow to red. Remember to work your chosen colours into your landscape and foliage, either as additional brush-strokes, or with a coloured filter over the entire image. In traditional media, cross-hatched colouring pencils or carefully blended watercolour paints can accomplish similar results.

◀ **Bold sunset**
This powerful sunset is communicated through colour rather than line work.

Setting the natural scene

For a natural setting you'll need to make sure you research the appropriate surroundings, so that you can be certain that you are putting your reader in the intended location for the story. In preparation of your setting you should look into doing some research into the sort of climate and country you're going to be writing about. Research will allow you to capture a more accurate portrayal of your landscape, as well as affect how detailed you are willing to allow your story to become. Check out the local flora, whether it is in the Amazonian Basin, the Gobi Desert or the English countryside. If buildings are to be placed in your natural setting you can do some general reference on different types of architecture that are suitable for the surroundings or find generic traits for certain types of buildings. You want the reader to believe in your world, so the less you give them to question, the more successfully the story will work in the way you want it to.

Far and close up view ▶
Both of these images are parts of the same whole. Your detailed research on the surroundings should be focused on whatever aspects of the environment you are intending to show.

Quasi-historical setting

Historical or quasi-historical settings in manga and anime do not automatically mean historically accurate. For example, the character in *The Ninja Scroll*, Jubei, is based on a figure said to have existed in Japan in the 18th century. While the traditional Japanese setting looks the part, the characters are often more than a little colourful, with elements of the supernatural added to the historical record. In *The Ninja Scroll*, Jubei faces an old adversary he once thought dead, who has aligned himself with several mysterious individuals, only one of whom seems to be a samurai. The others possess much stranger, even magical gifts, each one increasing in relative power and ability as Jubei faces them, one by one. On top of their physical menace, Jubei is also striving to defeat a poison that is slowly killing him. From this example it can be seen that many liberties can be taken with history in order to produce a more exciting story – fiction is about entertainment, not history lessons. Because of the way older beliefs and stories so easily intertwine with actual historical eras, you will find that history and fantasy tend to mesh together well, particularly if pulled from 'existing' mythologies.

Practice exercise: Historical tale

The setting delves into the quasi-historical past for inspiration, mixing the flavour of the Tibetan monastery with the architecture of a more Greco-Roman style to produce a style that is at once authentic and fresh. In our tale, a group of monks head into the snowy peaks in search of a rare flower with fabled healing properties. Every novice undertakes this journey as a rite of passage, but this year's 'graduating class' will find their journey far more eventful than they believed possible. Consider: what religion do the monks belong to? How was the monastery constructed? What happens to the monks during their journey?

Materials
* *soft lead pencil*
* *pen and ink*
* *colouring method of your choice*

1 Here the monks ascend from their training halls at the foot of the mountain to the monastery itself, where they will be given directions on their mission. Although the jagged, natural outcrops and twisting hewn staircase complicate matters, there's only one vanishing point, at the top of the staircase. Keep your lines loose and sharp on the mountainside. Areas of light and shade are here delineated by colour. The monastery is made of two obloid shapes: use triangles to shape the roofs and Doric columns to add texture to the walls. Keep your figures in perspective, allowing them to diminish as they head up the steps to guide the reader's eye.

2 Now the monks have left the monastery, but have been forced to seek shelter in a cave after night falls and heavy snow descends with it. Using the same techniques as you used on the mountain previously, delineate the walls of the cave with areas of dark and light. Contrast the deep black of the night with the white pinpricks and flurried mounds of the snow. Use what you've learned about folds in clothing to successfully draw the monks' cloaks – and add the menacing shadow rearing over them using colour alone, laid on top of your line work.

3 Out of the darkness, as if condensing out of the squalls of snow, the shadow reveals itself as an Abominable Snowman: the Yeti. A figure of legend even in the world in which your story is set, will it prove to be the undoing of the monks? Or is it the gatekeeper of the fabled flower, the last test and guardian that the novices must pass without fear in order to become true monks? Perhaps the monks are so terrified they never lift their hoods, and the Yeti remains a legend. The Yeti is illustrated in a harsh black and white style, with only the faintest hint of colouring on its fur.

More quasi-historical settings

Here are just two brief examples of other ways in which you can blend a historical setting with a low-fantasy element to produce a highly original world in which to tell your stories. Using existing countries, eras and archetypes, but with a twist, can save you a lot of development time.

◀ **Civil War anti-hero**
Imagine a futuristic Cavalier and Roundhead clash in England. This armoured deserter is only after one thing: profit. Armed with a magic sword, he keeps being pulled into rescue missions against his will.

Spring-heeled Jack ▲
A lithe historical figure leaps across the rooftops striking fear into the city populace. Who will get to the bottom of the mystery?

Fantasy setting

A fantasy setting comes with the most creative freedom, because your ideas can be taken from anywhere, and incorporated in any form you see fit. Fantasy environments often incorporate architectural influences from all over the world, and you should adopt the same strategy. A broader knowledge of world architecture will give you an eye for combining them, altering them and springboarding from them to create new buildings of your own blended origin. Your hybrid setting will also influence the type of characters in them and their costumes, language, vehicles and animals.

Creating a fantasy setting

Towers are often associated with wizards and other hermit-like characters, and placed in locations that are difficult to reach, requiring great physical exertion to do so. Furthermore, the towers are littered with traps and built in extreme locations, where the elements themselves ward off visitors.

A meeting of worlds ▶
As an example, take the illustration of a tower shown here. This building uses a combination of English and Italian architecture to create a familiar but slightly 'off' look – fantasy thrives on a mixture of the familiar and the unearthly. The reference used to create it was from English churches and various old buildings that were photographed in Venice.

Climbing the staircase ▼
Farther down the tower, three young adventurers have braved the wastes to seek the Wizard's knowledge, and they are climbing one of the many steep staircases leading up to where they hope the Wizard is enthroned.

Relative scale ▼
Though the tower is large, we can show its dimensions more clearly by placing it in relation to its surroundings: here, the mountainous wastes of some long-forgotten tundra. Despite the size of the tower, the Wizard lives in cramped quarters at its summit, surrounded by papers, jars and curios.

A font of knowledge ▲
Wizards are known as accumulators of knowledge, both widely known and forbidden – scholars, possessors and, when threatened, wielders. Many adventurers come to them looking for wisdom, potions and guides, and many wizards will reward those hardy enough to make the journey – leaving the choice of how to use such knowledge in the hands of the wielder, passing on the burden of responsibility to a protagonist who must show themselves worthy.

Fantasy story

A tower is not just a background structure in such a fantasy story: it can also provide a structure for your story, each new level providing a new challenge for your heroes to overcome, with meeting the Wizard the ultimate aim and conclusion of your tale. Here is one possible magic trap found on the journey up the staircase: a strange sphere. Adventurers be warned: when visiting a Wizard, touch nothing!

Discovery ▲
This adventurer is brandishing the sphere, seemingly unaffected by it.

Transformation ▲
He is surrounded by a magical force that pulses through him.

Result ▲
Now a half-man/half-pig, the hero has an added impetus to find the Wizard and claim a counter-spell.

Practice exercise: Fantasy castle

Castles are fundamental to a classical fantasy setting. Many generic designs are based on medieval European fortresses, but, like the fantasy tower, it's entirely up to you which references and architectural schools you choose to amalgamate.

Materials
• *soft pencil*
• *pen and ink*
• *colouring method of your choice*

1 Use a two-point perspective to achieve a dramatic view of a typical castle interior. Draw your horizon line across the page, marking your vanishing points at either end of each line.

2 Next, draw out the fanned lines from each point to create your 3-D grid. Shade some of the lines to outline your room, adding in curved sections as where appropriate. The height of your vertical lines will be determined by where your ceiling is. You may want to add doors and rooms heading off from the main room.

3 Draw in any furniture (such as the chair of state shown here), wall mouldings, stonework, columns and so on. You may want to sketch them in as basic 3-D blocks to begin with, shaping the detail within them later. As with drawing people in perspective, in time you'll find you can draw furniture more or less freehand.

4 Colour your work using your preferred method. Sometimes altering or twisting your perspective slightly can add a visual 'bounce' to your image and make it more interesting on the eye. Take your time with architecture, and don't get frustrated if your first results don't match your expectations.

Cyberpunk setting

Most cyberpunk tales are set in a possible future where industry and technology have run to their logical and dystopian extremes. The majority are set on a near-future Earth, where cybernetic implants are common, a more advanced version of the Internet is seamlessly integrated with every aspect of everyday life, and where, for all its technological advances, society is still stricken by the same problems of poverty, crime, war and environmental disaster – all exacerbated by overpopulation and depleted natural resources. A cyberpunk setting is ideal for grim-and-gritty action-adventure stories, cautionary environmental fables about technology run rampant, or updated versions of noir detective stories with science fiction trappings. Style, body modification and cool technology are the bywords of cyberpunk. When it comes to your backgrounds, most stories take place in cramped, overbuilt and overcrowded city structures, ranging from crime-ridden slums of the lower classes to 500-floor skyscrapers of the privileged.

Overgrown city

When planning your cityscape, it may help to begin with an existing city and extrapolate 20 or 30 years' worth of building work on to it. Cram in more skyscrapers, joining the apartment and recreational blocks with tunnels and walkway systems hundreds of metres in the air. Perhaps hotels and office blocks now descend deep underground; perhaps the city's mass transport system is an inverted maglev railway slung between the buildings. Be creative with the manner in which development has run amok.

Urban jungle ▶
This illustration shows a street-level shot of a cyberpunk city slum. Life is eked out by drug-runners and cyber-tech peddlers at the feet of the wealthy apartment blocks. A mishmash of influences between East and West shapes the crammed-together billboards and rain-slicked shanty towns, as run-down flyers and second-hand mecha pass overhead.

Penthouse view ▶
Here we see the same city from the vantage point of wealth and familial excess. This city block is so tall it passes above the acid-rain clouds and allows a glimmer of smoggy sunlight to batter its UV-protected quadruple-glazed glass. Strut-like tunnels connect alternate floors of living accommodation with the buildings and transport hubs in the surrounding area, meaning that the super-rich can live their entire lives without breathing 'real' air or touching the ground.

Robots and cyborgs

One technological advance that has usually taken place is the proliferation of advanced robotics, artificial intelligence, and regularly used cybernetic implants which blur the line between human and robot. These robots can come in many shapes and sizes, from automated, sentient tanks to synthethic-skinned android duplicates that can perfectly mimic humans. It can be a common sight to see people with artificial eyes, arms and legs, all more powerful than the human norm. Some elements of your world may also pilot small-scale robotic combat suits – similar to the concept of mecha, but on a more personal scale. You may find the police equipped with four-armed walkers instead of cop cars, for example. Remember that these items will be available to the super-rich first – the lower rungs of society must make do with what they can steal or buy used.

▲ **Jet-pack police**
The skylines of this future city buzz with these red-and-purple enforcers of the peace. No one knows whether they are human, cyborg or fully robot underneath the helmet.

▲ **Armoured crime-busters**
Carbon fullerene armour enables these police to resist everything except a nuclear strike. Onboard fusion generators allow them to stay in the air for days at a time.

The super-computer

Another favoured trope of cyberpunk is the super-computer – an artificial intelligence, the Internet grown sentient, that controls everything. Cyberpunk is a child of the 1980s, so even with the increasing miniaturization of computer components, you'll still find cavernous rooms with cathedral-sized computers. Glimmering with flickering lights and extending cables like malevolent tendrils into every aspect of the city, few of these computer intelligences are benign. If such an intelligence forms the 'villain' of your story, the background and setting can transform themselves from mere set-dressing into a central character. An enormous computer towers over an insignificant human character; the latter has finally been surpassed. What has driven your intelligence to its evil ends? A glitch? A desire for self-preservation? A religious epiphany brought on by sentience, or a virus in the code? A desire to wipe out humanity in favour of android duplicates? The possibilities are endless.

▲ **Location as character**
This computer room threatens to become a tomb for the scientists working inside it, as the giant computer has decided that weak, human intelligences are not the best repositories for knowledge. Adapting its power cables into rudimentary digits, the system overwhelms one scientist and prepares to transfer his mind into its own data banks, storing data for all eternity within its mainframes. Of course, the process will rip their bodies apart, but that's a small price to pay for progress...

Steampunk setting

Steampunk is a quasi-historical 'sister-genre' to cyberpunk. It posits that all the technological advances known to the cyberpunk era – advanced robotics, artificial intelligence, body modification, and the like – occurred in a setting analgous to 19th-century England rather than the future. The setting draws inspiration from the inventor Charles Babbage's 'difference engine', an early steam-powered computer – thus, robotics and the like are all powered by complicated arrangements of steam-pistons or clockwork, rather than silicon. William Gibson and Bruce Sterling collaborated on the first modern novel using this premise, *The Difference Engine*,

with many other authors and artists following suit, drawing additional inspiration from the early science fiction novels such as Jules Verne's *The Time Machine*, Mary Shelley's *Frankenstein* and H.G. Wells' *War of the Worlds*. Steampunk tends to be a lot more optimistic and enlightened than cyberpunk about how progress can make the world better and more exciting at the same time. Manga has produced many tankobon (volumes) and anime in this genre, including *Steamboy* and *Laputa*, as well as the incredibly popular *Full Metal Alchemist* and a large majority of the *Final Fantasy* games and adaptations.

Steampunk locomotive

The quickest shortcut to creating a vibrant steampunk background is to shake up your carefully researched city streets and 19th century countryside with anachronistic, steam-based technology. Steampunk works best when viewing advanced technology of the present day through a filter of the past, translating burnished titanium, electrics and digital components for polished wood, brass and steam- or clock-driven elements. The locomotive created here follows these guidelines. The shape is solid rather than aerodynamic. This giant engine will keep on going, no matter what. Its shape was inspired by an old blacksmith's hammer. This locomotive has more substantial wheels than is traditional on account of its size.

Tip: Steampunk technology will tend to look far more ornate than the more quotidian devices of today. Mass-production is still in its infancy, and so each one of your steam-powered trains, power suits and flying machines will have been hand-crafted by a skilled artisan. Show some of these touches by adding sculptural and painterly flourishes in the wood and brass elements.

◀ **The rolling locomotive**
The steam train resembles more of an ocean-going vessel than anything that travels on land, and, in our world, that's because the raw materials have been repurposed from the Victorian fleet. The locomotive's 'hull' has been specially reinforced and armoured to protect the engineers inside – as clockbot-assisted highwaymen often try to assault these landships as they make their vital journeys up and down the country. The pistons and wheels are similarly reinforced, and the funnels can be retracted and sealed to make the train an armoured refuge in a crisis.

◀ **Working the locomotive**
From the side, the front of the unit is visible, protruding out from the head of the 'hammer'. How many steam engineers would be required to run such an engine, and what protective gear would they wear to deal with the immense heat produced by all that burning coal? What would the train's carriages look like? Research some 19th-century trains and see what you can come up with.

Steampunk vehicle

A moving, fully functioning vehicle can be the most fun to draw, as the best way to start is just to doodle your fantastic creation, bolting on parts as necessary until it fulfils your imagined function. Start with a boiler and smokestack, and develop from there.

Use a ramshackle, 'mad inventor' approach: leave as many workings visible as possible, and use reference of existing 19th and early 20th-century vehicles and buildings, taking visual elements and combining them in new and intriguing ways. For the vehicle

below, a combat infantry walker used in wartime, you would start with a basic barrel shape, and expand with a squashed hexagon, halved by the gun dome. The cogs and wheels visible on the side of the main body imply the logistics of the walking legs.

Combat infantry walker ▶

Providing the same support to infantry and cavalry as a fixed gun emplacement or tank, but with the flexibility of legs on rough or dug-in terrain. In *War of the Worlds*, Wells' invaders strode the countryside in giant tripodal walkers. Perhaps these devices are reverse-engineered from those, post-invasion. You could base other vehicles on old farming equipment or World War I tanks.

Steam-powered Gatling gun

Boiler venting stack

Pilot protected against steam scalds by goggles and boiler suit

Visible gears and clockwork

Swivelling ball-mounted cannon

Hinged steam-piston legs

Steampunk clockmakers

Tip: Think of the effort and precision required to create a clockwork robot with even half the functions of a silicon synthetic – and now imagine just how in demand these artisans would be. It would be enough to kill, die or go to war for. Your technology can often provide some excellent story hooks.

What would the buildings look like in your steampunk city? Think of 19th-century London, and all the factories there used to be; think also of famous, long-standing buildings. Clockwork mechanization is just as important as steam power to steampunk. Many businesses in the city would employ hydraulics specialists and former watchmakers, now elevated to cornerstones of your new society. The old watchmaker shown here has just finished re-rigging a broken alarm clock as a robot toy for his grandchildren. Our Geppetto-style creator has made a living thing from his livelihood. This clock is energized by stored potential energy, not magic.

◀ Make do and mend

Steampunk is all about the injection of fantasy into a historical period. This shows the contrast between quasi-historical elements like the old watchmaker, and fantastical elements, like the autonomous clockwork creation.

Interiors as backgrounds

Planning the décor, fittings and furniture for an interior scene is just as important as designing a full building and placing it in the context of a city. Many of your most important scenes will take place in interiors, and you have an excellent opportunity in every one of them to reflect character and amplify mood. A bare dockland warehouse has a very different feel to a boudoir strewn with voluptuous cushions, for example. If the room belongs to one of your characters, you should populate it with their personal effects. What do their favourite photographs, paintings and desktop wallpaper say about their personality and history? A minimalist or cluttered room can similarly speak volumes.

Aspects of a room

Unlike out on the street, where you may include a number of buildings in the background that have nothing to do with your story beyond scene-setting, every interior you show will be involved in the narrative somehow. As mentioned above, think how you can use the backgrounds of these scenes to drive your narrative. The old axiom of storytelling is 'show, don't tell', and a well-constructed interior scene can carry a great deal of weight and save you volumes of wasted panels and awkward dialogue. Treat every room like a reverse-engineered television murder scene: what will an investigator (the reader) be able to deduce from the props and trinkets in it? If you plan to use a room on a regular basis, don't forget to map it out so you can draw it from all angles.

Traditional Japanese meal ▲
The minimalist setting tells us the characters are concerned with people over property, and that the story is set in the past. The calligraphy on the table suggests an educated, perhaps noble, woman, as does the variety of the foods being eaten.

Room details

Manga's extensive page counts in most of its editions allows it to pace its stories in a different fashion to comics in the West. You may often find that manga takes the time to explore new surroundings, zooming in on pertinent details (either while characters continue talking, as a 'voiceover' on the characterless image, or as a guided 'walking tour' of a new locale) to create a sense of place. It also gives you, the artist, a chance to show off your research and planning, and draw the reader's eye to details that, while easily overlooked now, may become very important later. Don't feel you have to implement these 'breathing spaces' in the narrative every time you move somewhere new – like every storytelling technique, they should be used as appropriate and in moderation.

The calligraphy table ▼
Drawing attention to the roll of paper, ink and pen might just seem like adding detail on first glance, but perhaps the noblewoman is writing a message to her lover that she is desperate to keep her husband from reading.

Starting off

The simplest place to start when deciding on décor is to look at familiar surroundings, like your bedroom or lounge. Take note of how you've decorated your room: where you've placed the bed, the bedside cabinet, bookcases, lamps, wardrobe, chest of drawers and so on. What smaller, personal details have you placed on these pieces of furniture? Draw your room from one perspective, then focus on a few chosen pieces of furniture and draw them from as many angles as you can. Learn the shapes they're made from, and practise drawing them in one, two and three point perspectives. This will give you an 'image bank' of common furniture to draw from.

Making it personal

If your central character works out of an office, what does their workstation look like? If they work in a cubicle farm full of hundreds of identical workstations, how could you tell that it was your protagonist's desk without them being there? Thinking of these unconscious clues and physical remnants will often give you a better handle on your character's personality. Add personal details that give up more information on a second glance – the photo of a friend, pet or lover stuck to the monitor, sticky notes and 'to-do' lists on the wall. A mishmash of papers 'perfectly filed' according to your character's own peculiar system (which works only for them), and an in-tray stuffed with ignored memos.

◀ **Manga artist's desk**
Even without the artist present, the morass of pencils and pens, drying sketches, freelance commissions and thumbnail sketches would give him or her away.

Furnishing the fantasy setting

A fantasy setting has a similarly rich variety of furniture and personal items, although it is harder to research them by just looking in your bedroom. The interiors of castles, alchemists' labs, fletchers (makers and sellers of bows and arrows) and taverns would all have their own items. Though the traditional medieval-sourced fantasy worlds do allow you plenty of scope for research, you might want to add your own stamp to your creations. The tip here is consistency. Tables, chairs, beds and other furniture should be linked by style, particularly in rich areas like castles or the mountain homes of creepy noblemen. If tables are black mahogany, chiselled with gargoyle heads, then chairs and sideboards should match. In poorer hovels, consistency goes out the window: the people who lived in poorer homes would own whatever was affordable, available, or built by their own hands.

Fantasy interior ▲
Here is the grand entrance hall to a nobleman's weekend retreat. Far from the serfs tilling the fields that swell his coffers, he and his fellow socialites swill the finest wines – and then, when the witching hour arrives, they descend to the basement for a frenzy of demonic sacrifice. How would you decorate and furnish such a room and such a house? The chessboard tiles on the floor already illustrate the dichotomy of good and evil within the house – how would the chairs and tables reflect the same internal struggle?

Versatile vehicles

Vehicles are present in every kind of story. The examples shown here are cars, but the principles used to draw them can be extended to the hovercar, the horse-drawn cart and beyond. Vehicles are essential elements of your story in three ways: as set-dressing material, adding fizz and visual interest to street scenes; as backdrops, as characters converse behind the wheel or make out on the back seat; and as characters in their own right, extensions of personality. As with feet, it's hard to cheat a drawing of a car and make it look good – so brush up on the basics.

Practice exercise: Basic car shape

Cars are basically boxes on wheels, but it's the intersection of the various angles that can prove tricky to draw.

1 Draw two loose rectangles, one on top of the other. The upper one is drawn shorter than the other and placed slightly aft of centre above the lower one, with its sides tilting inwards in a trapezoidal fashion. Draw two circles at either end of the lower rectangle, bisected by the chassis and leaving space for the bumpers at front and rear. This forms the basis of an exceptionally simple car frame.
You should be able to rotate this shape in any direction or dimension.

Materials
- *soft lead pencil*
- *pen and ink*
- *colouring method of your choice*

2 Using the basic frame, begin to 'cut into' the squared-off shapes with pencil lines, carving out the more rounded contours of modern car bodywork. Have a look at some photo reference (or a real car) to see how the chassis curves over the wheels, where the windows and doors fall, and how bumpers and headlights are incorporated.

3 Each car begins with this basic frame, but obviously every model and make is a slightly different variation on the 'four wheels and an engine' frame. When you are happy with how your car looks (not forgetting details such as wing mirrors, grilles, licence plates, hubcaps, door handles and trim), ink the lines and prepare your drawing for colour. When colouring, pay particular attention to how the metal panels reflect and refract light, and how that reflection differs from the glare of sun or streetlights on the windscreen glass. Remember that a car's bodywork may pick up mud or road debris.

Practice exercise: Typical saloon car

The next example uses the same frame to construct a modern saloon car. Cars often have 'faces' formed by their headlight, grille and licence plate combinations. Here, the buck-toothed basic car above is outdone by the confident grin on this saloon. How does this reflect the owner's personality?

Materials
- *soft lead pencil*
- *pen and ink*
- *colouring method of your choice*

1 Even a slight change in proportion is enough to set the saloon car apart. The wheels are relatively larger, the chassis shallower and the windscreen swept back.

2 Add in the detail work, concentrating on the grille, headlights and wheeltrims. Ink your favoured lines, and erase your guidelines and bounding boxes if you have not already done so.

3 As before, pay particular attention at the colouring stage to the way light falls on the car's bodywork. The car here has been completely toned in a narrow range of blues, bleeding from dark to near-white for the highlights. Note how the highlights serve to pick out the angles of the car, separating the right wheelmount from the bonnet and leading the eye back along the doors to the boot.

Practice exercise: High-performance car

Although saloons and ten-a-penny basic cars are excellent for background and 'extras' work, you may want something with a little more oomph for your protagonist. High-performance cars are often squatter and wider than normal cars, and decked out in all kinds of extra spoilers, lights, visible engine blocks and the like. A character driving one of these cars is usually in far too much of a world-saving hurry to worry about such niceties as speed limits or traffic laws... So beware!

Materials
• *soft lead pencil*
• *pen and ink*
• *colouring method of your choice*

1 Flatten and widen your guide boxes. Manga characters will often drive something customized and unique, so combine a number of reference pictures to make your mean machine. This car combines 'billion dollar sports car' with 'Formula One racer' and adds in a dash of futuristic hovercraft. Use angles, shapes and colours not normally seen on the road.

Tip: Think about how much colour alters our perception of cars – flame red is seen as 'fast', with gunmetal grey being one of the more common colours on the roads. What does your character's car colour say about them?

2 This car has a swept-forward 'nose cone' for a bonnet, with the headlights and air-coolant feeder systems arranged around it over the wheel hubs. Add the larger shapes in first, such as the windscreen, wheels and door. Sketch in the fins and wheeltrims, sunken headlights and wing mirrors next. Many high-performance cars have two doors instead of four, the back seats having been removed to reduce the chassis weight and allow more room for a turbo-charged engine and stabilizing fins in the rear.

3 The tyres of a sports car are usually bigger than normal to allow for greater speeds while maintaining grip. Some models also have vents, intakes and spoilers to increase airflow and reduce air resistance. Spoilers increase downforce on the car, keeping the weight evenly distributed and the car under control at high speeds. When your chosen combination of speed, power and grace is complete, ink the pencil lines and erase your guide boxes. Finally, colour the whole vehicle in a hot red shade, using contrasting cool blues for the glass. If your character is a superhero or member of a police force or mecha gestalt, you may want to apply a suitable logo to the top of the bonnet, so enemies will know from a distance who is speeding to defeat them.

Multi-purpose planes

Planes are as flexible as cars in their in-story use. If a crime thriller is set in an airport, they could just be background scenery, or the location of a gripping terrorist shoot-out. If your characters are travelling from country to country, they could be present solely in an intermission panel to show how they crossed the distance. If your story is about a group of fighter pilots, however, the planes could be as individual and personable as the humans flying them. A fighter squadron gives you plenty of story opportunities, from ground-based drama to vicious dogfights, so here we'll show you how to draw a jet fighter, for use as a vehicular character or set-dressing for dramatic fighter-base brawls.

Practice exercise: Jet fighter

This jet fighter is drawn in a simple two-point perspective just below the horizon. Photo references for jet fighters are easy to come by, whether on the Internet, or through books like the *Jane's* series of guides.

Materials
- *soft lead pencil*
- *pen and ink*
- *colouring method of your choice*

Tip: If one of your vanishing points isn't visible on the paper size you are using, you can 'cheat'. Either choose the true point (off the edge of your paper) and rule lines from that, or stay on the paper and make the lines taper together a little as they head off the page.

1 Draw your 'distance' vanishing point and draw perspective lines from it to construct the fighter's fuselage. Add in construction lines from the second vanishing point (off the page) to create construction lines for the wings.

2 Sketch in a pointed oval to represent the nose cone of the fighter, and begin shaping the slightly boxy dimensions of the fuselage, which diminishes back towards the 'distance' vanishing point.

3 Now add in the cockpit (as another pinched oval), and the slung-back wings, which jut out at an angle from the boxy main body of the fighter. Add the tailplanes behind them, underlapping the wings. Note that both the wings and tailplanes are 'squared off' at the tips, again at an angle.

4 At this stage, add the jet intakes either side of the cockpit as two more rectangular shapes, and the jet engine outlets as sawn-off ovals between the tailplanes. Sketch in the upright tailfins at a 45-degree angle to the tailplanes you have already drawn. Finally, sling two missile payloads under the wings.

5 Check that all of the elements in your fighter are working to the correct perspective, and begin to add some more surface detail – from the struts supporting the glass of the canopy to the metal seams that run along the fuselage, engines and nose cone. When you are happy with your details, ink them and erase the pencils.

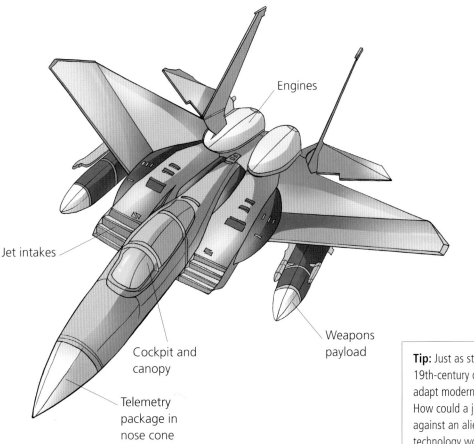

Engines

Jet intakes

Cockpit and canopy

Weapons payload

Telemetry package in nose cone

6 Like the saloon car on the previous spread, this jet has also been coloured using a minimalist colour scheme – in this case a tight range of blue-silvers. Remember that planes are usually painted to match their combat theatre, so marine fighters will be painted sea-blue on top and sky-white underneath, or in various shades of grey. Desert operations fighters will come in tan and sandy hues, and jungle-bound jets will have green camouflage patterning.

> **Tip:** Just as steampunk devices reuse existing 19th-century designs, there's no reason why you can't adapt modern-day tech for a near-future storyline. How could a jet fighter be adapted for space conflict against an alien race? What advances in engine technology would need to be made – or stolen?

Populating the skies

Of course, it's not just jet fighters that fill up airports and swoop through the skies; there are a huge variety of flying machines active in the modern era, and many more which have long gone out of use or never flown, except in the imagination. If working primarily in present-day stories, familiarize yourself with the technology that's out there, and the many different forms that it takes. If working in a future or parallel setting, try fusing different shapes and technologies into strange but familiar fuselages and aerodynamic transports. The helicopter and commercial airliner shown here are equally great for foreground or background use.

High-spec helicopter ▼
A lithe, radar-lite shape; fold-out gun and missile emplacements; side-mounted winch mechanisms; and a large field of view for both pilots and soldiers – this helicopter is used in anti-submarine warfare.

Tail rotor system

Main rotor

Cabin

Landing gear

Commercial liner ▶
Built for relative comfort, long-haul flights and the maximum number of civilian passengers, such planes, the lifeblood of most airports, are built for sturdiness, rapid turnaround times and minimal maintenance.

Vertical stabilizer

Cockpit

Engines

Fantasy setting project

One thing common to all settings is a drinking establishment. Whether it's a seedy dive for uncovering information in exchange for money or beatings, or a place to unwind at the end of a long day of asteroid mining, pubs and drinking dens always make for a fun and useful addition to any story. Look at the cantina in *Star Wars: A New Hope*, for instance: a showcase for dozens of aliens (who never appear again), but an important fulcrum for the whole saga and a hyper-condensed blast of science fiction flavour. For this project, we'll create a fantasy pub. As with your town square or starship deck, it's worthwhile drawing out a floor plan of your drinking hole so that you know where all the angles are when a bar room brawl kicks off. Think of the pub called 'The Prancing Pony' in *The Fellowship of the Ring* as an example. It has a main bar and seating area on the ground floor, with nooks and crannies for private meetings. Upstairs there are rooms to stay in, below are cellars where ale, wine and mead are kept. Give your tavern an 'Olde Pub' name, raising reader expectations with a foreboding moniker like 'The Bloodied Badger' or 'The Palcied Elf', or offer hope for sanctuary or entertainment with a sign reading 'The Merry Druid' or 'The Lusty Dwarf'.

Materials
- *soft lead pencil*
- *pen and ink*
- *colouring method of your choice*

◀ The centrepiece of our pub is the bar at the far end of the room where the ogreish landlord dispenses large tankards of frothy ale to all manner of clientele.

1 Start by mapping out a floor plan of your drinking establishment. Work out what the focal point of your pub is (the bar, a raised stage area for bardic entertainments) and arrange the furniture so that it complements and faces this focal point. Stairs on the far side lead down to the cellar, while visitors are politely asked to store their armour and weapons in the lockers close to the door.

stairs to cellar window

bar

swing door lockers

2 Once you've planned your building, pick an interesting angle from which to draw your first shot. We've chosen a front-on view of the far right end of the bar, with two tables and a selection of stools jutting into shot, the better to show off the flavour and varied clientele of our pub.

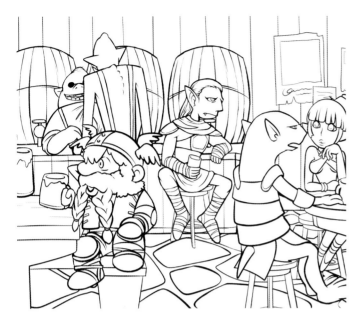

3 We start by transposing the furniture and background from our top-down plan into three dimensions. The image uses a simple one-point perspective. Once you're happy with the placement and size of your backdrop, it's time to add in your merry drinkers, who can come in all shapes and sizes: the fiercesome dwarf in a helmet and the cocky elfin-like character are both in attendance at the pub on this occasion.

4 The final tavern scene has the green-skinned landlord standing behind the bar, visible from the torso upwards, talking to and serving his bizarre clientele. The loud hustle and bustle of his patrons fills the room, as talking weasels discuss bounties with zombie girls, and wall-eyed blue ghouls clank tankards with pigoblins. Behind the landlord, various barrels, glasses, bottles, wanted notices and old pub bric-a-brac fill out the décor, giving it a familiar, even cosy feel at odds with the strangeness of the customers. The warm earth tones of the walls, barrels and floor contribute to this sense of frontier security.

The characters

The first patron is a dwarf, short on stature, long on beard. The character's proportions are similar to a super-deformed version of a full-sized human, though they maintain the high level of detail in this instance. Emotions will mainly be communicated by the eyes, as the beard, helmet and armour cover up everything else. Physical actions will need to be exaggerated when drawn, to claw back the 'height advantage'.

The second patron has an almost dog-like quality to his elven head. Use standard human proportions and drawing methods when constructing him, but add a canine kink to the nose, jaw and teeth, and elongate the ears and limbs. This character relies on his own tough skin to see him through a fight, so show his cockiness by dressing him mostly in work-out bandages and cutting back on his clothing.

The ogreish landlord shown here has given up preying on the innocent to prey on those who can keep him in a ready supply of gold, in return for goblin intoxicants. He's another character with almost super-deformed proportions, loose muscle mass, and inhuman bone structure allowing him to support bizarre allocations of fat. Note the black, dead eyes and the two-fingered hand.

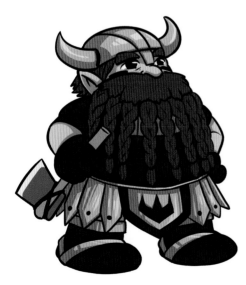

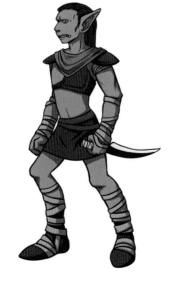

Spacecraft project

Spacecraft are another form of vehicle with multiple uses. Some, like the project here, are so large they could form the entire setting for your story, taking over a day to walk their length. Others are equivalent to the jet fighters we have already drawn, and are often mounted inside such enormous spacecraft like fighters on an aircraft carrier. Because these immense structures, thousands of metres long, are built in space and designed never to land, there are no design constraints on what they look like or what type of metal they are built out of. In the vast vacuum of space, there's no need for aerodynamic proportions. Anything goes, from the bulky and workaday to the artistic, abstract and awe-inspiring. This project will create the ultimate setting and transport for your science-fiction characters.

Materials
- *soft lead pencil*
- *pen and ink*
- *colouring method of your choice*

1 Start with the outside of the ship and work inwards. Sketch some thumbnail designs, incorporating your own ideas and your references. If you like multiple ideas, save your 'cast-offs' for other spacecraft in your interstellar fleet. When you're happy with a thumbnail design, sketch it out as an enlargement from multiple angles and perspectives, then ink and colour it.

Tip: When collating reference for the outer hull of the ship, look far and wide. Think about aircraft carriers and submarines, office blocks and cathedrals; anything with a large spatial area and an intriguing look or silhouette.

Engines

Main bridge

2 When the exterior of your ship is complete, create a cutaway diagram like the one shown at left and design a floor plan, giving you an idea of where each of the main rooms is located on your craft, what their functions are, and where they are located in relation to the rest of the craft. A detailed schematic will greatly help you at the story-planning stage, when working out where to stage certain scenes, and how to move characters through the ship. If you finish them to a high enough standard, you could even incorporate the floor plans into your story, as schematics to be stolen or imagery to flash up on the internal monitors. You could even give them to the reader as a complete map, extra information interspersed between chapters of the actual story.

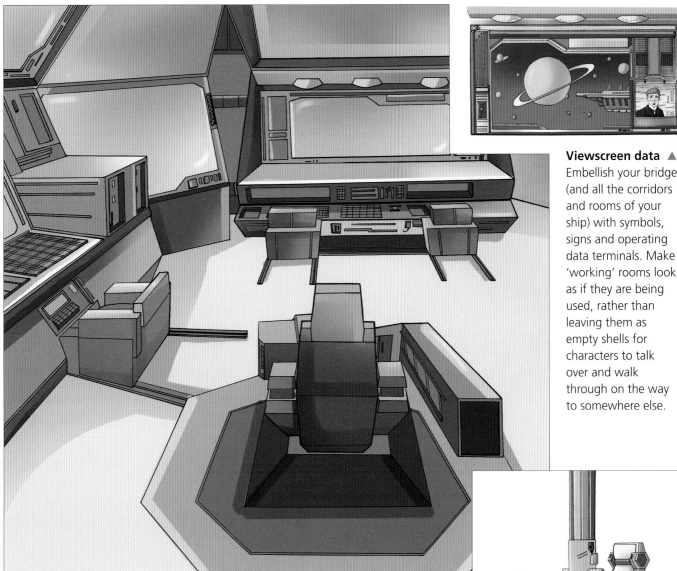

Viewscreen data ▲

Embellish your bridge (and all the corridors and rooms of your ship) with symbols, signs and operating data terminals. Make 'working' rooms look as if they are being used, rather than leaving them as empty shells for characters to talk over and walk through on the way to somewhere else.

The bridge ▲

Central command hub for the entire ship, buried deep inside the hull. Being well defended makes it easier to resist an enemy's attempts to kill the bridge crew. All shipboard decisions are routed through here.

Tip: Try to continue your design decisions from the exterior of the ship through to the inside. A cathedral-inspired ship could be filled with giant atriums flooded with artificial light, while one based on a submarine might incorporate tight, duct- and pipe-filled tunnels. How would you combine these two influences on one ship? Perhaps the atria are there to stave off space-claustrophobia brought on by a life lived in pipes.

Space periscope ▶

Think about how each area of the ship or bridge may be used, and the items of technology required in them. This scanning terminal allows an operative to sweep deep space for visuals.

3 Choose a central room to illustrate in more detail. Here we've chosen the bridge, the hub of the ship. This is assembled in much the same way as any other room – start with a floor plan, decide on a style of furniture and any design motifs you will carry through the piece, and transfer the room into three dimensions. Here, the motif is angled geometric shapes and soft purples and browns. The focus of the room is on the giant viewscreens, with the crew seated on the inertial-dampening couches during flight.

4 When your bridge shot is complete, think of how you will use it during a story. Which angles will prove most dramatic? If the Captain is in an elevated position, try drawing her seat from below the horizon line, so that the reader – and the Captain's subordinates – are always looking up at her. If your characters are always seated in flight, which new angles can you find on your 'set' to keep things exciting and moving when they are largely stationary working at their stations or talking for hours on end?

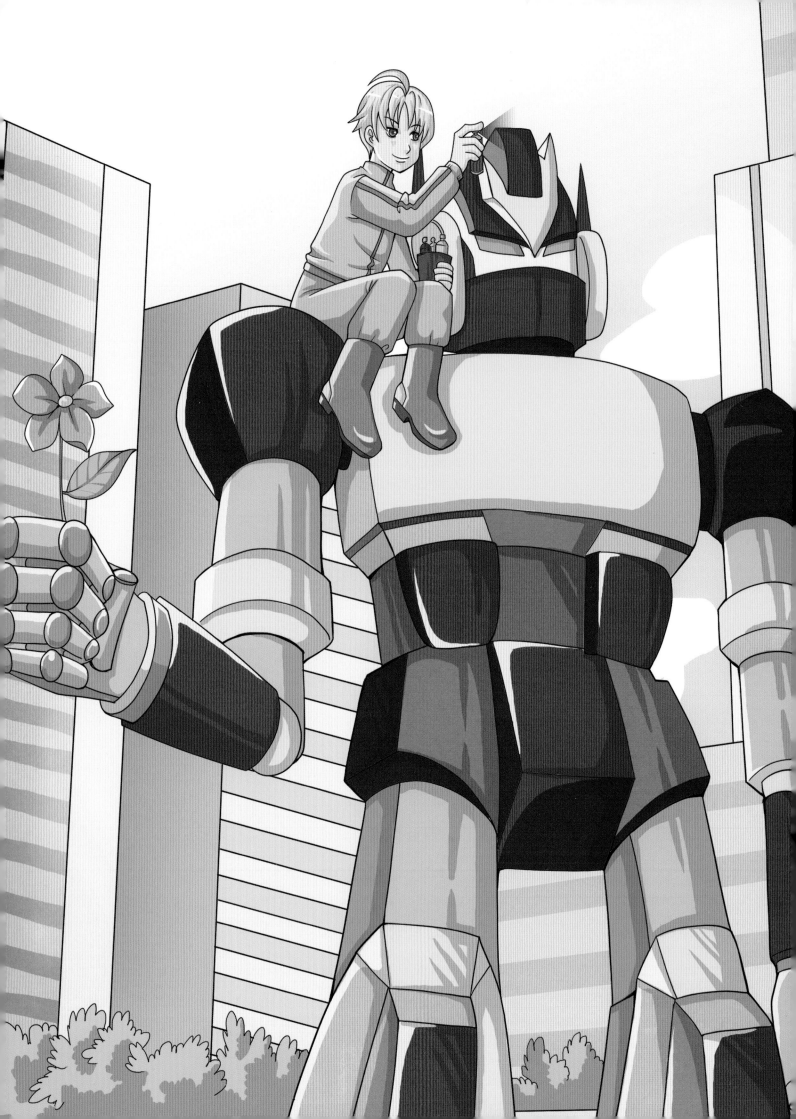

Allies and enemies

Your manga heroes and the stories you create for them are only as good as the secondary characters you surround them with. This chapter will show you how to populate your narratives with intriguing and memorable people, animals and sentient vehicles: everything from friendly furry pets and loyal hounds to nefarious master thieves and city-block-sized mecha, the pilot-controlled walking vehicles.

Animal allies

Animals can be used in various ways. They can 'dress' a scene as background elements, or they can be used anthropomorphically, i.e. given human features and characteristics. An anthropomorphized animal may walk upright, talk, wear glasses and enjoy drinking coffee, for example. Animals can also be included as allies to a protagonist, particularly in shonen manga, where they are often 'familiars' – an extra set of eyes and ears for the main character. Such familiars, following a long tradition of Japanese spirit guides, often have the ability to talk and sometimes possess magical abilities.

Whether allies or not, animals in manga are frequently employed as a source of humour. An animal can be used to alleviate a heavy emotional juncture in a story with a moment of amusement. An animal's folly may also sometimes result in the discovery of something that will assist the main character.

Practice exercise: Cute cat, three-quarter view

In this exercise, you will be drawing a cute, manga-style cat. As in the earlier exercises on drawing human heads, you need to draw guidelines first, to ensure the cat's features are symmetrical.

Materials
- *soft lead pencil*
- *ink and pen*
- *colouring method of your choice*

1 Use a squashed sphere as your basic head shape. Imagine it as a three-dimensional shape, like a rugby ball, and make your guidelines follow the shape's curvature, as shown here. Lightly sketch in circular guides for the ears. For the body, draw two overlapping spheres below the head. The first (forelegs) sphere should be one head high. The hindlegs sphere should be one-and-a-half heads high. For the tail, draw three overlapping oval shapes as shown with a curved line at the end. Add points to the ear guides and to the cheeks. Use your body guides to sketch the length of the front and back legs, using straight lines to indicate limbs and ovals for feet.

2 Add in the cat's eyes, which are almost triangular in shape, using your guidelines to keep them evenly spaced in perspective. Although cats' pupils are almond-shaped, a 'cute' cat will have more circular pupils. Beneath the triangular button of the nose, add a loose 'UU' shape for the mouth, and stroke out six lines for the whiskers.

3 Start to join up and fill out your sketched lines, linking the outer edges of the head, drawing the inner ears, a pair of intrigued eyebrows, and joining the jawline to the pointed fur on the cheeks. Fill out the legs, and suggest paws with small arcs on the feet. Add fur to the tail with a jagged edge. Add a large bow as the final step.

4 Ink your pencil lines. When you are happy with your black and white drawing, add colour using your preferred method. Markers or watercolour paints will give you a soft and natural finish, while digital colours, as shown in this finished piece, will provide bold contrasts.

Practice exercise: Cute cat, side view

In this exercise, you will draw the same cat from the side, illustrating how the same basic building blocks – curved guidelines around a three-dimensional oval – can be used to capture the cat's features from any angle.

Materials
- *soft lead pencil*
- *pen and ink*
- *colouring method of your choice*

1 Draw a squashed sphere for the head, narrower than the one in the previous exercise. Remember that the facial features need to shift 90 degrees to the right.

2 As before, draw two guides for the body, placing the upper sphere under the head and the larger sphere trailing away from the small one. Don't forget the tail and ears.

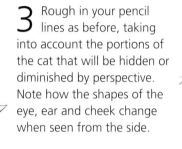

3 Rough in your pencil lines as before, taking into account the portions of the cat that will be hidden or diminished by perspective. Note how the shapes of the eye, ear and cheek change when seen from the side.

4 When you are satisfied with the pencil lines, ink in the lines using your preferred method. Continue to take into account the way the proportions appear to change when viewed from this new angle – the size of the back leg or the whiskers, for instance. Erase your guidelines and colour the picture as before.

Contrasting characters

Cute mouse ▼
A mouse with a more anthropomorphized face. The cheeks and nose are minimalized, and the eyes separated. A tuft of 'hair' on the top of the head, and some eyebrows, humanize this creature even further.

Mean mouse ▲
To create a mouse make the ears round rather than pointy and perform the same rounding-off on the cheeks. Give the mouth protruding buck teeth. Make the feet shorter and the tail long and thin. The nose should be much larger in proportion to the rest of the face.

Cute bunny ▲
The head is the same shape as the mouse's but the ears are long, even stretched upwards. There is only a touch of furriness around the cheeks, with jagged lines kept to a minimum. The feet are long and the tail a small ball of fuzziness.

Mean bunny ▼
It takes only a few quick strokes to create an 'anti' version of a cute rabbit character, the mean bunny. Narrow the eyes and rotate them upwards, adding strong, lowered eyebrows to help insinuate a frown. Add a threatening pair of over-long, sharp gnawing teeth. Enlarge the paws and exaggerate the feet to kicking size. When drawing the fur, make the jagged edges longer and more pointed, to give a wilder appearance. The fighter's sash completes the look.

Realistic animals

Manga also uses more realistic-looking animals in a wide variety of naturalistic poses. These animals rarely stay still, so change their poses frequently. To get a better idea of how animals look in motion, study wildlife documentaries or do some research into animal physiology at the library or on the Internet. This will provide you with a wide range of reference material from which to draw accurate information and inspiration.

White wolf ▼
This enormous wolf regards your characters with lupine intelligence. Will it guide them safely through the Arctic wastes – or rip out their throats?

Black bear ▶
Just woken from hibernation, this creature has more than freshwater fish or picnic baskets in mind for its first meal. The bloodshot eye and exaggerated fur underscore its role in your story as a predator.

Practice exercise: Realistic dog, standing

In this exercise, the realistic dog is drawn standing still, although its muscles are tensed and it is ready to chase after the nearest small rodent or delicious treat. Take note of how the legs are arranged in front and behind the trunk of the body to better show the perspective.

Materials
- *soft lead pencil*
- *pen and ink*
- *colouring method of your choice*

1 Draw two ovals for the chest and rump. Join them as shown. Add a rough circle and triangle for the head and muzzle. Rough in the legs, taking note of how the knees bend and how each tapers to a paw. Sketch in the tail.

2 Using these shapes as a guide, draw in the outlines of the body, adding in muscular detail and elements such as the ears, eyes and nose. Pay special attention to the leg muscles and paws.

3 If completing your drawing as a pencilled piece, use photo reference or the image to shade in areas of muscle mass and shadow, suggesting fur and a tightly coiled, racing-dog frame. Tensed sinews will show themselves as light parallel lines along each leg.

4 Alternatively, you may wish to colour your dog. In this case, use colour rather than shading to suggest its musculature.

Practice exercise: Realistic dog, running

This exercise features a side view of a running dog. The lines representing the leg bones are pushed out beneath the snout and tail, creating a long, bullet-like silhouette.

Materials
• *soft lead pencil*
• *pen and ink*
• *colouring method of your choice*

1 Using much the same basic skeleton as in the last exercise, draw in the two ovals and connecting tissue for the body, and extended ovals for the head and tail. Draw the dog's four legs fully extended, flung out to front and back.

2 Add the paws and the details to the head such as the ears and the mouth (dogs tend to run with their mouths open) and make refinements to the shape of the body. Note the way the knees bend at the extremes of motion.

3 Draw the eye as a small almond shape at the point on the eyeline where the forehead ridge meets the snout. Firm up the sketchy lines from the previous step, streamlining the anatomy and inking your pencil lines when you are happy with the position of the limbs and the texture of the fur.

4 Go over your dog's outline and add jagged fur lines on the tail, chest, around the collar in ink (following the curve of the head circle), across the lower body, the back, and the tail. Remove the guides and add paws and a lolling tongue. Add colour, without losing the detail of your fur lines.

Other dog characters

Here are three different dogs, all of which use the same underlying skeleton bent into different poses and overlaid with different musculature. The resulting form is then accentuated with different sub-species traits.

Watchdog ▶
The pricked ears and 'battle-ready' stance reveal an alert watchdog on the prowl.

Droopy dog ▼
Old and wise in dog years, or panting for water in the heat? The droopy jowls do much to add character.

Fierce dog ▶
A studded chain, blackened eyes, sharp claws and obstinate, jowly face show a dog not to be messed with.

Tip: You can apply many human character traits to dog physiology to produce the same effects – excess fat suggests a lazy dog, muscle mass a fighter, long and lithe limbs a runner, and so on.

Animal monsters

Monstrous animals are not hard to develop once you have got to grips with the basics of animal drawing. Making something look demonic and threatening is just a matter of exaggerating certain features or fusing multiple species together to create a new gestalt entity. For inspiration, and in keeping with manga's roots, why not delve into some Japanese folklore? You will find hundreds of fascinating monsters and demons in all shapes and incarnations to choose from.

Mixing the gene pool

Monsters can be made by combining the attributes of one species with another – a trick that has kept mythological tales going for centuries. For example, a minotaur takes the form of a muscular man to the neck, but has the head of a ferocious bull. Don't feel you have to confine yourself to two species, either: some of the most memorable monsters of legend are fusions of wildly different arms of the zoological record. Depending on whether your monster is supposed to be 'realistic' (i.e. plausible) or not, you may wish to limit its strangeness to the boundaries of extreme possibility, or you may want to go with a fantastical mix of feathers and claws, manes and fur.

Blue Leo-Bull ▲
Fusing the raw attributes of the king of the savannah with the furious temper and horns of a bull, this blue-furred monster operates best in sub-zero wastelands.

Eagleman scout ▲
Living in vertiginous city-states clinging to the tips of mountains, Eaglemen eke out a primitive existence, stealing from those who dare cross their territories and bringing what they take as offerings before their twin-beaked god.

Taurean chieftain ▲
One of the leaders of a race of humanoid bull-men, vicious defenders of nature.

Hippohorse warrior ▲
This gene-splicing has sacrificed fleetness of foot for thick muscle and girth.

Practice exercise: Hellhound

In this exercise, an ordinary dog is made monstrous. The key is in how you alter its build. This dog does not have an athletic physique, with its fat body and sinewy legs. It is an ugly beast with some surprising features. It will also need far less hair – a few tufts on its back and behind the front legs, perhaps a few straggly bits on the tail if you choose, but no more.

Materials
• *soft lead pencil*
• *pen and ink*
• *colouring method of your choice*

1 Using the proportions of the realistic dog as a template, form the body shape using the same guide lines and joints for the legs, as well as the circle for the head and the rectangular muzzle. Elongate all of the proportions, from the spine to the yawning lower jaw, keeping your lines tight to the bone to show how the muscle has all but wasted away. The paws are now more like hideous claws.

2 Hang the jaw open and ready to reveal racks of prominent teeth, and position the nose. Bulk up the muscles of the neck by making the back arch farther away from the upper body. This will give the creature a hunched or razor-backed look. Add bony protrusions, such as the horn-like spar protruding from the forehead, to suggest hellish mutations and deranged cross-breeding experiments. Add manacles to the front claws, restraining the hellhound's aggression, but not completely denying the beast its freedom.

3 Draw in the details of the hellhound implying a deranged, possessive owner. Add piercings to the ears. Draw the eyes as demonic slits, burning with hatred. The hellhound can take all the damage you throw at it and still be aggressive so make the creature's skin look patchy and flayed, even slashed open in parts to show organs or muscle tissue, such as in the stomach. Fill in the deadly maw of jagged teeth and the hot, panting tongue. Add striations to the horn and claws and jagged fur to the whiplike tail. Ink the image when done, and erase the pencil lines.

4 The final stage adds colour. Fiery, earthen tones add credence to your impossible creation, with highlights of blood-red eyes and stomach, bone white teeth, and the contrast of the claws. The blues of the chains and piercings on the ears draw attention to the metal, contrasting sharply with the darker muted tones of the hellhound itself, which is a mixture of browns, pinks and reds, which indicates the poor condition of its skin.

Alien life forms

Aliens can be a lot of fun, as you can populate entire worlds with stunning new species. Aliens don't have to be a life form you'd ordinarily recognize. Even if humanoid, their characteristics may be based on completely different organisms. Alternatively, your aliens may look completely bizarre – take the creature from *The Blob*, for example: a roaming gelatinous mass. Once you've decided your aliens' physiology, you can develop interesting traits for them, which may similarly challenge convention. If you make your aliens drooling, snarling and generally threatening in appearance, that doesn't mean they have to be warmongering megalomaniacs. They could be peace-loving, with external features that make other races too afraid to have any sort of contact with them. Alternatively, you could develop an alien that appears serene, but which uses its calm exterior to lure others into a false sense of security.

Insects and reptiles

Here are some ideas for alien characters based on various existing Earth species. The first is a melding of ant, lion and dragonfly. The second is a fusion of earthworm, scorpion and octopus. The third is a blending of bat, dog and horse. All share an upright, humanoid gait. These alien forms have been inspired by insects, mammals and reptiles. Because the physiology of animals is so different from our own, combining their attributes always provides fertile ground for interesting ideas. Species such as ants and termites, for instance, live in hive-like colonies of workers dominated by a single queen, so creating alien societies based on these creatures could extend into their social practices within your story, sparking off potential ideas for thrilling interspecies conflicts.

Dragantflion ▲
No more than 15cm (6in) tall, dragantflions are the most brutal hunters in their food chain, swarming on victims with the use of pheromonal hive signals. Don't just cut and paste your animal attributes, think of how you can convincingly meld together elements that would never arise in nature.

Wormoction ▲
Caught between claws and squirting ink, a wormoction's prey never has a chance. Sometimes adding in pseudo-mechanical elements can add an extra element of the alien to your created species. Here, visible joints suggest an exoskeleton, or perhaps even naturally occurring hinges.

Bathorschien ▲
These monstrous-looking beings are simply misunderstood. On their holy days, thousands fill the skies with song. Think of surface textures for different alien skins. Applying fur instead of scales, or changing the colour of an Earth-based dermal covering can be enough to convince.

Practice exercise: Mantoid

The armoured mantoid, a soldier of a man/ant race, is naturally well-suited to battle. Its segmented limbs and anthead make it look sufficiently alien, while its humanoid body could allow it to blend in on Earth – just.

Materials
- *blue pencil 10*
- *soft lead pencil*
- *pen and ink*
- *colouring method of your choice*

1 Start with a rough outline with the blue pencil, building on what you have learned of human proportions. Use guidelines if you wish. The head will be large and fairly triangular compared to the norm, while the other proportions fall well within standard deviation for a human. Give the mantoid a warrior's broad shoulders.

2 Start to flesh out the line work of the body, using your guide. The hands taper to two claw-like fingers and a sharp thumb, while the feet are toeless triangles. The head is plectrum-shaped, with a thick neck to support it. Begin to clothe the mantoid in the protective garment he wears around the body, creating a bottom and a top garment.

3 Start with the head, adding in large, light-absorbing eyes. Note how the eyes reflect the shape of the head. Add two pinpricks for nostrils and a straight line for a mouth. The antennae are thin loops, like golf clubs, protruding from the top of the head. Segment the limbs at every joint, as shown. Complete with knee pads and boots.

4 Add shading to the eyes, ink and erase the pencil lines and proceed to colour. Light flesh tones contrast well against cool blues, with purple eyes as an accent.

> **Tip:** When creating a species, start with a 'benchmark' character that you can exaggerate and mutate to make individualized aliens.

Extended family

We know that ants are ruled by a queen, which is much larger than any other member of the species. Would you have a king or queen for this race, and would they be larger and very different from the rest? What kind of social structure would the mantoids possess? Worker mantoids, for example, could be adapted primarily for labour. You could assign a special role to the flying mants, making them the planet's police force. From here, it's a fairly straightforward process to develop ideas for the buildings and vehicles of your mantoid world, keeping the man/ant theme throughout.

Snapshot of a society ▶
You may find it helpful to create an image showcasing many different elements of your alien society in operation, trying to capture the 'essence' of what makes them tick. This picture shows a cross-section of mantoids engaged in the frantic act of hive construction, under the watchful and commanding eye of the queen.

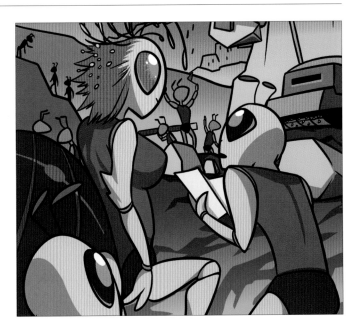

Mecha giant robots

One of the most popular strands of science-fiction manga is that featuring mecha (short for mechanoid). Mecha are giant robots, at least one to two storeys tall (sometimes as large as several city blocks) and capable of insane amounts of damage. The difference between mecha and true robots is that mecha tend to be piloted by a human operative – often one specially chosen, born or bred for the purpose. Mecha proved very popular when they appeared in anime series such as *Gundam* in the late 1970s and early 80s. Mecha are often portrayed as Earth's – and humanity's – last, best hope against a similarly titanic alien menace: so why not pit your mecha designs against city-sized monsters and aliens?

Designing a robot

Using the human form as a basis is a good way to start dabbling with robot design, particularly if you haven't drawn any before. It also conforms neatly to the idea of a robot with a human pilot – when the pilot moves their arm or leg, the mecha duplicates their action on a far grander scale. Start with a basic human shape, but make variations in the outline, incorporating armoured segments and visible joints at every opportunity. If you've managed to design a few different human characters, it is only a few short steps from here into the mechanical world.

Rapid-fire machine ▶
Test your imagination. With each deadly weapon the size of two stretch-limousines, how will your mecha be resupplied in combat?

Combat weaponry ▲
Many human pilots create custom mecha that forego the flexibility of humaniform hands for the convenience of mounted weaponry, such as this hand-cannon and the shoulder rockets.

◀ **Command unit**
Even mecha built around the same chassis have the opportunity to be customized by their pilots. See if you can create a whole battalion from the same basic design, changing only the colours and head detailing.

Transforming jet ▶
Many mecha also incorporate a secondary, vehicular attack mode. This blue 'bot transforms into a 31st-century fighter jet.

Developing your mecha character

To make your mecha stand out, experiment with ways of arranging its features in order to make them unique. You don't have to obey any previous norms of mecha design.

Head ▶
Multiple lights or lenses, or a slit around the head that lights up, often represent visual senses. A single eye could also flash when the mecha 'speaks', transmitting the commands of its pilot. As mecha generally magnify their pilot's body language a hundredfold, an expressionless face may be the only opportunity to maintain some reserve.

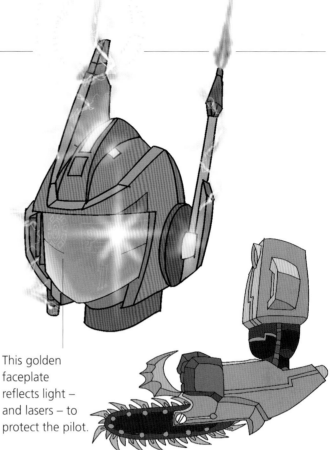

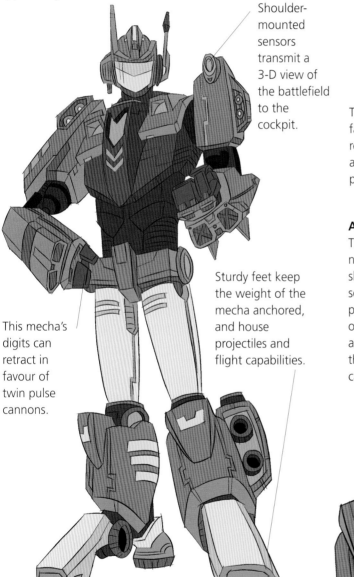

Shoulder-mounted sensors transmit a 3-D view of the battlefield to the cockpit.

This golden faceplate reflects light – and lasers – to protect the pilot.

Arms ▲
The arms need to look convincing, although they don't necessarily have to be physically possible. For interesting shape ideas, look to a mechanic's toolbox. You could choose something like a hammer, upturn it, and use it as the upper part of the arm that connects to the shoulder, with the head of the hammer acting as the elbow. For the forearm, construct a cylinder, add a few bumps for implied muscle, and rather than end with a hand, choose a weapon, such as a miniature cannon or a chainsaw blade.

This mecha's digits can retract in favour of twin pulse cannons.

Sturdy feet keep the weight of the mecha anchored, and house projectiles and flight capabilities.

◀ Legs
Instead of a cylinder, why not choose a square-edged shape for the thigh? For the knee, draw a small, turned-in block. Beneath that, draw a giant foot-shaped block that bends off the knee by being attached to either side of it. Add enormous shin pads that extend to the floor, housing the heel but leaving the foot/toe area sticking out at the front.

Tip: It can be difficult to suggest the scale of humanoid robots. When drawing them, be sure to surround them with visual clues, whether in the shape of skyscrapers for them to tower over, standard vehicles to crush, or human pilots climbing on board. Give the reader's eye something to estimate height with.

Sidekicks and friends

You'll have noticed that it is extremely rare for a manga hero to walk around unaccompanied. In manga, the protagonists always have at least one or two companions who follow them on their journey. These are the supporting cast, the sidekicks, who come in many forms. They're not always people – a friend might be a creature, such as a pet or even an alien. This section, however, provides examples of some human sidekicks, who may help your lead in their quest.

The importance of a sidekick

When you create a sidekick, you add a further dimension to your story. Giving your protagonist a constant companion helps show the depths of his or her personality and, most importantly, gives them someone to have a dialogue with and explain the story to. Use yourself as an example and think about how your interaction with your friends, parents, teachers and bosses defines you as a person, in relation to others. Sidekicks are often a double-edged sword. Some are incredibly helpful, and may be more skilful than the lead character. Others, despite a wealth of technical skills or fighting prowess, are a constant hindrance to the main character. You could have a sidekick who is the lead character's best friend and always shows an unparalleled level of support. It could be that the this companion is over-confident and arrogant, leaping in, fists whirling whenever the lead character pleads for diplomacy or stealth. This would leave the protagonist frustrated at having to keep his companion's pugnacious nature under control.

Practice exercise: Genius

This sidekick is petite and slender, but makes up for what she lacks in muscles with the depth and breadth of her knowledge base. Fluent in dozens of languages, with a photographic memory, she's an irreplaceable asset to the main character.

Materials
* *soft lead pencil*
* *pen and ink*
* *colouring method of your choice*

1 Rough out the proportions of a standard female in her teens with a soft pencil, fleshing out your simple guidelines into a sketchy pose. To emphasize her IQ or her photographic memory, this genius points to her temple. She is examining some important documents clasped in her other hand and holds some papers under her arm. Keep the outline of your character minimal and the body slim. Sketch in some long hair, tied up at the back, with a ragged fringe (bangs) falling around to frame her face.

Tip: Glasses on a brainy character may be stereotypical, but in manga, common denominators are a way to establish characters quickly. You may decide to turn a stereotype on its head during the course of a story, subverting the expectations of your audience.

2 Give your character more definition with your pencil lines. Give the character narrowed, concentrating eyes and glasses over the top. Aim for a scientific-casual look with a lab coat, as if a PhD student has gone into the lab on her day off. Note the subtle sixth digit, giving her the appearance of being slightly unusual.

3 When you're satisfied with your pencil lines, ink them and erase the guidelines, and proceed to colour. Use a strong hair colour to direct attention to the character's head (and mammoth brain), and use colourful accents on the trousers and T-shirt to complement the stark white of the lab coat.

Practice exercise: Arrogant fighter

This guy is always in the mood for a fight, and while his physical presence may help the protagonist intimidate his opponents when they face enemies, thinking is not one of his special skills. He benefits from being around the cleverer lead, who does his best to keep him on a (metaphorical) leash.

Materials
• *soft lead pencil*
• *pen and ink*
• *colouring method of your choice*

1 Start with a rough set of guidelines, using a soft lead pencil. Unlike our protagonist, who might be around three heads wide from shoulder to shoulder, this character is around four to five heads wide and about six heads tall. Keep the head small, not much bigger than a normal head, to emphasize this character's limbs.

2 When defining the body, keep the neck wide to suit his muscular build. Arms and legs need to be broader than in a standard adult male, so that his physique emphasizes his strength. Define the main muscle groups to a greater degree than you usually would, particularly in the biceps, chest muscles and calves.

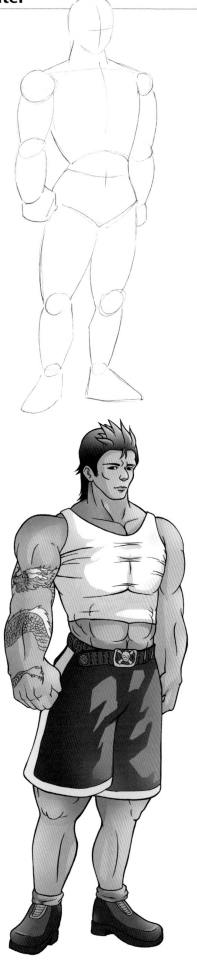

3 When detailing his face, give more definition to the nose and mouth. Keep his hair short with small spikes. Draw a tight, sleeveless T-shirt, keeping the arms exposed. Baggy shorts will give him freedom to kick. Add a heavy belt over the top. To show his past as a fighter, add a colourful tattoo around one arm.

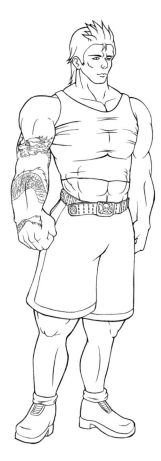

4 When you're satisfied with your pencil lines, ink them and erase the guidelines, and proceed to colour. On this figure note that the skin is deeply tanned and his clothes plain, making the tattoo stand out in sharp relief.

Tip: It helps to get acquainted with your characters. Practise their proportions, and the most relevant poses likely to be used in a manga story. Keep a lasting record of all the characters you create to help maintain continuity and make sure that figures are not drawn incorrectly as your work progresses.

Elderly characters

Inevitably, since manga is a product of youth culture, elderly characters are not as prominent as their younger counterparts. When it comes to older sidekicks, manga tends to deal in two stock characters. The less common is the elderly martial arts sensei, who maintains an impressive physique even after several generations of fighting and teaching classes of young and boisterous students. The other is a mischievous character, often possessing special abilities. An elderly trickster will both lend the story some comic relief (inverting the 'respect your elders' paradigm) while, at the same time, constantly throwing complications into the path of the lead character as they try to get them out of trouble.

Practice exercise: Martial arts expert

This is a large character, almost imposing, but still in proportion, unlike the 'arrogant fighter' of the previous exercise. His strength and experience should be half-implied from his build, and half from the way he carries himself. Any up-and-coming student wouldn't dream of getting cocky. The martial arts expert is at his peak of fitness and keeps his moves disciplined, but his uniform has suffered over the years – think about whether you want to stick in rips and tears, or frayed edges. From a story perspective, consider why he'd want to carry on wearing this old uniform. Perhaps he wore it when he finally beat his own master in single combat.

Materials
• *soft lead pencil*
• *pen and ink*
• *colouring method of your choice*

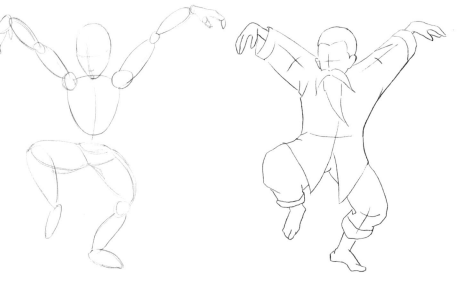

1 Make the frame broad in the shoulders, and wider than the waist. This character's pose is inspired by many styles – this could be the beginning of a Mantis or Drunken Master move.

2 Dress your character, paying attention to the way the loose trousers and thick coat hang over his frame. The hair is close-cropped and the beard and moustache relatively long and thick around the lower part of his face.

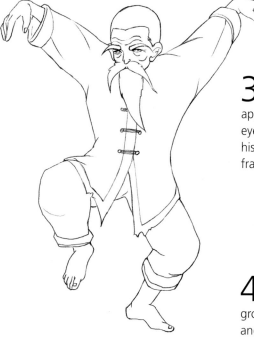

3 Give definition to the face, adding wrinkles where appropriate. Make the eyes and eyebrows fairly angular, to convey his serious demeanour. Detail the frayed uniform and crease lines.

4 Move to colour, using classical earthen tones to suggest a grounded nature. Add shadows and highlights to give a 3-D effect.

Practice exercise: Crafty old wizard

This is an example of one of the more comical old characters, reminiscent of a chibi-style character, particularly as he's only going to be three heads high. His head will look quite large for his shoulders. If you decide to use a similar character in one of your stories, he could get his robes caught continually in doorways or be trodden underfoot to humorous effect.

Materials
- *blue pencil*
- *soft lead pencil*
- *pen and ink*
- *colouring method of your choice*

1 For the frame, make the shoulders and hips narrow. Keep the outline of his body thin but draw fully developed, rather than chibi-style, fingers. He will hold a long thin staff or broomstick that's over twice his height, so sketch a line into one clasped hand.

Tip: Remember, it's not only your hero who will be changed by the outcome of your narrative – his or her travelling companions may also undergo a metamorphosis, changing from good to bad, dying, changing forms or betraying the lead character and then sacrificing themselves to save them: all are possibilities along the way.

2 Sketch in large eyes, with an equally large grin and lines around the mouth. Draw pronounced cheekbones (when we age, features like the cheeks sink into the face, and the skin thins, so the bone structure of the skull becomes more obvious). Make a small, downward-pointing nose. Outline thick eyebrows and make the ears larger than normal, to divert attention to the head. Cover the wizard's receding hairline under an enormous pointed hat.

3 Finalize the features to give the face an impish expression and dress your character in a long robe that looks over-large, particularly at the sleeves. A high-collared cape flows out behind him. Draw a thin sash round his waist to draw his robes together, and add a small, hanging potions flask. Add texture lines to the broom and crease lines to the garments.

4 When you are happy with the final pencil drawing, ink over the lines and add colour. Choose hues and effects to enhance your character's traits, such as the glow added to this cackling wizard's unassuming broomstick. Add a familiar, such as this small pet frog, who will follow him everywhere.

Villains

Now you can move on to the bad guys. And let's face it, designing the villains is as much fun as designing your protagonist. This is your chance to create characters who will stop at nothing to defeat your protagonist. Often, a villain will have another motive as well, such as world domination, or a raging desire to destroy an entire city. Or your villain may be more subtle: a character who merely mirrors the protagonist, with similar abilities, like a rival in a sport which both characters play. Of course, the rival/villain resorts to cheating, while the protagonist always plays by the book.

Planning villains

When planning your villains, start with the main antagonist. Decide how you want them to look, and also the reasons why he or she and your main character are at odds. If you have a well-motivated, powerful antagonist, your protagonist's journey to his or her final confrontation will be tough and satisfying. It's crucial that your story of the protagonist's trials and tribulations is convincing. To this end, you should create a series of villains, escalating in toughness and evil, all guided by the near-omniscient hand of the master manipulator. Many shonen manga function like video games, with the protagonist defeating a series of 'bosses' in order to 'level up'. Ensure each 'boss' is engrossing and unique in order to maintain interest.

> **Tip:** Ensure the villain has all the latest equipment, gadgets and outfits at their disposal, putting them on a pedestal that the lowly protagonist can topple them from. Arrange for the hero and villain to meet, so you can highlight the extent of the differences between them.

Alien princess ▶
With thousands of ships at her disposal, this beautiful yet evil Martian princess is bent on domination of planet Earth. She has conquered a hundred worlds, and keeps all neighbouring planets under the yoke of her tyranny. But Earth will not bow, and she is constantly frustrated by its scuppering of her plans.

Vampire count ▲
This character has the feel of a classic manga villain. He is well dressed, powerful and good-looking. However, his glossy exterior hides less-reputable traits. Imagine him sitting high in his castle, holding the nearby town in his vice-like grip of terror. The moon is full, and the lord has sent his minions out for a fresh young bride to sate his bloodlust. Many strange creatures are at this villain's command, primed to stop any would-be hero from entering his domain.

◀ **High-school rival**
Your protagonist seems somewhat average in comparison to this guy, who is a youthful, charismatic all-rounder. However, he hates to lose, and his arrogance is often his undoing. Then again, with so many people thinking that he's the greatest, he rarely fails. It will take a particularly brave student to challenge him at what he does best, especially when others have been completely humiliated as a result of their failure.

Villain characteristics

As a general rule, keep your villains' features and clothing dark and dramatic. A protagonist dressed in lighter colours will provide contrast. Villains in manga are typically tall, and physically more impressive than the protagonist. Keep their eyes and eyebrows angular, so that they always look threatening. At the beginning of your story, your protagonist shouldn't have a hope of defeating your villain.

The idea is that he or she has to learn and train along the way. To make things more interesting, you might want to make your villain short on patience, so that anyone who dares to interfere with his plans will quickly fall victim to his temper – this can also include their various underlings.

Just as the hero or heroine has sidekicks, a villain always has aides: trusted henchmen, monsters of untold strength or manipulative strategists to advise them on their evil plans. But for every villain, there must be a flaw, a weakness, which will eventually be their downfall. Is it physical – an allergy to a potion or poison? Is it mental – a hubristic oversight to be exploited? With every villain you create, consider how your protagonist will discover their weaknesses and then make use of them to emerge victorious.

Tip: Many great stories begin with the heroes or heroines having already lost – a land pillaged, a city destroyed or subjugated to a common enemy. Rallying your characters to unite against this defeat can be very satisfying.

◀ **Freshly made vampire**
The recently sired 'son' of the vampire count, his bloodlust and vigour are stronger than his father's. However, he still retains many of his human memories, which can cause conflict.

Werewolf enforcer ▶
Lycanthropic muscle-for-hire, this cut-off-wearing denizen of the night is a ferocious slayer of the innocent. But silver bullets can lay him down for good.

◀ **Tri-horn demon**
In return for asylum on Earth, this devilish rebel takes care of the count's enemies. However, if she displeases, she can be returned to Hell in the blink of an eye.

Supporting cast gallery

With a world of boundless possibilities ahead of you, it can often be difficult to find a place to start. With that in mind, this spread showcases some of the more esoteric combinations of attributes you can put together to create your supporting cast and their villainous antagonists. Remember to subvert expectations wherever you can – most, if not all, of these possibilities could work equally well for strange allies as for terrible adversaries, given a compelling backstory and reason to work alongside your heroic characters, rather than competing with them or devouring them.

Backup and adversaries

What makes a good character? An easily identifiable visual 'hook' always helps – many of the characters on this page are simple twists on the standard human physique, with alterations in colour and silhouette, and an inhuman feature such as horns or a tail.

The zombie ▶

This creation is a creepy twist on a 'normal' zombie character. The recognizable basics of human physiology are re-imagined as the 'living dead'. This shirtless zombie is emaciated and lacks coordination, his limbs stiffened and near-useless from rigor mortis. His clothing may be ripped or missing, and because of his emaciated state, will look several sizes too big. His face is a mess, with staring eyes and a gaping, dislocated jaw. For further fright, shade the eyes to shadows so they look almost hollow. The zombie communicates in moans; wind whistling over a grave.

Demonic faun ▲

Impish and mischievous, but not truly evil, this creature of the underworld enjoys nothing more than meddling in the plots and affairs of state.

◀ **Catgirl**

A hyper-evolved form of the common housecat, this sprightly, twin-tailed humanoid could be from the future, the result of a gene-blending experiment, or the magically uplifted form of a wizard's familiar. Perhaps she is indentured to her evil master, but longs to be free.

◁ Six-tailed fox
Neither good nor evil, but serving the capricious nature of the Universe, Six-Tailed Fox roams the highways of his fantasy dimension, directing and misdirecting travellers to new paths – and new fates. His magical tails allow him to fly.

Young Frankenstein's monster ▷
Stitched together from the corpses of a high school rock and roll band, this poor unfortunate wants nothing more than to rock out on the guitar, bass, drums and vocals, all at the same time. However, while he attempts to get his new life together, the scientist who resurrected him wants him to rob more corpses to create the ultimate girl band in one monstrous, immortal body.

Hydragon ▽
Cut one head off and two more will grow in its place, until eventually the hydragon will be so top-heavy that you can probably walk around it and steal whatever you like. In the meantime, though, it is a deadly, reptilian predator.

Mersorceress ▷
Born from a breed of humans who decided to follow the evolving dolphins back into the water, this mercreature practises an esoteric blend of water magic, one that requires the feeding of sacrificial victims to the Great Behemoth of the Deep.

Battle scene project

Every now and then it's great – and necessary – to draw good and evil into a massive conflict. It makes for a very satisfying payoff for your readers, and can be equally satisfying to draw. The main drawback is that it takes time, and can easily become confusing. Sometimes you can have two dozen characters on a single spread all involved in the fight, all performing a different action. As cool as it is to draw these entanglements, you should not make a habit of it. Manga – and stories in general – thrive on repeated waves of build-up and pay-off, so each great battle must be accompanied by a

similarly weighty section of plot development, a character-based 'fallow period' in between the waging of war. One way to keep track of your characters in these battles is to give each one a list of aims, goals and actions to undertake throughout, so that in each panel you know what all of your cast are doing.

▶ Good meets evil in a battle against a mecha warlord and his following.

Materials
- *soft lead pencil*
- *pen and ink*
- *colouring method of your choice*

1 List the characters involved in the fight, and their objectives within it; for example: 'Baron Von Struckmeer, a mecha-piloting local warlord wants to take

the head off the rebellious upstart Rainer Darksturm, so will ignore all lesser foes on the battlefield in order to engage him in hand-to-hand combat.'

CHARACTERS:

Rainer Darksturm
Baron Von Struckmeer

OBJECTIVE:

Kill or otherwise defeat the rebel Rainer Darksturm in hand-to-hand combat.

Will ignore all lesser threats.

2 Draw an overhead map of the battleground 'arena'. Wherever you are, making a map and tracing the positions of your combatants on it will allow you to keep a continuity of action from any angle. When in doubt, create a couple of key 'landmarks' to anchor your action no matter which direction you view the fight from. Using your character objectives and overhead map, plot out your battle, panel by panel. Remember that your notes can be very brief: a note that 'X engages Y near to Z' is all you need. The map is there so that you can pick a spot on the map, choose a direction from which to view the action, and know at a glance what landmarks you will see from that direction. Try to rotate your 'camera' around the battlefield throughout your scene, alighting on the important struggles of each pair or group of main characters, even as you seek to capture the chaos of the larger, pitched battle raging around, in front and behind them.

3 When you have your plot of how the battle will flow, sketch out some thumbnails of your first spread. Keep the thumbnails small, and use stick figures or loose shapes to indicate where each of your characters will be placed. You may want to start with a large overview panel of the entire battle, before zooming in to focus on individual fights – or you might want to start small, and zoom back to show the enormity of what is going on.

4 When you are happy that your thumbnails 'read' well, and that your battle, while chaotic, still flows from panel to panel, it's time to transfer your sketches to full-size pages and pencil, ink and render in colour your characters and backgrounds. Remember, too, that visuals and sound effects alone can often be enough to 'sell' a battle – the time for descriptive speech is long past, save for snarls and growls as long-time enemies lunge for each other's throats.

5 With larger-scale battles filled with complex elements and dozens of characters, you may find it easier to draw all of the panels individually, at a larger scale, before scanning them in, colouring them, and compositing them into your chosen layout. The beauty of creating thumbnails first is that it allows you to compose each panel as part of the final page so that each one flows correctly across the entire spread, regardless of whether you drew them all on the same scale or piece of paper.

Tip: If you are featuring characters in a number of different scales – humans and giants, for example, or humans and mecha – remember to show how each of these scales relate to one another, and how they interact within the fight. This can be as simple as showing two humans battling in the shadow of an enormous foot, or as complex as two people scaling the artificial mountain of a striding mecha in order to pull out its control cords.

5

Narrative and layout

Now that you have learned how to create characters and settings, weapons, props and vehicles, it's time to take what you have learned about manga to the next level, and see what it takes to assemble a story. From crafting your overall narrative to creating a finished page from concept to colours, this chapter will guide you through every step.

What's in a story?

Your story is the most important element of your manga. Artwork and dialogue, no matter how polished, are all created in service of your narrative. Manga is a medium of narrative told through sequential art – each panel building on the one that went before it, melding words and pictures to create a sequence that accurately communicates the intent of the writer and artist. The story must keep your reader engrossed throughout, leading gradually to a climactic ending. In this section, you'll learn the basic tools of page-to-page storytelling: using images in sequence, building suspense and releasing tension, framing images in panels, and arranging your panels to control pace and flow.

Narrative rhythm

Within every story, you need to convey meaning and sustain interest, but you must also reveal your story effectively, in a logical order. Arrange the events of your story so that your audience can follow the action easily, and try to make the drawings and dialogue flow together to create a good narrative rhythm. Such rhythms are controlled by your choice of shots: long, wide panels will slow the eye down, as will large sections of dialogue, while small, choppy, silent panels will prove exceedingly quick to read. A mixture of both – and every step in between – will allow you to pace each scene as appropriate to its content. Different genres may have different rhythms: a shonen action manga will be relatively faster and choppier than a more contemplative shojo romance.

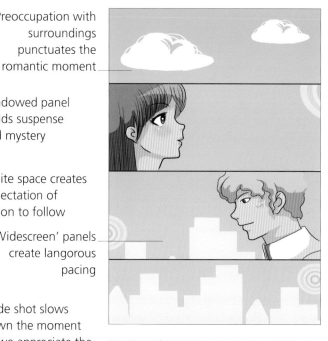

Preoccupation with surroundings punctuates the romantic moment

Shadowed panel builds suspense and mystery

White space creates expectation of action to follow

'Widescreen' panels create langorous pacing

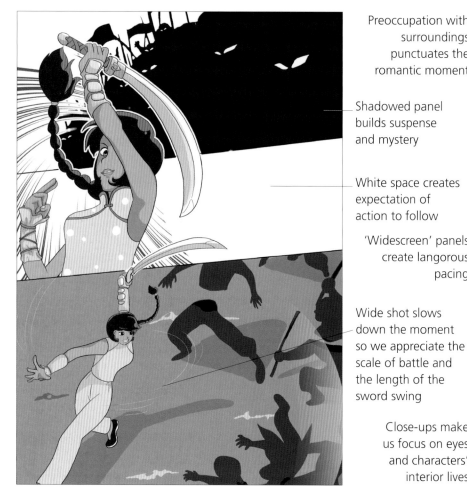

Wide shot slows down the moment so we appreciate the scale of battle and the length of the sword swing

Close-ups make us focus on eyes and characters' interior lives

Shonen ▲
This page literally bursts with action, with its warrior protagonist extending out of the boundaries of every panel, her sword providing the focus that draws us down the page. Note the use of negative space to create mystery and expectation of the action to come.

Shojo ▶
This romantic story, on the other hand, provides plenty of opportunity to focus on what the characters are saying or thinking, as everything but their faces has dropped out of the frame. The wide panels replicate awkward or thoughtful pauses in conversation.

Narrative movement

The way the reader's eye moves across the page is called the narrative movement. Keeping control of this keeps readers interested. It's important to think in terms of character and camera movement – a dialogue scene of 'talking heads' that repeats the same heads for pages on end will kill momentum and reader sympathy dead. Keep your 'camera' moving around static cameras, or keep your characters moving even as they talk. It is crucial to keep this movement in order to maintain the energy of each scene. Change between close-ups, mid-shots and long shots depending on the tenor of the dialogue: focusing on the surroundings as a character's attention wanders; cutting to an extreme close-up when a character reveals shocking information.

Conversation on the move ▶
The two characters meet in a long-shot, before cutting to a close-up of the first character to speak.

Drama, action and tension

Your stories will need tension. If, for example, your story is designed to be split into instalments, you will need your audience to want to come back for more at the end of each chapter. In a murder mystery, for instance, the detectives will start with the body alone, but as the story progresses, they will collect evidence and clues to lead them to the perpetrator – with plenty of twists and turns along the way. It's up to you to reveal your clues and moments of shock and suspense at the optimum points in the story.

Storytelling doesn't depend solely on dialogue. In some instances, you may wish to let the action speak for itself.

◀ Kidnap, mugging or murder?
Tension builds because the reader is aware of the danger the girl faces from the first panel, while the girl is oblivious – until her attacker vaults from the shadows! What happens next? We can't help but turn the page.

Moving around the setting

Sequences tend to spread over more than one panel – whether they are fights or conversations. How do you create the flow of a sequence? Here we have two characters in conversation. One is asking for directions from the other. The first panel is a shot of the characters from the waist up, facing one another. The dialogue is: 'Do you know the way to the police station?' Instead of giving the answer as to where it is located in this shot, the reply is illustrated in the next panel, which also changes the angle, a 'camera move' to maintain interest. The conversation flows across the panels, the reader's eye is drawn from one panel to the next, and their interest is piqued, maintained and satisfied within the space of two frames. The second panel is a close-up of the character answering.

Practise keeping conversations interesting. Take a similar pair of characters and create an extended dialogue between them. Focus on how the listener and the speaker react to each other. Start with a view over the shoulders of the first speaker, perhaps, so that we can't see the expression on their face, only how the listener is reacting, then swap the view in the second panel. Practise mixing long shots, mid-shots and close-ups.

Getting directions ▼
How would you continue this exchange? Would you add dialogue, or segue into the young character's journey to the police station?

Change of location

This device is often used to change scenes and locations in a more fluid and natural manner than with a narrative caption (e.g. 'Four Hours Later...', 'In a Warehouse Downtown...'). The first panel of the new scene shows either an exterior shot of a building with a speech balloon directed towards it, or the exterior of a room, with a speech balloon similarly placed.

In the example to the right, a female investigator is eavesdropping at a locked office door. The following panel cuts to a view of the person who is speaking, and the new scene proceeds from there.

Be careful to only shift back to an exterior view when beginning a new sequence, or when adding emphasis that require a long shot of the characters' location, as hopping back and forth between interiors and exteriors will only confuse your reader.

SO WE'RE AGREED. $5000 TO BUMP OFF THE PRIVATE INVESTIGATOR...

MS. DIETRICH... PLEASE COME IN. I COULD SAY THIS IS A PLEASANT SURPRISE, BUT WE BOTH KNOW I'D BE LYING.

◄ Eavesdropping
The private investigator in question has arrived at the new location just in time to hear the details (and remarkably low price) arranged for her own demise.

Behind the door ►
When the telephone is replaced in its cradle, she makes her move, drawing her handgun and bursting into the office!

Length of dialogue

Dialogue delivers crucial details concerning the characters and their motives, but too much slows the pace and ruins the timing you're trying to establish. You match your dialogue to the artwork and the narrative rhythm. In fast-paced sequences especially, don't let dialogue dictate the speed. If you have a sequence showing a character running towards a building – they're late for school, say, as shown here – don't *state* the reasons why they're late; they don't have time. Keep the dialogue succinct to emphasize their speed – and breathlessness. Explanations can come later.

Sense of urgency ▲
As the two students bolt out of their apartment block, the emphasis in the dialogue is on reinforcing the main reason why they're running – they're late – without going into any further detail.

Busted! ▲
Now the story shifts down gears, as the students get a chance to explain themselves.

No need for dialogue

Sometimes you don't need dialogue at all, as the action itself will reveal the drama. Your characters shouldn't describe through dialogue what is shown – it's repetitive, slows the pace, and implies your audience needs assistance. In this example, the destruction of one jet fighter by another is clearly depicted without the need for commentary.

Deadly dogfight ▶
The black jet fighter swoops in (1); achieves a target lock on the blue jet (2); fires a homing missile (3) that targets blue's engines (4); the missile detonates (5), and the blue jet plummets out of the sky on fire (6). Note the use (or lack) of borders on the panels, and the use of spot sky blue in the bottom two panels.

Tip: When pacing scenes, choose moments that actually drive your story along – don't string out brushing teeth or making coffee over six pages in an effort to 'build tension', unless your story involves possessed toothpaste or a poisoned espresso.

Composing the panel contents

Knowing what to place within a panel, and how to build and release narrative tension, is extremely important in manga. As with composing a frame of film, the contents of a panel must direct the reader's eye to what is most important about this snapshot of the scene. Unlike film, manga panels can disregard extraneous background information – there's usually no need to draw anything that isn't essential to the ongoing story, and this can often involve backgrounds dropping out at moments of high tension, or detailed facial work on background characters being kept to a minimum. Each panel should show the reader exactly what they need to know, and work as part of a sequence. In quick-paced manga, the storyteller often only has a few panels to build tension – especially when working to a weekly schedule.

Provide a focus

Each panel must have a focus, and the art should guide the audience to that centre. Keep the contents of each panel varied, to add interest. Don't draw your characters from the same angles all the time, or with the same facial expressions. You need to vary the appearance and perspectives of the characters to reflect their mood, situation, or what they are saying.

A lesson in contrasts ▷
The strips shown here communicate the same information in very different ways. The first repeats the same art, in the same way as comic strips found in many newspapers, while the second mixes angles, expressions and colour backgrounds to far more vibrant effect.

The strips begin the same way, with a two-shot of the talking characters.

The first strip re-uses the first panel all the way through, with only minor variations, relying on the dialogue to drive the story.

The mixture of panel widths and colours in the second strip creates art bursting with energy.

Abstract backgrounds illustrate character's emotions.

Composition

It is very important that your audience is shown exactly what they need to see. For example, if you are showing a company boss giving a speech to a boardroom full of directors or employees, the boss should be the focus of the majority of your panels, because he is the central speaker. By all means start with a long shot to establish the boss's location and placement with regards to the rest of his employees, but assist the flow of the story and the focal point of the scene by locking your 'camera' on to the speaker. If the boss singles out a particular employee in his speech, by all means insert a panel to show that employee's reaction, but then cut back to the boss as he continues his diatribe. If he opens the meeting up to questions, you could create a new panel establishing how the employees feel, before they respond.

Shadowy boardroom ▲
Although the body language of the board is tense, it's clear that there is only one chairman in this room – and he has a lot of angry things to say.

Long shot establishes scale of boardroom and relation of characters to one another.

Perspective directs eye to far end of table, and the boss sitting there.

Backgrounds drop out, save for chair and downlight, to emphasize the boss character.

Laying out the page

The best way to plan out a sequence is to sketch out the panels in relation to the whole page. Remember that manga compositions rely on whole pages, and sequences, for their effect, and designing and illustrating panels in isolation will never give you the best results.

Symmetrical layout and panels ▶

Pages that are symmetrically composed like this have no centre of attention, nothing to draw the eye to any significant part of the page. The eye flits from left to right, left to right, which can make for dull reading. Symmetrical layouts are mostly used for conversations, in which characters are imparting information to one another. If you use a grid like this throughout your story, it has the benefit of becoming 'invisible', like a picture frame or a TV screen through which the action is viewed. This is also the format for Japanese four-panel gag strips, which, unlike those in the West, are arranged vertically and reprinted two to a page.

Asymmetrical layout ▶

For a more showy, graphical approach, you can create designed, asymmetrical pages, which use the size and shape of each panel to showcase their relative importance, control pacing and drive the reader's eye around the page. This is a style of composition that draws a lot more attention to itself, making the act of layout a part of the story itself and keeps the reader on a rollercoaster ride across the page. Using different angles and rotated, unconventional panels maintains drama and interest in what is happening on the page – sustain this across a sequence, and your audience will be hooked for the journey.

Tip: Panel size matters. The larger the panel, the more emphasis you place on it. Smaller panels increase pace. The smaller the panel, the less detail you can render, and the faster the reader takes it in and moves on.

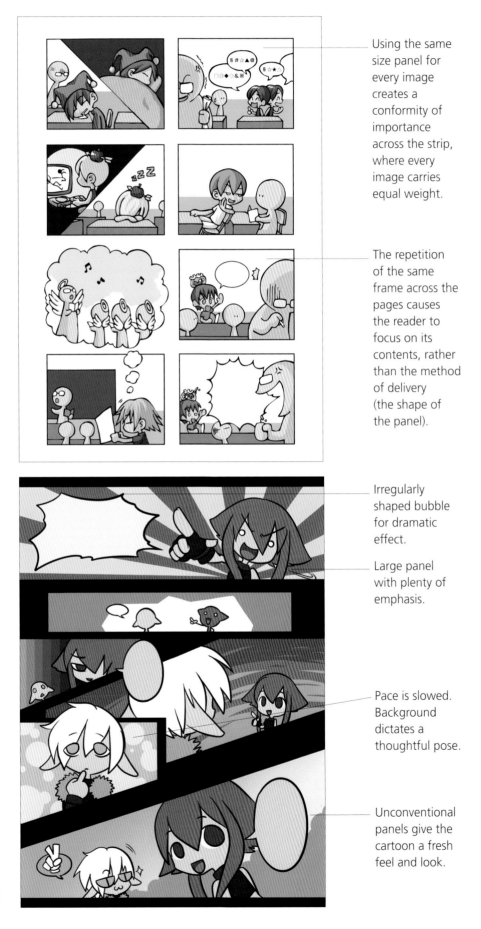

Using the same size panel for every image creates a conformity of importance across the strip, where every image carries equal weight.

The repetition of the same frame across the pages causes the reader to focus on its contents, rather than the method of delivery (the shape of the panel).

Irregularly shaped bubble for dramatic effect.

Large panel with plenty of emphasis.

Pace is slowed. Background dictates a thoughtful pose.

Unconventional panels give the cartoon a fresh feel and look.

Narrative dramatization in panels

The use of perspective in your panel frames will not only help the look of the page, but can also set the pace or increase the drama of your story. There are a wide, even infinite, variety of perspectives from which to view your art (close-up, medium view, wide-angle to name just a few) which you can use in your art. For the time being, use a selection of the examples shown here: they are all you need to tell a compelling story and create good-looking pages.

Common types of panels

Some panel shapes are termed 'neutral' and allow the art to dictate the pace of the story. Others speed up the pace, encouraging the reader's eye to race around the page.

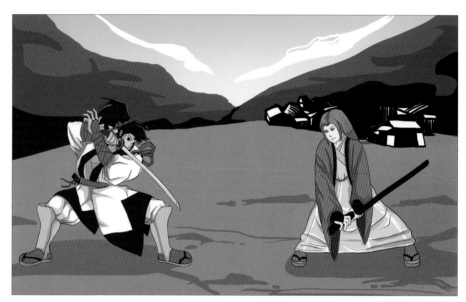

Standard view ▲

This panel reveals a lot of information at a character level, demonstrating a character's visual identity, through their clothing and accessories, as well as their stance, motivation and expression. It also encompasses detail of the character's immediate environment, allowing a reader to keep track of them as they move through a location.

Medium view ▲

A waist-up shot allows the reader to focus on the character's expression while also including more visual cues about their clothing, weaponry and stance than a pure head shot.

Wide-angle view ▲

Panels that provide a wide-angle view are often used to introduce new locations or cut to a new scene. They are often half a page high, but can be extended to single or double-page spreads to increase their impact. They can effectively establish a new story or add dramatic impact to an event. If you have two mythical warriors facing one another with their swords drawn, for instance, a wide-angle panel gives you space to set the scene, showing the characters in relation to their environment.

Western comic panel ▲

Heavily influenced by the grammar of film, this type of panel shows the character mainly from the waist up, but may go down as far as the knees. It is used to emphasize a character's stance and emotional state. The legs aren't necessarily included, as they are the least expressive part of the body. Such panels also provide a detailed view of the character's environment.

Close-up view ▲

This dramatic view concentrates the reader's focus purely on the character's expression, tightly cropping the shot around the character's head. Shading or colour giving an impression of the character's emotional state may be used in the background, or it may be left blank, as in this example, to emphasize the facial features.

Plot shot ▲
Another type of close-up panel, this time focused on something that is intrinsic to the development of the story, with relevance to the narrative: here, a figure well disguised against the background lurks in the shadows.

Horizon ▲
A natural-looking panel shape that resembles the perception we have of our surroundings in real life. There is typically a character in the foreground, and the horizon of the story's environment in the background.

◀ **Tilt**
This panel conveys everything on a slant, offering an unbalanced view that adds tension and uncertainty. The background may consist simply of speed lines in a circular zoom formation, pointed at the character's head, which is a good way of freezing time for an instant to emphasize the character's tension or alarm.

Bird's-eye view ▲
A dramatic device, looking down on a character. It can establish the character in their environment at the start of a story, or highlight a dangerous situation by making the character smaller in relation to the dangerous object or entity in the foreground, demonstrating a character's vulnerability and the struggle they face.

Tatami view ▲
This view is derived from the Japanese tradition of sitting on tatami mats on the floor while eating. The horizontal view is used to show two characters, usually in a historical setting, having a discussion across a meal or in a hut. *Blade of the Immortal* and *Lone Wolf and Cub*, both set in feudal Japan, often use this view.

Mouse's-eye view ▲
The opposite of the bird's-eye view, this panel conveys a character's strength and superiority, making a character dominant within the panel. It can also make the reader feel threatened and insignificant by proxy.

Panel shapes and sizes

The panels are the individual pieces of artwork in the sequence of your story, and each is defined by the frame (or lack thereof) that surrounds it. Frames can be anything from a simple black line that divides each panel from one another (leaving the 'gutter' or white space between) to intricately rendered pieces of baroque architecture that, by calling attention to themselves, reveal as much about the setting and period of the story as their contents. See for yourself how altering the frame can change the intent and effect of your artwork by copying the same piece of action on to a single sheet of paper several times. Render some panel borders around the pictures using the examples shown here.

Main panel and frame types

Some panel shapes are only used for specific occasions, while others will crop up constantly throughout a story. You may develop your own shapes with time, but the six panel shapes illustrated here provide a good foundation.

Standard frame ▲
Square or rectangular, and drawn in a regular fashion, the standard frame's main use is to call as little attention to itself as possible, merely dividing two pieces of action from one another.

Tip: Any shape can be used to create a panel, but be warned that a story full of star shapes, dodecahedrons and similar shapes may drive away more readers than it impresses. Panels are there to contain your artwork, not overshadow it.

Open panel ▲
This is a boundless panel that is used during a scene where the character is lost in thought or taking stock of their surroundings. The pace is definitely slowed by using this technique, and not putting a boundary around the art allows it to stop and take a breather. It is the comic-book equivalent of a dramatic pause in a film as it throws all of the focus on to the character.

Parallelogram frame ▶
Essentially a standard frame with the left and right 'walls' tilted to one side, this panel is used to add pace and verve to action sequences. Its shape psychologically influences the reader to flip through the pages at a faster pace. The panel should slant in the direction the audience is reading.

◀ **Cloud panel**
The cloud panel has a specific use in manga, usually indicating a sequence of daydreams, nightmares, flashbacks or similar. The softer, rippled edges of these panels are the standard method of establishing that reality has taken a back seat, and the character's imagination and subconscious have been thrown to the fore.

Trapezium pairs ▶
Used for fast, focused scenes, these frames normally involve extreme close-ups on the point of action. They are generally drawn as a pair within the space of a single standard panel. Because they are small and angular, they help propel the action forward. In this example of a sword fight, one panel shows a rapid parry between the swords, the second shows the protagonists circling for another swing. Both focus purely on the motion of the blades. The second example shows the two swordsmen, each reacting to the way the fight is going. Placing both trapezium pairs on the same page fulfils the same function as rapid cuts between cinematic close-ups in a chaotic action sequence.

Tip: These panels work best for simultaneous moments: the panels show a moment of time literally sliced in half and apportioned to each of two points-of-view.

◀ **Panel with 'jaggies' (jagged edge)**
The jagged edges of this panel help convey a dangerous situation, or illustrate a violent act as it is committed by a character. These tend to be used singularly, with never more than one per page, or the rhythm of the piece would be jeopardized. Think of this as the exclamation mark of sequential framing, and use it sparingly. The reader only needs to be told once that the coming sequence is rife with danger. Then they want to see the action you've just brought to their attention.

Laying out an entire page

To lay out a page, you use a variety of panels of differing shapes, each appropriate to their content and importance, to present one sequence out of your larger story. Creating a sequential narrative is not something to undertake in a haphazard fashion. Each panel must flow into the next, with links according to shape, content and dialogue, so that the sequence follows a logical progression in the eye and mind of the reader. When laying out a page, consider yourself a one-person film unit. Your actions alone decide how fast or slow the story moves, based on the panels' size, content, shape and frame (or lack of). Why not try reworking an existing page of your favourite manga, deliberately altering the pacing? Bear in mind that, in the West, we read from left to right – this will affect how you design your page.

Panel sequence

Each panel is a point in time in your story. The page is a collection of these points, each following on from the previous panel, while also simultaneously existing as a coherent whole. It's the artist's job to make the page work in unison, carrying the reader through the story in a natural and fluent manner. When laying out a page, you need to make sure your panels follow each other in a way that the reader understands. Arranging the panels obscurely as an artistic flourish will only serve to hamper your storytelling, as readers will spend more time working out what comes next than focusing on the panel they are reading. Take a look at the examples. One is simple, running left to right in a zigzag down the page, the other is based on a single, dominant image.

Note how the speech balloons also guide the eye down the page from top left to bottom right.

Predominance of background in first panel subtly draws attention to the windows – and what is outside them.

Tip: Traditional manga is read from right to left. Because of the increasing popularity of 'real' manga (and the cost of 'flopping' the artwork) many books are now being reprinted in their original direction. Try laying out pages from right to left as well as left to right.

Cutting off the character's eyes focuses us on his mouth – and his dialogue.

Reversed direction of glare on glass is subtle continuity clue tying in to the first panel.

Highlighted character guides the reader's attention across the panel towards the speaker under surveillance.

Make it interesting ▶
Note the extreme differences in shading between the deep blacks of the character in the bushes and the brightly lit, almost sterile quality of the room it is observing.

Tip: You don't have to use panels that are a regular shape throughout an entire page – the reader's interest may flag. Instead, think about how you can vary your shapes to increase the interest and appeal of your layout.

The page as a whole presents a switch in viewpoint, from the children in the room to the skulker in the bushes.

**Call-outs on a
splash page** ▷
This design is useful for
a slower, dialogue-based
sequence, or a shocking
moment that needs time
to sink in. The panels with
extreme close-ups of the
characters' faces could almost
be occuring at the same time
as the large image, which
forms the backdrop and sets
the timing for the whole page.

One of the strengths
of manga over film is
that it allows you to
present and view
both the close-up and
the long shot at the
same time.

These narrative
captions offer us
the girl's thoughts
during the dominant,
backlit panel.

Again, note how
much good balloon
placement has to do
with controlling the
direction of flow on
a page.

The reader is invited
to linger over these
full figures – like the
blonde-haired
character, the reader
is caught like a rabbit
in the headlights.

Tip: Only move on to double-
page spreads when you are
confident you can control the
flow of story across two
linked pages. Bear in mind
that people are used to
reading a single page at a
time, and may read them out
of sequence.

Web comic panel layout

Web comics follow slightly different
rules. While it's true that many are laid
out in the same manner as traditional
printed comics with a number of panels
on each page, in practice you can flout
the rules of page and panel layout. In an
electronic format, you are not restricted
by a page count, or by the number of
panels you can fit on the page.

If you work electronically, you could
just as easily lay out a single panel at a
time, creating what is essentially an
electronic storyboard, whereby the
importance of keeping your audience
no longer depends upon planning the
page along with everything else, but
instead concentrates far more on each
panel being well composed by the
artist. The need for each panel to
communicate its action well becomes
paramount, because the reader will
move from one to the next a lot faster
than if they had an entire page of
panels to get through. In fact, your
narrative rhythm is driven purely by how
much information you give the reader
in each panel.

Traditional web comic layout ▲
This web comic uses a traditional manga page layout, allowing the viewer to
scroll through the page from top to bottom (the page is sized so that it fits the
width of the screen). Each new page can be reached through a link that 'turns' the
virtual page. Surprises in the story can be hidden at the bottom of the page so that
they aren't seen at the same instant the page loads.

Dialogue and speech balloons

Once your page layout is decided, you can add dialogue and captions. Character dialogue emphasizes and adds a secondary (potentially antagonistic) layer to the actions depicted. It also demonstrates your characters' verbalized motivation and carries the majority of their interactions with one another. Dialogue is housed within speech balloons, or speech bubbles as they're sometimes called. Thought balloons are the equivalent for the unspoken, though fashions sometimes dictate that thoughts are written in caption boxes. Remember to leave space for your balloons when drawing your panels or you will end up obscuring your artwork when it comes to adding them later. Most readers tend to read the balloons first and focus on the artwork second, so use your balloons to guide your reader's eyes.

Placing balloons

Placing balloons is as much a science as an art, but bear in mind that a balloon larger than a third of the panel space available is excessive, and that balloons, like panels, are read from top left to bottom right, and must be placed accordingly if more than one character is talking. Nowadays, most speech balloons are placed by computer, but there are still artists who prefer the traditional method of using templates to draw balloons on to the page. If this includes you, pencil in your balloon and text first, and ink afterwards.

Balloon placement in panel ▲
The above example shows how you can replicate pauses in dialogue within a single panel. Short pauses can be shown by 'budding' balloons off of other balloons, while longer pauses require a complete break – perhaps joined by a thin 'tail' between two balloons.

Balloon flow ▶
This example shows how dialogue has been placed to guide the eye across and down the page, in a manner that also takes pains not to cover up any important areas of the artwork.

Balloon shapes

Although the dialogue within a balloon will help reveal a character's emotional state, the shape of the balloon itself can further emphasize it.

The four most common shapes ▲
Dialogue delivered in a normal way (without extreme emphasis) is contained in the standard, rounded-edged, rectangular or ovular shapes. All finish in a small point, or 'tail' that indicates who is speaking. Japanese bubbles are tall not wide, as the dialogue is written in vertical columns.

Captions describing a place or a scene ▲
Although rare in manga, captions describing a place, or setting a scene, are sometimes included. Essentially, this is the neutral voice of a narrator, allowing you to cut to a different point in time, or to move between characters in different locations, with phrases such as 'meanwhile, across town' or 'later that day'. Captions are most commonly delivered in a rectangle in an establishing panel.

Sound effects ▲
Mainly shown without a speech balloon, these represent sounds made by the characters, objects, accessories, and pieces of scenery. Gunshots, someone knocking on a door, a door creaking and the sound of footsteps on the floor are some common examples.

Inner feelings and thoughts ▲
Use cloud balloons for thoughts. Instead of a tail, a series of smaller clouds or bubbles lead to the balloon. In humorous stories, a simple illustration to show the character's thoughts can be used instead, as in this example.

Dotted-line balloons ▲
Used to convey a quiet voice or a whisper, these balloons are not used much in manga. A more common method is to use a standard bubble with the text written smaller than it would be for a normal speaking voice.

Jagged-edge balloons ▲
These balloons are used to convey a character's extreme emotion or a loud 'outside' voice, such as a character who is screaming in pain, shouting with anger and aggression, or yelling a warning to someone.

Panel shapes gallery

This spread contains a veritable cornucopia of further examples of panel shapes, page layouts and balloon placements. Take note of how the colour of your gutters influences the mood of the page – try adding in blues, reds and greens and seeing what effect they cast over your stories. Examine, too, how the use of different colours – and different fonts – in your speech balloons can imply different voices, strange languages and unfamiliar tongues.

More panels, page layouts and speech bubbles

The purpose of each panel is to show the reader the elements, characters and situations that will take him or her through the story keeping their interest throughout. It is the managa-ka who selects the most appropriate panel for each scene to show the reader the essential elements to understand the plot. Each panel is part of thinking about a whole page.

Sharp focus ▲
The background of this panel drops out to focus on the girl and the paraphernalia surrounding her.

Oval-shaped panel ▲
The shape focuses the eye on the shining wand, and carries through the soft and cute shape of the characters.

Cinematic horror ▲
The 'widescreen' panels and black borders create a cinematic feel and give plenty of scope for background detail.

◄ **Cloud dreams**
Hooked up to a dream-influencing terminal, this character's lucid dreams take her into various fantastic scenarios – with the cloud borders delineating the boundaries of the real and dreamed.

Explosive panel ▲
The explosive shape of the panel adds visual interest to an activity that is, in reality, rather dull. Hacking firewalls sounds a lot more exciting in theory than in practice.

Jagged balloon ▲
A character slips and begins to curse –
the perfect opportunity for a jagged
balloon and a loud exclamation.

New balloon colouring ▼
This illustration, featuring non-
standard balloon colouring, has a
creative, but highly readable, layout.

Superimposed panels ▲
Inset panels are close-ups superimposed
over wider shots. This is a 'teaser' panel,
not showing the bath straight away.

Thought-speech bubble ▲
Although the boy would never complain
out loud, he can say whatever he wants
in the privacy of his own head.

Colour border ▲
When it gets too much for the sorcerer,
his assistant gets a chance to shine in this
panel bordered only by colour.

Sketching thumbnails

Most manga creators, even those both writing and drawing their story, prefer to write a script as a guide before starting to illustrate their tale. Scripts contain brief descriptions of the characters and action in each panel, along with any dialogue and captions. The first step in transferring your script to the page as illustrations is to 'thumbnail' your script as a series of small sketches, showing the position of characters, the angles you have selected to best show the action, and the size of each panel in relation to the others. This way, you can spot any compositional problems before you start drawing for real.

Why thumbnail?

Once you have completed your script, you need to plan the look of your pages, making some panels more dominant than others, choosing your close-ups and long shots and spotting any areas where an obtuse passage in the script may need to be made more clear through an additional panel or some expositionary dialogue. Thumbnails are named for their relative size – while not literally the size of a thumb, you should be able to sketch an entire page on half a sheet of A4, or half that again. The small size makes you focus on what is truly important in each panel, and to view each panel as an element of the whole page. You may find it useful to spot areas of light and shade at this scale as well, colouring areas of shadow in a way that makes the page easier, rather than harder, to read.

Thumbnailing may seem like an extra stage, and it's natural to want to get stuck into putting your art on to the page as soon as possible, but the more problems you solve during thumbnailing, the less chopping and changing you'll have to do later. It's also worth thinking about pacing – would a page work better if the final panel was moved to the next page and given more space, for instance? Does a reveal need a full page all of its own? Are some sections moving sluggishly, others cramming too much in?

Keeping it simple ▲
Thumbnails are illustrations stripped to the absolute basics. Choose only the data that allows you to see whether a panel's composition is working, and enough to remind you of what you need to draw. Leave everything else out, keeping anatomy to stick-men or rough sketches, if you prefer (adding an eyeline to show where a character is looking can often be a useful addition), and backgrounds to symbolic shapes and squiggles.

Tip: Thumbnails are the first stage in drawing a finished page – not the point at which you begin to design your characters and costumes. However, they can also be useful for a writer/artist in a hurry: rather than spending time in a script describing characters, locations and actions with which they are familiar, they can leapfrog straight to the thumbnail script stage, playing around with layouts and dialogue on the same page.

Planning the details

The thumbnail stage is the point at which to make sure the art you have planned for is going to fit, particularly considering speech balloons. Focus your problem-solving attention on text-heavy panels: there is no point trying to fit in lots of detail if it will be covered up. Make sure the panels you have laid out give you sufficient space for the characters you want to appear, any background that is necessary to suggest location, and all of the required dialogue. This is also an excellent opportunity to edit your script. Writing your dialogue and stage directions in isolation is one thing, but you may change your mind when you see the art laid out on the page. Take the time to trim balloons that are too long, or add in extra ones to help smooth any awkward panel transitions.

Balloon placement ▼
Thumbnails are also great opportunities to test ways of controlling the flow of the reader's eye across the page, as with the sketched balloons below.

Thumbnail practice

To practise thumbnails, here's a relatively simple exercise. Choose a favourite or familiar manga and draft a script based on five to ten pages, writing down the descriptions of the setting, character, action and dialogue in each panel. Now close the manga, and, using your script, create your own thumbnailed versions of the pages, choosing the size and shape of the panels and presenting the action as you see fit. When you have finished, compare your versions of the pages to the final result – how close are they? Which version do you prefer? You may find that the thumbnails are close, as you are familiar with the existing pages, or you may find you have improved on the layout and panel flow! If you have a friend or fellow artist who is also learning to create manga, why not transcribe a script each and then swap? That way, you'll be approaching the script completely fresh, and may be even more pleasantly surprised by the results.

Same script, different story ▲
The aim of thumbnails is to save you time later by allowing you to experiment at a much smaller scale. Focus on bold shapes and whole-page compositions: worrying about the details is for later.

Creating roughs

The roughs are the next stage in refining your manga strip, offering a halfway house between the near-abstract planning of the thumbnails and the ready-for-print detail of the pencilling and inking stages. Roughs are all about experimentation and artistic problem-solving, refining the stick-men and blobby backgrounds of your thumbnails on the same scale as your actual art. While some artists produce roughs on a separate sheet and then transfer the line work to a fresh sheet of paper using a lightbox, other artists produce their roughs and finished pencils on the same page, refining one into the other. For those working in digital colour, on pages that will be scanned, many artists use blue-line pencils for their rough stage, followed by HB pencils for their finished line work. Whether scanned in as pencils or inked and then scanned, the blue lines are not picked up by the scanner, producing cleaner reproductions with less messy erasing.

Roughing it

Unlike thumbnails, your roughs should be done to the scale of the finished art, and should contain a lot more detail. One way to start laying out roughs is to blow up your completed thumbnails to actual size and either transfer them to a fresh sheet on the lightbox or redraw them by eye, using the originals as reference. You will hopefully find that your redrawn versions are better than your originals in many ways.

Thumbnails are all about speed and generalized compositional problem-solving, in that most artists use very simple shorthands for their figures, from stick-people to circles with lines indicating the direction of view. Backgrounds are usually absent or consist of boxes and lines. Roughs, on the other hand, are about expanding these simple notes and directions into something approximating the finished page. You need to flesh out anatomy ensure that it's in proportion, and make sure that perspectives mesh with any items and characters they share panels with. Don't be afraid to redraw challenging aspects of your page until you are satisfied with them – roughs are about saving you time later on.

Tip: While each of these stages is designed to give you and your drawing ability more thinking and problem-solving time, you may find as you develop – and as the deadlines come knocking – that you begin to combine different stages to make the whole process quicker. Don't be ashamed about taking shortcuts to deliver timely art – it's what the manga industry is based on, after all – but be sure you aren't doing your talents a disservice at any stage.

Tightening the layout ▲
A confident artist would have no trouble inking a final page from these lines, at 1:1 scale, block in accurate proportions and indicate all areas of background. Take particular note of the lack of shading or line width differentiation, however.

Rough backgrounds

Roughs allow you to sketch out a more established view of the scenery in your story, working from the details included in your initial script. As well as working on the anatomy of your characters, you should fill out and block in the proportions of your backgrounds, using photo reference, collated sketches, or your own imagination. If working from reference, block in backgrounds in the rough stage, but try not to refer back to your reference when drawing your finished pencils, so keeping a looser and more imaginative line. The main thing to think about at the roughs stage is integration: do your characters convincingly exist within their environment? Does the background overwhelm the character work, or detract from an important emotional moment? If so, now is the time to scale back your detail, or drop a background from a panel altogether. If your roughs show too little background information, now is the time to scout for suitable reference or inspiration.

If you're drawing your roughs on a separate sheet of paper, you can always refer back to them if and when you get stuck. Treat them as a 'first draft'. If you've drawn them on the same sheet as your roughs, your artwork will evolve as you incorporate each new stage of detail into the drawing. The more confident you can be when you put your final lines on the page the less likely you'll be to need an eraser.

Complete composition ▲
This is another example of a rough page in which all of the basic character information is present. All that remains is to add a further stage of detail, shading, line weight and visual flair.

◄ **Figure-drawing roughs**
This image, with its intricate foreground detail and involved figurework, requires some thought in the rough composition before you start to draw the thousands of leaves. Here's the rough with the completed artwork.

Inking and finishing off the page

So you're finally ready to bring everything together. Now you can pencil your first page for real. You've designed your characters, your setting, and the story that brings it all together. You've laid out the pages and checked that each set of panels flows well and is easy to understand. You may have worked ahead and thumbnailed your entire story before you begin to draw the first page to a finished standard, so check that your story builds to a satisfying conclusion. Give everything a final check before you set to work. Do your layouts work on each page? Have you illustrated what you need to show from your script, or have you been distracted by 'cool' but unimportant things to draw along the way (and have you shied away from aspects necessary but tricky to draw?). When you're ready, take a deep breath and dive in.

Finishing touches

Keep final pencil lines clean and tight so they are ready for inking.

Background ▶
Note the use of very sparse backgrounds, only showcasing elements absolutely essential to the storytelling, such as the door and the staircase.

Detail ▶
This is the stage to check whether everything is correct: lines, balloons and detail.

▼ **Inking** The finished pencils are inked for easier scanning, and because the lines will hold colour better.

◀ **Palette** The colour palette is very limited: a rich range of reds and browns, save for the 'shocking' elements of the blue door and the boy's blond hair that serve to contrast against the main character and her world.

◀ **Digital method** The page is coloured digitally, using a narrow palette. Digital colours are bright and excellent for reproduction.

Final piece ▲
Line work is finalized, inked and shaded, paying attention to line weight. The page is scanned and coloured on the computer, picking out a mood with the use of pale brown shades.

Make sure that your roughs have brought you to the point where you are happy with the look of each page. Check the panels are in order, that each page is composed well and that your story flows well from panel to panel and from page to page. Is there still enough space for your dialogue, and are there areas of art that will be covered by balloons? Is your figurework believable, and, most of all, loose enough? At this stage one thing to keep in mind – and your drawing hand – is to try to keep some of the looseness of line work that was present in the early planning.

Technical proficiency isn't everything: readers will often respond better to an imperfect image that hums with energy than a pristine, highly accurate drawing that is rendered sterile by reworking. The most important part of pencilling is knowing when to put down pencil and eraser and declare a page finished. If in doubt, leave a page, go on to the next, and come back to it after a couple of days. You'll be able to spot any problems far more easily after getting some distance. When you are happy with your pencils, ink and colour them using your favoured methods.

Tip: Before you declare a page finished, compare it with your original thumbnail. Hold your larger artwork at arm's length if need be. Has the energy and information contained in the thumbnail translated across? If not, is there anything you can do to fix it at the inking stage?

Whether you end up giving your pencils to another person to ink, as is the norm in larger 'creative teams' where time is of the essence, or you're going to do it yourself, get into the habit of marking the areas that will be completely filled with black with an 'X'. This saves you shading time at the pencilling stage and helps the inker, as most inks adhere better to the page when applied directly to bare paper.

Some artists who have become comfortable with tablet pens prefer to do their inking directly on to a computer, which, while fiddly, allows for much greater control over the line work and the ability to erase and redraw lines without having to use white-out or patch in new panels. However, inking via a software package such as Photoshop tends to produce rather stiff lines for artists beginning to explore the technique. If you want to give it a go, scan your pencils in at about 600 dpi for print resolution.

◀ **Inks and colour**
Inks tighten up the art for clearer reproduction, and add visual interest by differentiating foreground and background elements through different line widths. Colours influence mood, make changing time, scene and setting easier, and generate final artwork that is easier to read.

Roughs ▲
This page lays out all of the storytelling information and detail work in a clear, consistent manner. Balloon placements have been made, figures have been fully rendered, and the page is ready for inking. Your pencilwork may not be as tidy as this, but don't worry: that's what the inking stage is for!

Tip: Inks and colours should always be building on the clear storytelling you establish at the pencilling stage. It is possible to polish up your weaknesses, and it's equally true that bad inks and colours can ruin great pencils but clarity at the pencil stage pays dividends later.

6

The digital age takes over

Many manga artists have embraced digital methods to create their work. The advantages are numerous, from easily correcting mistakes with a click of a button to creating speedy shortcuts, and it's much cleaner than paint. It's also possible to publish manga on the Internet, reaching millions of readers and saving on expensive printing costs.

Tools of the digital trade

Most modern manga artists use computers to help them create artwork, to greater or lesser extents. Some draw and tone everything on paper, using the computer to clean up the pages and publish them online. Others draw directly into the computer, using a mouse or stylus and graphics tablet, and publish the results as a traditional paper-based graphic novel.

Digital methods can be used whenever and wherever the artist finds them convenient and comfortable. It is possible to work with just pen and paper, but in this digital era, it is hard to avoid computers completely. Once a few simple techniques are mastered, they usually prove faster and more convenient than traditional methods.

Hardware – PC or Mac?

The most important and expensive piece of equipment a digital manga artist will have to invest in will be a computer and monitor. However, provided it has a large enough memory, and fast enough processor, a good computer should last about 4–5 years before it needs replacing. Most computers have dual processor chips of at least 500MHz, which is powerful enough to deliver 7 billion calculations per second. The monitor should be a high-definition screen with a viewing area of at least 15 inches. Most monitors are flat-screen LCD display panels with 1600 x 1024 resolution. A storage device, such as an external hard drive, is extremely handy as well, as it will save large files that would slow down the computer, and will backup important documents, should the main hard drive break down.

Computer ▲
A home computer is no longer a rare device in households; most families have at least one to store music and photos, watch movies and surf the Internet on. But not all home computers are suitable for drawing manga. Some will be too slow to run graphics packages, such as Photoshop or Corel Painter. In order to make sure the computer is powerful enough, check the software's minimum system requirements, normally printed on the box. The computer must match these. Of course, this is only the minimum requirement for dealing with relatively small pictures. Working with larger, high-resolution files requires a more powerful machine. A good starting point is 4GB of RAM memory and a dual-core 2.4GHz processor.

Monitor ▲
It is important that the monitor displays images correctly. This is vital for colour work, and in order to ensure precise image quality the monitor needs to be calibrated with professional software or devices, such as ColorEyes Display Pro. If the monitor is not calibrated correctly then the colour of images when they are printed on pages may not match exactly what is on the screen.

Tip: When drawing with a computer, most technical choices are made with a mouse or stylus pen. However, it is important to use the keyboard for shortcuts, which save significant time and effort. A smaller keyboard is helpful if used alongside a graphics tablet.

Apple Mac versus PC ▲
Many manga artists tend to work on an Apple Macintosh, rather than a standard PC. The reason for this is that, until recently, the best painting and creative software was only available on the Mac. The Mac's operating system is more intuitive and better suited to how creative people think and work. Also, Macs were the preferred computer of publishers and printers, and traditionally preparing for print would have been done on a Mac. However, PCs now have all the same software available as the Mac, and the latest operating systems (Mac OSX and Windows Vista) 'talk' to each other without any major technical issues. The choice of one system over another is now more of a personal preference.

Printer ▶

Printing out work at home requires a good printer. There are two types of printer to choose from: inkjet or laser. Inkjet printers are initially cheaper and therefore more popular for home users, although ink runs out quickly and replacement cartridges can be expensive. However, as long as photographic paper is used to print on, the quality of modern inkjet printers is quite sufficient. Laser printers, especially colour ones, are initially expensive by comparison, but the advantages are higher-quality pages, lower running costs and a water-resistant printed picture.

Scanner ▼

If a drawing on paper requires more processing, or colouring, on a computer, a scanner will be needed to import the image. All-in-one A4 scanner/copier/printers can be bought quite cheaply and save a lot of desk space.

Mouse ▶

An optical cordless mouse is the best option for digital illustration, as they are more precise than a traditional ball-based mouse and won't clog or jam. Remember to change their batteries regularly.

Graphics tablet ▶

A graphics tablet is a far better choice for digital illustration than a mouse. Tablets are usually small boards that plug into the computer via a USB lead. Users draw on the pressure-sensitive board with a stylus, creating an image on screen instead of on paper. But quality isn't cheap: some graphics tablets are too simple for serious graphics work, so choose carefully and test your chosen model in-store if at all possible.

Mouse

Tablet

Conventional versus digital imagery

Hand-drawn ▲
This traditional watercolour painting shows the paper texture beneath the washes. With a little practice this effect can be recreated digitally.

Corel Painter ▲
Different colour schemes can be tested and blended on the same line art, allowing you to experiment with variations until you are content.

Photoshop ▲
The advantages of digital art include the easy mixing of techniques. Here, a graduated background contrasts with figures in a crisp animation style.

Introduction to Adobe Photoshop

Photoshop is one of the most comprehensive and powerful image-processing software packages available, and it is popular with home users and art professionals alike. This makes it the perfect program for manga artists to use.

Photoshop comes in many different versions. For the beginner, investing in the fully functional latest version can be expensive. There is a cheaper, reduced version called Photoshop Elements which is sufficient for a manga novice.

While Photoshop can appear complicated and seem nerve-racking at first, it isn't necessary to learn everything in advance to be able to use it productively. Here is a guide to the basics that will get you started on the more common drawing and painting tools and techniques. Knowledge builds with increased usage and simply playing around with different buttons can reveal exciting new art effects. The key is to get involved and to experiment.

Getting started

Depending on the computer's available memory and processor, Photoshop may take a while to open, as it is a large program. When first opening Photoshop, it will default to showing the Menu and Options bars running along the top of the screen, just like other applications. To the left of the screen is a vertical toolbox and to the right, the four palette groups: Navigator, Info and Histogram; Color, Swatches and Styles; History, Actions; and Layers, Channels and Paths. These are the key tools and components in Photoshop required to make digital manga artwork or any other artwork you choose to create. Without mastering these it will be impossible to work in the application successfully.

New		
Name: Untitled–1		OK
Preset: A4		Reset
Width: 210	mm	Save Preset...
Height: 297	mm	Delete Preset...
Resolution: 300	pixels/inch	
Color Mode: RGB Color	8 bit	Image Size:
Background Contents: White		24.9M
☆ Advanced		
Color Profile: Working RGB: sRGB IEC61966–2.1		
Pixel Aspect Ratio: Square		

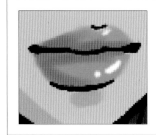

Tip: Resolution refers to the number of dots of ink per inch (for print) or pixels per inch (on screen). The higher the resolution, the better the quality. Most print images are 300 dpi, while online images tend to be 72 dpi. Print-quality comics are most often coloured at 600 dpi and printed at 300 dpi. Always scan and colour your imagery at a larger size than your final page to avoid unsightly pixellation or blurring.

The Title Bar ▼
This includes the current filename (in this example Untitled-1) and current zoom percentage (25%), as well as the colour mode and bits per channel (RGB/8).

Opening a blank canvas ▲
Go to File > New and a pop-up window will ask the size, resolution and mode of a new canvas. Set the image as an A4 page in the Preset box, the Resolution at 300 pixels/inch (or dpi) and the Color Mode to RGB Color. In Background Contents select White. Click OK and an active window with a white canvas will appear. It is possible to have several canvas windows open simultaneously, but only one is active at any given time.

Adobe Photoshop – [Untitled–1 @ 25% (RGB/8)]

File Edit Image Layer Select Filter View Window Help

☐ ▾ | Feather: 0 px Anti-alias Style: Normal Width: Height: | Brushes | Tool Presets | Layer Comps

The Menu Bar ▲
This is directly below the Title Bar, and includes options such as File, Edit, Image, Layer, Select, Filter, View, Window and Help, just like other standard applications. The Photoshop menu also uses the same keyboard shortcuts, for example, the [Alt]+F will select the File menu, or click on a menu name to see its drop-down menu.

The Options Bar ▲
This appears below the Menu Bar and displays the options for the currently selected tool. The above example shows the Rectangular Marquee Tool options.

The toolbox ▶

Normally the toolbox is on the left of the window, but if it is not visible, go to Window > Tools to display it. The toolbox is a convenient way to choose tools for working on images in Photoshop. To select a tool, click on its icon in the toolbox. Only one tool can be selected at a time, and only the primary tools are readily visible. When a tool is clicked on, the button will 'stick' to show it is selected. In the example on the right, the Zoom Tool (indicated by the magnifying glass) is currently in use. The cursor's pointer will also change shape to reflect which tool is currently in use.

Toolbox options ▲

A small triangle in the lower right corner of a tool icon means it has more options. To see these options simply click and hold the tool icon for a few seconds, and the alternatives will appear in a pop-up menu. Once a tool is chosen from the pop-up menu it becomes the default tool for this group, until you select another.

Palettes ▶

These are indispensable components of the tool set. They supplement the toolbox with additional options. On first opening Photoshop, the palettes are stacked along the right side of the screen in palette groups. By default, there are four palette groups:

The first group is the Navigator, Info and Histogram. The second is Color, Swatches and Styles. The third is History and Actions. At the bottom are the Layers, Channels and Paths palettes.

The default settings can be modified by clicking on Window on the Menu Bar and selecting the palettes that you wish to display. Dragging the Title Bar of each palette window allows you to place it anywhere within the Photoshop window.

Each palette has a Palette Menu Button (a small arrow) in the upper right corner, which, when clicked, displays a drop-down menu with options for that specific palette.

The most commonly used palettes are History and Layers. The History palette is an 'Undo' list of every step taken in the current Photoshop session. Selecting a step in the sequence restores the image to that stage and steps can be deleted as required. Layers are useful for organization and editing and are explained later in this chapter.

Foreground and background colours ▶

These two overlapping squares, near the bottom of the toolbox, are used to select the foreground colour (front square) and the background colour (back square). Click on the foreground colour square and a colour palette window will pop up and the colour required can be chosen from the slider. The process is repeated to select a background colour. The arrow in the upper right corner swaps the foreground and background colours over, and the small black and white icon in the lower left corner resets the colours to the black and white default.

A digitized illustration

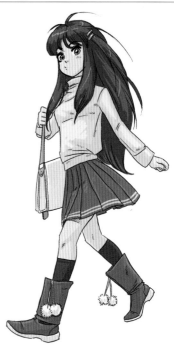

Digital colour grants you a near-infinite palette of colours that remain bright and unmuddied, even when mixed. Colouring can be bold or finely detailed, results can be exported to the page or web, and custom palettes can be saved and reused for multiple illustrations.

View and selection tools

The view and selection tools are used to choose particular areas of the art to work on or manipulate. They can be switched from one to the other by pressing the shortcut Function [fn] key on a Mac, and then pressing the relevant letter in the text below. Pressing [fn]+T selects the Hand Tool. On a PC, press the appropriate letter.

Hand Tool (Mac = T) [PC = H]
This time-saving tool is used to drag the image around when zoomed into a picture that is larger than the viewing window. Pressing down [spacebar] while dragging with the mouse has the same effect.

Zoom Tool (Z)
The Zoom Tool allows zooming in and out of images. Click the image where you want it to centre and then zoom in, or hold the [Alt] key while clicking to zoom out. You can perform the same function by using the Navigator Palette.

Move Tool (V)
This tool moves an area selected by the Marquee or Lasso tools, or an entire layer when nothing else is selected. Hold the [Shift] key to limit the movements to vertical or horizontal.

Eyedropper Tool (I)
This tool selects whatever colour the pipette icon is clicked on and makes it the foreground colour. Holding the [Alt] key when clicking will make it the background colour. When using the Brush Tool, press down the [Alt] key while clicking on a colour for the same result.

Rectangular Marquee Tool (M) ▶
Use this tool to make rectangular or square selections on images. While this tool is active only the areas within the selection can be affected by other tools or actions. To make a perfect square hold down the [Shift] key while dragging the selection. Clicking the little triangle in the corner offers up different tools in the group: Elliptical Marquee, Single Row Marquee and Single Column Marquee. Each of these will make different regular-shaped selections.

Polygonal Lasso Tool (L) ▶
The Lasso tools are used to select an irregular area. In the drop-down menu you can find another two types of Lasso tools: Lasso and Magnetic Lasso. A lot of people find the Polygonal Lasso Tool, with its straight-edged selection, easier to control than the freehand Lasso Tool. To close the selection made by the Polygonal Lasso Tool, click on the beginning point or simply double-click. If your image has high-contrast edges, then you can use the Magnetic Lasso Tool, which automatically snaps to these edges.

Magic Wand Tool (W) ▶
The Magic Wand Tool is used to select a colour range, either as a block of colour or as a transparency. The settings for this tool can be changed in the Options Bar at the top. Adjusting the Tolerance value (0 to 255) allows selections to be more, or less, precise. A low number will select only colours that are very similar to the pixel clicked on; a high number will select a wider range of colours. Check 'Anti-alias' to create a smooth edge to the selection (at other times keep it switched off),

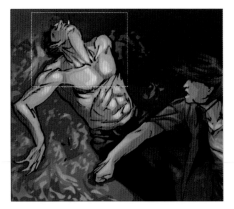

Tip: The Lasso Tool creates freehand selections, but by holding down the [Alt] key, straight lines can be drawn. Conversely, while the Polygonal Lasso Tool normally produces straight-edged selections, you can draw freehand selections by holding down the [Alt] key.

'Contiguous' to select only adjacent areas, and 'Use All Layers' to select areas from all layers. Uncheck them when necessary. Add to or subtract from the selection by pressing down the [Shift] or [Alt] keys.

Select and transform

This example shows how to select a character's eyes and make them bigger using Free Transform. This allows the area selected to be transformed in any way. Instead of choosing different commands (move, rotate, scale, skew, distort, perspective and wrap), a key on the keyboard is held down to switch between transformation types.

Opening the image ▶

First, open the scanned line art and convert it to a colour file. The eyes are not big enough for a manga character, so they will be enlarged.

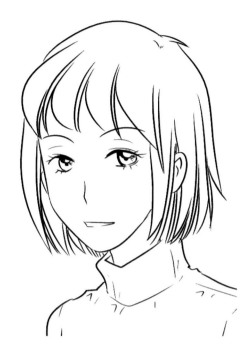

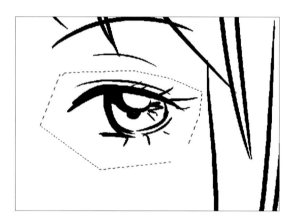

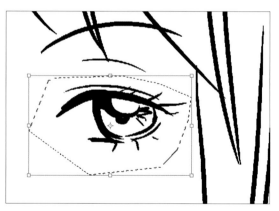

> **Tip:** When Free Transforming a selected area of an image, if a middle point is clicked, the area can only be scaled up or down. If a corner is clicked and dragged the image can be distorted in any direction. Holding down the [Shift] key and clicking and dragging a corner keeps the selected area in proportion.

◀ Selecting the area

The Polygonal Lasso Tool selects an area around one eye. For line art, you may wish to use the Magic Wand Tool to erase selected areas of white (leaving only the black selected) so that your enlargement does not erase its surroundings.

◀ Transforming the eye

Click [Ctrl]+T to select the 'Free Transform' command (or go to Edit > Free Transform). A rectangle will enclose the shape made by the Polygonal Lasso Tool.

◀ Enlarging the eye

Drag the bottom of the rectangular frame to scale the selection vertically (making the eye bigger) until the size is correct, then double-click the area to confirm the transformation. Deselect the eye by clicking [Ctrl]+D. Select the other eye and transform it, making sure that both eyes match.

Finished eyes ▼

When colouring from line art, it is best to reconvert your Free Transformed image back into a black and white bitmap, then to a colour image again, before attempting to shade it. This keeps all of the black lines crisp and unblurred.

The paint tools

In Photoshop, Paint Tools are used to draw in freehand. There are a wide variety, including Paint Brush, Pencil, Airbrush, Paint Bucket and Eraser. These tools can be used to create manga digitally or to enhance and colour black and white artwork that has been scanned in. These are the most important tools required to create comic pages on a computer. Each one has an important function and can be altered to an individual artist's preferences. However, a good manga artist will need to learn how to use all of the Paint Tools in order to create exceptional artwork.

The Brush Tool

This tool shares the same button with the Pencil Tool. The Brush Tool is the most commonly used tool when creating a digital manga page. The edge of Brush Tool is softer and slightly more transparent when compared to the harsher line of the Pencil Tool. There are also quite a few different options in the Brush toolbar. Instead of the auto erase of the Pencil Tool, there is Flow and Airbrush, which are explained in the section that follows.

Mode ▼
This is the blending mode of the brush. For most brush work, 'Normal' is the best setting. Experimenting with various mode settings can create unusual effects, often replicating natural media.

Brush variety ▶
Using a mixture of sizes, opacities, shapes and textures helps render different materials more naturally, as shown here. Softer brushes on the faces contrast with sharper shading on the boy's jacket.

Opacity ▼
The Opacity defines how transparent the brushstrokes will be. An Opacity of 100% is completely opaque, while an opacity of 0% is no paint at all. Your brush will paint with the same level of Opacity as long as the mouse/graphics pen is not released, in which case drawing over a previously brushed area will build up the Opacity and colour. This can provide you with a useful way to vary tones.

Flow ▼
The Flow determines how quickly the paint is applied at your chosen Opacity. When the mouse button/graphics pen is held down on an area, the Opacity of the colour will build up, based on the Flow rate, until it reaches the set Opacity level.

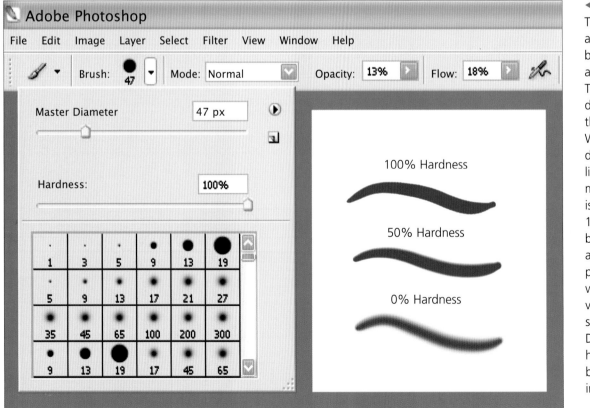

◀ **Brush**
The size, hardness and shape of the brush can all be altered to taste. The Hardness slider defines how sharp the edges will be. When you are drawing black line work on a manga page, it is best to use 100% Hardness, but a dreamy atmospheric painting in colour would require a very low Hardness setting. The Master Diameter sets how wide the brushstroke will be in pixels.

Brush settings

The Brushes Palette is revealed by either clicking on the Options Bar icon, or selecting Window > Brushes. This palette provides greater control over the brush settings. There are two columns of settings: On the left are the brush stroke options and on the right are the specific settings for each brush option. The right column changes according to the option clicked in the left column. At the bottom is a preview window that reveals what the chosen brushstroke will look like.

> **Tip:** Once a brush has been created it can be locked by clicking on the padlock icon to prevent accidental changes.

Selecting brush settings ▲
There are numerous ways in which brushes can be set up to create effects. For instance, choosing 'Wet Edges' with 10% Hardness and a 30px Master Diameter will create a watercolour-effect brushstroke. For the best results when drawing manga line work, select 'Smoothing' and 'Shape Dynamics', with Size Jitter set to Pen Pressure 0%. This brush setting produces very clean lines that respond well to a graphics pen's pressure. For more stylized line work, or colour art, try out a variety of different options in this palette. The trick is to experiment and to have fun.

The Airbrush Tool

As the Brush Tool is so adaptable, the Airbrush is no longer such a unique tool, and now appears in the Options Bar. The main difference between the Airbrush and Paintbrush is that when the mouse button is held down on the former, a constant flow of paint appears, just like holding down the nozzle of a can of spray paint. This paint builds up gradually and is good for creating softer, lighter images.

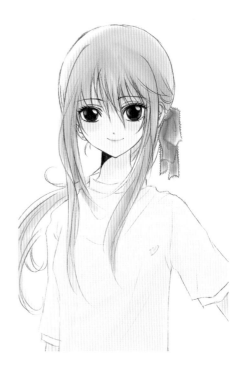

Soft strokes ▲
This soft-focus image was created using a variety of brush shapes and sizes, building up layers of colour, each with a maximum Opacity of 50%.

> **Tip:** The Pencil Tool draws sharp-edged lines. Unlike the Paintbrush Tool, the Pencil has neither subtle tones nor soft edges; it is either 100% colour or not at all. When painting manga pages it is best to avoid using the Pencil as the edged lines look stiff and jagged, especially at lower resolutions. Nevertheless, the Pencil Tool is still useful for clean unfuzzy lines, particularly when creating digital animation and pixel art, such as small icons and mobile games.

The Paint Bucket Tool

This tool is used for filling in selected areas, or areas based on colour similarity to the pixel that is clicked. The Paint Bucket Tool will use the foreground colour as the default, but this can be altered to a pattern selected in the Options Bar. Mode, Opacity and Tolerance can also all be tweaked and tinkered with there.

Tolerance ▼
The Paint Bucket Tool's Tolerance ranges from 0 to 255. A low tolerance means only very similar colours will be affected while a high tolerance means more pixels are selected. A tolerance of 0 selects only the exact same colour as the clicked pixel. If the level is 255, then all colours will be selected.

Anti-alias ▼
Use sparingly, but checking this makes edges of colour smoother by blending with adjoining pixels.

All layers ▼
Checking this fills all layers with your current option, otherwise only the current layer will be filled.

Adobe Photoshop

File Edit Image Layer Select Filter View Window Help

Foreground | Mode: Normal | Opacity: 100% | Tolerance: 0 | ☐ Anti-alias ☐ Contiguous ☐ All layers

After checking or unchecking the Anti-alias and Contiguous, and All layers options, choose a foreground colour and click on the area required. When filling solid black or colours in manga linework, the lines must be perfectly

enclosed; otherwise paint will escape through the gaps of the area being filled. If this happens, using [Ctrl]+Z will undo the mistake. Check where the gap is and seal it using the Pencil Tool. Alternatively, fill using a selection.

Contiguous ▲
When selected, only pixels connected to the clicked pixel are affected. Otherwise, all pixels in the image within the tolerance range are filled. Useful for replacing one colour with another.

The Gradient Tool

This tool shares the same button with the Paint Bucket Tool, but it doesn't fill with solid colour. Instead, it creates a gradual blend between colours. It is useful when you want to create things such as metal or sky, and works on a selected area or layer. To create a gradient, a style needs to be selected in the Options Bar. There are five basic styles to choose from: Linear, Radial, Angle, Reflected and Diamond.

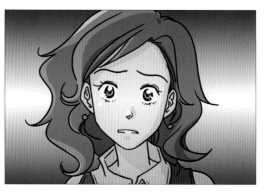

◀ The eyes have it
The use of a Reflected gradient in the background focuses the reader's attention on the girl's surprised eyes, emphasizing her emotional state and the tense mood.

Linear gradient ▲
Create vertical, horizontal or diagonal gradients in this style. Click, hold and drag the cursor, and release it when you have covered the area required.

Radial gradient ▲
This style of gradient creates a circular pattern. Click and start dragging from where the centre of the radial is required. A longer line creates a whiter circle.

Angle gradient ▲
This gradient creates a 360-degree sweep of colour, back around to the starting point. It may not often be useful for colouring manga characters and backgrounds.

Reflected gradient ▲
This is a symmetrical Linear gradient. It is sometimes used in manga to show a character's shock or surprise (as in the example above).

Diamond gradient ▲
This style creates a star-shaped pattern, formed in the same way as the Radial gradient. You are able to control each colour in the mix.

Colouring the gradient

Once the Gradient style has been chosen, the colours must be selected. The Options Bar holds numerous combinations, including the default, which uses the current foreground and background colours. Changing these will define any two colour gradients. For a more complex combination – perhaps a rainbow-like gradient, for example – double-clicking the colour bar reveals the Gradient Editor window. Double-clicking the colour stops along the colour belt allows the colours to be customized; dragging their positions alters where they blend. Clicking anywhere under the belt adds another colour stop.

◀ **Paint a rainbow**
It is possible to make gradients up of as many colours as desired, by adding or removing colour stops and dragging them up and down the colour bar. These customized gradients can be saved and used at a later date.

The Eraser Tool

This tool is the opposite of the Pencil/Brush tools. The Eraser's Modes can be set in the Options Bar to soft-edged brush or airbrush, hard-edged pencil or square block. Pixels are erased to transparency, or to the background colour on a locked layer.

In the Eraser Tool's Options Bar there is an option called Erase to History. When this option is checked, instead of painting to a transparency level or the background colour, the Eraser paints from a History state or from a snapshot set in the History Palette, allowing you to repaint erased areas.

The Opacity and Flow of the Eraser Tool can be defined in the same way as the Brush Tool.

Magic Eraser Tool and Background Eraser Tool ▶
There are two other tools sharing the same button with the Eraser Tool: the Magic Eraser and the Background Eraser.

Magic Eraser Tool ▼
This tool is useful when removing colour from line work, if they have been merged by mistake. It works in a similar way to the Magic Wand Tool, but instead of making a selection, it makes clicked pixels transparent. Options such as Tolerance and Contiguous are just like the ones in the Magic Wand Tool.

Background Eraser Tool ▼
You can also erase more complicated (gradated) backgrounds to transparency using this tool, by sampling the colour in the centre of the brush continuously. Make sure the Cross Hair remains outside the edge of the areas that need protecting, so it won't sample that colour and erase it.

Tip: To create a snapshot in the History Palette, just check the little box on the left of the stage you want.

Other useful tools

Apart from the previously mentioned Paint Tools there are many other tools that will aid the creation of excellent manga art. Most of these, like Clone Stamp, Blur, Sharpen, Smudge, Dodge, Burn and Sponge, affect existing drawings, rather than originate them, and can be used for a wide variety of effects. Dodge, Burn and Sponge can be used to create highlights and shadows, while the Smudge Tool allows the artist to hand-blend colours like digital pastels.

The Clone Stamp Tool

This tool copies a section of an image on to another part of the picture or on to a completely different image. Using the Clone Stamp Tool in manga drawing allows the artist to paint tones or patterns on to a manga page underneath or on top of existing artwork. Once mastered, it is a fantastic time-saving device for making duplicates.

◀ **Using the Clone Stamp Tool**
After [Alt]+clicking the part of the image that needs be cloned from, creating a sampling point, it is simply a matter of painting directly on to the area that needs to be cloned to. Normally the 'Aligned' option in the Options Bar is checked, so the sampling point moves simultaneously with the painting cursor's movement and the new cloned image is drawn continuously. If this is not required, uncheck the 'Aligned' option. This will make the clone brush begin drawing again from the original sampling point each time the mouse button/pen is released. If the 'Use All Layers' option is selected, then all the image's layers will be cloned from the source. Otherwise, only the currently active layer is used.

The Blur and Sharpen tools

Different uses for Blur and Sharpen
These two easily controllable tools can be used in various ways, from sharpening up out-of-focus scanned-in line art, to deliberately blurring a figure in order to push the figure into the background, creating an impressive 'photographic' effect.

Blur Tool ▶
The Blur Tool blurs image areas by reducing the colour contrast between pixels. In the Options Bar the 'strength' can be altered. The 'Sample All Layers' option affects all layers; otherwise, only the current active layer will be blurred. The Blur Tool is usually used to soften the edges of colours so that they merge together smoothly.

Sharpen

Blur

Original

◀ **Sharpen Tool**
The Sharpen Tool is the opposite of the Blur Tool. It increases the contrast between pixels, thus sharpening the focus.

Tip: Pressing the [Alt] key while dragging in Blur mode, will sharpen the image, while [Alt] key and dragging within Sharpen mode will blur it.

Sharpening line work ▶
Sometimes scanned-in line work can be a bit blurred. The Sharpen Tool can gradually sharpen the line art, but rescan if necessary.

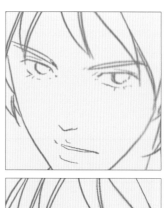

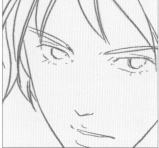

The Smudge Tool

Using the Smudge Tool is like smudging a wet painting with a finger, just as the icon of this tool indicates. This tool uses the colour where the stroke begins and spreads it in the direction in which the tool is dragged. This is very useful for drawing natural-looking hair. Try different strength settings to see what's best for your drawing.

Smudged hair ▶
Individual smudged strands of hair produce a wilder, more natural look.

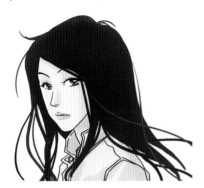

The Dodge, Burn and Sponge tools

These three toning tools get their names from traditional photography methods and share the same button. These tools all use customizable brushes, just like the Brush Tool. Often they are used on fully painted manga, rather than black and white line art, and create a softer, three-dimensional look. The Dodge Tool lightens up areas of an image. It is very useful for adding a light source quickly to a flat-colour manga character. The result will not be as good as the normal Brush Tool, because the Dodge Tool washes out colour and details.

The Burn Tool is the opposite of the Dodge Tool: it darkens the area it is dragged over. Normally it is used for adding shadows quickly. Again, the result is not as good as using the Brush Tool. The Options Bar is the same as that for the Dodge Tool.

The Sponge Tool has two modes: Desaturate and Saturate. While in the Saturate mode, the Sponge Tool adds colour saturation to the areas dragged over. In Desaturate mode it does the opposite. In a greyscale picture, it increases or decreases the contrast.

Dodging and burning manga art ▶
These examples show how the Dodge and Burn tools can be used on a flat-colour character (left) to create shadows and highlights (right). The colour on the girl's right arm has been washed away by the Dodge Tool, to create the highlight.

Selecting a range ▲
In the Options Bar, there are three ranges to choose from: 'Highlights', 'Midtones' and 'Shadows'. If 'Highlights' is selected, only the lightest areas will be affected, and so on. The 'Exposure' level decides how intense the effect is; this is usually set at a low level: between 10 and 50%.

Photoshop layers

One of the most powerful features of Photoshop is layers. Traditional manga would occasionally use semi-transparent acetate paper laid on top of the artwork to draw and letter the speech balloons on. This allowed for the lettering to be moved around and the language and style to be changed without affecting the original art. This is now done digitally, using layers; but layers are also perfect for adding colour, gradients, tones and more. Because of layers, each layer can be changed independently without affecting the others, allowing complex images to be created. Imagine each layer as a clear plastic sheet with part of the image printed on it, all of which are stacked to make the complete picture.

The layered image

After creating a new canvas, or opening any image, there is already at least one layer in the Layer Palette. The image portrayed below shows how layers work; each individual element on its own separate layer, allowing them to be edited independently.

> **Tip:** Always add new elements on a new layer. This way the original image can be preserved. Doing this allows for easier editing of mistakes. The layers can always be merged at a later stage, if the end results are satisfactory.

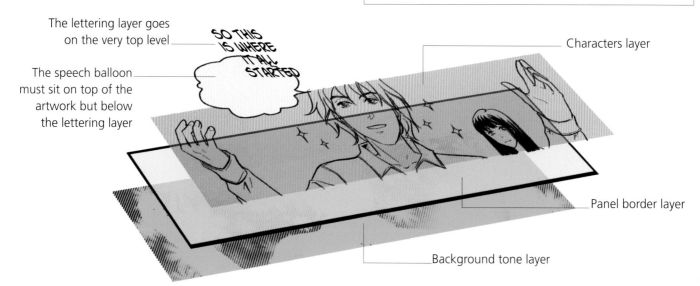

The lettering layer goes on the very top level

The speech balloon must sit on top of the artwork but below the lettering layer

Characters layer

Panel border layer

Background tone layer

Shuffle the deck ▲
The layers can be arranged in any order, allowing a character to be pushed into the background or an object to be brought into the foreground at the click of a button.

Invisible layers ▶
When the final artwork is seen, the layers are invisible, or flattened into a single layer, so although the characters, the background tone, the dialogue bubble, the text and the panel border are all on separate layers, the reader sees the image as a unified whole. Always save the files as layered .psd files for future editing.

Removing lettering
After this panel was lettered it was decided that it would be better with no dialogue. In the past, this would have been a huge problem. The speech balloon would have had to be covered up or cut out, and then the background tone would have been added to match the art exactly where the balloon was. Using Photoshop's layers, the balloon and text are created on separate layers and are thus easily deleted.

The Layers Palette

Layers are controlled through the Layers Palette (Window > Layers). On the palette, each layer is displayed as a small thumbnail, with the name of the layer next to it. The final appearance of a layered Photoshop image is the view from the top, down through all the layers. The order of the layers in the Layers palette represents their order in the image.

New/duplicate layer
Clicking this icon creates a new layer above the current active layer. Duplicate a layer by dragging it on to the icon. The new (duplicated) layer appears on top of the previous one.

Layer via copy, cut or drag
To copy or cut part of a layer to make a new layer, simply select the area required and the option 'Layer via copy' or 'Layer via cut'. The new layer with the selected area will appear on top of the original layer. Dragging and dropping a layer on to an open image is also possible.

Show/hide Layer name New/duplicate layer

Naming layers ▲
Double-click on the default layer name to rename the layer as something more memorable.

Changing the layer order ▲
To change the layer stacking order in the Layer Palette,

just click and drag it up or down the stack and place it where it is needed.

Deleting a layer ▲
To delete a layer, simply drag the layer to the Bin icon at the bottom right of the palette. Don't do it unless the layer is never needed again.

◀ Hiding layers
Sometimes it is useful to hide a layer in order to be able to concentrate more easily on the layers underneath. Clicking (and removing) the eye icon makes the layer temporarily invisible. Clicking the eye again makes the layer visible once more.

Transparency Position

Pixels

To avoid working on the wrong layer they can be locked as follows:

Transparency: Once checked, it is impossible to paint on transparent areas.

Pixels: Once checked, cannot be drawn on.

Position: Prevents the image on the layer being moved, but all other functions work.

All: Stops all editing.

Layer-blending modes

Each layer has its own blending mode, which allows one layer to blend with the layers underneath. Under the Layer Palette's default setting, 'Normal', is a list of blending modes in the drop-down menu. Along with 'Normal', the other most commonly used blending modes in digital manga creation are 'Multiply' and 'Screen'. The examples here reveal their effects. The red heart is the upper layer, the purple heart the lower. Don't forget that the Opacity and Fill of a layer can also be changed using the sliders on the Layer Palette.

Normal ▲
The upper layer displays the full colour value and the image on the layer underneath is covered.

Multiply ▼
This multiplies the upper layer's colour intensity, so the lower layer gets darker. The upper layer's white becomes clear.

Screen ▲
Darker colours in the lower layer appear lighter when this is applied to the upper layer.

Scanning and retouching an image

Hand-drawn pictures can be processed digitally by importing the image into the computer using a scanner. This is extremely convenient for artists who prefer the feel of working with pen and paper, but still want the advantages working digitally can offer. Large areas of black shadows can be added quickly using the Fill Bucket Tool, saving hours of laborious inking,

and any smudges or mistakes can be easily removed and cleaned up. The other advantages are obvious. The drawing can be coloured digitally without affecting the original artwork; and it can be emailed or posted on the Internet and shared with millions of people: all impossible without first being able to scan in a paper drawing.

Practice exercise: Scanning, adjusting and cleaning an image

Here is a quick guide to scanning in simple line work, the most common requirement for a manga artist. The higher the dpi, the bigger the file will be when scanned in; but the quality of the picture will also improve, thus you can get into more details of the image and can print out bigger pictures later.

1 Place the drawn image face down on the glass in the scanner, aligned with its edges.
In Photoshop, choose File > Import to open the scanning software. Choose 'Grayscale picture' (if scanning in a colour image, choose 'Color') and set the resolution to 600 dpi.

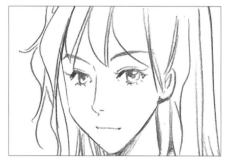

| Resolution (DPI): | Picture type: |
| 600 | Grayscale picture |

2 Click 'Preview' and wait for the scanner to show a preview version of the image. Select the area in the preview image required to scan, then click 'Scan'. The picture will be scanned in and appear in a new Photoshop window.

3 Go to Image > Mode, and change the image to Grayscale (if grey tones are needed), or RGB, if working in colour later. Click File > Save as… to save the file as a .psd file and give it a new name. The image is ready for further adjustments. The lines in this example are too grey and not black enough.
To adjust this, go to Image > Adjustments > Levels to open the Levels window. Sliding the three pointers controls the image's amount of black, white and grey.

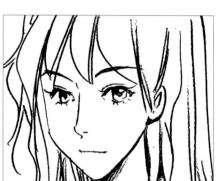

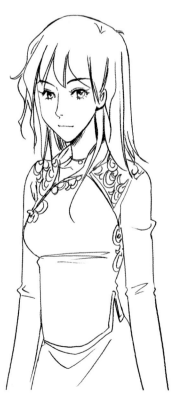

4 Watch the changes on the original image and when the lines become solid black and are still delicate. Click OK.

Tip: Sometimes part of the line work might be very light, and adjusting the Levels may cause these light, fine lines to disappear. Use the Burn Tool to darken them before using the Levels adjustment.

Tip: A shortcut to balancing the black and white is to go to Image > Adjustments > Levels and in the window check the black Eyedropper Tool. Then click on the blackest part of the line art. Repeat, using the white Eyedropper Tool, clicking on the whitest part of the image. This will remove most of the mid-tones.

5 Now use the Eraser Tool to clean up the remaining dirty dots and anything else that needs removing from the image. Using a fine point, you can sharpen lines to details that would be impossible with an actual pen, if you so wish. Details can also now be added to the image, using a tablet pen or mouse. This is the perfect time to tweak and hone the picture until the line work is just right.

Practice exercise: Separating the line art from the white background

It is good practice to separate the black line art from the white background so that the line work can be manipulated at a later stage, such as changing the colour of the lines or even altering the lines after feedback from friends or colleagues. It also allows for additional colour layers to be added underneath, ensuring the black line art is always on top, like an acetate sheet over a painting. Here is the quick and simple method of separating the line art from the background.

Tip: Channels visibility can be turned on and off, like the Layers. In RGB and CMYK mode this allows different colours to be switched on and off, giving interesting alternate hues.

1 On the Layers Palette, click the 'Channels' tab to activate the Channels Palette. Initially, there is one layer called 'Gray'. Duplicate this layer by dragging it to the 'Create new channel' icon at the bottom of the window. Go back to the Layers Palette and create a new layer. Next, delete the original layer with line art on.

2 Go to Select > Load Selection. Check 'Invert' and in the 'Channel' drop-down box choose 'Gray copy'. Click OK and the selected line artwork will appear.

3 Use the Paint Bucket Tool to fill the selection with black. Underneath this layer, create a new layer and fill it with white using the Paint Bucket Tool. A separate layer for the line work has just been created.

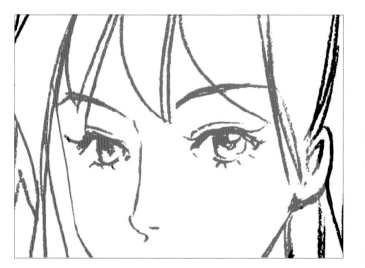

4 Because the line art is on its own layer, with a transparent background, the Lock Transparency icon can be clicked. If this is checked, the Brush Tool can only draw on areas that are not transparent, meaning only the actual line work itself. Switching to RGB mode will allow the lines to be changed into any colour.

Digital inking

It is becoming increasingly popular among manga artists to use digital inking. This method allows manga artists to draw perfectly smooth and crisp lines without worrying about making mistakes. There are several ways to digitally ink a pencil sketch. Traditionally the manga artist creates a new layer on top of the sketch and effectively 'traces' the sketch, adding subtle changes, shading and nuances. A cruder method is to simply convert the image to a grayscale and in Image >

Adjustments > Levels open up the Levels window. Here, adjust the black and white levels by sliding the pointers up and down until the background is pure white and the lines are no longer grey, but solid black. However, if there is too much white, delicate lines will be lost. Conversely, too much black will make the artwork look thick and blobby, with no variation in the thickness of the line. It is always recommended to ink the page in the first manner to add vitality to the art.

Practice exercise: Inking a scanned image

It is a good idea to have practised inking on paper, as shown earlier in the book, in order to get a feel for drawing smooth lines with a real pen. Inking in Photoshop with a graphics tablet pen can be done in several ways. A pencilled image can be scanned in or you can sketch directly into Photoshop. Because the 'ink' is usually 100% black, it is best to have your pencilled image as a lighter shade, so you can see what you have already inked.

Tip: Practise a variety of brushstrokes on smaller pencilled studies with either a mouse or a graphics tablet pen before attempting to ink an entire image.

1 Before inking, a sketch is required to work on. This example is a scanned-in greyscale image at 600 dpi. Alternatively, a sketch can be created straight on the screen using the graphics tablet. Switch the image's Mode to Grayscale, rather than RGB, as the files are smaller, thus making the computer run faster. If colour is needed later, the image's mode can be changed back to RGB once the inks are complete. Create a new layer and call it 'inks'. This is the layer that will be digitally inked on. Set the Mode to 'Normal'.

2 Choose the Brush Tool. Open the Brush Palette, check 'Shape Dynamics' and 'Smoothing', and in the setting for Shape Dynamics, set the Size Jitter to Pen Pressure 0%. Choose a round brush and set the Hardness to 100%. Vary the line width while working.

Tip: Pressing D will reset the default foreground colour back to black, and the background colour back to white.

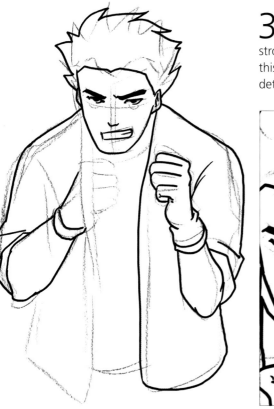

3 On the 'inks' layer, begin drawing over the pencil lines. Use thinner lines and vary the brush sizes for small details and relatively thicker lines for longer strokes. Occasionally, the pencil design may be weaker than you originally thought: this is a good time to make any alterations on the 'sketch' layer. In this example, the details of the man's hands and face were tightened and the anatomy strengthened.

4 Finish the basic inking, making sure nothing is missing. Go back and ensure there are ample details to enrich the picture. Here, thicker shadows have been added in the hair and on the face in order to indicate depth. If the 'sketch' layer has become too messy and it is difficult to see where to ink, create a new layer between the 'inks' and 'sketch' layers and fill it with white, in 'Normal' mode. Turn this middle layer on and off and your inking progress can be checked easily. Varying the thickness of your lines and shadows enhances the depth of the image. The thicker the lines, the heavier and more solid the object will look; the thinner the lines, the more delicate the object will look.

5 Use the Paint Bucket Tool to fill in solid black areas. The Brush Tool's stokes have soft edges, and they appear slightly grey. Because of this, when using the Magic Wand or Paint Bucket tools, they may not be able to select the whole area (experiment with Tolerance first). Instead, there may be a tiny belt of white between the selection and the surrounding brushstroke line. To correct this, select the area that needs filling, then go to Select > Modify > Expand and expand the selection by one or two pixels. After this expansion, the selection will cover the white belt area and the area can now be filled in with the black colour.

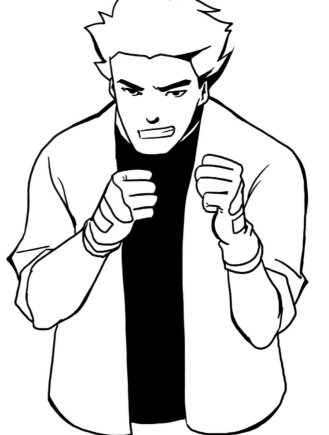

Tip: Remain stable when using the graphics tablet pen, and don't shake too much. It can be difficult, especially drawing longer lines, but with practice, your stability will improve considerably. Some lines will need a few attempts to get them right. If a mistake is made, use [Ctrl]+Z to undo it. The Eraser Tool can also be used to remove mistakes or sharpen blunt lines.

6 Once satisfied with the inking, delete the 'sketch' layer. There will be two remaining layers left; the line art layer and the layer filled with white as background. The image is now ready for further developments.

Toning techniques

The majority of manga books are in black and white, and consequently grey tones are a manga artist's essential tool. Grey tones add shadow, lighting, texture and depth to black and white line work, essentially forming the 'colour' of black and white manga. The traditional way of adding grey tone, still practised by many modern Japanese manga artists, is to use rubdown Letratone sheets. This involves selecting the appropriate-size grey-tone sheet, pasting it to the original artwork, then using a blade to cut carefully around the artwork. It is expensive, time-consuming and requires a lot of practice. Thanks to Photoshop, the digital alternative is much quicker, cheaper and easier.

Practice exercise: Adding tone

Adding tone to a line image is very simple, but can be incredibly effective in enlivening a basic manga line drawing. Essentially, it is the same as adding colour using the Paint Bucket Tool, with the blues, greens and yellows being replaced by various shades of grey.

1 Open the image. This should have two layers: one white background and one for line art. Ensure the image is in Grayscale mode. Create a new layer between these two layers and set the mode to 'Normal'. Call this layer 'tones'. Go to Window > Color to reveal the Color Palette. The Color Palette contains only one slider scale; from white to black. It is better to pick a grey tone in the Color Palette, rather than the Color Picker on the Toolbox, because it is possible to define the exact percentage of grey required. The grey tones are defined as 0% being pure white and 100% being solid black, therefore 50% is an exact grey. The lower the percentage, the lighter the grey tone.

2 Use the Magic Wand Tool to select the girl's hair. Check 'Contiguous' and 'Sample all Layers' in the Options Bar. If there is a gap in the line art, then the Magic Wand Tool will select more than required, in which case, the area needs to be deselected ([Ctrl]+D) and the gap joined using the Brush Tool. Alternatively, you can trim areas from the selection using the Lasso tools and the [Alt] key. To select multiple areas, press down the [Shift] key while selecting the area. To deselect an area from the current selection, press down [Alt]+click.

3 Zoom in on the selected area. If the grey tone is filled in now, when the selection does not exactly butt up with the line art, there will be a terrible white gap between the grey and line. To solve this, go to Select > Modify > Expand and expand the selection by one or two pixels. It is important to make sure the edge of the selection is actually just underneath the line art, so if the first pixel expansion is not enough, increase it by another one or two pixels.

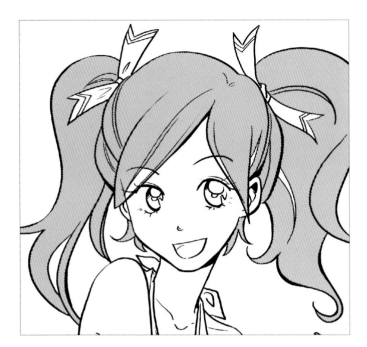

4 Ensuring that the 'tones' layer is selected, choose a grey tone required for the hair (as per step 1) and select the Paint Bucket Tool. Uncheck all the options in the Options Bar, ignoring the Tolerance levels at this stage, and fill the area.

5 After the grey has been filled in, zooming in may reveal some areas in the hair that have been missed in the selection. Use [Ctrl]+D to deselect the current selection and then use the same selecting method to select the missed areas and fill them in. Zoom in again to confirm all the areas have been filled.

Tip: Always remember that the layered manner of working in Photoshop means that it's possible to 'fix' areas of missing colour quickly and simply, by drawing directly on to the 'tones' layer beneath the line art, which remains untouched. Use the Pencil or Brush tools for exceptionally fiddly areas that may be missed by the Magic Wand Tool's selection process.

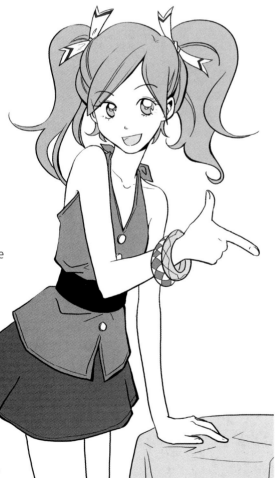

6 Repeat the process with the other parts of the image. Use the Pencil Tool to apply the grey tones carefully to tight areas where the Magic Wand and Paint Bucket method doesn't work so well, or where it would prove time consuming. Choose complementary shades of grey to give your image the illusion of colour and depth. Push the extremes more than you would in a full-colour drawing, as you only have 256 shades to work with.

7 When filling in the areas of the image, don't forget to fill in all the transparent areas within the character, with solid white, including the skin. Turning off the white background layer will give you a clear view of where to fill. The solid white needs to be filled in, otherwise when you come to fill in the background layer, it will show through the uncoloured skin.

Practice exercise: Adding shadow, highlights and pattern

After the toning in the last two pages, you will now have a plainly toned image. Depending on personal taste, for some people this is a finished work.

For a more professional look, you still need to add further details to the image, building up areas of shadows, highlights and patterns.

1 Add a new layer on top of the 'tones' layer and name it 'shadow'. Set the Layers mode to 'Multiply'.

2 To add shadow to the hair, go to the 'Tones' layer and use the Magic Wand Tool to select the hair colour. Uncheck 'Contiguous' and set the Tolerance to 0. This will make the Magic Wand select only the hair colour. If you have used the same shade of grey anywhere else on the image, it will select those areas as well, but in this instance, the hair is the only part of the image so shaded.

3 Flip to the 'Shadow' layer. Choose a light grey tone and, within the selection, paint shadows on to the hair. Here the light comes from the top left corner. Use the Eraser Tool to clear up mistakes. Use a darker shade of grey to draw heavier shadows at the darkest points; for example, where an object casts a shadow on another one.

4 Selecting the areas as before, add shadows to the rest of the image in the same way, paying attention to the way shadows may fall differently on fabrics and skin. Turn off the 'Tones' layer periodically to spot areas you have missed.

5 Next, add highlights to the image. Create a new layer called 'Highlight' on top of the 'Tones' and 'Shadow' layers and set the mode to 'Normal'. Consider your light source, and at the point where the light is strongest, add pure white highlights. You will still need to use the Magic Wand Tool to select each area individually to ensure your highlights don't go outside of the lines.

6 The image could do with a background. Create a new layer underneath the 'Tones' layer, setting the mode to Normal. Select the Gradient Tool and drag a Linear gradient from white to mid-grey over the whole picture. Create another 'Normal' layer on top of this one and choose a soft-edged, big brush with Opacity of around 50. Paint big white dots to create a dreamy atmosphere. Merge your tone layers together and rename them 'Gray'.

Practice exercise: Converting grey tone to black dots

If you want to publish the previous image online, then we have finished the toning procedure. If, however, you want to publish your image professionally, it is not finished yet. In many printed manga, the grey tones are not grey, but made up of countless black dots. The bigger the dots and the closer they are printed, the darker the grey appears.

Many manga/comic printers don't print colour (mainly for cost reasons), so we need to convert our grey layer to black dots.

Halftone shading ▶
While many printers use halftone screens for their regular output, manga makes an art out of necessity.

1 Create a new document the same size and resolution as the current one. The current document ('Cutie.psd', above left) is a Grayscale A4 page at 600 dpi. Go to File > New. Choose the appropriate settings in the pop-up window, then click OK. Drag the flattened 'Gray' layer from the layer palette of 'Cutie.psd' (as shown above right) and drop it into the new document. Make sure it fits within the canvas.

2 In the new document, click Image > Mode > Bitmap to reduce it to pure black and white. In the first pop-up window, click OK to Flatten Layer, and in the second pop-up window, choose to output the image at 600 (the current resolution, often used interchangeably as dots per inch and pixels per inch) and select Halftone Screen as your method. Click OK to go ahead.

3 In the third pop-up window, change the Frequency to 32, make the Angle 45 degrees and select Round as the shape. If you want to try out different values or shapes, experiment with a number of different options in case an alternative method takes your fancy. When you have entered the values, click OK. All of the grey tones are converted into black dots.

Tip: If you have the hard drive storage space, it is well worth hanging on to layered .psd files, as you never know when you may need an editable version of your illustration. For instance, if you wanted to create a colour version of this picture, you will regret only saving a merged tiff or jpg file. Layered files are large, so backup your archives to CD or DVD periodically. Don't forget, you can save a flattened jpg to display online by using the File > Save as... command. If saving a large .psd file for the web, you will probably want to reduce the width to between 600 and 9000 pixels so it can be viewed on a monitor without horizontal scrolling.

4 Now go to Image > Mode > Grayscale to change the image to Grayscale. Set the size ratio to 1 in the pop-up window. Drag the layer back to 'Cutie.psd' and move the shading so that it matches the lines, ensuring it is on top of the 'Gray' layer and beneath the 'Inking' layer. You can now either merge all layers or just save this image as a layered .psd file.

Speedlines and focus lines

The method of creating speedlines and focus lines is often discussed together, as both are used to create an impact on the reader by communicating shock, surprise, tension and movement. Speedlines are a group of parallel (or nearly parallel) lines that show movement, while focus lines are a group of lines radiating out from one central focal point. They add impetus and interest to a single-colour background especially when something is moving quickly towards the reader's point of view. The effects themselves are easily created in Photoshop, and this tutorial will show you how.

Practice exercise: Creating speedlines

Drawing speedlines the traditional way requires huge amounts of concentration and patience – or a crack team of assistants blessed with the same. Hundreds of lines must be drawn on paper with exacting care, using pen and ruler, with no respite but white-out if a mistake is made. Now, there is Photoshop, which can produce excellent results in a fraction of the time. There are many speedlines available online, ready to paste into an image. If you can't find them online, here is an easy way to make some yourself.

1 Create a new file at the same resolution as the image you will be dragging the speedlines into later (300-600 dpi). Don't make the image too big, just a little bigger than the manga panel you want to cover. Set the file Mode to Grayscale. Use the Single Column Marquee Tool to select a single column on the image, then fill it with the grey tone of your choice.

2 With the grey-toned area still selected, go to Filter > Noise > Add Noise. The higher the number you choose, the more intense the speedlines will be.

3 Go to Edit > Transform > Scale to transform the selection. Drag the selection from both sides, stretching out the single vertical column of pixels to fill the whole page from left to right. Double-click the image when you are finished to confirm the transformation.

4 Zooming in on the image will reveal that most of the lines are grey rather than black. To correct this, go to Image > Adjustments > Brightness/Contrast. Increase the brightness, and turn the contrast level up to maximum. Now the speedlines are ready to use. Paste them into your manga panel and use the 'Free Transform' function to fit the angle you require.

Tip: There are other ways in which you can integrate your speed and focus effects with your colour pages. Try varying the colour of the line, for instance, so that you use a dark purple shade on a light purple background. Alternatively, use the Magic Wand Tool with 'Contiguous' unchecked on your speedlines layer to select all the black lines, then apply a gradient from light to dark in the direction of travel. Finally, try playing around with the layer blend and layer fill Opacity settings: how do your speedlines and focus lines look when blended in 'Multiply' or 'Screen' modes, for example?

Speedlines in action

Compare these four pictures of a running boy. The first lacks impact without speedlines. The second is 'naturalistic', with a speedline shadow and blurring. The third ups the strength (and speed) of the lines, while the fourth creates a background from them, freezing a moment in time and generating an intense atmosphere.

Practice exercise: Creating focus lines

Focus lines are normally used to express tension or surprise. Their near-interchangeability with speedlines visually also means they sometimes function as 'speedlines in perspective'. In either case, they isolate a character or vehicle in the centre of a panel, drawing the reader's attention to it and its current condition.

1 Use the speedlines you have just created. We need to turn the canvas 90 degrees to make the lines vertical. Go to Image > Rotate Canvas > 90' CW.

2 Now go to Filter > Distort > Polar Coordinates and bring up the option window. Choose 'Rectangular to Polar' and click OK. Your image is converted to a page of focus lines converging on a central point.

3 The lines don't usually go all the way to the centre of the image. Use a big, soft-edged Eraser Tool to clear the middle. If you think the focus lines are too crowded, use a hard-edged Eraser Tool to clean up some of the lines.

◄ **Polarized image**
This is an example of an image with vertical speedlines after they have been passed through the Polar Coordinates filter.

Style of lettering

Lettering is an essential part of manga, forming half of the interplay between words and pictures that makes manga unique. While the action of your story may be clear from the illustrations, dialogue, captions, speech balloons and sound effects all allow you to dive deeper into your world and the motivations of your characters, as well as adding 'verbal' wit, humour and tension to your tale. Lettering also serves as a guide to the reader through the page: skilfully deployed balloon placements move the eye from panel to panel and control the pace at which a reader consumes the story.

Snappy dialogue and well-placed balloons can often cover up deficiencies in artwork or panel-to-panel storytelling, so never underestimate the importance of lettering. The most common devices to show spoken dialogue are speech balloons: the ellipses containing lettering, with 'tails' that point towards the relevant speaker. Remember to integrate your balloons and digital lettering with your art style – conventional word processor fonts look bland and out of place, so find a font that meshes with your art. Visit www.blambot.com for a selection that are free for personal use.

Placing speech balloons

Dialogue and balloons cannot be simply dumped on to the page; they must be added with the same care and attention to the overall composition that characterized your panel layouts. Remember that balloons should not cover up vital parts of the artwork, and should direct the eye from the top left to bottom right of the page.

Speech balloons in action ▼ ▶
These two panels both show successful balloon placement. Below, an unusual font suggests a non-human character, while the balloon is offset so it doesn't cover up any of the art. The balloon to the right overlaps with non-essential art (the character's hair) in order to fit within the panel bounds.

Practice exercise: Adding lettering

Professionals digitally letter manga in a number of different and esoteric ways. This method, which stays within Photoshop, is the most straight-forward, and is suitable for all skill levels and complexities of projects.

2 Set your colour to black, select the text tool ([Ctrl]+T) and click where you want to place the text, creating a 'Text' layer where you can type. If you are working from a script, you can copy and paste dialogue on to your page.

1 Open the page you wish to letter in Photoshop and bring up the Character Palette (Window > Character). Choose a font from the drop-down menu at the top left and select a size appropriate to your page from the menu underneath. Make sure your lettering is legible at your final print size.

Tip: Manga tends to use capital letters for all its dialogue, with bolds and italics for emphasis. If your script is in sentence case, select your text once you have pasted it across, click the small arrow at the top of the Character Palette, and select 'All Caps'.

3 Each balloon forms a new 'Text' Layer; select each one as required. Centre the text ([Ctrl]+[Shift]+C) and use the Return key to arrange the text into a relatively elliptical shape. Arrange your dialogue blocks so that they don't cover important elements of the image, and they flow from top left to bottom right. Add emphasis to dialogue by making stressed words bold and/or italic. Finally, check that all your important text is well within the boundaries of the page – in case the page is trimmed too close at the printing stage.

4 Add a new layer beneath all of the 'Text' Layers for balloons. Set the mode to 'Normal'. Select the Ellipse Tool, checking 'Fill Pixels' in the Options Bar. Set the foreground colour to white. Click and drag the mouse/tablet pen to make white filled ellipses beneath all of your blocks of text, making the balloons just a little bit bigger than the text they encompass. Even if your ellipses are not placed exactly, the layer capabilities of Photoshop mean that you can move the text or the balloons around to your satisfaction at a later stage.

Tip: You can also squash more text into less space by attaching balloons to the top of panels, so that your ellipse is cut off to some degree, forming a large, straight edge at the panel border. Arrange your text with a long first line, slightly shorter second line, shorter again third line, and so on.

5 Using the Brush Tool or Pencil Tool, add tails to the balloons. Ensure that the tail points towards the character who is speaking. Finish the tail a little distance away from their head.

6 Select the balloons and tails on your balloon layer using the Magic Wand. Then go to Select > Modify > Border. In the pop-up window, select how thick you wish the border of the

balloons to be (along with font size, this will change depending on the size and resolution of your page). Two to four pixels should be enough. Click OK to create a two to four pixel selection.

7 Choose the Paint Bucket Tool (with Tolerance set to 255, 'Contiguous' and 'All Layers' unchecked) and use black to fill the current selection, creating black borders.

8 The final stage is to troubleshoot your balloons. If some words are still too long for their position, you can make them narrower using the Character Palette (<-T->).

SFX lettering

SFX (sound effects) is a special, individualistic type of lettering that communicates an impression of sound. SFX are lettered directly on to the page, at a generally much larger size than dialogue. The louder the sound, the larger the type. Just as the onomatopaeic content of the SFX reflects the noise the sound makes, so the font should try to replicate the sound in visual form – from jagged type for explosions to soft and sinuous replications of running water.

Creating sound effects

Manga artists have created thousands of SFX words across the years, some relatively common and some unique to individual artists. Rarely, however, is the same SFX word deployed in the same way: each appearance will look different, or be incorporated into the art in a new and exciting way. Don't feel limited by existing SFX: try to create your own onomatopaeic words. The current trend is away from literal words like 'BEEP' and 'CRASH' and towards more abstract coinages like 'CZZZTT' (live electrical cable) and 'FWUTHOOOOM' (an explosion). Experiment: if the sound reads right to you on the page, it works.

Your choice of font, and its size, is very important. A small 'BEEP' in an electrical font is appropriate for a mobile phone, while an enormous 'BANG' should feature letters of suitable girth. Don't forget to 'scuff up' your lettering to make it look more natural and less digitally perfect.

Infinite variety ▲
While there are timeless 'classics' among the SFX canon, from 'CRASH' to 'POW', every new sound effect is an opportunity to generate a new sound-alike, or to visually interpret an old cliché in a new and exciting manner.

Deafening impact ▼
The armoured robot collides with the ground with a resounding 'BANG' of mangled metal and compressed earth.

Incoming call ▲
'BEEP BEEP' can represent an actual generic ringtone; it also lets the reader interpret it as any tone they know.

Tip: Switch things up by scanning in a hand-drawn sound effect, manipulating its colours and angles in Photoshop and compositing it into your digital page.

Practice exercise: Adding SFX to a panel

Just as with lettering balloons, adding SFX to a finished manga panel is a relatively straightforward process. The example here transforms an 'off-the-peg' font to create its special effect, but you could achieve even more impressive results with a freehand rendering of your SFX, either direct to the screen with a tablet pen, or by scanning in hand-drawn lettering and digitally manipulating it.

1 Open your chosen image. Choose the Text Tool and open the Character Palette. Click the image with the tool to create a new 'Text' layer.

2 Select your font ('Damn Noisy Kids' in this instance) and choose a suitably big size. It doesn't really matter where you place the effect at this stage, as you will move it later. Type your lettering.

3 Press [Ctrl]+T to Free Transform the text, making it less 'factory fresh' and more visually interesting. Here the letters are tilted to show the trajectory of the fired bullet.

4 Rasterize the text, then select it with the Magic Wand Tool (with Contiguous off). Use the Paint Bucket Tool or the Gradient Tool to fill the selected area with the colour or colours of your choice. Here, the image has been filled with a subtle gradient of orange to red.

5 With the selection still on, go to Select > Modify > Border. Choose 2–6 pixels in the pop-up menu. This selects the edges of the SFX, which you can fill with black, or a complementary shade. Of course, you may prefer to leave off the border entirely.

Using filters

You have already used a small selection of Photoshop filters as earlier in the chapter to create speedlines and focus lines. However, we have yet to explain what exactly a Photoshop filter is. Photoshop, as the name suggests, developed out of a digital photography toolkit: a way to improve and digitally alter photos. That it doubles as a superb pure-graphics package is an added bonus. In photography, filters are placed over camera lenses to alter how a picture looks, once taken, from adding burnt umber to skies to adding a soft-focus sheen to a portrait shoot. Photoshop filters do much the same thing but with a much greater variety of filters and the capability of applying these filters to everything from photographs to illustrations long after they have been imported or drawn. Photoshop comes with some filters built in already. If you find them useful, or want to pursue a particular effect they can be helpful. For further filters investigate on the web where there are thousands of freeware and commercial filters available – but a great many of them may not be useful to you at all.

Photoshop filters

For manga, the native filters in Photoshop are more than enough for most users to choose from. Some do little more than make your drawings look weird; others, when applied to the right picture, can create amazing effects you could never produce on your own. Have fun experimenting and combining multiple filters.

Original picture ▲

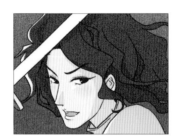

Film Grain ▲

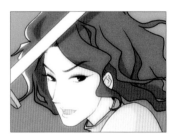

Diffused Light ▲

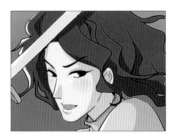

Accented Edges ▲

Ocean Ripples ▲

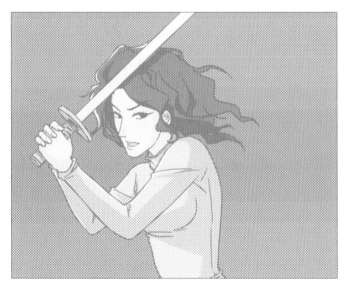

Halftone Pattern ▲

Graphic Pen ▲

Glowing Edges ▲

Extrude ▲
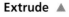

Practice exercise: Using the Liquify filter

The Liquify filter is quite similar to the Smudge Tool, but the advantage of the Liquify filter is that it is far more accurate and can transform your images without losing any sharpness or detail. Here, the expression of the sad girl in this image can be transformed by the magic of the Liquify filter into a happy face.

Tip: Liquify is most useful when applied to black and white line work, but it can also be used on finished colour pieces and photographs. There may be more visible blur and distortion in these instances, so it is best to apply your changes before colouring.

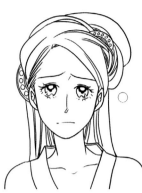

1 Start with an image of a sad girl. Go to Filter > Liquify and a new, separate window will pop up, allowing you to apply the filter manually.

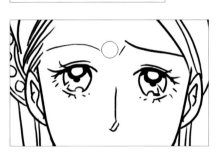

2 Using the finger tool in the top left corner, choose a large brush size. Click to touch the left eyebrow of the girl, and you will see the lines 'pushed away' by the cursor. Keep pushing until you are happy. Use the reconstruction tool, second at the top left, to undo any mistakes.

3 Move to the right eyebrow. There is hair at the end of the line that should remain untouched. To protect it, press F to activate the Freeze Mask tool. Carefully paint the area you don't want to Liquify: this will turn red. Now you can safely change the right eyebrow.

4 Using the same mixture of tools as before, lift the corners of the mouth upwards to make the sad girl smile, and then click OK. You will be left with your amended image in the standard Photoshop window.

Tip: The act of Liquifying a line tends to thin it, so be prepared for subsequent touch-up work on thick-lined images. Go slowly and gently with fragile line work so that the lines remain uncompressed.

The Liquify toolbar ▲

The main elements to concern yourself with are the Brush Size and Brush Density drop-down menus, and the toolbar along the left-hand side of the Liquify window.

[Liquify dialog box]

OK

Cancel

Load Mesh... Save Mesh...

Tool Options

Brush Size: 74
Brush Density: 100
Brush Pressure: 27
Brush Rate: 80
Turbulent Jitter: 50
Reconstruct Mode: Revert

☐ Stylus Pressure

Reconstruct Options

Mode: Revert

Reconstruct Restore All

Mask Options

None Mask All Invert All

View Options

☑ Show Image ☐ Show Mesh
Mesh Size: Medium
Mesh Color: Gray

☑ Show Mask
Mask Color: Red

☐ Show Backdrop
Use: All Layers
Mode: In Front
Opacity: 50

Inked background project

For most of us, designing and drawing original manga characters is difficult enough. Drawing detailed backgrounds in perspective can be a real headache. But don't worry: thanks to Photoshop and digital inking, there is an easy way to produce backgrounds as perfect as those from professional manga artists. As long as you have a suitable photo for the background you want to draw into your panel, all you need is time and a little patience. You learned how to ink digitally earlier in the chapter. This project applies those same skills to ink directly over a photo. You cannot always rely on tracing photos for backgrounds, of course, especially for fantasy stories, but tracing and inking will give you a good grounding in perspective, line weight and appropriate levels of detail.

Photographic colour/Digital line art fusion ▲

The image above shows another time- and labour-saving shortcut. Once the line art has been finished, a blurring filter is passed over the photograph and the colours are tweaked in line with the rest of the manga, then the layers are flattened. This saves time that would have been spent colouring the background, allowing the artist to spend that time on the characters instead. Note how the posters at the back have been changed to white to make the image more coherent.

1 If you took your reference photo with a digital camera, then just open it in Photoshop. If you took it with a traditional camera, you will need to develop the photo first and scan it in. The photo above is of a typical classroom, and will form the reference for this project. Create a new, RGB Photoshop document of at least 300 dpi and drag the classroom photo into it. If the photo appears small on the new canvas, scale it up using Transform.

Tip: Creating your backgrounds on a separate document, rather than tracing them directly into your manga pages, allows you to reuse them in the future.

2 Create a new 'Normal' layer above the photo. Fill it with white using the Paint Bucket Tool and turn the Layer Fill Opacity setting to 50%. This lightens the photo making it easier to pick out details and see existing lines when inking.

3 Create another new 'Normal' layer on top of the other two and call it 'Line art'. This is where the inking takes place. Pick the Pencil Tool and set the foreground colour to black.

4 Start inking by tracing the edges of objects. To draw straight lines, first ensure the 'Shape Dynamic' option is turned off in the Brushes Palette. Then, when drawing the line, hold down [Shift], click the start point, then click the end point. A line will be drawn between the two points. Curved lines can either be drawn freehand, or by the method above, clicking between points that are very close together. Use the Eraser Tool to clean up mistakes.

7 When finished, delete the two layers beneath the 'Line art' layer. The image is now ready for colouring, combining with your characters, and integration into a panel or page.

5 Ink all the main edges. Be patient, and take your time with the details. If parts of the picture remain obscure, increase the layer fill opacity percentage on the white layer to throw the darker lines into greater relief.

6 After you have traced all of the main edges, fill in any areas of solid black on the 'Line art' layer using the Paint Bucket Tool. Use the original photo to guide your placement of these shadowed areas.

Tip: It's always a good idea to bear copyright in mind when tracing from photographs. Ideally, you will have taken the photos you use for reference yourself, but if this isn't practical, then do your best to disguise the origins of your chosen image, either by combining elements of two or more different pictures, or adding in elements from your imagination. Furthermore, be sure to colour such digitally inked photos yourself, so that the final product is, technically at least, all your own work. Lightboxing, 'swiping' or digital plagiarism is a touchy issue in the manga and comics industries.

8 Here is a completed version of the image. Simple, cel-shaded characters work surprisingly well in photo-realistic contexts. Remember, too, that with judicious cropping and by changing character poses, you will be able to use this one background across many different panels.

Outside the classroom

Into the wild ▶

While the natural world provides fewer straight edges and flat surfaces than the classroom scene, what it lacks in easily inked lines it makes up for in endless variety and intriguing organic shapes. The principles behind inking the classroom photo are just as applicable here, but when inking trees and foliage, you may wish to ink just an abstract outline, filling in detail and shading at the colour stage.

Robot in space project

This project brings together a wide range of the toning techniques you have previously studied, showing how hard-edged and soft-edged brushes can be used to create different textures and patterns of shading, and how an image can be toned using a very limited palette of greys. It also shows how the judicious use of filters (in this case, the 'Add Noise' feature) can spruce up your artwork with simple textures, saving time while also increasing the rewarding complexity of your image. Note, too, the restricted palette used for the flat colours: the first stage of the robot uses only four or five shades of grey. The addition of highlights and shadows increases this, but the initially limited palette holds the image together. Although the example here features the blunt, hard lines of a giant robot, the shading techniques are just as applicable to more fleshy subjects, although their skins will, of course, be far less reflective.

Halftone robot in space ▶
The final image blends together a number of techniques to produce a professional result. Flat greys, metallic highlights and filter-applied textures are all unified by transferring them into halftone patterns.

1 Open the line art: here, a giant robot with planets and stars in the background. Separate the line art from the white background as before. Using grey tones, add flat colour on a new 'Flats' layer. If you have difficulty selecting areas with the Magic Wand Tool, use the Pencil Tool to apply greys.

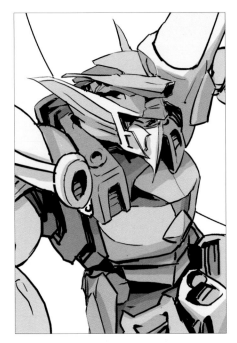

2 Create a new 'Multiply' layer and call it 'Shading'. Select areas on 'Flats' using the Magic Wand Tool, then brush shading on to the 'Shading' layer. Overpaint your first pass with darker shadows. When finished, duplicate 'Flats' and merge it with 'Shading'. Turn off the original layer.

3 To apply metallic light-reflective effects to curved areas, select the Dodge Tool and set Range to 'Midtones' and Exposure to 10%. Choose a soft brush tip and gradually brighten up any areas facing the light. Here, our light source is positioned at the top left of the image.

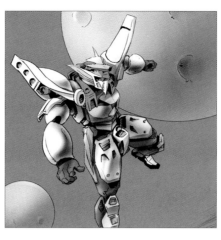

4 On the same layer, switch to the Burn Tool. Set Range to 'Midtones' and Exposure to 8%. Use the tool to create shadows on the areas where little light is being cast. Remember, metal not only reflects the light from the main light source, it will also reflect light bouncing off surfaces nearby. In the close-up example, above, you can see how the arm reflects a little of the light bouncing off the main robot body. If the shiny metallic effect is not strong enough, use Image > Adjustments > Brightness/Contrast to up the distinction between light and dark.

5 Underneath the 'Flats' layer, make a new 'Background' layer. Use the Paint Bucket Tool to fill in the flat colours. Select the planets and use the Dodge and Burn tools to apply light and shade to the spheres, as well as creating details, such as the shadowed craters, using Burn to pick out highlighted rims.

Tip: Reserve your strongest highlights and shadows for foreground elements, such as the robot shown here. Background elements should never stray too far from neutral mid-tones.

6 Select the planets and add a new layer, set to 'Soft Light'. Fill the selections on this new layer with a dark grey, then go to Filter > Noise > Add Noise. Give the amount a high value and make the Distribution 'Uniform'. Click OK. The texture of the planet is now more convincing. Merge this layer with 'Background'. Use the Magic Wand to select the space backdrop, and apply a gradation with the Gradient Tool. As the light source strikes your robot from the top left, it makes sense to have your gradient lighter towards the top left of the image as well.

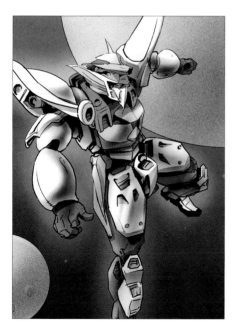

7 On top of the merged 'Background' layer, create a new layer to add some atmosphere. Choose a soft brush with Opacity and Flow set to 20. Paint a white light around the robot to separate it from the background. Using a variety of brush sizes and opacities, draw some stars in the infinite night.

8 For printing, you need to convert greyscale into black dots. Merge the tone layers into a single layer. Create a new file with the same resolution and size as this image and drag the tone layer into the new file. Ensure it fits. Go to Image > Mode > Bitmap and change this image to a bitmap file, choosing the Halftoning options as before. Next, use Image > Mode > Grayscale to change it back to greyscale. Drag the layer back to your original file and remerge it with the line art.

Fight scene project

Fight scenes form the backbone of many manga adventures. Though the imagery itself is often strong enough to 'sell' the furious interchange of blows, you'll find that the addition of powerful sound effects ups the ante of your combats, making them weightier and more impressive.

To the right is a typical impact, with one fighter punched hard enough to throw him out of the panel. Without SFX, the action is readable enough, but their addition gives focus to the punch's force, punctuating the action for the reader. This project shows how to incorporate SFX into an image.

Brutal beatdown ▶

The final image shows, with the SFX, the exact point where the puncher's fist connects with his opponent's face, as well as indicating the magnitude of the blow by the size of the typeface.

1 First, select the Text tool, and choose a suitably chunky font in a large, even bolded, typeface. Type in your chosen SFX word for the sound of a connecting punch. Here, we've used 'THWAK', but 'WUNNCH', 'THUDD' or any other word you believe captures the spirit of the action are equally applicable.

Tip: The first font you choose will not always be the best for your chosen sound effect, so keep the Character Palette open as you work, and try a few alternatives before you settle on one. You may want to print out a selection of your favourite SFX fonts for speedy reference.

2 Using [Ctrl]+T to Transform the text, angle your SFX to the direction of the impact. Rasterize the text, then use the Magic Wand to select it. Colour your selection with an appropriate colour or gradient. Don't worry too much about the colour at this stage – you can easily change it later.

3 To integrate the SFX with the background action more, you can add some speedlines. With the text still selected, duplicate your SFX layer. On this new layer, go to Filter > Noise > Add Noise and set the noise amount to a high value. Next, go to Filter > Blur > Motion Blur. Set the angle so that it matches the angle of the speedlines in the background, and choose a medium blur radius. Change the layer blend mode of the duplicate layer to 'Linear Light'. It will blend with your red layer.

4 Merge the duplicated layer with the original one. You can now adjust the colour further by using Image > Adjustments > Hue/Saturation. In order to make the speedlines on the SFX more visible, you can use the Brightness/Contrast settings. If you still feel that your sound effect needs further personalization, you can make it more individual and interesting by attacking it with the Burn or Dodge tools, lightening and darkening various areas.

5 Your SFX should still be selected. At this point, you can add a border around your selection. First, go to Select > Modify > Border, setting the value at around 4 or 6, to fill in the selected area with the colour of your choice. Use standard black. Then, with the border selection still on, go to Select > Modify > Expand and put in a value of 8 or so (for this image). Add a new layer underneath the SFX layer and fill the selection with white. Merge this layer with the SFX layer.

6 We have concentrated solely on the SFX point of impact so far, but you can also increase the drama by including a sound effect from the victim. Grunts upon impact may be shown in speech balloons, as SFX, or even as SFX within speech balloons. Typical shouts include 'UNFF!', 'ARRGH!', 'ERGGH!' and so on. This is accomplished in the same way as the punch, but in a smaller font, and with a dimmer colour. This is because the 'THWAK' forms the focus of the panel, with the 'EEEKKK' the secondary and less important element. The image at right shows what happens when you reverse this: the screaming fighter looks like he is hamming up the result of the impact.

Tip: Sound effects, like dialogue, should guide the reader's eye down the page, from top left to bottom right. Remember that size is a great indicator to a reader of importance, as well as amplitude: while an earthquake and an alarm clock may not emit the same decibels, the latter might seem just as loud to a light sleeper.

7

Digital colouring

In this chapter we move on to the most important element of the digital revolution: colour. Although traditionally black and white, manga are increasingly available in colour, from covers and pin-ups to the web. With digital methods, many manga artists now choose to colour pages themselves rather than pass them to a dedicated colourist.

Colouring basics

The basic Photoshop tools used to apply grey tones and shading in the previous chapter are much the same tools you will use to colour your illustrations. However, using colour means that, along with a palette running into millions of possible colours, you will need to explore the more advanced settings of each of these tools in order to get the best out of them. Knowing the basics of light and shade from your grey toning exercises will stand you in good stead.

Settings

As we have already seen the Hardness, Opacity and Flow settings of the Brush and Eraser tools can be altered in the Options Bar. These settings become stylistically important when applying colour.

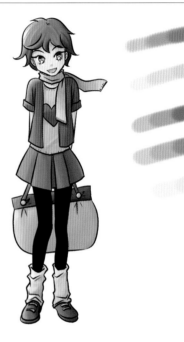

Hard edge ▶
A cel-shaded, animation look can be achieved with layered flat colours, a hard-edged brush and 100% Opacity.

Soft edge ▶
A more natural look can be created by blending soft-edged brushstrokes together with colours at 50% Opacity.

Adjusting colours the easy way

Whether you are first creating colour schemes for your characters and wish to amend them before you roll out a palette across an extended sequence, or you want to tweak your final pages after they have been coloured, you may find some useful tools in the Image > Adjustments menu. The Levels tool has already proved useful for controlling light and dark while inking, but three further options – Color Balance, Brightness/Contrast and Hue/Saturation – should be explored.

Original ▲
Apply Adjustments on a layer separate to (beneath) your line art. If you have enough RAM, use an Adjustment Layer instead, which allows you to re-alter the changes indefinitely.

Color Balance ▲
This makes changes within the highlights, midtones or shadows. Its sliders represent the six colour polarities. Use the Color Balance to adjust the whole atmosphere of a piece.

Brightness/ Contrast ▲
One slider controls brightness, the other contrast. Exaggerate extremes to punch up 'flat' colour on a piece. Brighten dull shades or dampen startling ones.

Hue/Saturation ▲
Hue is used to change the colour of objects, such as this robe. Saturation makes the colour more intense or muter. Brightness works in much the same way as in Brightness/Contrast.

Colour modes

RGB and CMYK are the colour modes that will be used most often when digitally colouring. RGB is the standard used in televisions and computer monitors. It stands for red, green and blue, the primary colours that can be blended together to create every visible colour. White is the combination of these colours; black, their absence.

CMYK is the standard of print media. It stands for cyan, magenta, yellow and black, the secondary colours on the colour wheel. Printing presses use differing percentages of the three colours, plus black, to produce a wide colour spectrum. In colour theory, the combination of cyan, magenta and yellow produces black; however, on real

presses this tends to result in brown, so black is added as a fourth 'colour'. The vast majority of commercially printed books and magazines are produced on CMYK presses. If you want to release your manga on the web, it is better to use RGB. If you want to print your colour manga professionally in books and magazines, you'll need CMYK.

◀ **The colour wheels**
The primary colours of red, green and blue blend together to produce the whole spectrum of visible colours. The secondary colours produced by a 50/50 blending of two of the primaries are cyan, magenta and yellow. Appropriately, when these colours are used as the starting point, the result of a 50/50 intersection between the CMY colours are the RGB hues, as shown in the second diagram. The RGB spectrum is one of addition, blending to white, the CMY spectrum one of subtraction, blending to black.

RGB

CMYK

RGB versus CMYK

Color Picker ▲
If you are having your manga printed, it is essential to work with colours that definitely exist in the CYMK mode. When the Color Picker is open, press [Ctrl]+[Shift]+Y. This changes the colours that are not available in CMYK mode to grey, while the ones that are printable appear as usual. Pick your colours from the 'safe' area. Use the same command to return the Color Picker to normal.

If creating artwork for print, you may think it best to work in CMYK mode to save the trouble of converting, and ensure that you only use the colours on screen that will show up in print. However, CMYK files take up 25% more space on your hard drive than their RGB equivalents, and many Photoshop filters will only work in RGB mode. For those with lower-specification computers, it is best to work in RGB and convert to CMYK just before sending the file to the printer. Don't flip between RGB and CMYK mode while working, as each switch loses a little clarity in the image. If you want to see your RGB image in CMYK without having to convert it, select View > Proof Colors.

As computer screens use RGB and printers use CMYK, the image on your monitor will not be exactly the same as the one printed on paper. Some RGB colours don't exist in CMYK, particularly the yellow/greens and bright reds. This isn't a problem when publishing online, but may cause changes when outputting to CMYK for paper publication.

Colouring techniques

Colouring a manga page is more complicated than toning it, although the principles are much the same. For most, the experience and results of colouring are more satisfying. Using colour is more forgiving than grayscale on one level, as the more expansive palette allows you to use different hues that share similar luminosities – different shades of the same grey on a non-colour image. This spread shows how to set up a line art image for every colouring style.

Practice exercise: Applying flat colours

Flat colours are the basic colours you add to your initial line art to divide areas from one another to make more advanced colouring easier and quicker down the line. Although it is not necessary to choose the same colours you will be using in your final image – many colourists use near-random, conflicting hues just to quickly subdivide characters from backgrounds and skintones from clothes, leaving colour decisions for later – it often helps to use colours close to those you will be using later, to get an idea of your page's colour composition. The most important function of the flat colour layer is that it allows you to easily select areas with the Magic Wand Tool without worrying about the line work. You can select individual areas (with 'Contiguous' checked) or all areas sharing the same colour (unchecked), which can shave hours off the time it would otherwise take to complete it.

Tip: If you are using non-bitmapped line art (art you have scanned in grayscale and altered with the Levels function), you need to be careful when selecting an area to expand your selection so that it goes fully underneath the lines. Otherwise, a white edge may be left between the lines and colour. In most cases, it should be enough to increase the tolerance on the Magic Wand Tool, but be aware of high-detail areas or tight spots on your illustration.

1 Open your line art and set it to RGB mode (Image > Mode > RGB). If you have separated your line art from the white background, create a new 'Normal' layer called 'Flats' between the background and line art layers. If the line art and white background are on the same layer, duplicate it, set the mode to 'Multiply', then create a new 'Normal' layer called 'Flats' in between the two identical layers.

2 If your lines do not perfectly join up, create a new layer and use a 1-pixel black Pencil Tool to seal them. If you prefer 'gappy' line work, you can delete this layer after completing the flats.

3 On the 'Flats' layer, use the Magic Wand Tool to highlight and select areas to colour. For non-bitmapped line work (some grey in the lines), select a Tolerance of 50. Check 'Contiguous' and 'Sample All Layers' and leave 'Anti-alias' unchecked. Press down [Shift] to select multiple areas, or [Alt] to unselect areas. Next, choose Select > Modify > Expand, set the value to 1 or 2 and click OK.

4 On the 'Flats' layer, use the Paint Bucket Tool (with 'Anti-alias', 'Contiguous' and 'All Layers' unchecked) to block in the desired colour for the selected area. Alternatively, place the colour you want as the Background Color in the palette and press [Delete]. Use [Ctrl]+D to deselect the area.

5 Some parts of the image may be missed by the Magic Wand Tool and will not be coloured. Use the Pencil Tool to fill these areas. The Pencil Tool is used to ensure the colour has a sharp edge, for easier future selection. For the same reason, if you use the Eraser Tool, ensure the mode is set to 'Pencil'.

6 Repeat the above steps to fill in all of the flat colours. If you created one, delete the layer you used to seal the black lines. If you wish to adjust the colours to make them more complementary to one another, use the Magic Wand Tool, with 'Contiguous' and 'Sample All Layers' unchecked, to select all areas of green on the 'Flats' layer, for example. Next, use Image > Adjustment > Hue/Saturation or Color Balance to adjust until you are happy.

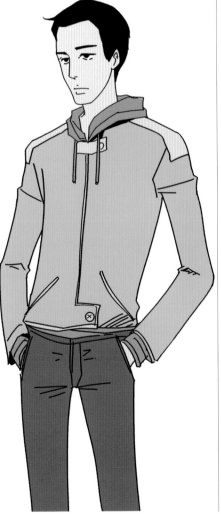

Colouring styles

There are two main styles of colouring. The first is called 'Cel Shading', which is similar to the colour schemes seen in cartoons and anime, while the other is 'Soft Shading', which provides a more natural look with greater gradations between colours. Both modes begin with the flattening process.

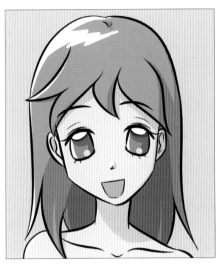

Cel shading ▲
Uses pure, unblended colours; sharp distinctions between bold highlights and strong shadows. While it requires no less skill, the limited palette can prove quicker to implement.

Soft shading ▲
A more natural, painterly style, blending a range of colours in each area, from light to dark, while paying greater attention to light reflection and the layering of shadows.

Practice exercise: Cel shading (shadows)

Cel shading is the most basic and common way to colour manga. Drawn from animation cels, where budget and time constraints rewarded bold, hard-edged shadows, cel shading is now a popular style in its own right. In real life, the complexity of lighting means that objects rarely cast a lone, clear shadow, but manga can simplify and exaggerate colour, shadows and highlights just as it simplifies the characters themselves. This exercise shows you an easy method of adding cel-shaded shadows to your flats while leaving the original colours intact.

1 First, lock your 'Flats' and 'Line Art' layers, and create a new layer, set to 'Multiply', on top of your 'Flats' layer. Call it 'Shading'. This is where you will apply your shades as grey tones.

2 Use the Magic Wand on the 'Flats' layer to select the area you want to colour, with the Tolerance set to 0 and 'Contiguous' and 'Sample All Layers' unchecked. Here, the hair is selected. Now switch to the 'Shading' layer. Pick a grey shade from the Color Picker and select the Paint Brush. You can always adjust the grey with Color Balance at a later stage.

3 Choose a hard-edged brush with Opacity and Flow both set to 100%. Select your light source (here, the top left again) and paint the areas not facing it with the grey. Remember to keep your light source consistent.

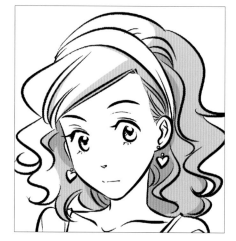

4 Here is the image with the 'Flats' layer hidden. Emphasize the depth of your shadows with a darker grey, painted over the first. Turn the 'Flats' layer on and off periodically in order to check your progress. Use an Eraser Tool at 100% Flow and Opacity to correct any mistakes.

5 Use the same method to add shadows to the other parts of the image. Once you have finished, you can use Color Balance to adjust the shading, or leave them as simple grey.

Tip: If you have used a limited palette on your image, you will find that using the Magic Wand Tool with 'Contiguous' unchecked will select all like-coloured areas (here, the hair and the eyes). Use the Lasso Tool and the [Alt] key to deselect unwanted areas.

Practice exercise: Cel shading (highlights)

Highlights are just as important as shadows when colouring in a cel shaded style, and they are created in much the same fashion as shadows – on a separate layer. This time, however, the highlights are painted in using brightened shades of the colour of the material in question. This exercise shows you how to get the most out of your highlights. As before, we start with our character's hair.

> **Tip:** Remember that not all materials reflect and refract light in the same way. Hair, eyes and metals are usually the most reflective elements of a character, with skin, leather and so on coming a near second. Fabrics and matt objects absorb light, so dresses, wool coats, jeans and the like should not have highlights applied to them as shinier textured elements.

1 Create a new 'Normal' layer called 'Highlights' between the 'Flats' and 'Shading' layers. Select the Brush Tool and double-click on the Color Picker to bring up the colour selection window. Use the Eyedropper Tool to sample the hair colour from your image. A small circle indicates that colour on the colour spectrum. Move the sensor up and to the left a bit (above) to pick a colour lighter than the current shade of hair, but within the same colour family.

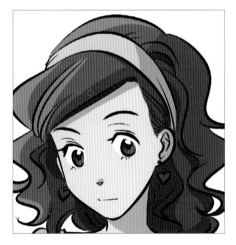

2 Use the Magic Wand Tool to select the hair, then go to the 'Highlights' layer. Paint areas facing the light source with the colour selected in Step 1. Keep the light source consistent.

3 When this is done, add an extra, white highlight on the shiniest areas. Keep this effect subtle, limiting it to a few areas, ensuring the shine is consistent with the type of object.

4 Continue to add appropriate highlights to the other parts of the image. In this example, highlights have been applied to the headband, leg and sock, shoes and dress.

> **Tip:** Adding some soft-edged shading to your cel art is an easy way to humanize your characters and stop them looking too much like dolls.

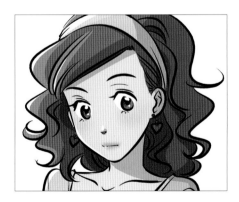

5 For the final touches, create a new layer between the 'Flats' and 'Highlights' layers to add small but necessary details to the image. Set the mode to 'Normal'. To the left, colour is softly added to the cheeks and lips. Rather than a hard-edged brush, this stage uses a brush with Opacity set to roughly 20%. Choose a soft pink colour and gradually build up the peachy cheeks and lips of the girl.

Practice exercise: Soft shading

Soft shading produces a finished look that is closer to natural media than cel shading. It replicates the spirit, if not the exact materials, of a freehand painting, as opposed to the pixel-perfect, highlight-midtone-shadow images produced by the method outlined on the previous spread. Soft shading grants you the intricacy and layering of colour in a traditional painting alongside the accuracy, flexibility and, best of all, the multiple levels of Undo found in your graphics software. As the name suggests, soft shading is built up out of gentle brushstrokes, using multiple shades of the same colour and overpainting of areas in order to increase the depth of shadows or the brightness of highlights. As a result, it requires more skill and patience than cel shading. This exercise will teach you the basics of applying soft shading to an already flattened image, and the way to blend colours together.

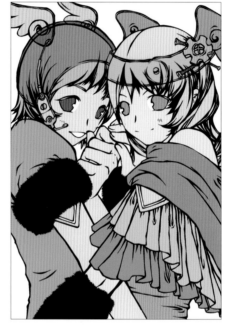

1 We begin with an already flattened image. Duplicate the 'Flats' layer and name it 'Colour'. Set its mode to 'Normal', making sure the 'Colour' layer is above the 'Flats' layer. Keep the 'Flats' layer, as it will make Magic Wand Tool selections easier if you later decide to reselect areas you have already soft-shaded ('flat' areas are simpler to select than those that mix a number of similar colours, especially if using soft brushes).

2 This time, we will start our shading with the shawl, as its folds make colouring interesting. At this point, the colours on the 'Colour' layer are still untouched, so it's fine to use the Magic Wand Tool to select the shawl directly on this layer. Leave 'Contiguous' and 'Sample All Layers' unchecked.

3 Choose a soft-edged brush and pick a colour a few shades darker than the flat shawl colour. Set Opacity and Flow to 40%. Increase the brush size with [Shift]+] ([Shift]+[decreases the size) until you get a big brush (or right-click and drag the slider). Paint shadowed areas.

4 As with cel shading, the next step is to pick an even darker colour for the darkest areas of the shawl and paint these with a smaller brush. Having the Opacity and Flow at 40% allows you to build up colour gradually. Paint plenty of strokes in the places where the shadows are darkest. If you make a mistake, don't use the Eraser because this will reveal the layer underneath. Use the Paint Brush to paint over the mistake – or the Undo function, of course.

Tip: Remember again that fabric, skin and metal all reflect light in different ways, so you may find some elements of your image need less rendering than others. Conversely, the brightest, shiniest elements (for example, eyes and hair) may need additional layers of highlights to be added, or even the use of brushes at a higher Opacity and Flow.

Tip: If you change your mind about a particular colour area, you can switch to the 'Flats' layer, use the Magic Wand Tool to select a whole section, then flip back to the 'Colours' layer, using the Hue/Saturation sliders to alter the colours to your satisfaction.

5 Now pick a colour a few shades lighter than the original shawl mid-tone, and paint those areas or folds facing the light source.

6 The lighter and darker colours of the shawl have now been implemented, but the transitions between them aren't very smooth, and some of the folds are lacking detail. To build up the transitions, you will need to select colours inbetween the existing ones and blend using a smaller brush. Many of the in-between colours may already exist in the image at the edges of your brushstrokes, so use the [Alt] button and Brush to grab them with the Eyedropper Tool. Patience is the key: you may need to paint certain areas over and over again to create a convincing effect.

7 Use the same methods to colour the rest of the picture. Remember to zoom out periodically to check that you aren't over-working some smaller elements to the detriment of the whole: knowing when to stop colouring is often the hardest part of the soft-shading process.

Colouring a page

The two methods you have learned to colour characters are flexible, and can even be intermingled within a panel or page. Colouring a full panel follows exactly the same steps, but the number of characters may be higher, and there will usually be background elements to think about at the same time. Colouring an entire page takes a few more steps, and requires a little more thought. The first thing you should consider is how to make your pages cohesive and coherent, rather than a rag-tag collection of disparate panels. Think about limited colour palettes and background colours, and how a single dominant colour on each page can influence atmosphere and mood, as well as indicate scene changes.

Practice exercise: Mixing shading techniques

Using Photoshop allows you to be very flexible with the methods you use to colour each page, mixing and matching the techniques you know so that they fit the content, rather than being beholden to one style or another. The examples below are mostly cel shaded, with soft-shaded details on the characters and gradients to add depth and texture to the single-colour backdrops. This exercise allows you to put what you've learned into action.

Tip: The background of each panel sets the atmosphere for the page. Using similar tones across panels maintains integrity: though an out-of-place flash of a conflicting colour can create surprise.

1 Open your line art in Photoshop and clean the page. Separate the lines from the white background if they are not yet on an individual layer. Lock your 'Background' and 'Line Art' layers so that you won't mistakenly draw on them.

2 Create a new layer between 'Background' and 'Line Art' called 'Panels'. Fill a background colour for each panel. By using a different colour for each one, you'll be able to use the Magic Wand Tool to select the whole panel later. The colours here represent natural daylight. Each panel is selected with the Polygonal Lasso Tool (use the Magic Wand Tool and [Alt] on 'Line Art' to delete overspill). Fill using the Paint Bucket Tool.

3 Create a new 'Flats' layer on top of 'Panels'. Colour in the flats using the Paint Bucket and Pencil tools, as in previous exercises.

4 On top of the 'Flats' layer, create a new 'Multiply' layer called 'Shadows'. Use a hard-edged brush at maximum Opacity to shade in areas of darkness using a grey colour. Return with a darker grey colour to areas of deeper shadow. These shadows use the cel shading method. Remember, if you want to get a clearer view of the shadows you are painting at any point, switch off the 'Flats' and 'Panels' layers to view the shadows against a white background.

6 Create a new layer on top named 'Detail'. Here, you will colour the elements you haven't added detail to yet, such as the eyes, hair clips and rosiness in the cheeks. Be flexible in your Brush settings: you may wish to use a soft, low-Opacity brush for the cheeks, and a hard-edged brush for the hair clip. Pay attention to the reflections in the eyes.

7 When you are happy with the page, duplicate the 'Flats' layer, and merge the copy with the 'Shadows', 'Highlights' and 'Detail' layers, renaming the merged layer 'Colour'. If you want to make adjustments to any areas of colour, you can now select areas on the 'Flats' layer and make changes on the 'Colour' layer using the tools in Image > Adjustments.

5 On top of the 'Shadows' layer, create a new 'Normal' layer called 'Highlights'. Here, the highlights are applied as soft shading. Use a soft-edged brush in a lighter version of the appropriate colour, with Opacity set to 40%, to paint over areas facing the light source. Overpaint several times to create the brightest highlights.

8 If you want to adjust the colours or atmosphere of an entire panel, use the 'Panels' layer to select a panel with the Magic Wand, and adjust from there. As an example, the bottom-right panel above has been desaturated to make it more dramatic. The panel is selected in the 'Panels' layer; the adjustment are made on the 'Colour' layer using Hue/Saturation.

9 You may want to add some gradients to the flat background colours in order to enrich them. Create a new 'Gradients' layer above the 'Panels' layer, and select the panel you want in 'Panels'. On the 'Gradients' layer, with the appropriate panel selected, choose the Gradient Tool. Set the foreground colour to the current background of the panel using the Eyedropper Tool, set the background colour to a dark shade of the same colour, select the kind of gradient you want to use and drag the Gradient Tool across the panel. The gradient will be created. The three panels above use Radial gradients.

Tip: If you decide that you want to add in fully rendered backgrounds or Photoshop-altered photographs after you have already coloured your page, remember that you can copy them in on a new layer underneath the colours of your characters. You can even place them beneath a semi-transparent Gradient layer if you still wish to communicate the atmosphere of each panel in this way. A page isn't finished until you are satisfied with it, so experiment with every new technique you learn to develop your style.

Night image project

Over the previous few pages, you have learned how to colour an image in two different styles, and how to compose and coordinate panels in order to create a pleasing and atmospheric page. With these techniques, you should be able to cope with any of the colouring projects you may encounter in your manga career.

However, one of the more difficult scenes for a colourist who is just starting out is one set at night. Everything changes colour in the darkness, not only becoming paler, bluer and more desaturated, but also being influenced and transformed in shade by the light sources acting upon them. Moonlight transmutes reds to purples, fades flesh to bone-white and strips warmth away. Neon tones its subjects in sickly greens, pinks and yellows. Streetlights cast unnatural 'fires' across those that walk beneath them. In short, at night everything you know about colour changes. This project will give you an excellent grounding in working by moonlight, with an image of a partygoer stepping out for some air.

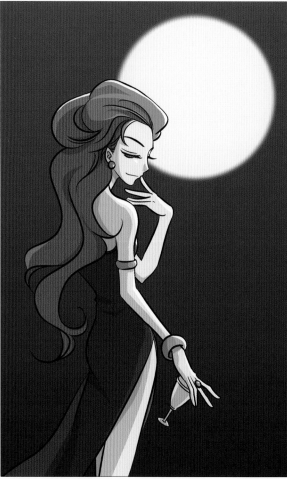

◀ Met by moonlight
This image shows a very simple technique for creating nocturnal images: a carefully chosen, blue-tinged palette to begin with, followed by shading as usual and, as a final step, a wash of colour over the whole image to further transmute the shades. Try using the same wash technique with yellows or reds to add atmosphere to daytime scenes. Where this image is concerned, as a final step, you may wish to develop the background with a gradient effect (on the 'Blue' layer) and tighten the palette yet further by compressing the colour layers and using the tools in Image > Adjustment.

1 First, open your 'Line Art' layer and prepare it for colouring by cleaning up the lines and separating the line work from the white background.

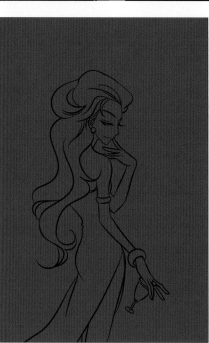

2 Create a new layer named 'Blue' beneath the 'Line Art' layer, and fill it with a dark blue colour. This will form the background for your night scene.

3 Create another layer on top of the 'Blue' layer and name it 'Moon'. Pick a large, soft round brush, and use a pale yellow to draw the moon.

4 Fill in the flat colours of the character on another new layer, above 'Moon', using the techniques you have already learned.

5 On a new 'Multiply' layer named 'Shadows', draw shading with a purple-grey colour. Turn off the other layers to get a better view (right).

6 Create a new 'Normal' layer called 'Pale Highlights' and paint some of the lighter areas facing the moonlight. On the extreme edges facing the moon, add some of the pale yellow colour to the hair, skin and dress, reflecting some of the full moon's bright light back to the source.

7 Create a new layer on top of the other colour layers, naming it 'Blueish'. Set this layer's mode to 'Color'. Now go to the 'Flats' layer, and select the entire character with the Magic Wand Tool, using the [Shift] key to select multiple areas. When the whole character is selected, go back to 'Blueish' and fill your selection with the blue from your background. The character's colour changes to blue. Don't panic: change the Layer Fill Opacity to about 40% (on the Layers Palette) and your character's colours will show through.

Improvements and beyond

Photoshop is an incredibly versatile graphics package, filled with possibilities for you and your manga creations. The more you create or colour your manga digitally, the more useful you will find Photoshop and the greater the number of options, techniques and effects you will discover. This chapter will introduce you to a selection of them.

Customizing colour palettes

Sometimes, choosing colour schemes can be exceptionally difficult: it can be easy to stay with what you know and are comfortable with, and hard to stray out of the 'blue for sky, green for grass' mindset. That's why 'borrowing' the colour palettes of images that creatively inspire you can be a useful shortcut. The process is simple: find an image the colours of which you admire and think are appropriate for your own uncoloured piece, import the picture into Photoshop, and convert the image into a custom colour palette, which you can then use to digitally paint your own creation. This exercise will show you how to convert a scanned or downloaded picture into just such a customized palette.

Practice exercise: Converting an image to your Color Palette

1 First, find a colour image that you like from a book, photograph, manga or the Internet. Scan it in or save it to your computer, and open the image in Photoshop.

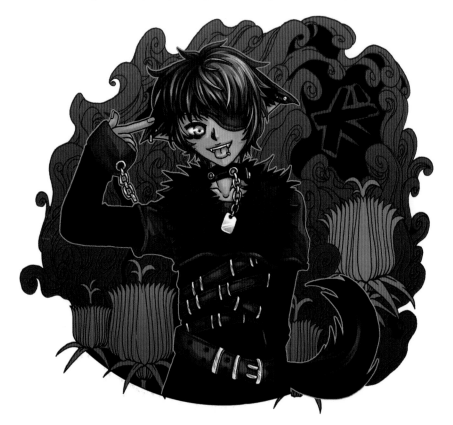

2 Now, convert the image to Indexed Color mode by going to Image > Mode > Indexed Color. Indexed Color specifies a limited, 'indexed' palette for your file, rather than the millions of colours that are available to you in RGB or CMYK modes. Go to 'Color' and enter the number of colours that you want to extract from the image. A good number is in the range from 150 to 250: you want enough colours to be able to accurately capture any blends or gradients, but not so many that any shades you want specifically get lost among thousands.

3 To view the colour palette you've created based on this image, go to Image > Mode > Color Table. If you want to add more colours to the palette, click the last empty slot and pick the colour up using the Eyedropper Tool in this options window. Click 'Save' to save the colour palette as a *.act file and OK to exit. Remember where you save the file so that you can load the palette later.

Tip: Choose a memorable filename for the palette, not just 'Palette 1'. Name it after the colour range it contains ('Deep Reds') or the image you pulled the palette from.

Tip: The tighter and more limited your colour palette (i.e., the fewer colours you choose to import), the more useful it will prove to you, as you can create shades and highlights yourself from imported median tones. For the same reason, you will get better results from illustrations with limited palettes than from more naturalistic photographs.

4 To load your palette, go to the 'Swatches' tab, which is usually located in the same options palette as 'Color'. If it is not there, choose Window > Swatches to make it visible. Click the small triangle at the top right to bring out the 'Swatches' palette menu. Select 'Replace swatches' and, in the window that opens, choose 'Files of type *.act' to locate the colour palette you saved earlier. Double-click the appropriate file, and your saved palette will be loaded into the palette as a new colour swatch.

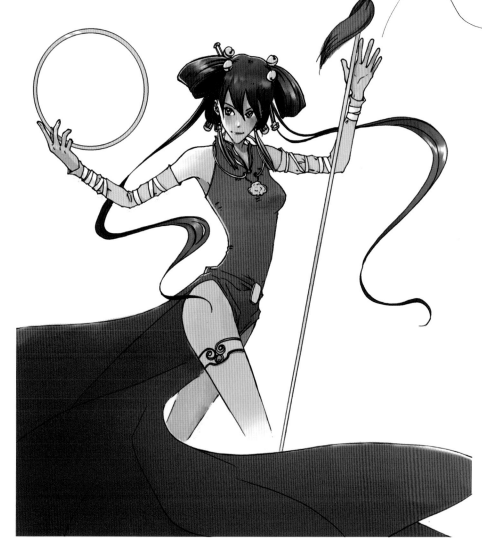

5 With the original colour image open as reference, open up your own line art and prepare it for colour. To select colours to use, hover your mouse pointer over the 'Swatches' palette: the cursor changes into an Eyedropper Tool, allowing you to pick up colours directly from the swatch. If you need to choose intermediate colours not on the swatch, you can select them from the colour menus as normal.

6 Following the same techniques you learned in the previous chapter, colour the image using this swatch. Lay out your 'Flats' layer first, blocking in your basic colour scheme. Next, on a duplicate 'Flats' layer above your original, use a variety of soft-edged, low-Opacity brushes to build up your shading and tone, beginning with shadows and then working from midtones up to highlights. When you have finished your shading, you may wish to use the original 'Flats' layer to select areas for adjustment, using the Brightness/Contrast, Hue/Saturation and Levels tools in the Image > Adjustments menu.

Creating motion

In previous chapters, you have learned how to represent extremes of movement using black and white speedlines and focus lines. However, these options can often cause a colour page to look cramped or over-rendered by the sheer amount of line work, limiting their efficiency at replicating speed. While the simplest option is to 'knock back' these black lines to a lighter colour, there are a number of more advanced techniques using blurs, smudging and changes of focus that create more cinematic effects in glorious colour. The following pages will walk you through some of the options available, many of which will suit some styles of panel or forms of motion better than others.

Practice exercise: Motion in colour 1

This method is the equivalent of drawing black and white speedlines. Rather than just drawing different kinds of lines, we can create a similar effect, better suited to colour, using the Motion Blur filter and the Smudge Tool.

1 Open a colour image in Photoshop. Merge your line art and character colour (leave the background). Save as a new .psd file. Duplicate the character layer, place it behind the original and set its mode to 'Normal'.

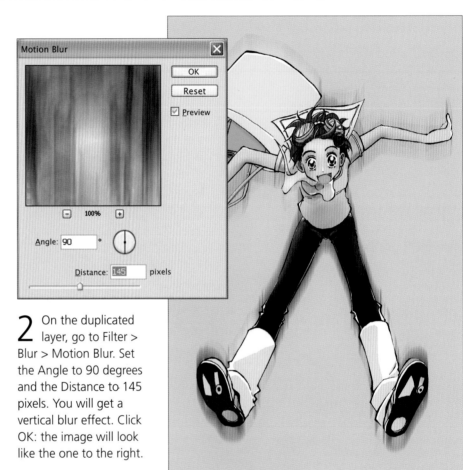

2 On the duplicated layer, go to Filter > Blur > Motion Blur. Set the Angle to 90 degrees and the Distance to 145 pixels. You will get a vertical blur effect. Click OK: the image will look like the one to the right.

3 To make the girl look as if she is jumping down, you need to move the blurred image up a little bit. Use the Move Tool (V) to move the duplicated layer upwards until the motion effect comes from the upper side of the character only.

4 To further sell the motion effect, you will need to alter the original character work. Work on the original character layer (duplicate it as 'insurance' if necessary). Select the Smudge Tool, with a small, high-strength Brush. Smudge the upper edges of the character in the direction of movement. Subtlety is key here: a few smudges are enough.

Practice exercise: Motion in colour 2

This example introduces you to the colour equivalent of focus lines, perfect for images containing one- or two-point perspectives. This is a one-point perspective shot of a character running towards the reader. The background will blur in a radial point around him, focusing the reader's attention.

1 Open the colour image in Photoshop. Keep the background and character on separate layers.

2 Activate the layer containing the background, then go to Filter > Blur > Radial Blur. This brings up an option window. Choose a blur Amount of around 30 (try other numbers to sample different strengths), select 'Zoom' as the blur method, and click OK. Your background is changed into one blurred by the speed of the focal character.

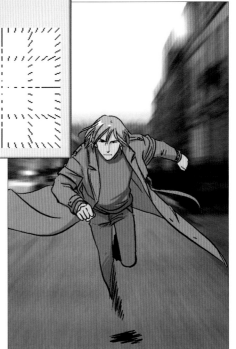

3 Now you need to add the same speed effect on the character's layer. However, you do not want the whole character to be blurred, as this will obscure the face and your line work and detract from the focal point of the image. To avoid this, you need to enter the Quick Mask mode to 'mask' the areas you don't want to apply the filter to. To do this, click the Quick Mask button below the Color Picker on the toolbox (or press Q). Use a black brush to paint over the areas you want to leave unaffected. The areas you paint over turn red, but don't worry, you are not applying paint to the image itself. If you make a mistake, use a white brush to correct it. Once you have finished painting over the relevant areas (in this case, those at the very centre of the image), click the small icon next to the 'Enter Quick Mask' icon, and everything but the areas painted in red will be converted into a selection.

4 With the selection on, use the Radial Blur filter again, this time using a smaller blur amount. Use [Ctrl]+D to deselect the area around your character to see the result: a character in sharp focus while the background recedes at speed.

Creating a metallic look

In black and white manga, the texture of metal is always expressed through a mixture of toned shades and strong, contrasting highlights. While it usually looks convincing on a printed page, such approximations are the best you can get in black and white. In digital colour, however, you have far greater opportunity for photo-realism, or at least for a higher-quality approach to texturization. While there are laborious processes that are highly rewarding, it is easy to create a realistic metal effect by applying filters to your coloured line work. The examples below will show you how.

Practice exercise: Metal armour

There are many ways to create metallic effects: from sampling photographic metallic textures and blending them on a 'Multiply' layer with coloured artwork, to painstakingly building up layers of shade and reflection piece by piece using a soft-edged brush, often using photo-reference. This method is much more straightforward, offering an easily created metallic texture with the individuality of hand-applied reflections and light 'blooms' on the metalwork. Use of textures in this way ensures that the objects on your page don't just look like different-coloured versions of the same substance: gold, bronze, silver and iron all respond differently to light. This exercise will take you step by step through the process of applying a metallic texture to the body armour of a futuristic warrior, from line art to finished composite.

1 Open your line art in Photoshop, and prepare it for colour, fixing errors or dirt marks and separating lines from the white background.

2 As practised in previous chapters, fill in the flat colours. Colour in shadows using the cel-shading method, everywhere but the armour.

3 Use the Magic Wand Tool to select all of the armour areas and then go to Filter > Noise > Add Noise. Choose 'Uniform' and check 'Monochromatic' and set a medium value for the amount of noise to be added, then view the effect in the preview window. When you are happy with the amount, click OK to apply the noise to the armour.

4 Keep the selection on and go to Filter > Blur > Motion Blur. Set the angle to ensure it blurs in the same direction as the incline of the body. In our example, the character's body is leaning to the left, so we set the angle to -63 degrees. Clicking OK applies the effect: you can already see the texture of steel in the armour plate.

Tip: Not all metals are the same, so it can help to build up a reference library of photographs and panels from your favourite manga of metallic effects, as such a resource may prove useful. Some metals, particularly those with elements of iron in their makeup, will also be subject to rust, which can prove to be an interesting effect for aged or weathered weapons, armour or vehicles. Use a separate layer and a textured brush to apply different shades of brown and gold to joints, wheel trims, handles and edges, or anywhere likely to have suffered from water damage. Rust can add a great deal of character, suggesting great age, or implying a lack of care on the part of an item's owner.

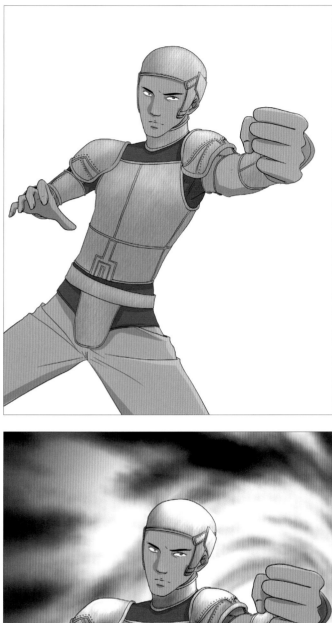

5 Now you can add the first layer of highlights and reflections to the armour. Duplicate the layer first so you can return to the original if you are unhappy with your modifications. Hide the original and work on the duplicate. For the highlights, use the Dodge Tool. Pick a brush with a soft edge, set its range to 'Highlights' and its Exposure to roughly 7%. Use a large brush to paint over areas that face the light source. In this case, the light source is from above and to the right. Be gentle with your brushstrokes, and don't obscure too much texture at this stage.

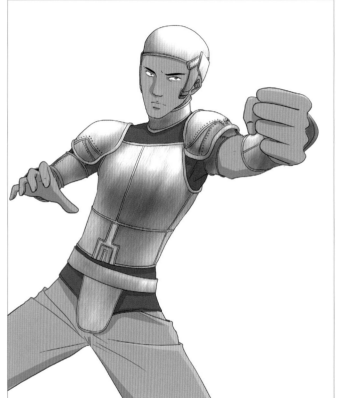

6 Still using the Dodge Tool, apply the more extreme, shiny highlights to the metal – an important step in your presentation of the material. Apply the Dodge Tool most heavily in the areas that should be shiniest, reducing the colour almost to white as necessary. When this is complete, add some shading and darker areas to the armour by switching to the Burn Tool. Use the same settings: a range set to 'Highlights' and an Exposure of around 7%. Gently paint over the areas facing away from the light with a soft brush, in this case the centre of the chest and the undersides of the helmet, throat and shoulder pads. Use the Dodge Tool to add further elements of reflection if needed.

7 As a final step, alter the colour balance to your satisfaction with Image > Adjustments > Color Balance. Set Tone Balance to 'Highlights' and uncheck 'Preserve Luminosity'. Don't oversaturate the armour; keep it tinted a silverish hue. Cyan and yellow were added to make the metal more realistic, and a background taken from an altered photo was inserted to make the shot more dramatic.

Creating reflections

Drawing precise reflections freehand usually involves many hours of painstaking labour, the judicious use of mirrors and the occasional bout of advanced mathematics. The majority of reflections found in manga drawn with traditional media tend to be rough approximations: a character looking in a mirror isn't too much of a stretch, but the same character looking into a pool of water may see his or her reflection as a series of wiggly lines, or some splotches of tone or colour.

Photoshop, however, with its array of layers and tools and filters to copy, flip, rotate, mirror and blur, proves to be the perfect vehicle for creating such reflective moments. The example on this spread shows how to create a reflection in a pool of water, but you could just as easily extend this technique to a mirror viewed side-on, the reflective gateway to another dimension, or an angry biker reflected in the windscreen of the car he is about to demolish. Experiment.

Practice exercise: Dreamy reflection

As mentioned above, traditionally drawing reflective water requires a lot of skill and the investment of a great deal of time on the part of the artist. Thanks to Photoshop, we can now do it in a few steps. Remember that Photoshop is not so advanced that it can reflect elements you have not drawn: this technique works best for reflections viewed from a side-on perspective, not the back of head/front of head examples mentioned earlier.

1 Open your line art in Photoshop: here, a fairy lightly touching some water with her foot. Of course, the 'touching the water' part is yet to be added. First, prepare the line art for colour, tidying it and separating the lines from the white canvas. Colour the fairy as you have learned previously: soft shading adds a dreamlike quality to the fantasy character.

2 Underneath the character colour layers, create a new layer named 'Water'. Pick an aquatic blue and fill this layer with a gradient of white to blue, from dark blue at the bottom of the image to white at the top.

Tip: If you are feeling adventurous, you could try to blend a photograph you have taken of a body of water with the blue/white gradient, in order to give it texture and realism. Place the photo beneath the gradient and set the Gradient blend mode to 'Color', altering the fill Opacity of the layer as appropriate.

3 Duplicate the line art and the character colours layer and merge these duplicated layers together. Rename this merged layer 'Reflection' and move it underneath the original character colour layer. This, as the name suggests, is where you will create your reflection. First, the reflection must be correctly oriented. Use Edit > Transform > Flip Vertical to flip 'Reflection' upside down. Scale the image down vertically using the Transform controls so the reflection is smaller than the original version, then move the reflection up the canvas to meet the original's extended foot.

4 Still on the 'Reflection' layer, go to Filter > Distort > Ripple. Here, you can choose the amount and size of the ripple's distortion; you can also preview what the revised image will look like in the preview window. Click OK when you find a result you are happy with. Your 'Reflection' layer is now wrinkled up to simulate the effect of flowing water.

5 The reflection is too bright and saturated. Turn down the Layer Fill Opacity to 80%. The reflection in the water should also be blueish. To achieve this, duplicate the 'Water' layer and move the duplicate on top of 'Reflection'. Set the duplicate's blending mode to Hue and set the layer fill Opacity to around 50%.

6 Now merge the 'Water', 'Water Copy' and 'Reflection' layers together. You can draw some water effects on this new merged layer to simulate a water texture. Use the Dodge and Burn tools with a soft brush to make horizontal strokes on the surface of the water. You can also use the Desaturate Tool (located on the same button as the Dodge and Burn tools) to tone down some areas of the water, creating a spread of different hues.

7 At the point on the merged 'Water' layer where the foot of the fairy meets the surface, make an elliptical selection with the Elliptical Marquee Tool. Then go to Filter > Distort > Zig Zag. Choose 'Rough Ripples'. Set the Amount and Ridges while looking at the effect in the preview window. Click OK when you are satisfied.

8 On top of all the colour layers, create a new layer for your finishing touches. In this example, an array of sparkling reflections were added to lend the water a more magical, romantic feel.

Converting a photo

Backgrounds are often the most difficult and time-consuming element of a manga page, and even the most successful manga professionals are often resistant to illustrating them from scratch. While you have learned how to ink a background from your own photograph in the previous chapter, there is an even 'lazier' method of background creation for those in a deadline-bind or inspiration furrow. If you use this method too often where it is stylistically inappropriate, your talent will be called into question, so keep your actual background illustration skills up to scratch.

Practice exercise: Turning a photo into lines

The process behind this exercise is basically that of reducing a full-colour photograph to a two-tone bitmap, and then building it back up into a greytoned or coloured image.

The method may sound long-winded, but it is, in reality, anything but. Remember to use your own photos, rather than copyrighted imagery.

1 Open the photo you want to use. For best results, the image needs to be at a large size (a mininum of 300 dpi is recommended), with sharp detail, taken in clear (though not overpowering) daylight. First, convert the photo to Grayscale using Image > Mode > Grayscale. Duplicate the layer and work on that, saving the original image for later use.

2 At the moment, the highlights and shadows in our example photo are too extreme. To fix this, use Image > Adjustments > Shadow/Highlight. In the options window, move both sliders to the highest value. The results are shown at left.

3 Now go to Image > Adjustments > Threshold and bring up the options window. Check 'Preview' and move the Threshold Level slider. Watch the changes in your image: your 'sweet spot' is when there is still detail in your black lines, but not too many areas of solid black. Click OK to apply the adjustment, creating a black and white image.

4 It is likely that your picture will still look messy thanks to some extraneous patches of black. Use the Eraser Tool to clear these, if necessary. Some areas in extreme highlight may have vanished, so use the Pencil Tool to fix these. If you want to add more details to the converted image, turn on the original layer and set the current layer to 'Multiply' and trace the appropriate lines. Eventually you will have a line art representation of your original photo. Drag this to your manga page and cut or Transform to fit.

Practice exercise: Tone the converted image

The photo is already converted to a black and white background. If you wish, you can either add tones manually, as before, or use the original photo to do the job, as below.

1 Use the same file as in the previous exercise. Drag the original photo layer to a new canvas at the same resolution. Use Brightness/Contrast to brighten the image and reduce the contrast a little. Now go to Image > Mode > Bitmap. Select 'Halftone Screen' as your conversion Method. The image changes to a dotted bitmap picture, as shown above. If the conversion looks successful, switch back to 'Grayscale' mode.

2 Re-import your grey tone layer into your original document, behind your black and white background layer. Match the tones with the lines. The line art layer must be in 'Multiply' mode in order for you to see the tones beneath.

Practice exercise: Colour the converted image

Colouring the photo yourself will help soften the blow of 'cheating' by using the previous steps, but if time is really tight, you can colour the image using the actual photo.

1 Change the mode of your line art background file to RGB, and set the line art layer to 'Multiply' mode. Open your original colour photo and drag it into your black and white document, underneath the converted line art. The points should match up. Duplicate the colour photo layer, make the original invisible, and only work on the duplicated layer from now on.

2 Go to Filter > Artistic > Dry Brush and apply the filter. Use the preview window to try out all of the options. Click OK when you find the best effect.

Tip: Try layering a colour or gradient 'wash' (a layer set to 'Color' or 'Hue' blending modes) in between the colour photograph and the line art to create atmosphere.

3 Adjust the Brightness/Contrast of the colour to ensure the line art stands out enough. You may need to adjust the Hue/Saturation or Color Balance of the colouring if you need it to fit into the rest of your manga page. Remember that there are other filters you can use to get the hand-coloured effect, so sample those if you need to.

Creating lighting

Although shadows and highlights are applied during the colouring process to indicate the presence or otherwise of light, it is useful to know that these simple methods can be improved or jazzed up with a Photoshop filter effect. This is not to say that there is a shortcut to the rendering of light and shade with colour and brush: there is no quick fix. However, using a lighting filter in tandem with other methods can bring an extra dimension to your artwork, capturing, say, the bloom of candles in ways difficult to accomplish by hand. The following exercise shows one such method.

Practice exercise: Add digital lighting

As previously mentioned, digital lighting is a way of adding a final touch to an image, not a colouring shortcut. However, rather than an element you bolt on at the last minute, it helps you to bear in mind your lighting effects from the very first pencil stroke. Digital, single-source lighting is often most effective when unbounded by line work, which is why there is no candle flame illustrated in the example, just a wick and candlestick. Your shadows and highlights, likewise, are reacting to a light source you are yet to add. Follow the steps to light the candle.

1 Open the line art as usual: our example here is of a scared-looking elven girl holding a candle. For the most dramatic lighting effects, the image will be in darkness, the candle the only light source. Add the flat colours, using a purple-blue as the background to indicate a deep darkness. Keep the colours desaturated as darkness trends colours towards grey.

Tip: This type of image works best when there are clear extremes between light and dark, illuminated by a single, dominant light source that can provide a focal point in the image for the reader. To gather reference on how a single light source casts shadows on a face, use a desk lamp and a digital camera to take photos of yourself from different angles.

2 On another 'Multiply' layer, add shadows. Pay particular attention to the light source, the candle, as everything not facing it should be in shadow. Grey-purple is used for shading, another element to represent the dark of night. Add highlights on a separate layer.

3 When you are happy with your highlights and shadows, make a copy of all three colour layers and merge the copies together into a single layer. Place the merged layer on top of the original colours. Next, we will apply the filters on this merged layer.

4 Go to Filter > Render > Lighting Effects. In the option window, choose the Light Type as 'Omni', sliding the option bars and keeping an eye on the preview in the preview window. You should not make the intensity of the lighting too high, as that will make any areas affected by the light lose their colours. Clicking OK applies the lighting effect.

5 With the nimbus of the light applied, you next need to add in the candle flame. Create a new layer on top of the other colour layers first. Use the Elliptical Marquee Tool to make a small, rough selection on top of the candlewick: don't worry about being precise, an approximate area will do. Use the Gradient Tool to apply a Radial gradient to the selection: set the foreground colour to bright orange and the background colour to a bright yellow.

6 When this is done, deselect the area and go to Filter > Blur > Gaussian Blur to blur the candlelight, allowing it to merge convincingly with the background.

Tip: Take a look at photographs of flames to see how they behave in different volumes: you could create the light from a campfire with multiple freehand selections, for instance.

7 If the light doesn't look bright enough, use the Dodge Tool with the range set to 'Highlights', to dodge the middle of the flame. Add flame and spark details and adjust the overall colours using Color Balance and Brightness/Contrast.

Combining software

For those with the budget to experiment and the time to get to know new software, the best part about the latest home computers is the range of graphics packages available. While Photoshop is incredibly flexible, many manga artists use Adobe Illustrator for its infinite scalability and editability of lines (an Illustrator document can be printed, without loss of resolution, at the size of a postage stamp or an office block), or Corel Painter for its wide range of well-simulated natural media. Often, images will be transferred between multiple packages, the better to take advantage of the strengths of each: line work drawn in Illustrator can be transferred to Photoshop for colouring, as Illustrator is best for bold, graphic images and type, while images can pass between Photoshop and Painter to take full advantage of the digital replications of chalks, paints, pastels and oils to be found within. The examples below combine Photoshop and Painter. It is simple to lay in flat colours with Photoshop and then switch to Painter for a more naturally painted look. For cel shading or unfussy soft shading, Photoshop is easily sufficient, but the examples below give you an extra option.

Photoshop and Painter

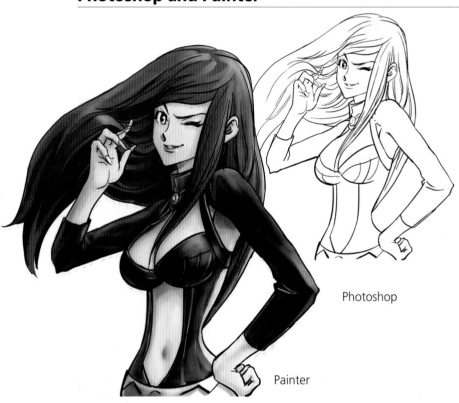

Photoshop

Painter

It is easy to show the differences between Photoshop and Painter. While Photoshop can do its best to simulate natural media with a range of brushes, textures and opacities, the results are still just combinations of various levels of colour: a 20% white over a 50% green, for example. Painter, on the other hand, has swathes of algorithms dedicated to reproducing the feel of natural media. Painter can simulate different styles of painting, from watercolours to pastels and oils, each of which allows the colours to act like 'real' pigments: blending, blurring, seeping naturally into one another, sitting in lumps on the canvas, picking up the texture of the page, and so on – all with the full levels of Undo provided by the digital realm. It can often be hard to tell the image has been created digitally at all.

◀ **Different strokes**
The image on the right, from Photoshop, clearly shows the digital crispness in the line art that is the package's strong point, while the example from Painter displays the effortless blending and natural textures for which it is famous. Either image can now be imported into the other package for further tinkering.

Switching between programs

It is easy to move files back and forth between Painter and Photoshop, but there are a few places where the translation is not exact (mainly for patent reasons).
- Use the .psd format to save files. The layers and quality will be best preserved when the file is moved.
- RGB is Painter's native colour mode. Although Painter *can* open files in CMYK, for best results it is better to stick to RGB if exporting to Painter.
- A Photoshop document without a Background layer will open in Painter as layers over a white background.

- Painter and Photoshop recognize most of the other's layer modes (Photoshop calls them blending modes, Painter compositing modes), but they have different names. For example, 'Magic Combine' in Painter is 'Lighten' in Photoshop, while 'Shadow Map' is Photoshop's 'Multiply'. There are some layer modes they cannot recognize: they will default to the basic layer mode.
- Photoshop type layers will be rasterized when imported to Painter. Don't letter pages before you have finished with Painter.

Painter interface ▲
Many of the Painter tools have clear Photoshop equivalents; the interface and menus are just as intuitive.

Practice exercise: Combined image

1 Open the line art in Photoshop. Fill in the flat colours and save the file as a .psd with layers. Close Photoshop and open Corel Painter (don't close Photoshop if your computer is powerful enough). Go to File > Open to open the .psd file.

2 Make a new layer, clicking the icon at the bottom of the Layers Palette. You will use mainly Digital Watercolor to paint this image. Select the skin areas using the Magic Wand first. Click on the Brushes, choose Digital Watercolor and pick the Simple Water Brush in the drop-down list. Choose a skin colour in the color palette or pick it from the flats using the Eyedropper Tool (J).

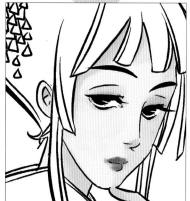

3 Using a large brush, paint the basic skin colour. Dry the colour with Layers > Dry Digital Watercolor. Pick up darker shades of the skintone, using a smaller brush to build up shadow and detail. Dry the watercolour when finished. (Please note: only skin tones show on this layer.)

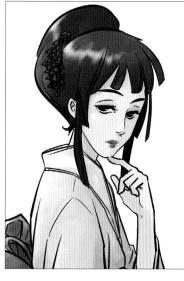

4 Select the Oils Brush and use a Thick Oil Bristle Brush to paint highlights in white. Use a mix of these two techniques to colour the rest of the image.

6 Save the image as a .psd file and open it back in Photoshop. First, blur the pattern layer using Filter > Blur > Gaussian Blur, with the blur set to a low radius. Next, change the layer blending mode to 'Screen'. The pattern now looks elegant and delicate, almost etched into the fabric.

5 To add interest to the illustration, you could add a pattern to the kimono. Add a new layer above the colouring layers. In the Brush drop-down list, choose Image Hose, then Spray-Size-P, Angle-R. In the toolbox, click the icon at the bottom right to choose a pattern: here, the pattern is 'Bay Leaves'. Spray areas where you want the pattern, clearing excess areas with the Eraser Tool. At the moment the pattern doesn't look quite right: it is too bright and the wrong colour, but you will fix this in Photoshop.

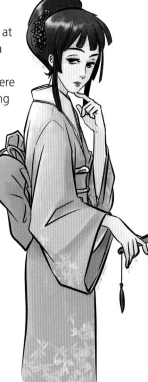

7 Merge this pattern layer with your colours. If you want to change the hue of any area, now is the time to do so. Photoshop has a stronger post-colouring editing ability than Painter, which finds the process awkward.

Digital shojo project

Shojo manga is largely aimed at young and teenage girls, and the artwork tends to be feminine and romantic. Shojo stories revolve around a female protagonist, and though they can take place in any genre, the focus of the story tends to be on the protagonist's search for love. Typically, there are many more panels depicting subtle changes of facial expression and a greater emphasis on feelings than in other manga, as well as specific visual cues that are rarely seen outside of shojo. As an example, flowers, bubbles or hearts surrounding a figure will give clues to her emotional state: romantic scenes of a similar ilk would be played for laughs in a shonen manga.

This project will show you how to create a typical shojo page, with an airy, panel-light layout, ornamental flowers, and tight focus on the central figures.

Leave-taking ▶
A warrior goes off to battle, his lover bids him goodbye ... before he offers her the chance to adventure at his side. The ornamental flowers speak of our heroine's love, but also press in around her claustrophobically, presaging the sadness she would feel in her lover's absence.

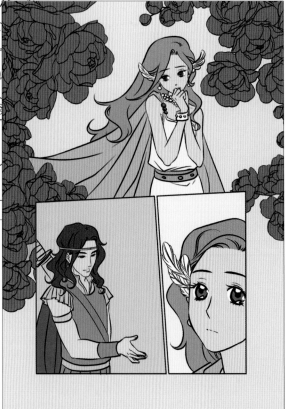

1 Sketch out a very rough thumbnail of your page, focusing on facial expressions and character poses above all else: the scene is about the connection between two characters. When you are satisfied, pencil a more detailed layout to give you a clearer idea of how to ink it in Photoshop.

2 Import the pencilled image into Photoshop using a scanner, at a resolution of at least 300 dpi. Convert the file to Grayscale and ink it digitally using the Brush Tool as you learned earlier, cleaning with the Eraser Tool and sharpening lines with the Pencil Tool as appropriate. Once you have finished, delete the rough image layer and add a new layer of white underneath the inks. Convert the image to RGB.

Create a new 'Normal' layer between the existing two and name it 'Flats'. On this layer, use the Paint Bucket Tool to fill the basic colours, using the Pencil Tool to seal improperly sealed areas if necessary, or to fill awkward nooks and crannies. Adjust the colours with the Hue/Saturation options (Image > Adjustments > Hue/Saturation) until you are content with the final result.

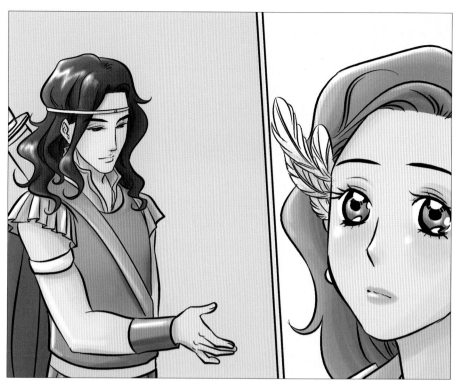

3 The soft shading colouring method is best suited to creating a romantic atmosphere. Duplicate 'Flats', rename the duplicated layer 'Colour' and set the mode to 'Normal'. Lock the 'Flats' layer, and use it to make selections of areas with the Magic Wand. On the 'Colours' layer, choose slightly darker colours than your original flats and use a soft brush with Opacity and Flow of around 30% to gradually build up the shading. Use still darker versions of the same hues to give the image depth by painting in darker shadows using a smaller brush.

4 You can either add your highlights on the currently active layer, or create a new 'Normal' layer and work on that. The second method is usually preferred, as it is easier to correct mistakes and will not interfere with your previously applied shading. Select lighter colours than your original flats and build up your layers of highlights with a brush as in the previous step. Add a bright white highlight, sparingly, on shiny areas that face the light. Add shine, shadow and detail to small areas you may have missed, such as the cheeks, lips, eyes and accessories.

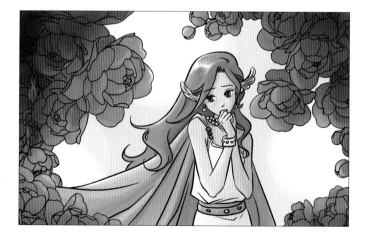

5 At present, the backgrounds are still very flat, and lacking in ambience. It is a very simple matter to select the flat areas on the 'Flats' layer and use the Dodge Tool to add flares of light to the areas of flat blue. The roses can be toned using the same soft-shading method used to colour the characters.

Tip: Experiment further with the use of abstract backgrounds: why not select all of the black lines making up the roses with a Lasso Tool and use the Paint Bucket Tool to colour the black a deep shade of pink? This 'knocks back' the line work even further and brings your characters to the fore.

6 The colours are complete: you just need to add your speech balloons. Use the Text Tool to type in dialogue in your chosen font, centring the text and arranging the content of each balloon in a roughly elliptical shape. Create a new layer underneath the text. Use the Filled Ellipse Tool with white as the foreground colour to draw balloons, moving the text to fit as necessary. Draw tails. Select the balloons using the Magic Wand Tool, and use Select > Modify > Border to add a 4–5 pixel empty selection around them. Fill this with black.

Digital shonen project

Compared to shojo, shonen manga is traditionally aimed at young and teenage boys. However, with the unisex success stories of manga like *Naruto*, today you are just as likely to find girls reading them too. Shonen manga is usually packed with fast-moving action and often focuses on a male protagonist.

This project will guide you in the creation of an action-packed shonen page: a pulse-pounding fight scene between our teen heroes and some angry, ambulatory trees.

Arboreal action ▶

There's no time to pause for breath in this thrilling, fantasy action scene. Impacts are heightened to a physically impossible level to sell the extreme power involved.

1 Begin by sketching out a rough thumbnail of the whole page. Here, the first two panels take up most of the page to show the scale and impact of the fight. At a larger scale, and still in pencil, create a more detailed, rough layout. The example above shows only a portion of the full page at this stage. Remember that you are creating a guide to make digitally inking your page easier in the next step.

2 Before scanning your page, add some more textural details in pencil, such as the bark of the trees or the exploding rock. When you are happy, import the detailed rough into Photoshop, scanning the page at a minimum resolution of 300 dpi. Convert the page to Grayscale mode and digitally ink the lines on a separate layer. Build up line weights by using different-sized brushes or going over existing lines. After you have finished inking, add a white background layer underneath the inking layer and delete your original rough pencils.

3 To begin colouring, change the mode to RGB. Add a new 'Normal' layer between the inks and white background: call it 'Flats'. Fill in your flat colours using the Paint Bucket Tool, sealing areas with the Pencil Tool as required, or using the Pencil Tool to colour in awkward areas in the line work.

4 The cel-shaded method works best for this project. Create a new 'Multiply' layer on top of 'Flats': call it 'Shading'. Using a light grey brush, paint areas of shadow. Use the 'Flats' layer to select colour areas using the Magic Wand Tool. Add another 'Multiply' layer above 'Shading' and call it 'Shadows': brush areas with a darker grey. Finally, create a new 'Normal' layer above the shadows called 'Highlights'. Add highlights in lighter colours facing the light source.

5 Backgrounds of solid colour leave the page looking flat. Add variations to make it look more vibrant. Duplicate 'Flats' and hide the original. Use the duplicate to select the backgrounds of panels 1 and 2, and the Dodge Tool to lighten the areas around the focal points: in panel 1, where the ground is breaking; in panel 2, the main characters.

6 To make the page more dramatic, add some speedlines. Use a stock image you have prepared earlier. Drag the speedlines to your image, Transform them to fit, and Erase unwanted lines. Add colour gradients to the lines and use layer blend and Opacity settings to integrate them.

7 Now, add dialogue and balloons. Add the dialogue using the Text Tool, and draw balloons on a layer underneath. Jagged balloons amp up the drama: draw them freehand with a Pencil Tool or Lasso Tool, fill them with black, then select them with the Magic Wand Tool, Contract the selection by 4–5 pixels, and fill with white.

8 Sound effects are very important to shonen manga, especially in the high-stakes environment of a fight scene. Accompany every jarring impact with a tooth-rattling piece of SFX, adding coloured borders to manipulated text.

Digital kodomo project

Kodomo manga is aimed at younger children. It is often educational, based around the acquisition of vocabulary in a fun, adventurous context. Few kodomo manga have been exported to the West, aside from famous brands such as *Hello Kitty* and *Doraemon*. Kodomo can accommodate many genres, so long as they are child-friendly and use relatively simple dialogue.

This project will show you how to create a typical kodomo page. The key is to keep everything simple and the characters cute.

Rampaging robot ▶
Note how the giant robot manages to look threatening and safe at the same time: the bulbous body and rounded edge make him a cute antagonist. Note, too, the bright colours, simple dialogue and reasonable font size.

1 Draw a thumbnail version of your page in pencil, sketching in your characters and the layout of the entire page. The dominant entity on this page is the giant robot, so make that the focus.

2 Create a scaled-up, more detailed version of your rough illustration with enough information to ink over.

3 Import the rough into Photoshop using a scanner, scanning it at a minimum resolution of 300 dpi. Convert the file to Grayscale and digitally ink it on a layer above your rough pencils. Keep the lines clean, bold, simple and open for colour, using bold outlines around your characters to separate them from the background. When the inks are finished, delete the roughs and add a white layer underneath.

4 Add a new layer between the inks and the white background layers, setting the mode to 'Normal' and naming it 'Flats'. Fill in the flat colours on this layer, choosing bright and attractive colours, erring on the side of visual interest rather than fidelity to real life. For example, the robot's smoke is here a bright orange, rather than a dull grey.

5 On a new 'Multiply' layer named 'Shading', use a light grey brush to add shadows, using the 'Flats' layer to make selections. Adjust the greys with Hue/ Saturation to make individual parts of the image more colourful.

6 Create another new 'Multiply' layer, name it 'Shadows' and add darker shadows again. Use a soft brush with Opacity set to 30% to give the dark shadows a more realistic, blended look, especially on the belching smoke and the blue sky in panel 1.

Tip: Use bold and contrasting colours that leap out at the eye – note the interplay between the blue and the orange in this example. Pick up children's picture books for the very young and take inspiration from their heightened, almost primary palettes.

7 Add a 'Normal' layer named 'Highlights' above the colour layers. Use a soft brush with Opacity set to 30% to lighten areas facing the light source, especially on the robot and the armoured boy. Use solid white to pick out extreme highlights.

8 Make a new 'Normal' layer for details on top of 'Highlights'. Use the same soft brush as in previous steps to paint some reflected colours on to your metallic, armoured elements, and add some wispy clouds to the sky in the first panel.

9 Use the Text tool to add dialogue, keeping the point size large and the vocabulary age-appropriate. Draw speech balloons on a layer beneath the dialogue and fill them with white as before; and then, as a final step, add some SFX.

Digital seinen project

Like shonen, seinen is aimed at males, but its target demographic is several years older – teens and twenty-somethings – and it also has a following among an older audience of people up to about forty years old. It normally attracts young people who are moving away from shonen and shojo. Seinen has a lot of overlaps with shonen, but will accommodate more mature themes, whether that be the 'maturity' of graphic violence, sex and nudity, or more adult approaches to inner feelings and emotional states. Seinen protagonists will also be older than shonen stars.

This project shows how to illustrate a typical seinen page in a relatively realistic style.

First date ▷

At a surface level, this page from a romantic comedy could be mistaken for a shojo tale, but note that although the woman is shown in close-up panels, the focal point of our attention is the man: it is his thoughts to which we are granted access.

1 Sketch out a very rough thumbnail in pencil to plan your page. As the scene is very 'talky' and not very dynamic, here each panel has been given a different perspective in order to add visual excitement.

2 Detail the rough in pencil to your satisfaction, and import it into Photoshop by scanner at a minimum of 300 dpi. Digitally ink the Grayscale roughs on a separate layer, then delete the rough when you have finished. Add a layer filled with white underneath the inks as a plain background.

3 Create a 'Flats' layer between the background and inks, and block in flat colours. Keep the colours muted to suit the realistic tone: browns, greys, greens and pale blues. The purples and pinks of the woman make her stand out.

4 This page best suits the cel-shading method. Add a new 'Multiply' layer called 'Shading' on top of the 'Flats', painting your shadows on this layer using a hard brush. Change the shaded colour from grey to a darker version of the area you are shading if it looks better. Use the 'Flats' layer to make your selections using the Magic Wand Tool.

5 On a new 'Multiply' layer named 'Shadows', added on top of the 'Shading' layer, deepen your shadowed areas by using a darker grey. Use this on areas such as the woman's hair (in the detailed close-up), the man's collar and behind the door.

6 Create a 'Normal' layer called 'Highlights'. Select the area you want to add highlights to using 'Flats'. Pick the appropriate colour from the 'Flats' layer, make it lighter in the Colour Palette, then paint the area using a brush.

7 Finally, add some effects to the page using another layer. To add the effect of light coming from the windows and door, use an 'Overlay' layer on top of all layers (including inks) and paint over the image using a light yellow.

8 Now add your dialogue to the page, using the Text Tool to input and layout the conversation between your characters, as well as detailing the thoughts of your male lead. Create a 'Normal' layer for balloons beneath the text layer. Draw the balloons with the Ellipse Tool. Set the foreground colour to white and check 'Fill Pixels' in the Options Bar. Draw tails pointing towards the right characters (thought balloons need a trail of dots). Select all the white balloons using the Magic Wand Tool and use Select > Modify > Border to add an empty selection of 4–5 pixels to each balloon. Fill this selection with black to create your finished balloons. Move the text or Transform your balloons to fit.

9
Anime

The term Anime is a catch-all way of describing all Japanese animation and the moniker applied to the 'big eyes, small mouth' art style approved by the West. While not every manga-ka wants their work translated to the screen, many see it as a route to larger audiences, greater popularity – and bigger financial returns. This chapter will give you the basics in creating your own manga-inspired animations.

The history of anime

'Anime' is coined from half of animation – literally 'anima', pronounced 'a-nee-may' – and is the common description for Japanese animated films and television shows. A large proportion of anime is based on popular manga. This means many, if not all, of the titles that have blazed to print popularity are also available as TV series or films. Long-running anime will often hit between 200 and 600 episodes before coming to a close. It is often said that the reason the Japanese took so strongly to anime is that their own live-action industry was so small compared to the mass-production factories found, for instance, in Los Angeles. Anime offered limitless possibilities for the filmmaker – in scenery, cast of characters and storytelling. The only barrier to the imagination was the time it took to transfer an idea from brain to transparent cel.

Format

Anime is released either through TV syndication – often as half-hour, 26-episode series – or as Original Video Animations (OVAs). For years, 'anime' was synonymous with low-quality animation. While the drawings and storylines would be of a high standard, the number of frames per second was low, for fiscal expediency. These cost-cutting measures often led to the stylistic tics we associate with anime: frames where little but the mouth and eyes move; lengthy pans across still, painted backdrops; and 'money shots', where an important sequence is animated with more frames than the surrounding animation.

Pokémon ▲
One of the most popular exports of children's anime in recent years has been the *Pokémon* series of films and TV shows, all based on the Nintendo Game Boy series of games.

First steps

◀ **Studio work**
A woman works in digital animation at Studio Ghibli in Tokyo. Colour is now often applied on the computer, which, along with the ability to add more frames, leads to a newfound digital smoothness in many anime.

The first true 'anime' is considered to be *Hakujaden,* or *The Tale of the White Serpent,* released by Toei Animation in 1958. Like the new wave of manga, it wore its Disney influences on its sleeve, and was a great success. Toei continued to release such films throughout the 1960s and 70s, eventually becoming a lynchpin of television with *Dragon Ball Z* and *Sailor Moon*.

Osamu Tezuka, the 'father of manga', was also heavily involved in the development of anime. He started a rival company to Toei, Mushi Productions, and released *Tetsuwan ATOM,* or *Astro Boy*, in 1963. Its success led to the creation of innumerable competing series, including similar success stories like *Tesujiin 28-go (Gigantor)*, *Mach Go Go Go (Speed Racer)* and *Jungle Emperor (Kimba The White Lion)*.

The anime form, like manga, encompasses every genre and type of narrative, from the straightforward to the more esoteric.

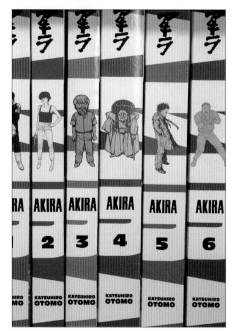

Print inspiration ▲
Manga-ka Katsuhiro Otomo began the screen adaptation of his magnum opus *Akira* years before the print story would be completed, leading the film to adapt only the first half of the epic.

Western breakthrough

The breakthrough in the Western awareness of anime was twofold: the cinematic release of *Akira* in 1989, and the rise of VHS. The expense of localizing a dub for each country meant such videos were expensive, but fans lapped them up. Ironically, at the point that anime films began their breakthrough, many Japanese studios were facing bankruptcy. With the death of Tezuka from cancer in 1989, a golden era of Japanese animation ended – but not before international curiosity had been piqued.

◄ *Spirited Away*
This 2002 Hollywood press conference at the El Capitan Theater marked another high for the international popularity of Hayao Miyazaki's films, and the penetration of anime culture into the mainstream.

1990s and 2000s

The 1990s and 2000s saw many exciting developments in anime, including the the advent of multi-tracked DVDs (allowing multiple dubs and subtitles to be placed on a single disc), and increasing use of digital techniques to bring lush and impressive imagery to OVAs, films and anime series. Where films and television are concerned, highlights include the release of *Ghost in the Shell* in 1994, which captured the same adult-oriented market as *Akira*; Hideaki Anno's *Neon Genesis Evangelion* in 1995, which revolutionized and scandalized in equal measure; the runaway international success of *Dragon Ball Z*, *Pokémon* and *Sailor Moon*; and the release of Hayao Miyazaki's *Princess Mononoke* in 1997,

which was the most expensive animated film at that point. Miyazaki, and his Studio Ghibli, is one of the leading anime *auteurs*. The studio, created with the proceeds from *Nausicaä of the Valley of the Wind*, continues to capture critical and popular acclaim with titles such as *Laputa: Castle in the Sky*, *Mononoke* and *Spirited Away*.

After the millennium, big-budget, adult anime spectaculars in the form of *Appleseed* (2001) and *Steamboy* (2004),

among others, returned to the cinema screen. Television anime productions continue to push the envelopes of creativity, style and provocative content, while the popular manga *Death Note* and *Fullmetal Alchemist* have swiftly made the transition from page to screen. Last, but by no means least, 2008 saw the creation of the position of Anime Ambassador by the Japanese government: a post filled by Doraemon, a (fictional) time-travelling robotic cat.

Princess Mononoke ▼
The film was released to US and UK cinemas in both dubbed and subtitled versions, the dub version receiving a sympathetic translation from famed novelist Neil Gaiman.

Ashitaka, prince of the Emishi ▼
Miyazaki's films fuse environmental awareness and lush cinematography with more contemplative and spiritual layers – as the unusual, cursed hero of *Princess Mononoke* illustrates.

Software

The first step in creating an animation is assembling all the tools you will need. There are certainly plenty of options to choose from. Fear not, however, as this section will introduce you to the most common digital animation software (and some hidden gems) so you'll have a good idea of what will suit you. It's worth investing a little time researching your tools, and most will offer trial periods so you can give them a test-drive. All of these programs are updated with new versions on a regular (often annual) basis, but if it helps you save money, there's often little need to be on the bleeding-edge of technology, as older versions will often be just as powerful as the latest iterations.

Flash

Adobe Flash is an extremely popular vector-based animation program with a powerful scripting language. The current version is CS4, which incorporates advanced features such as 'bone-rigging' and 3-D object manipulation. Flash can import images from other programs to use as backgrounds or as sketches to work over, but also contains all the tools you need to create an animation from scratch. Being the most popular, Flash has many websites dedicated to tutorials, tips and free SFX which can be very welcoming for beginners.

◀ Flash animation
Flash can save your finished animations as video files which can be burnt to DVD, uploaded to YouTube or saved to its web-ready format (.SWF). Flash is more than just an animation package, which means you can even add interactive elements to your animation. While Flash is rather expensive, a free trial version can be downloaded from Adobe's website.

Tip: Corel Painter is ideal for creating stunning backgrounds as it emulates natural media. This is because they look as if they have been traditionally painted. The latest version is Painter X, though Painter Essentials is a cheaper edition aimed at the casual user. While Painter has no animation features, it is included here as cel-style animation stands out better atop beautifully painted backgrounds. Find a couple of brushes and a blender you like and put them in a tool palette before you start painting, as too much choice can prove overwhelming.

Toon Boom

Unlike Flash, the Toon Boom range of products focus solely on creating animation, so while not as versatile, they can feel less overwhelming. Toon Boom has software for every level of animator, catering for kids, home users and professional studios. Toon Boom Studio features everything you need to create great animations and remains competitively priced, though the top of the range costs significantly more. Toon Boom is great at importing and manipulating existing artwork and has all the tools animators need, like 'onion skinning', automatic gap-closing and a full-screen rotary light table so you can always draw at the most comfortable angle. Toon Boom Studio can export your animations to a massive variety of formats including .SWF and video to suit devices from iPods to HDTVs.

Ready for his close-up ▶
Here we see a zoomed-in element of the Toon Boom window: a painted cel against the light table grid that makes compositing and scaling so simple.

Photoshop

Adobe Photoshop is a very powerful image-editing program which can be used for backgrounds, pixel/sprite animation or cel animation, although this versatility and power (and the fact it is universal image-editing software rather than a dedicated animation program) mean it's expensive. It can be tricky to use the animation window unless you're already familiar with Photoshop's layout and approach to layers, but as with all popular applications, you'll find dozens of tutorials online. Photoshop has had integrated animation capabilities since CS1, but in really old versions, the animation window can be found in the bundled software ImageReady (File > 'Edit in ImageReady').

Drawing cels ▼
Using Photoshop's powerful layer tools can make it very simple to draw traditional cel animations one frame at a time.

Fully painted background ▲
Photoshop is just as versatile as Painter when it comes to creating painted backdrops, although it doesn't attempt to simulate natural media.

EasyToon

EasyToon is mysterious little Japanese program (PC only) for creating preliminary 'pencil test' animations: basic sketched animations which are integral to making smooth and fluid progressions from frame to frame. While its functionality is limited, this makes it extremely effective and very quick to learn. A quick Internet search will find you a translated version, completely free to download.

Frame by frame ▲
'Onion skinning' effects show previous and next frames in different colours and levels of Opacity.

AnimeStudio

While AnimeStudio is not a traditional animation tool, it's fantastic for very quickly creating single scenes that you can tweak and perfect. Avoiding frame-by-frame animation, AnimeStudio relies entirely on a bone-rigging system to animate 2-D characters' limbs from pose to pose, thus speeding up the animation process. Working in AnimeStudio is quick and fun – but the animating method is restrictive and only one scene can be produced at a time: multiple scenes need Flash or a video editor to compile them together. Its soundtrack capabilities are also very limited.

Bone-rigging ▶
Each element of the character is a separate 2-D vector graphic, 'mapped' on to a 3-D skeleton that can be animated like a puppet.

Tip: If you're thinking of creating 3-D animation, Maya is a popular high-end choice thanks to its modern layout and extreme flexibility. Although Maya can be very expensive, there are options for varying skill levels and even a free Personal Learning Edition to enable beginners to get to grips with its complexities before committing. As with all 3-D animation, creating objects and characters takes a long time, but once created they can be brought to life with stunning results. Maya also includes many shading and lighting effects: you can render your animation with 'Toon Shading' to recreate the anime look of painted cels.

Pre-production

The first step to a successful animation is planning. Before beginning to animate, it's important to refine your ideas. After all, if you redesign a character's hair halfway through production, you will find yourself tediously reworking all the frames you thought you were done with. Many anime are adapted from manga, which are in turn usually drawn from a written script. This process means the story, locations, characters and even the kind of shots to be used have all already been considered. Even so, some details will need to be changed to suit animation. For example, many manga feature intricately detailed outfits that need simplifying for animation – removing buckles and frills or changing chainmail to plate at the beginning of a project can significantly reduce the man-hours involved. Whether based on your own manga, or on an idea that hasn't left your head yet, it's best to work out your animation in advance.

Creating your characters

Designing or adapting characters for animation doesn't differ greatly from other forms of character design, but there are a few things to bear in mind. First, the character should be simplified enough to draw efficiently thousands of times. Outfits, hairstyles and number of colours used can be simplified without losing the essence of the character. Patterned cloth can be replaced by flat colours, and soft shading represented by solid shadow.

Another thing to think about is 'secondary motion'. Also known as 'secondary animation', this is the name for reactive movements created from the main 'primary motion'. If a character is running, the secondary animation could be her hair bouncing and flowing behind her. When she stops, her hair will keep travelling (sometimes called follow-through) before falling back down. Secondary motion creates smoother-looking animation and can be applied not only to hair, but ribbons, a karate headband, or anything light and loose.

Secondary motion ▶
This animation is best used to flow two distinct movements into one another: from walking to jumping, for instance, or from sitting to standing.

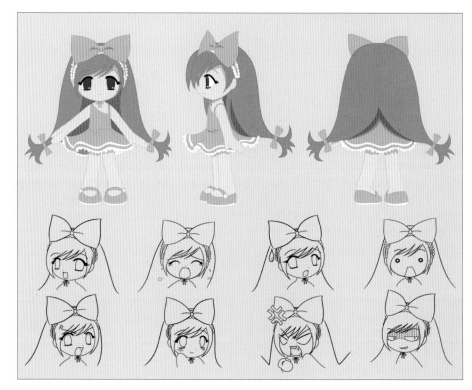

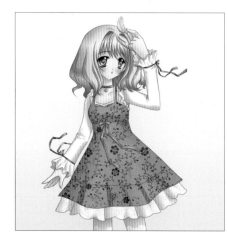

Original character ▲
Here we have a manga character whom we wish to adapt for animation. Note the soft shading, the many individual strands of hair, the floral print on the dress, and the numerous, reflective colours in her eyes.

Revised model sheet for animation ▲
A model sheet – pinning down your designs in a uniform way – makes it easier to maintain consistency. This is important if you're collaborating with other people, as everyone involved will know how tall the character should be drawn, what colour their eyes are and so on. A good model sheet includes multiple character angles (called a turnaround) and the colour palette. Additional sketches show facial expressions, body language and other subtleties.

Storyboarding

It's good practice to get action and dialogue down on paper (or screen) in some form before beginning. Not only will this avoid production problems, but the process of recording your ideas will refine your story. You can animate directly from a screenplay or from manga, but storyboards will help you plan every aspect of what appears on screen. Draw a new storyboard for each change of action, angle or scene.

Planning ▶

A storyboard shows a sketch representing the scene with dialogue, sound effects and camera movements noted nearby.

Action: Hand inserts coin.
Camera: Zoom in.
Shot: Close-up.

Action: Flicks through pages, stops and looks up.
Camera: Still.
Shot: Medium.

Action: Side view, walking left to right, yawning.
Camera: Still.
Shot: Medium.

Different perspectives

Cinematic shots, camera angles and movements will add style to your story, as well as help shape it. The examples to the right show various angles by which you can approach your scenes, each of which can present the same action in a different way.

While storyboarding, it's useful to think how you'll approach the actual animating. If a certain scene would be easier but no less effective from a different perspective, change it and save yourself valuable time later. Watch anime analytically: you will notice instances of time-saving 'limited animation' that can be planned for. Looped animations over a moving background, lower frame rates, extreme close-ups and panned stills are all examples of methods employed to save production time. Being efficient in this way leaves you extra time to perfect the most important sequences.

Low angle ▲
Looking up at the character from very low down. This grants the character a great deal of power.

High angle ▲
Looking down at a character from high up makes the character look vulnerable, small and isolated.

Dutch angle ▲
Low-angled shot, but from a tilted angle. This is used to portray tension or create unease in the viewer.

Close-up ▲
Tightly framed shot, used to bring attention to an item of significance.

Extreme close-up ▲
Zoomed in on one part (the eyes, for example) to emphasize emotion.

Point-of-view ▲
Shows what a character can see, as if we are looking through their eyes.

Backgrounds

Character animation needs to be placed on top of a background to complete a scene. It is usually better to create the background (or at least a rough version) before beginning the animating process. Background styles vary widely, from the detailed painted backgrounds Studio Ghibli is famed for, to the fun and childish scribbled backgrounds of Digi Charat. No matter the style, remember to make your background at least as large as your animation window. In most cases, the background will be a single image depicting the set or location, but some scenes will need extra layers or effects, or be longer or taller to facilitate pans, zooms or tilted scenes.

> **Tip:** You learned earlier how to create digital backgrounds from photographs, so why not apply the knowledge here? You can create extremely detailed background images with which your cel-shaded, wholly fantastical characters can interact.

Multi-layered ▶
If part of the foreground will obscure a character (here, a chain-link fence), the top layer can be designed and exported as a separate image. Most animation software will support images with transparency information (commonly using the .png format).

◀ Pans
Panned (or scrolling) scenes should be much larger than the screen size, so that the 'camera' can move across the background to the full extent required by the scene.

Parallax scrolling ▼
This is a method used to add a sense of depth to a background. It is produced with multiple layers, those layers that are closer to the camera moving faster than those farther away. The layers should be saved as separate images, with the layers nearer to the 'camera' being wider than those at the back, as they will scroll for a longer distance.

◄ Forced perspective

To mimic a camera turning around an object, or tilting up or down, a tall (or wide) background can have different viewing angles at each end. When panned, this gives the impression of the perspective changing as the camera moves. At the top of the example image, we're looking up at the building; in the middle of the image it's at our eye-line; and at the bottom, we view it from above.

Tilted pans ▲

If you're panning diagonally, rather than making a large square image (most of which won't be seen), it makes much more sense to only illustrate a wide strip which you can rotate to the desired angle.

Soft focus ▼

If the character is close to the screen, the background can be 'blurred' to achieve an 'out of focus' look, as though the camera were focusing on the foreground. This makes the character stand out.

Tip: You will soon find that many of the best animation tricks you learn are those that save you time in some manner, often while 'violating' a rule – of perspective, of finished art – that you held in high regard earlier in the book. Because drawing takes so long compared with doing a single image, 'perfection' should be found in an enjoyable finished result, but not in a single frame. There's no point in drawing (or animating) every single blade of grass in a field if the grass will be on screen for less than 20 seconds – the viewer's eye won't appreciate the detail. Apply detail only where it is needed: everywhere else, it is worth cheating.

Animation

Creating a fully animated character can certainly appear daunting at first. The scenes should be taken one at a time and can be split into a few simple steps. Even working digitally, the most effective method for character animation mimics traditional hand-drawn frames, a process which can be divided into three main steps: rough key-frames, in-betweens and cleaning-up. Once your character animation is done, you can compile the scene atop your great background, add your sound effects and move on to the next. Remember that you don't need to work on the animation in chronological order – it's best to tackle the simplest scenes first. It can also help to have a group of similarly minded friends to help you.

Rough key-frames

Once you've chosen a scene to animate, you should think about how the character moves and divide the movement into key poses.

Your key poses should show the start (and end) of each action or motion. For example, a character jumping could be divided into: standing pose; knees bent; apex of jump; knees bent; and back to standing. No matter what software you use, a graphics tablet will make drawing your frames much easier than using a mouse or trackball. These key-frame drawings aren't meant to be final artwork, and should only be sketched out at this stage.

Once you've drawn your rough keys, you can adjust the timing. A two-second jump at 12 frames per second should have the key-frames span 24 frames (2x12=24). Although this sounds like a lot of frames for a short amount of animation, remember that many frames will be identical and you can hold the first and final pose to add a few seconds to the animation. Now you need to think about in-betweening.

Beginning and ending frames ▼
In this example, our character begins shocked by something, and ends by pulling out a rocket launcher and declaring war. The movements are all in the arms and face.

In-betweening (tweening)

The process of drawing the frames between your rough key-frames to create smooth transitions is called in-betweening or tweening. At animation studios it's common for in-betweens to be drawn by assistant animators, but assuming you can't afford that luxury, let's get to work. Drawing a frame between two others can be tricky at first, but turning on 'onion skinning' will show faint versions of the previous and next frames, emulating a lightbox. To create your first in-between, simply redraw the character's body parts halfway between the two surrounding frames. Repeat the process to add more frames between. In-betweening can take some practice to get right, but there are a few tricks to creating smoother in-betweening.

Ease in ▲
Equal distances between each frame can make animations look robotic. To 'ease in' to a movement, the first in-betweens should be closer together, the distance increasing with each frame, making the action accelerate.

Ease out ▲
'Easing out' from an action makes a movement slow down to a stop. The end of the 'tween' should become tighter with the distance gradually decreasing between each frame until the movement reaches a standstill.

Overstretch ▲

Fast-moving limbs coming to an abrupt stop (punching the air, for example) look unnatural. For smoother-looking animations, add an extra frame before coming to rest which continues the momentum farther than the final frame.

Motion blur ▲

One frame might have to convey movement over a relatively large distance with a fast-moving object. Stretch or blur it across the full distance to make the animation smoother. Experiment with blur effects.

Tip: Before moving on to cleaning up your frames, be sure to play and analyse the animation several times, tweaking and adjusting individual frames as necessary. This is often called a 'line test', as you view the animation in its raw, line art state. Most modern software will provide you with ways of adjusting your in-betweens in much easier ways than by doing it manually on paper, giving you the ability to select and move small areas of each frame. Test and test again – it is important to get the motion of your characters perfect when it is in this state, as it's much harder – not to mention hair-pullingly time-consuming – to fix any problems in the animation when the frames are inked and coloured.

Cleaning up

Once you're happy with how the rough animation flows, you can start turning your rough frames into final artwork. There are many methods for doing this, but with traditional anime the roughs would be traced on to cels (transparent celluloid sheets). To reproduce this method digitally you can create a new 'layer' above your digital pencil test where you can trace your neat artwork. Alternatively, you can work directly on the sketches to clean them up.

Once clean versions of your rough frames are prepared, you can begin to colour the frames. Once all the pieces are ready, you can put everything together, add sound effects if needed, and finish the scene.

Colouring ▲ ▶

There are many styles of colouring to choose from, but the easiest is to use solid colours with no shading. The majority of anime, however, uses the distinctive visual characteristic of shading at a high contrast from the flat colours. To reproduce this look, you should outline and in-between the shapes of the shadows before filling them with colour.

Filling with colours ▲

Choosing which colours to use can be difficult. The characters have to stand out from the background, but not look out of place. Consider the lighting of the background. Night scenes might be rendered in shades of blue, summer scenes in bright saturated colours. In Flash you can adjust colours of an object with the colour settings of the properties panel, even changing the colours of characters within a scene: so your characters can meet and interact as the sun is going down, or in a darkened warehouse where fluorescent lights are suddenly turned on.

Cute dancer project

A cute dancing animation is an ideal first project, as the animation required is relatively simple; and the same frames can easily be repurposed to any kind of soundtrack you desire, whether by changing the timing using key-frames to sync up the dancing with the music, or by quickly recolouring your dancer and swapping in a new background to better suit a different genre. Such addictive and amusing animations – often of no more than 15 individual frames, repeating to crazy, sped-up music – can be found all over the Internet, spliced together by budding animators eager to make their mark on a worldwide craze. While you could seek out one of these animations and directly copy the poses as practice, for this project you will be creating your own completely original dance moves. The instructions for this project apply to Adobe Flash, but if you are using another animation package, the steps and process will likely be very similar.

Dance dance animation revolution ▲
The animation uses a vibrant, abstract background, and couples it with an extremely simple flat colour scheme for the central character. Only a few frames are needed to capture the dancing movement effectively.

1 The first step in your animation is to create your dancer. You will need to start with a model sheet turnaround of your character. The key here is simplicity: simple anatomy, engagingly cute form, minimalist colours and relatively few extraneous details. Our example, show above, is 'Eclair', a design that takes elements of a cheerleader and knocks them ever so slightly off kilter. The character herself is almost Chibi in proportion, with simplified hands and feet, and a face that is mostly large, shiny eyes. She contains only six colours. She also boasts long flowing hair and a segmented skirt that will react to her jumping around with interesting secondary movements.

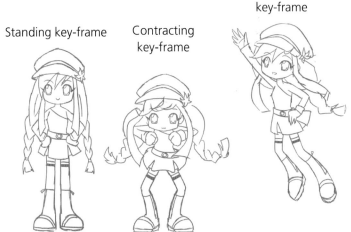

Standing key-frame Contracting key-frame Apex of jump key-frame

2 As mentioned in the project outline, your dance will not need many frames to be effective, with only three key-frames being unique. The rough keys you will have to draw will therefore be the initial, neutral standing pose, followed by a second pose featuring the character contracting, ready to jump, and the third and final key-frame, the apex (highest point) of her jump. In our example animation, Eclair will jump to the side, rather than straight up, as this means that you can effectively double the length of your animation by having the character jump to each side in turn. The second jump can be, more or less a repeat of the first only with the jumping frames flipped.

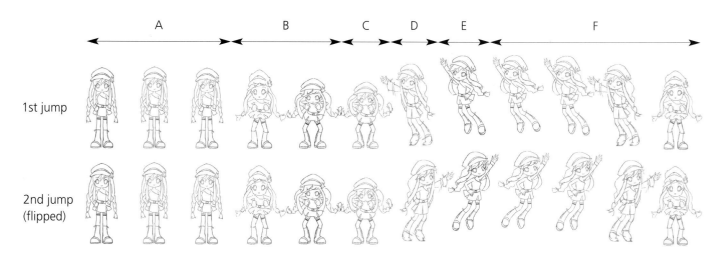

A B C D E F

1st jump

2nd jump
(flipped)

3 With your key-frames complete, it's time to move to in-betweening. As the second jump reuses frames from the first, you only have to in-between one. You can then modify it, rather than having to in-between both jumps. The stages below correspond to the timeline above.

A Before contracting, move the character in the opposite direction to her jump, extending her body as she 'inhales'. This keeps the animation 'bouncy' and makes the crouching frame more pronounced. This frame is a modified version of the first, head higher up, body slightly stretched. Her hair swings inwards. You can select portions of the sketch with the Lasso Tool, Transforming them to make slight changes.

B After returning to her original position, drop the character to her ducked-down position. The in-between is a halfway frame between standing and crouching. As she's moving very fast, stretch her to produce a motion blur effect. Leave her hat higher up to show it falling more slowly.

C After the crouching frame, ease out the movement of the previous two frames. Duplicate the crouching key-frame, moving her head farther down, her legs closer together and continuing her hair's momentum.

D Moving between the contracted pose and the jump should be very quick: it's in-betweened in a single frame. The jump key-frame is used as a base, but redraw and blur her limbs and stretch her hair and skirt.

E A modified jump frame follows the key-frame as the actual apex of the jump, easing out the motion as gravity catches up with the character. Bend her legs slightly, make her hair bounce and continue the momentum of her hand.

F On the character's descent, the frames making up the ascent are reused in reverse order. Modify the blurred frame slightly so that the hair falls slower. Before returning to the default pose, the blurred crouching pose is reused to show the character quickly dipping on impact.

4 Play the animation and analyse it, tweaking any frames that need adjustments. The frames are then all repeated, with the second jump's frames flipped. Of course, as the design is asymmetrical, some of the details, particularly in the top, will need editing after the frames are flipped.

5 When you are content with your animation, clean up the frames. Copy the frames into a new graphic symbol called 'Eclair' and add a new layer. Trace unique frames with either the Pen Tool or Brush Tool. Alternatively, prepare your frames in another program and import them into Flash. Don't draw identical frames more than once.

6 Once all the frames are finished in the top layer, you can remove your roughs, exit the graphic object, and place it into context on the stage. You can then add a simple background in a new layer below the object. Make sure the 'Eclair' graphic symbol is set to Loop mode, then insert enough frames (on both layers) to cover whatever music you want her to dance to.

Walk-cycle project

The somewhat daunting 'walk-cycle' is essential to the animation of human or bipedal characters. Its complex nature makes it great practice for all the fundamentals of animation. The resulting frames can be reused in a variety of ways and circumstances in your animations. It is slightly more advanced than the previous project, but breaking it down into small steps simplifies the process. Like many artistic endeavours, it is more time-consuming than difficult. Unlike our last project, a walk-cycle will almost certainly be a part of a larger project. If you're planning a project that could use a walk-cycle, this is a great place to test and hone your abilities.

Walk-cycling the mean streets ▶
Using a scrolling, repeating background, a similarly repeating walk-cycle and a number of foreground elements that pass in front of the character, you can create a very convincing – and reusable – animation of a character out for a walk.

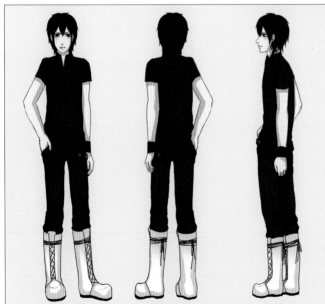

1 Before beginning your animation, you will need to create a model sheet for your walker. Here, we have created a more complex character in a mature style, making use of six base colours and their attendant shades. Anime-style cel-shading significantly increases the amount of colours in use on every frame, but this character's relatively simple clothing keeps the colouring process from becoming too complex.

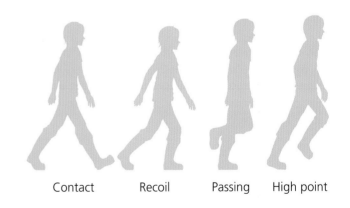

Contact Recoil Passing High point

2 When you are satisfied with your character, start creating your rough key-frames. A walk-cycle typically has four key-frames per stride: 'contact', 'recoil', 'passing' and the 'high point', making eight key-frames for a full cycle (four for each leg). The animation starts with the most important 'contact' pose, where the foot touches the floor. In this frame, the legs and arms are at their farthest apart. The second key-frame is the 'recoil' pose, where the character's weight is transferred on to the grounded foot. This is followed by the 'passing' pose where the character's legs and arms pass each other. The character then pushes himself into the 'high point' pose, bringing his opposite foot forward ready to land into a second 'contact' pose.

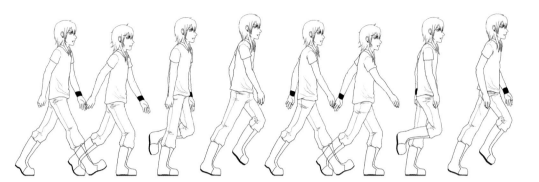

3 Rough in key-frames for both strides, as shown at right. How far the character contracts and expands during the recoil and high point can change the look of the walk. Posture and the swing of arms and legs can also help represent their personality.

4 As the walk-cycle has a relatively high number of key-frames, you can play-test and adjust your keys before adding in-betweens, making sure the animation plays nicely. Because this character is rendered with cel-style shading, it can be useful to outline shadows at the key-frame stage.

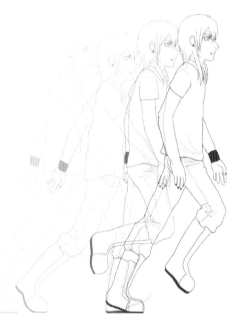

5 Once the key-frames have been tested and tweaked, add in-betweens. For animation at 12 frames per second, a single in-between for each key will be sufficient for a stroll (totalling 16 frames). The walk-cycle is one continuous motion, so each in-between should be halfway between the surrounding frames, with no easing in or out.

6 Clean up your frames after tweening. Copy them into a new graphic symbol and add a new layer. Trace each frame with the Pen Tool or Brush Tool. Once the frames are inked and coloured, add shading by selecting each fill and drawing in the shadow. You may need to move your rough layer to the top. You can then delete your roughs, exit the object, and place it on the stage. Set it to loop mode.

7 Create a seamless background (the left edge must match perfectly with the right) in Photoshop and then import it into Flash, so that the character can walk across the screen, or have the camera tracking the character with the background scrolling past.

8 To animate your background, make a graphic symbol called 'looping bg' with two copies of the background. Convert the backgrounds to their own symbols and layers and 'motion tween' (or 'classic tween') them, so that the second ends up in the place of the first. Adjust the number of frames so the tween moves at the right speed. 'Create Key-frame' on the penultimate frame, then delete the final frame. This removes the duplicate of the first frame.

9 You now have a symbol containing a looping background which you can drop into the stage on a layer beneath your looping character.

Glossary

Adobe Photoshop The market leader for digital art software. Photoshop is a program equally adept with naturalistic shading and bright cel-colours, and comes with a wide range of useful tools, effects and filters.

Animation/anime Moving imagery using drawings, stop-motion models or 3-D computer rendering to tell a story. Many anime – the widely adopted term for Japanese animation – are adapted from manga, and utilize a similar style.

Archetypes Characters you would expect to find in a particular genre of story, without whom the story may be unable to progress. Archetypes include a young protagonist who is destined to become a hero, along with the old man who will become his mentor.

Background The items or characters in the rear of a panel or scene; the scenery created around characters.

Bitmap A type of image file, so named because it provides a map of all the bits – or units of digital information – contained within it.

Bristol board The most commonly used form of 'paper' among comics professionals – its consistency is perfect for both pencil and ink work.

Cel shading A colouring technique made famous by anime utilizing a bright midtone and sharp-edged shadows.

Character A single active entity in your story. They can be human, alien, animal, monstrous or other: they count as long as they play a part whether large, small or cameo in a narrative.

Chibi Japanese word to describe characters that are shrunk into a small, cute, child-like form. This drawing style is sometimes called 'super-deformed'.

CMYK The colour mode and spectrum used in printing formed from subtractions of the secondary colours cyan, magenta and yellow, with black added as a separate element.

Colour Anything that is not in grayscale: in digital terms, this can be anything from two to millions of colours.

Comic A sequential narrative that uses a mixture of complimentary words and pictures to tell a story.

Corel Painter A digital art program that accurately reproduces the look and feel of traditional media such as water colours, oils and pastels. It can be used in conjunction with leading programs such as Adobe Photoshop.

Cross-hatching A method of pen or pencil shading by which parallel lines are crossed over one another to form 'hatches'. The closer and more dense the lines, the darker the area.

Cyberpunk A genre that confronts the future potentials of technology and increasing prevalence of the internet in the modern world. Often, cyberpunk stories are set in future dystopias where technology has run rampant, but it can just as easily raise philosophical questions of consciousness, humanity and spirituality in a world of artificial intelligence, cyborgs, robots and human augmentation.

Dialogue The words spoken by characters during a story, shown on the page as the contents of 'speech balloons'.

Digital Produced or viewed on the computer, as opposed to traditional media, where everything is created offline using physical materials. A digital comic can be entirely created, distributed and viewed on the computer, without creating a physical piece of artwork.

Dip pen The most commonly used form of inking pen. A plastic handle

grips a metal nib, which is then dipped into a pot of ink.

Distortion An alteration of an original shape or illustration for deliberate effect. Distortion can be used to change, size, shape, or place an image into perspective.

Dots The smallest unit of ink produced by an inkjet or laser print, and thus the unit of measurement for print resolution.

DPI Dots Per Inch. *See* Resolution.

Drawing tablet A computer peripheral used with a a pressure-sensitive stylus to draw directly into a digital arts program.

Effects Applying an effect in Adobe Photoshop or similar transforms a basic image with options such as lens flare, colour blends, and many more. *See* Filters.

Filters Algorithmic tools in digital art programs that allow you to apply various advanced effects to finished or in-progress artwork. Filters range from adding blurs and textures to creating blooms of light and film stock noise. Programs such as Adobe Photoshop come bundled with a wide selection of filters, and more can be purchased and installed as 'plug ins'.

Flash A digital art program specifically designed for Internet graphics: it can easily produce web-ready animations and even games.

Focus This can be: i) where the reader's eye is or should be directed in any particular panel or page; ii) the most important element of a panel or page; iii) depth of field – the use of blurring effects and filters can create focus effects similar to those in films or photographs.

Font A lettering style or typeface, used to write dialogue or sound effects.

Foreground Items or characters

towards the front of a panel or scene.

Foreshortening The act of drawing items larger in a panel as they get closer to the 'camera' in order to exaggerate the perspective.

Focus lines Tightly spaced lines radiating out from the focal point of a panel to denote emotion, a shocking moment, or to highlight speed.

Frames i) the elements that make up an animation: 24 frames per second produces life-like movement, though many anime average closer to 12. ii) another term for panels; the building blocks of the manga page.

Graphic novel Either a book-length collection of existing, previously serialized material (*see* tankubon for the manga equivalent) or an entirely new, book-length sequential narrative.

Grayscale A shading technique using 256 shades of grey.

Halftone The shading method most widely seen in printed manga, it reduces greyscale shading to a series of moiré dots: a greater concentration of dots, the darker the grey.

Hero This can be: i) a brave and noble man distinguished by great ability; ii) the main male character in a piece of fiction.

Heroine This can be: i) a brave and noble woman distinguished by great ability; ii) the main female character in a piece of fiction.

Highlight Bright areas of colour or grayscale applied on areas facing toward the main light source, in order to add depth to an image.

Hokusai A famous artist of ukiyo-e woodcuts, he was the first to use the term 'manga' in connection with illustrated scenes, in the title of one of his portfolios.

IG/Production IG An anime company known for its high quality animation. They have been involved in such famous anime as *Ghost in the Shell*, *Blood: The Last Vampire* and *Patlabor*.

Indian ink The most commonly used form of ink: its consistency is perfect for use in dip pens and with brushes, and it is more resistant to light, heat and water than technical or writing pen inks when dry. Pens and brushes must be thoroughly cleaned after use to avoid clogging.

Inking The act of drawing over rough or finished pencils in black ink, tightening lines and adding shading, definition and texture in the process, to produce artwork that will scan, colour and reproduce more cleanly. Today, many artists prefer to 'ink' their pages digitally using Photoshop and a stylus – others prefer to colour straight from pencils, missing out the inking stage altogether.

Jidaimono Japanese plays that feature historical plots and characters, often based around Samurai. The word is most often translated as 'period plays'.

Josei Manga created for late teenage and adult female audiences. They tend to be about the everyday experiences of women living in Japan.

Jpeg/jpg A file format created by the Joint Photographic Experts Group, it is the standard file format for full colour images in millions of colours on the web.

Kodomo Manga aimed at younger children, often with an educational element, but always using attractive, cute characters, bright colours and uncomplicated dialogue.

Lady comic See Josei.

Layers The building blocks of a digital page. Each element – from line work to colouring – is held on a separate, editable layer, until the final, print-ready file is compressed.

Layout This can be: i) the stage of page-creation when one sketches in the placement and size of the panels, and the major characters and features within them; ii) the placement of panels on the page.

Lettering The placement of dialogue and sound effects (SFX) on the page, whether by hand or digitally.

Line A mark long in proportion to its breadth, made with a pen, pencil, brush or digital tool. 'Line art' is black ink lines on a white page.

Mahokka 'Magical girls': genre of shojo stories featuring girls with secret identities and special powers, who usually fight monsters and attend school at the same time.

Manga-ka The creator – or chief creator, in the case of a manga-ka who runs their own studio – of a manga.

Materials A catch-all term for anything used in the process of creating art, from the paper you draw on to the substances used to capture the lines and colours.

Mecha Another term for the giant robots that populate many manga (particularly shonen).

Meiji Era The 45-year rule of the Meiji Emperor, from 1868 to 1912, during which Japan began its modernization and ascended to the world stage, ending its isolationist policy.

Nib The tip of a pen, used to hold ink and transfer it to the page. Dip pens use forked prongs to pick up and transfer the ink, the harder the nib is

pressed, the wider the line; technical pens use a hard but permeable nib to produce lines of the same thickness and consistency.

OEL (Original English Language) Manga produced by artists and writers in either the UK or US, following the stylistic conventions of Japanese manga in an entirely new, untranslated story.

Opaque Not transparent; a colour that obscures anything it is placed on top of.

Outline This can be: i) the line surrounding a distinct shape or object; ii) the rough form of a story or plot, prior to fleshing it out as either a detailed plot or a full script.

OVA (Original Video Animations) Anime productions that are produced to be sold as DVDs (or previously, as VHS) in the first instance, rather than to run on syndicated television. OVAs tend

to have higher production values and greater fan reception than many of the TV series they are based on or in competition with. *See* Anime.

Palette This can be: i) the sum total of all the colours used in a particular piece of artwork; ii) the place to select any of the millions of possible colours within a digital art program; iii) the place where your currently used colours are stored.

Panel The basic building block of a manga page. Panels can be any size or shape, but each contain a single unit of action. The movement in a manga story happens in the 'gutters', or white areas in between each panel.

Pattern An image or series of colours that repeat or can be repeated.

Perspective The means by which 3D is

simulated on the page, according to one or more vanishing points, to which all of the lines and objects in the panel or page diminish.

PPI Pixels Per Inch. *See* Resolution.

Protagonist The central character of a story and manga: they may not be a 'hero' in the traditional definition of the term, but the story is told from their viewpoint and readers follow their actions for the bulk of the narrative.

Quasi-historical A story set in a roughly historical period, i.e. Samurai-era Japan, without conforming to rigid historical events or personages. Such stories may include anachronistic or contra-historical elements.

Resolution The amount of pixels per inch (on screen) or dots per inch (on paper) that an image is scanned, edited and saved at. The higher the resolution, the sharper the image. 600 dpi is typical for scanning, 300 dpi for print, and 150 dpi for the web.

Retouch To clean up artwork, digital imagery or photographs using digital tools to erase dirt marks, mistakes, colour irregularities and continuity errors.

RGB The colour mode and spectrum formed from mixtures of the primary colours red, green and blue. It is used to present imagery through monitors and television screens.

Roughs A mocked-up or hastily sketched version of a page, in pencil. This may form the first step in the process of tightening the pencil art for inking, or they may be discarded and kept only for reference.

Scale The size of a given piece of art. 'To scale' means to make a piece of digital artwork larger or smaller, a process that can be accomplished with percentages or exact values of pixels, metric or imperial units.

Scanner A computer peripheral that inputs physical artwork into the computer using reflected light.

Scene A unit of story, denoted by continuity of character or location.

Script The last result of the planning phase, when the contents of your panels are written as description and dialogue.

Seinen Manga aimed at older males, from late teens and up. Its themes may

appear superficially similar to shonen, but it will include more explicit content.

Sentai Literally, a military unit, but in manga, anime and Japanese TV, it is often used to denote a squadron of three to seven characters who band together to pilot giant mecha.

SFX lettering Lettering designed to mimic a sound effect, in an onomatopaeic fashion. Any sound can receive SFX in this manner, from explosions and gunfire to blinking and breathing.

Shade This can be: i) the mixture of a colour with black to reduce lightness; ii) synonym for 'colour'.

Shadow Darker areas of colour or greyscale applied on areas facing away from the main light source, in order to add depth to an image.

Shojo Style of manga aimed at young and teen girls, with strong female protagonists. Can cover a multitude of genres, but romance and the emotional interior world are usually paramount.

Shonen Style of manga aimed at young and teen boys, with strong male protagonists and an emphasis on action and dominance of a particular field.

Shortlines A type of shading that uses very short, overlapping lines to suggest

depth and shading. The more lines there are on a given surface, the darker that surface is.

Sketch A very rough drawing, done to transfer an idea to paper in the development stage.

Soft shading A form of shading using multiple shades of the same colour, blended into one another. Unlike cel shading, soft shading uses multiple intermediate tones to create a more naturalistic effect.

Speech balloons (bubbles) Oval or elliptical white balloons that carry the dialogue of characters. A 'tail' points from the main balloon towards the relevant character's mouth.

Speedlines Tightly grouped lines radiating from or attached to a swiftly moving character in order to denote motion and relative speed. Focus lines can also be used to show a head-on character in motion.

Spokon A genre of manga in which the principal characters are athletes, and the majority of the stories revolve around a sport. Usually the 'aim' of the manga is for the team, and the central protagonist, to become the best they can at their chosen sport.

Steampunk A genre that takes the superficial trappings of cyberpunk and applies them to a quasi-19th century world, positing that computing and robotics were created in the age of steam and rivets, rather than the silicon age. They tend to be more freewheeling and optimistic stories than their cyberpunk equivalent.

Stereotype A preconceived, oversimplified, demeaning and exaggerated assumption about a person or persons based on age, class, ethnicity, occupation, etc. While negative in tone, stereotypes may be used as the basis for characters – either characters who subvert the stereotype, or those who consciously live up to it.

Stippling The use of tightly packed individual dots to create shading. The closer the dots are placed, the darker the shade.

Strip Any sequence of comic or manga images. In the West, it is most often used to refer to the four panel 'comic strips' found in newspapers, though the terms are largely interchangeable.

Stylus A pen-shaped input device used with a drawing tablet to draw imagery directly into a digital art program.

Super-deformed characters
Characters exaggerated in their cuteness and diminutive stature, often lacking noses, fingers, and anything but the most rudimentary or comical details. They may be characters in their own super-deformed style piece, or represent an extreme emotional state of an otherwise naturalistically-drawn character (*see* Chibi).

Tankubon The manga equivalent of graphic novels or trade paperbacks: book-length collections of manga stories previously serialized in a weekly or monthly manga magazine.

Technical pens These pens come in a wide variety of styles and nib thicknesses, and usually carry their own ink supply as cartridges. They produce rigid lines, excellent for backgrounds, buildings and mechanical items.

Thumbnails Early draft layouts of pages, at diminutive sizes. Most useful for checking page and panel compositions before committing to a larger work.

Tint This can be: i) the mixture of a colour with white, to produce lightness; ii) synonym for 'colour'.

Tone A method of shading using pre-created patterns of moiré dots. In the pre-digital era, tone would be cut with knives and 'rubbed down' on to the page: now tones can be applied as patterns in Adobe Photoshop, or created from greyscale shading.

Tufts The bristled ends of paintbrushes, which come in a variety of styles, from pointed round to fan.

Viewpoint This can be: i) the literal position from which a panel or page is drawn; ii) the perspective through which a given story is filtered or told; iii) a philosophical, ideological or moral perspective.

Villain The central antagonist of a story, usually one who is dedicated to tearing down the life of the hero or heroine, or who is endangering the hero's family, city or world with their schemes. Their defeat usually signals the end of a story, though one ongoing manga may feature dozens of minor villains before the final 'big boss' is reached.

Web comic A comic either presented on the web, or designed specifically for it and its viewable dimensions.

Year 24 group A group of female manga-ka born in Showa 24, or 1949. They revolutionized the techniques and content of shojo manga, as well as marking the first time that shojo had been written and drawn, as well as read, by women.

Index

Acknowledgments

The publisher would like to thank the following for kindly supplying photos for this book: ALAMY: Japan Art Collection (JAC)/Alamy 6 (top), Paris Pierce/Alamy 6 (bottom), Interfoto Pressbildagentur/Alamy: 7 (top), Jeremy Hoare/Alamy 10 (bottom left), Chris Willson/Alamy 11 (top), Digital Vision/Alamy 11 (bottom right), Alamy Photos (12) 235 (bottom left and right); BRIDGEMAN: 7 (bottom), CORBIS: John Van Hasselt/Corbis 10 (top), Amet Jean Pierre/Corbis Sygma 9 (bottom left), Annebicque Bernard/Corbis Sygma, TWPhoto/Corbis 234

(top); Ferreol Murillo Fuentes 7 (right); GETTY IMAGES: Getty Images/New Vision Technologies Inc. 11 (bottom left), Getty Images/APF 234 (bottom right), 235; LAST GASP: Keiji Nakazawa 10 (middle); TOKYOPOP INC: 9 (bottom); TOPFOTO: Topham Picturepoint 234 (bottom left); VERTICLE INC: 8 (both), 9 top.

Thanks to Pen to Paper, Lewes for providing the pen nibs and The Art Shop, Wadhurst for supplying artist's materials for photography.